DESMOND MORRIS
50 YEARS OF SURREALISM

Silvano Levy

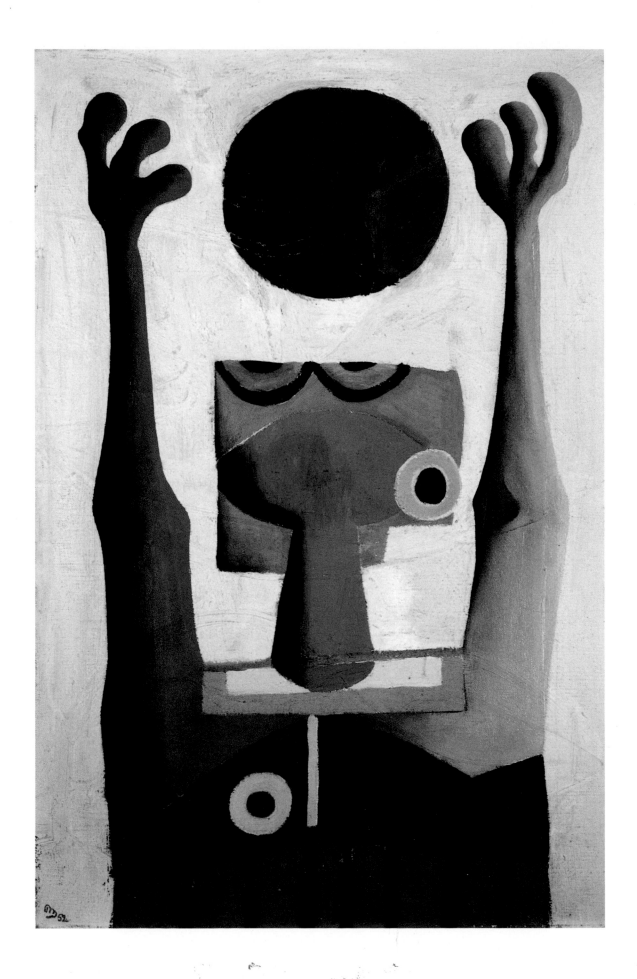

DESMOND MORRIS
50 YEARS *of* SURREALISM

Silvano Levy

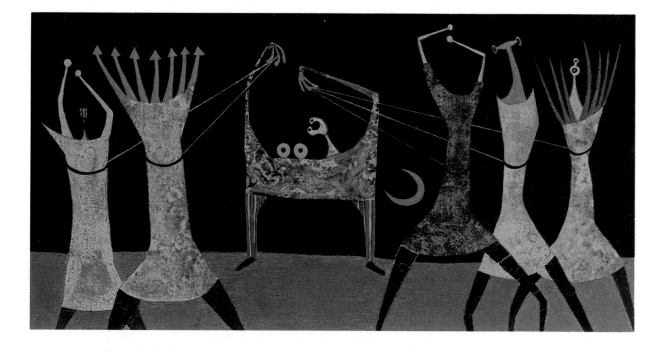

BARRIE & JENKINS

For Conroy Maddox

First published in Great Britain in 1997 by Barrie & Jenkins

1 3 5 7 9 10 8 6 4 2

Designed by David Fordham

Barrie & Jenkins Limited
Random House, 20 Vauxhall Bridge Road, London SW1V 2SA

Random House Australia Pty Limited
20 Alfred Street, Milsons Point, Sydney, New South Wales 2061, Australia

Random House New Zealand Limited
18 Poland Road, Glenfield, Auckland 10, New Zealand

Random House South Africa (Pty) Limited
Endulini, 5A Jubilee Road, Parktown 2193, South Africa

Random House UK Limited Reg. No. 954009

A CIP catalogue record for this book is available from the British Library

ISBN 0 7126 7298 2

Typeset by MATS, Essex
Printed in Singapore

BALL GAME *(page 2)*
1952
Oil on canvas
24 x 16 in. (60 x 40 cm.)
Collection Jens Birger
Christensen, Klampenborg,
Denmark

THE CHARIOTEER *(page 3)*
1957
Oil on canvas
7 x 14 in. (17.5 x 35 cm.)
Collection Mr John Nadler,
London

THE NEST II *(page 5)*
1947
Oil on canvas
13 x 19 in. (32.5 x 47.5 cm.)
Private Collection, Vienna

Contents

Acknowledgements

I AM GRATEFUL to Desmond Morris for the considerable time and thought that he has devoted to the discussions and interviews from which the ideas in this book have developed. Despite his many filming and writing commitments, he made himself available to answer questions and to voice opinions whenever the need arose. Thanks are also due to Katherine Emma Jones for her enlightening and perceptive comments on the paintings and on the novel *Inrock*. Andrew Murray of the Mayor Gallery has provided valuable assistance in the planning and realization of this book. Ian Vines and Sarah Macdonald of the City Museum and Art Gallery, Stoke-on-Trent, facilitated access to many works and gave useful comments on their interpretation. I am grateful to Julie Jackson for her help with bibliographical research. Helpful insights were provided by the professional expertise of Dr Jeffrey Sherwin. I wish to thank Terry Bolam and Jane Bown for their excellent photographic work.

Particular thanks are due to Damon de Laszlo for his invaluable support during the preparation of this book.

Preface

THAT THIS BOOK can be written at all owes much to the art critic Mervyn Levy. Had it not been for his encouragement and support during the late 1940s, Desmond Morris might well not have persevered along the course which has led him to a significant position in the history of Surrealism in Britain. During those years, when these two art devotees were brought together by National Service, Surrealism was an extremely unpopular movement. This public mood meant that Morris's espousal of Surrealist techniques and ideals invariably met with derision or, at best, indifference. Against the tide, Levy furnished the much needed impetus. It was his endorsement that provided the crucial catalyst which goaded the teenage Morris towards what was to become a lifelong dedication to Surrealist exploration.

Such was Levy's confidence in the artistic potential of his fellow conscript that in 1948 he spoke of him as follows in a BBC radio broadcast:

> Man is an animal. The only thing which makes him greater than other animals is his ability to create a work of art. But there are degrees of artistry, and a painter has to decide whether he is merely going to accept the superficial, purely visual world as it stands – a tree, a face, a ship – or whether he will endeavour to record the intangible kernel which is to be found within, at the heart of every physical shape and form in existence.
>
> Desmond Morris, like many of his contemporaries, uses the merely visual world as the starting point from which he distils his own universe of shapes and patterns, colours and feelings. Already his work displays a power, vision and personality peculiar only to himself.
>
> His strongest quality in the present stage of his development is his unusual ability purely as a craftsman – a technician – a tremendous attribute in an age of brutish mass-production, when most forms of artisanship are extinct. I feel certain that once he has fully realized and developed his own imaginative potential, he may well produce an important and unique art.

PREFACE

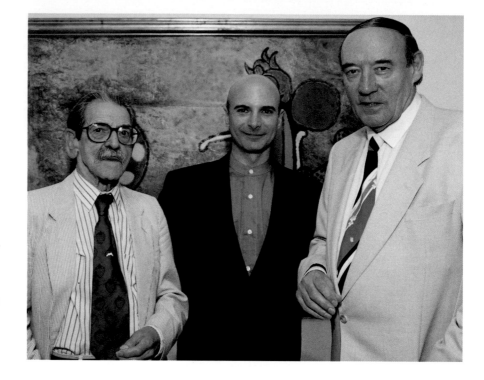

Left to right: Conroy Maddox, Silvano Levy and Desmond Morris at the opening of the exhibition 'Desmond Morris: 50 Years of Surrealism' in June 1996 *(photo: Sentinel, Stoke-on-Trent)*

Credit for the persistence of Morris's endeavours as a painter is also due to Edouard (or 'E.L.T.', as he preferred) Mesens, who, with René Magritte, Paul Nougé and Camille Goemans, had been responsible for the rise of Dada and then Surrealism in 1920s Brussels. As a result of the discernment of this Belgian poet, collagist and art-dealer, Morris not only enjoyed his first solo exhibition in London at a very early stage in his career, but he did so in distinguished Surrealist company. In February 1950 the London Gallery at 23 Brook Street showed eighteen works by the twenty-two-year-old Morris alongside a show by Joan Miró, who, as the catalogue pointed out, was already by that time well recognized as a 'painter of world-wide reputation' who had 'work in the permanent collection of the Museum of Modern Art (New York) and in the most important collections in Europe and the USA'. Of Morris the same catalogue states: 'His recent works show a steady affirmation of personality.' In a review of the exhibition, Wyndham Lewis asserted his confidence in the young artist: 'I feel sure that something will emerge,' he wrote. It is due to Mesens that Morris, as he himself later remarked, 'stepped right into the middle of the history of English surrealism'.

Whilst Levy and Mesens were instrumental in launching Desmond Morris into the world of Surrealism, it was the inspiration provided by Conroy Maddox that propelled him along his chosen artistic trajectory. What primarily kindled the flame of Morris's rebellious art was the example and influence of the work and personality of Maddox. It is in recognition of that pivotal role that this book is dedicated to him.

1

Zoologist or Artist?

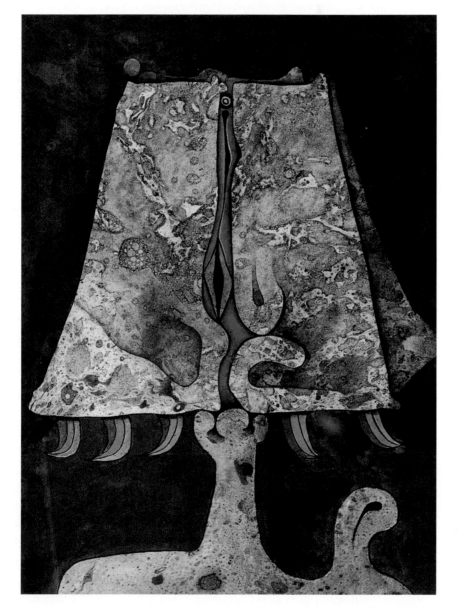

Secret Thinker
1988
Mixed media
11½ × 8 in. (29 × 21 cm.)

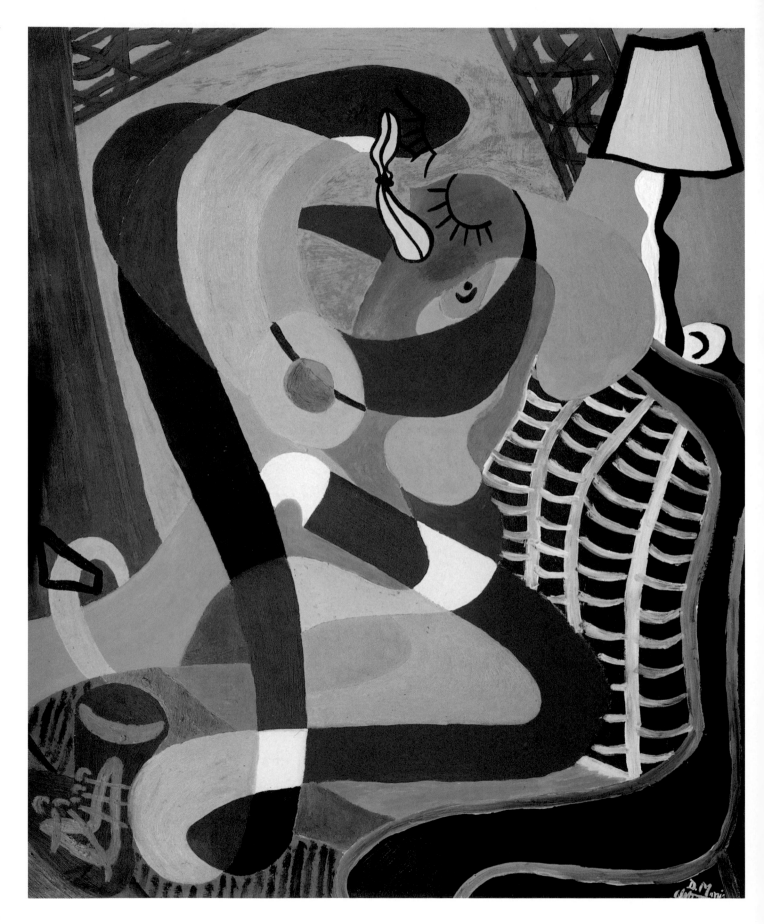

Zoologist or Artist?

It's no good, they won't go away, they are following me into the studio and grazing all over the canvases.
DESMOND MORRIS, 'THE DAY THE ANIMALS CAME', 1949

D ESMOND MORRIS has an international reputation as author, broadcaster and zoologist. He is best known for his pioneering work on human behaviour, which was first brought to the public's notice with the publication, in 1967, of the enormously popular and, according to some, shocking book *The Naked Ape*. Over twelve million copies have been sold throughout the world and it has been translated into most languages. More than a quarter of a century later the highly acclaimed BBC television series *The Human Animal* has been a testimony to the enduring appeal of Morris's original view that human beings can justifiably be regarded and studied as just one of the many animal species.

Morris's reputation as a scientist and television presenter has, however, overshadowed another, equally passionate facet of his life's work. What is less known about him is that from the age of sixteen he has been a committed and practising Surrealist painter. In no way inhibited by his academic success as a zoologist and his celebrity status as a writer and television personality, he has made, since the 1940s, a steadfast and significant contribution to the Surrealist movement in Britain. The aim of this book is to examine the nature and the ramifications of that contribution.

One day during his childhood Desmond Morris happened to be rummaging around in the attic of the family home at Purton, a village in Wiltshire. By chance he came across a seventeenth-century anatomy of internal organs, *The Comparative Anatomy of Stomachs and Guts Begun* by Nehemiah Grew, which contained strangely disembodied illustrations of an array of biological vitals. The strangely contorted, almost abstract, forms of intestinal tubes, bladders and gizzards aroused a fascinated wonder in the young boy's mind.

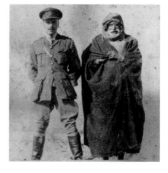

The artist's father, Captain Harry Morris, in Mesopotamia in 1918 with a local inhabitant

THE KISS *(opposite)*
1946
Oil on board
16 × 13 in. (40 × 32.5 cm.)

11

ZOOLOGIST OR ARTIST?

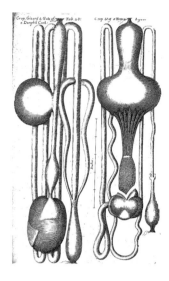

Anatomical drawings from
Nehemiah Grew's *The
Comparative Anatomy of
Stomachs and Guts Begun*

Desmond Morris in 1946,
aged 18

Seated Woman *(opposite)*
1946
Oil on card
19 × 14 in. (47.5 × 35 cm.)

These sinewy structures which were identifiably biological but which could not be overtly equated with recognizable living organisms were to haunt his imagination for decades to come. They constantly remained in the back of his mind and indubitably fuelled his vision as a painter.

Another find in the attic that day was a dusty mahogany box containing an old brass microscope and a large collection of slides which had belonged to his great-grandfather, an enthusiastic Victorian naturalist. Once set up, the long-abandoned instrument became the source of many revelations. The unexplained images captured on the Victorian slides opened up a whole new world, not simply of the animal kingdom but of incomprehensible abstract patterns, shapes and colours. 'I was shattered by what I saw,' he later recalled; 'I felt I was entering a secret kingdom.'[1] This twofold experience, biological data on the one hand and forms with their own autonomous aesthetic on the other, was to prove significant in the development of Morris's works.

Indeed, as he grew up, his activities led him in two main directions: he was to pursue a successful career in natural history and, at the same time, he was to dedicate himself to art. These ostensibly antithetical courses sometimes dovetailed and often conflicted, but they continued to develop side by side over many years. For example, Morris found it quite natural, after an army teaching post in fine arts, to go on to read zoology at Birmingham University. And the two vocations must have appeared interchangeable when, at the end of his first year as a science student, he had a solo exhibition in London of the drawings he had made of shapes seen under the microscope. But this level of intellectual concord was only rarely to be repeated: the two facets of his thinking were, on the whole, destined to remain distinct. For him, the creative impetus – 'the rebel element', as he put it – involved the non-critical, non-reflective mind and was opposed to the thought processes of the analytical and exacting scientist. As soon as thought becomes self-conscious, he has insisted, creativity is diminished and invalidated. He recently explained the phenomenon by relating an anecdote about a millepede who, on being asked how it managed to coordinate its leg movements, became so conscious about what, for all of its life, had been a natural process, that it ceased to be able to walk at all and, as a consequence, died: art for Desmond Morris is an automatic, instinctive process and, as such, remains alien to the conscious deliberations of the mind.

Morris was to discover what mental monotony really meant in 1946, when on 24 October he began his two years' National Service as Private no. 19090439. His time as a conscript in various army camps was an unhappy one, made bearable only by his eventual posting in the autumn of 1947 as lecturer in Fine Arts at Chiseldon Army College, just a few miles from his home in Victoria Road, Swindon. Thanks to his departmental head, the art critic Mervyn Levy, Morris began to mix in artistic circles and met, among others, Dylan Thomas. Art became a solace, an escape from the rigours of regimented life. As the weeks passed he painted more and more, holding his first exhibition of thirty-two paintings at Swindon Public Library from 10 to 24 January 1948. To his delight, this created intense reactions: 'I was called

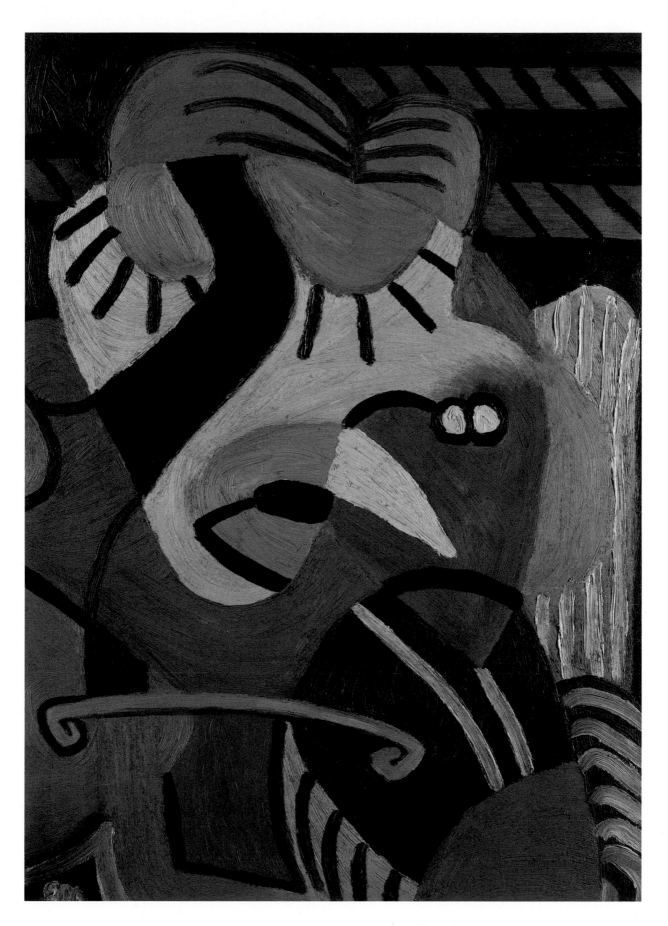

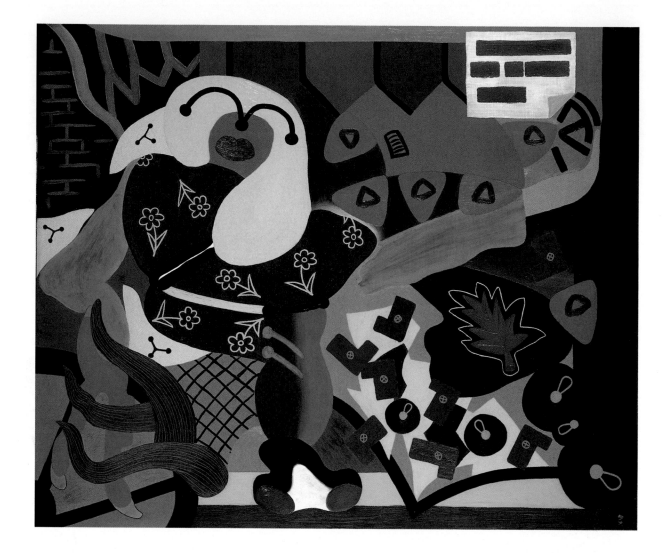

A GIRL SELLING FLOWERS
1946
Oil on board
29½ × 35.5 in.
(72.5 × 87.5 cm.)
Collection Public Art Gallery,
Swindon, Wilts

WOMAN READING *(opposite)*
1947
Oil on card
16 × 12 in. (40 × 30 cm.)
Collection Mr Ron Crider,
San Francisco

a lunatic; someone wrote to the papers demanding that all my works be burned.'[2] According to one correspondent to the Swindon *Evening Advertiser* the paintings were 'nightmares masquerading as art'. A subsequent exhibition held in the summer of 1948 prompted further attacks, with one reader commenting: 'It would be counted a magnificent gesture of benevolence on the part of any philanthropist were he to buy up all these zygomorphic distortions in colour, and destroy them in a furnace.'

For the moment, animals had been relegated to the back of Morris's mind and art was dominating his thinking. And yet the subjects which appeared in his works owed much to the creatures that he had spent his boyhood observing. 'I tried to create a private world in which my own invented organisms evolved and developed,' he later wrote.[3] In his paintings he was beginning to create a personal fauna and flora, which originated in his imagination. Although they looked quite unlike animals in the outside world, these strange creatures seemed, nevertheless, to be subject to biological rules. Their forms implied growth and metamorphosis, just as though they had been real creatures. So engrossed did Morris become in his

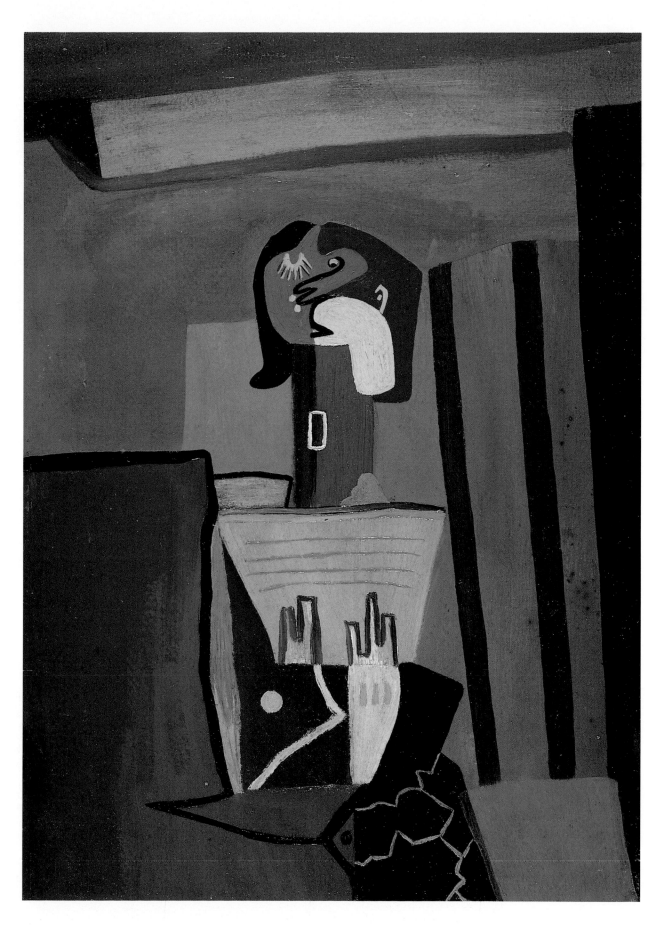

15

ZOOLOGIST
OR ARTIST?

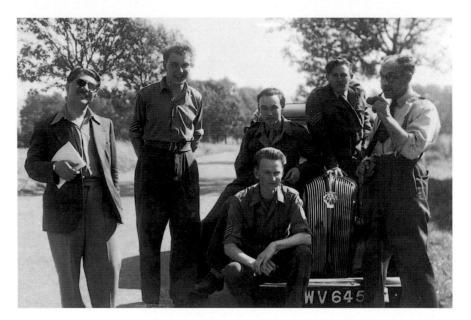

Desmond Morris and other art
lecturers at the Chisledon
Army College, with their head
of department Mervyn Levy
(far left), in 1948

inventions that he was captivated by their very nature: 'To me they did
become increasingly real, so much so that I could almost study them and
their natural history as if I were still an exploring zoologist.'[4] It was this
serious application to painting that led to a spate of exhibitions in 1948.

As army life drew to an end on 29 September 1948, Morris increasingly
hankered after the animals that appeared incessantly to be haunting his
paintings. He wanted to find out more about them in a formal way and, fresh
from demobilization, in October of that year he found himself gravitating
towards and enrolling at the zoology department of Birmingham University.
Ironically, it was while he was a science student there that he made what was
probably the most significant breakthrough of his artistic life: he discovered
Surrealism in a concrete form.

Morris's first awareness of Surrealist thinking can be traced back to his
sixteenth year in 1944 when, while still a boarder at Dauntsey's School in
Wiltshire, he came across the book *The Painter's Object* edited by Myfanwy
Evans[5] in which he read and was fascinated by a translation of Max Ernst's
'Comment on force l'inspiration'.[6] 'I discovered [in *The Painter's Object*],' he
later recalled, 'that you could paint without being a slave to the external
world.'[7] But it was as a university student that he embraced the Surrealist
frame of mind wholeheartedly. From the moment he arrived in
Birmingham, far from applying himself single-mindedly to his studies, he set
about exploring the local art scene. He would attend seminars on art at the
Barber Institute, often engaging in heated arguments with art history
students about the merits of 'conventional' art. His taste in art at that time,
he recently recalled, was far from 'typical', and at the Barber discussions he
was sometimes regarded as a rather disruptive influence on otherwise
conservative proceedings. The reason why Morris had turned his back on the
more traditional values in art was that he was looking for what he terms that
'mystery or special quality' that the creative mind can conjure up.[8]

Essentially, he regarded the creative process as a challenge to the established and accepted mental protocol. For him it was a means of provocation.

When the university rag of November 1949 was being organized he saw his chance to put his ideas into practice. He designed and constructed a fantastic float entitled 'Alice under the Microscope', in which the observer at a giant microscope was a full-size model of a giraffe and the specimen under observation was a real girl strapped onto the plate. With this simple, albeit technically ingenious, fabrication, Morris metaphorically overturned our conventional view of the relationship between humans and animals. For once, it was the human being that was the observed specimen and that underwent all the degradation which that entailed: the girl had been snatched from her world, it was implied, to be placed in a vulnerable predicament and subjected to the dehumanizing eye of scientific scrutiny. The animal, conversely, was placed in the superior, dominant position of the observer: the giraffe gave the impression of peering critically and judgementally at the helpless human victim. The finishing touch was the addition of two balloons placed under the giraffe to represent testicles, but these were censored before the float could begin its parade. It would seem that the idea of a human female being the object of bestial lust had to remain an inadmissible taboo. All the same, Morris had managed dramatically to challenge the supremacy with which Man endows himself in relation to the animal kingdom, a feat that was to be repeated in a systematic manner in *The*

THE HERMIT DISCOVERED
1948
Oil on canvas
16 × 22 in. (40 × 55 cm.)

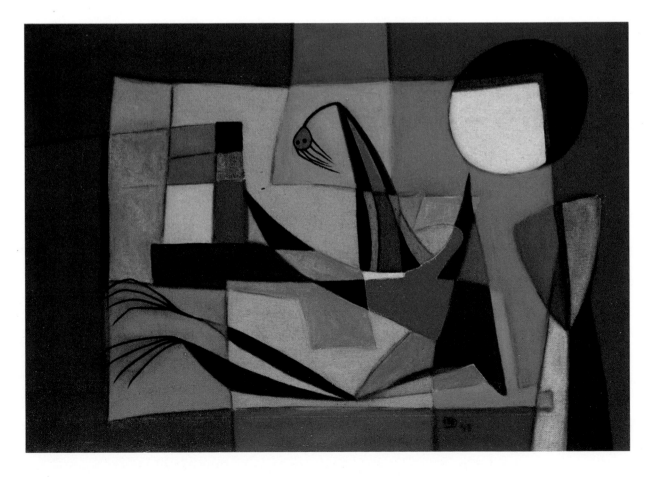

ZOOLOGIST
OR ARTIST?

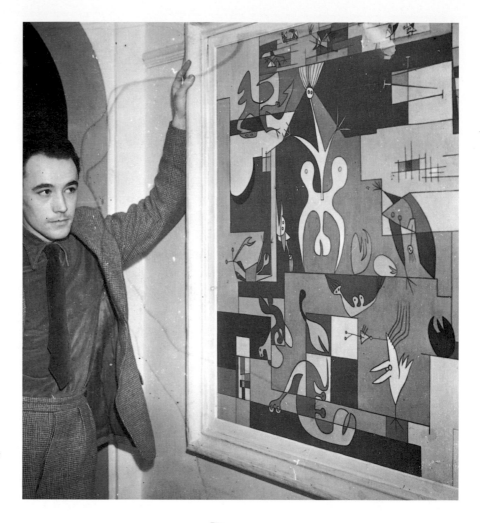

At the London Gallery
exhibition in 1950, in front of
The City (1948) - which has
since been destroyed

Naked Ape many years later. Like Lewis Carroll's Alice, he turned common sense and conventional wisdom upside down. In a small but, nevertheless, public way he had defied the order that reason places on reality. He had, unknowingly, made a Surrealist statement.

It was inevitable that Morris should sooner or later make contact with the Surrealist circle that existed in Birmingham at the time.* After some enquiries, he was eventually directed in November 1948 to the home of a member of the original 'Surrealist Group in England', Conroy Maddox, who, in the days before the war, had frequented such personalities as André Breton, Marcel Duchamp, Georges Hugnet and Man Ray. In an eleven-roomed house at 29 Speedwell Road in Edgbaston, Morris discovered regular meetings of a thriving Surrealist group taking place; and, above all, he found a mentor. Conroy Maddox had been promoting Surrealism, formulating its policies, publishing in its journals, populating its exhibitions with canvases and generally propounding its spirit since 1935. Morris 'sat at his feet', as he later put it, and learnt all he could. He regularly attended the 'Surrealist evenings' hosted by Maddox, and very quickly became spellbound by his fertile and ingenious mind. He has recalled a particular instance of Maddox's enigmatic thinking:

* From the beginning of the Second World War Conroy Maddox's home served as a venue for the regular gatherings of the Surrealists in Birmingham, who became known as the 'Birmingham Seven' or 'the Birmingham Group': Emmy Bridgwater, Oscar Mellor, John Melville, William Gear, Desmond Morris and Robert Melville. George Melly would sometimes come from London with Mick Mulligan and his band. Robert Melville and Maddox maintained links with the London Surrealists.

One winter evening Conroy suddenly announced to the assorted group of students, painters and poets who, time and again, were drawn magnetically to his Birmingham home, that he would like to buy a piece of land and have a house built on it. It would be an ordinary-looking house, made of brick. Ordinary except for one detail: it would be completely solid. Solid right through. No rooms – all bricks. And when it was finished, he would simply leave it there. There would be no announcements, no fanfare. It would quietly make its own statement.[9]

Such was the impression made on him by Maddox's obsessive and haunting visions that the young zoology student felt compelled to follow in the footsteps of his new-found champion and guru. On 2 September 1949 he went to Paris with fellow Surrealist Oscar Mellor in search of the roots of the movement. He met the sculptor Prinner and Frédéric Delenglade, the illustrator of an edition of *Alice in Wonderland*. Having been overwhelmed by the Surrealist texts that he discovered at the Minotaur Bookshop and at a Roberto Matta exhibition, he returned home with publications illustrated with Surrealist works and an imagination ready to spark off 'primordial images and the forms born of the constant movement between the internal and external worlds'.[10] Morris recognized in Maddox his 'next major influence' and promptly joined the Birmingham group of Surrealists, with whom he exhibited under the aegis of The Birmingham Artists' Invitation Committee Exhibition organized in 1949 by Mellor, Bert Barton and Trevor Denning.

Maddox still recalls Morris's impact on the fortnightly gatherings at Speedwell Road:

> I remember my first meeting with Desmond Morris . . . Since Desmond was a painter with a strong commitment to Surrealism, we had much in common. On one of the evenings he gave a talk ... called 'Neotenous Man', in which he argued that human beings are infantile apes, who retain their juvenile playfulness throughout life and that this had led us to direct our energy into writing and painting and other creative activities.
>
> Since Desmond was a regular visitor we had many discussions on Surrealism. I always felt that the imagery in his Surrealist paintings, which he calls 'biomorphic', was a natural outcome of his research in biology. Bringing, as it were, those images which he saw through the microscope to the canvas, he was to inspire, rather than evoke relationships that defied the habitual.[11]

This view seems particularly pertinent to another memorable ·early Surrealist statement by Morris, which involved public spectacle on a grand scale. While still a student in Birmingham in November 1949 he caused general consternation when, in the middle of the night he and some hefty accomplices deposited the skull of a full-grown bull elephant in a shop doorway in Broad Street. Early next morning a crowd gathered, becoming so agitated that the police had to be called. The mystery could not be fathomed, and eventually it was decided that the offending object should be

THE VISITOR
see page 105

taken away in a police car. The skull was so massive that it jammed in the car doorway and damaged the vehicle. Like Maddox's solid house, the incident remained without explanation. It was enough that it should have caused such alarm and challenged all possible commonsensical attempts at comprehension. In the words of Maddox, it 'inspired'. All that the local paper could conclude was that there had been 'a dinosaur in Broad Street.' The animal skeletons discarded by the university zoology department, from which the Broad Street elephant skull had been salvaged, proved to be a fertile source for Morris's imaginative devilment. Skulls and their transformation preoccupied him at this time, and he next applied himself to a goat's skull that he had found, administering brightly coloured paint to it. The effect was grotesquely farcical. The morbid solemnity of the remnant of the dead creature was uncomfortably negated by such festive jollification. The shocking aspect of this object, entitled *The Visitor* (*The Uninvited Guest*) (1948), lay in its connotations of distasteful defilement. Later, he was to create a similar defiance of conventional taste in a tableau comprising a horse's skull with two ripe plums pressed into its eye sockets. As recently as 1995 he has been toying with the idea of filling the skull of a tiger with eggs, a notion that becomes particularly macabre and disturbing when it is borne in mind that Morris knew and personally tended the animal in question when it was alive.

Back in the late 1940s the young zoology student, eager to capitalize on his ventures into the surreal, decided to continue to explore creativity and the irrational through the medium that he felt suited him best then, that of film. He believed that the cinema held enormous possibilities for the development of Surrealist sequences. Again wavering from his academic course of study, he set about writing two Surrealist scenarios. Having seen Dali's and Buñuel's *Un Chien andalou* at the University Film Society, he was convinced that film held enormous potential for Surrealist exploration.

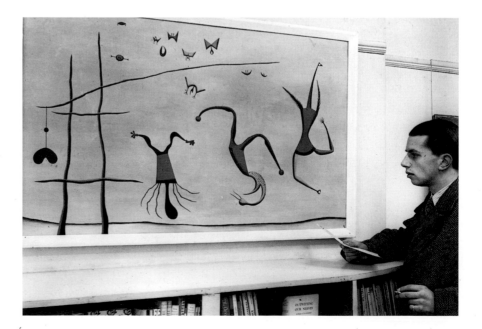

George Melly at the London
Gallery in 1950, in front of
The Jumping Three (1949)

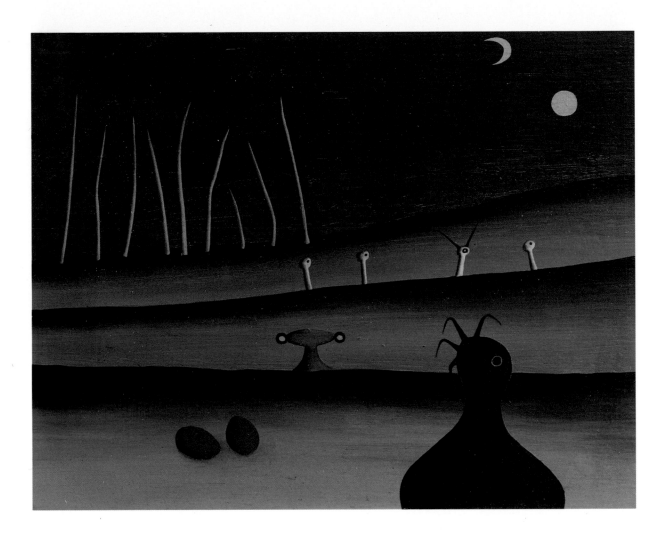

As in Dalí's and Buñuel's film, the scenario for *Time Flower*, written in the summer of 1950, conjures up a series of disturbing events and metamorphoses. The sequence in *Un Chien andalou* in which body parts, such as lips and armpit hair, are transposed between a man and a woman is echoed in Morris's film: a man opens his mouth to reveal a third eye, whilst another character appears to have lost one of his. The film goes on to evoke the irrational in various other ways. For example, we see the inanimate endowed with living traits when a clock bleeds on being pierced by a dart. Similarly, natural laws are contradicted when a man who is transfixed with a sword and is bleeding profusely appears quite unaffected by the assault, quickly resuming the mundane task that he had been performing before the incident. Equally inexplicable is a scene in which a man discovers a corpse that has his own head lying on a slab and then proceeds to fall down a hill to his death.

Morris's commitment to devising Surrealist film was beyond question, but without the necessary technical and financial means at his disposal he was unable to develop this passion beyond two films. *Time Flower* and *The Butterfly and the Pin* (1951) were filmed by Christopher Simpson, an amateur film-maker, and in March 1951 *Time Flower* was given an award by

LANDSCAPE WITH WATCHERS
1950
Oil on board
10 × 8 in. (25 × 20 cm.)
Private Collection, Berkshire

the Institute of Amateur Cinematographers.* What was in no way curtailed at this time was Morris's pictorial impetus. In 1950 he was still painting at a frantic rate, and by the end of the year had completed over three hundred works, of which 272 have been traced. In that year he also shared his first London exhibition with Joan Miró at E.L.T. Mesens's London Gallery, which was the official headquarters of the Surrealist Group in England.

But 1950 also saw a turning-point in Morris's life, when on 19 November he attended a lecture given by the famous Dutch Nobel Prize-winning ethologist Niko Tinbergen. 'That was it,' Morris explained; 'In one hour he converted me. Crash. It sort of hit me like a ton of bricks.' He became obsessed with the idea of studying man as an animal and becoming a naturalist. Fired by his passion, he made the decision to apply himself single-mindedly to his zoology studies. As a result of the new trajectory that he had set himself, he was forced to abandon his current initiatives in the sphere of art. He did exhibit at an international arts festival in Belgium in July 1951 and at the Ashmolean Museum in Oxford in May of the following year, but he sensed that the two vocations were competing for his attention. He felt frustrated that he could not be in his laboratory and in his studio at the same time. In an interview in 1990 he acknowledged this:

> There are two Desmond Morrises, and they are quite different people. I can easily pass from one to the other, but I cannot be both at the same time. When I'm Desmond Morris the painter, I am quite different . . . There is rarely any clash between the two aspects. The one helps the other. I obey the two sides of my brain alternately.[12]

After an unstinting dedication to zoology and an abstinence from Surrealist exploits, he gained a first-class degree at Birmingham University in June 1951 and went on to study reproductive communication systems under Tinbergen at Oxford University, from where he was to graduate in 1954 with a doctorate on the ten-spined stickleback.

In March 1956, after a year of post-doctoral research on the reproductive behaviour of birds, Dr Morris was invited to lead a production unit at Granada Television which had been set up in conjunction with the Zoological Society to make programmes about animals. Much to the dismay of the television administrators and contrary to all previous practice, he insisted that, rather than the animals being transported to the television studio, the studio itself should be brought to the animals. He hoped to be able, in this way, to convey a faithful impression of animal behaviour and habits. The resistance to this novel idea was eventually overcome and in that year, broadcasting live from London Zoo, Desmond Morris brought *Zootime* to the screen. This proved to be a highly popular programme, drawing millions of tea-time television viewers for no less than eleven years, from May 1956 to 1967. For the first time exotic and dangerous animals were presented in a comprehensible and, even, endearing manner.

One of the stars of the programme was an exceptionally intelligent chimpanzee named Congo, who made weekly appearances. It soon became

* *Time Flower* was judged 'the most outstanding film' by an individual member entered in the Institute of Amateur Cinematographers' competition. The film was awarded the Institute's medal and the Bassett-Lowke trophy, a bronze replica of a film-projector, which were presented at a London banquet in March 1951. The film was shot in six weeks during the summer of 1950. The interior scenes were filmed in the interior of Morris's parental home in Swindon, and the exteriors at an old brickyard site near Groundwell Road, Swindon, and at Silbury Hill, Avebury. The cast comprised Desmond Morris, Paul Weir and Ramona Baulch.

clear that the superior capabilities of this mascot of *Zootime* warranted further investigation, and so Morris decided to conduct an experiment in chimpanzee behaviour – an experiment, moreover, which was to give rise to considerable controversy in the art world. The ape was given a pencil and was encouraged to make marks on a piece of card. Instead of scratching at random, as might have been expected, he made a composition based on recognizable, albeit primitive, visual patterning. This was the first of many picture-making tests with Congo. Over a period of three years he made some 384 drawings and paintings.

What Desmond Morris wanted to establish was whether and to what extent it would be possible to detect an 'aesthetic sense' in a chimpanzee. Certainly Congo did devote much concentration and intensity to his picture-making. He valued his 'creative' sessions so much that, when once it was attempted to curtail one of these prematurely, he erupted into a screaming tantrum and calmed down only when he was allowed to continue the work in which he was engaged. It would seem that, for Congo, picture-making was as valued an activity as any of the basics of existence. At times, he preferred it to being fed.

Whilst rarely transgressing the confines of abstract markings, Congo's works nevertheless displayed a remarkable degree of visual control. For example, it could be said that the chimpanzee possessed a personal and recognizable style. He would typically produce a radiating fan shape. And once this had become a fixed visual concept for him, he proceeded to make variations of it: he split it in two halves, he curved the bottom of it, he divided it by a central spot. Apart from the fan shapes, Congo also produced zigzags, loops, crosses and, even, reasonably accurate circles. On one occasion he filled one such circle with dots. Morris has speculated that this particular design may well have been a rudimentary represention a face.

Morris noted that, whilst making a picture, Congo would be fully in control of the process. He would carry on working at a particular picture, holding his brush in a typically human grip, only for as long as he considered the work unfinished. Once he regarded it as completed, he would stop and refuse to add anything further. The unhesitating manner of execution showed that every line or blob was being placed exactly where it was wanted, convincing Morris that Congo was displaying a controlled and deliberate aesthetic sensibility: 'There was no doubt about it,' he later wrote, 'he knew what he liked'.[13] The point was that the ape was showing a will to bring order to his painted lines and shapes. He was, effectively, attempting to organize the senseless raw materials at his disposal into thoughtful, well-controlled compositions.

As a result of this experimentation, Morris organized what was to be an extremely controversial exhibition of paintings by Congo and Betsy, a seven-year-old American female chimp, at the Institute of Contemporary Arts in London in September 1957. Despite the fierce criticism and mockery which this event received, Morris was not deterred in his belief that he had undertaken a profound investigation into the origins of the artistic impetus. The *New Statesman* ridiculed the whole venture as 'the reflex twitching of

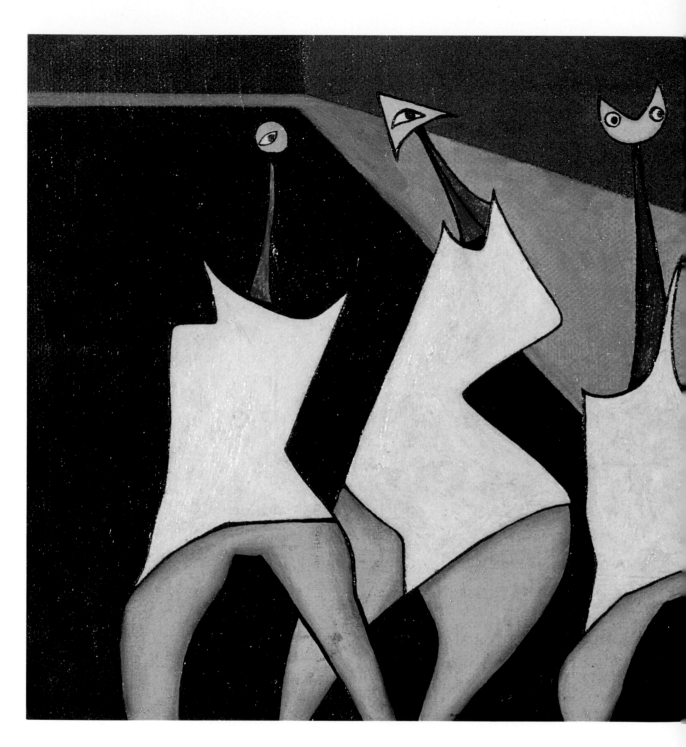

apes'. But ever since Morris had seen the seventeen-thousand-year-old paintings of the prehistoric *Homo sapiens* in a cave at Lascaux in 1954, he had been convinced of the intensity and primordial nature of the aesthetic urge of the human species. As he was later to learn, man's pictorial exploits, usually focused on the commemoration of animals, were not only a widespread phenomenon but, also, they dated back to extremely early times: in France alone one hundred and twenty painted cave sites have been found including those at Rouffignac, Fontanet, Pair Non Pair, Cougnac, Ariège, Eraïn, Clastres, Charente, Cosquer, Arcy-sur-Cure and Chauvet, the

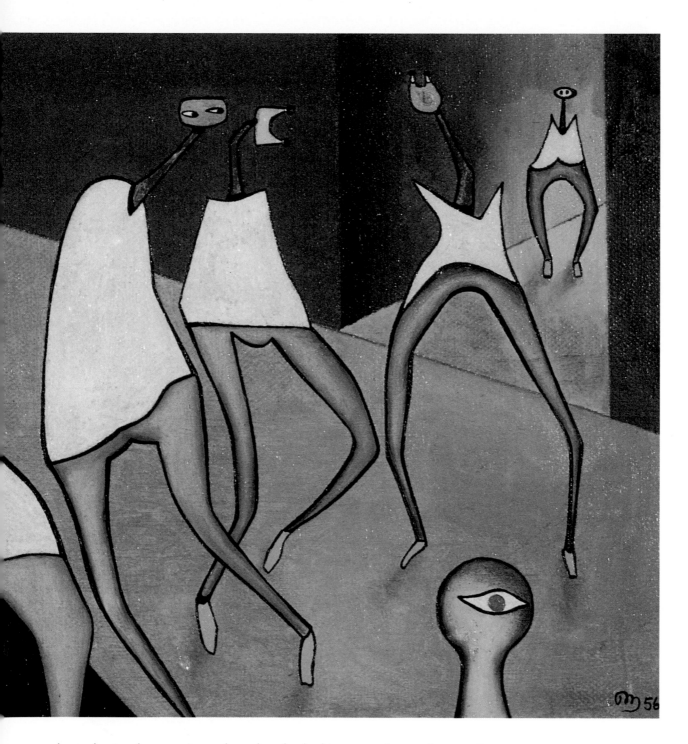

KEEP TOGETHER
1956
Oil on canvas
7 × 14 in. (17.5 × 35 cm.)
Collection Mr John Nadler,
London

latter having been estimated to date back thirty-two thousand years. In Australia colouring materials some fifty thousand years old have been discovered, and in Israel a find of pierced, coloured shells has been estimated to be ninety-five thousand years old. Fairly recently a small figurine of a woman, fashioned some three hundred thousand years ago, was found in an archaeological site in the Golan Heights. It would seem that even Neanderthal man had the urge to create.

The dedication and motivation with which Cro-Magnon man applied himself to the task of creating elaborate artwork had undoubtedly impressed

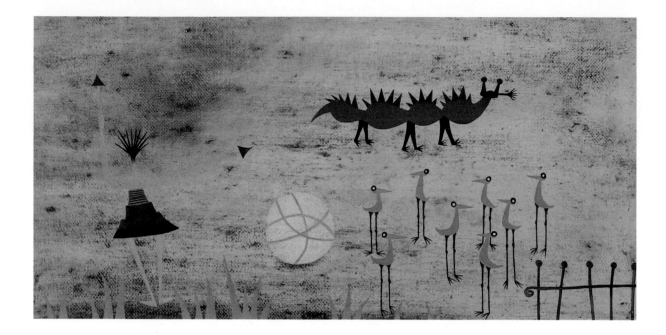

itself on Desmond Morris. Congo, with his obsessional interest in picture-making, had strongly implied to him that this yearning to create visual images could be regarded as no less than a primordial aspiration which had been inherited by Man across the expanses of evolution. One commentator goes so far as to regard ape pictures and prehistoric graphic art as inextricably linked: 'It is possible to interpret these artifacts as the end result of the same process.'[14] Morris certainly inferred that picture-making was a deep-seated compulsion; and, moreover, it was one to which he himself would soon, once again, succumb.

On 1 January 1959, after acting as host for *Zootime* for three years, he left television to become Curator of Mammals at London Zoo. His intense interest in animals made him want to work with them in a way that the demands of producing a television programme would not allow. As he later remarked, 'I wanted to know everything there was to know about every mammal in the world.'[15] His many achievements in this new role, one of which was the highly publicized unsuccessful mating of Chi-Chi the giant panda with the Russian male panda An-An during October 1966, made it inevitable that he should, once again, become a media personality. In fact, during the eight years he held the post of Curator of Mammals, from 1959 to 1967, he continued to present television programmes, scripting and hosting a total of about five hundred *Zootime* programmes for Granada. BBC2 invited him to devise and present a new, one-hour, fortnightly series entitled *Life in the Animal World*, which dealt with animal and human behaviour and spanned fifty-two programmes. In addition, he took part in many BBC radio programmes on natural history subjects and was a regular reviewer of animal books for the *Times Literary Supplement*.

In spite of this exhaustive workload, which was to make him very ill for a period of months, his obsession with art and the creative process did not

diminish. The work with Congo continued and, as if inspired by the ape's creativity, Morris himself began to paint again. Working furiously in his Primrose Hill studio whenever he had some free time, he produced hundreds of works every year. In fact, so absorbed was he by art at this time that in his autobiography *Animal Days* he presents a visit by the Surrealist Joan Miró, rather than some zoological achievement, as the highlight of his London Zoo curatorship.

By the mid-1960s Morris was already author of some forty-seven scientific papers and twelve books, including *The Biology of Art* (1962), a study of the roots of picture-making, *The Mammals: A Guide to the Living Species* (1965), *Zootime* (1966) and *Primate Ethology* (1967); and, with his wife Ramona, *Men and Snakes* (1965), *Men and Apes* (1966) and *Men and Pandas* (1966). By 1966 he had established an informal research unit at London Zoo comprising students undertaking doctoral work in animal behaviour, and other visiting scientists.

But Morris's most stunning achievement was yet to come. *The Naked Ape*, a book about the human animal, started as an idea about which he himself had reservations: 'I was frightened of what people would say, how they would react to this cold, very objective treatment of themselves.' He was right in his apprehensions: in some parts of the world the book was banned and illicit copies were confiscated and burned by the Church, while the *Chicago Tribune* pulped an entire issue of its magazine because its owners were offended by a review of *The Naked Ape* that had appeared in its pages. Generally, however, the volume was hailed as a brilliant, albeit provocative, work which, according to the *Sunday Times*, 'changes people's lives'.

It was at this time of heightened achievement as a zoologist, in 1967, the year in which *The Naked Ape* was to appear, that Morris resigned his curatorship at London Zoo and became executive director of the Institute of

THE SPANISH TABLE
1957
Oil on canvas
7 × 14 in. (17.5 × 35 cm.)
Collection Dr Gilbert Manley,
Durham

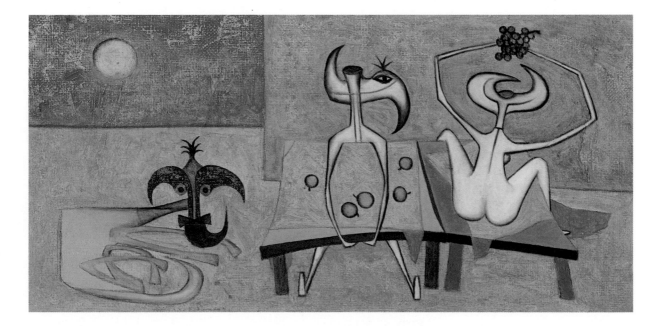

28

THE DEBRIS OF FIXATIONS
1968
Oil on board
48×60 in. $(120 \times 150$ cm.$)$

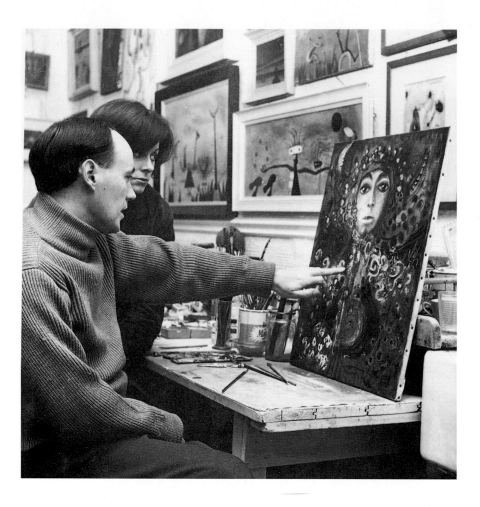

Desmond and Ramona Morris
Primrose Hill studio in 1960

Contemporary Arts. Made on a sudden impulse, the move represented an
abandonment, if a temporary one, of his career as a zoologist. Ironically,
however, this newly acquired status in both the London and the
international art world had a negative effect on his own artistic activities.
During the year of his appointment, which coincided with the
administrative nightmare of transferring the Institute to a new base in The
Mall, Morris was to produce not a single painting. Although he was in
frequent contact with such artists such as Moore, Hepworth, Miró, Calder
and Bacon, this was a period when, as he recently recalled, he 'couldn't pick
up a brush'. The millepede theory was being realized: Finding himself at the
artistic hub, surrounded by artists, critics and the media, he was
experiencing a depletion of his own creativity. The analytical mind could
not, it would seem, converge with the free forces of imagination.

It must also be said that professional success in general was beginning to
take its toll. Under the strain of increasing commitments, Morris was
gradually becoming ill with exhaustion. He was writing an average of one
book a year in addition to his full-time curatorship, which had placed him
in charge of a staff of eighty. He was also writing book reviews, had two
television series – *Life* and *Zootime* – and was responsible for a radio
programme. He had clearly overburdened himself and desperately needed a
respite.

The publication of *The Naked Ape* in October 1967 gave him the opportunity. Relieved for the first time of all financial restraints, he was now in a position to escape the burdens and complications of his professional life. He resigned his post at the ICA, and in February 1968 he emigrated to the island of Malta. There he and his wife occupied a large villa with a swimming-pool and an orange grove, where, as well as setting to work on his next book *The Human Zoo*, which was to examine the behaviour of city-dwellers, he experienced a period of renewed artistic creativity. 'I wanted to go off to an island and paint,' he explained. He set up a studio and, over five years, he produced many large bold works which reflect a new-found peace of mind. This move to the Mediterranean was interpreted by the media as an attempt to circumvent the onerous demands of the Inland Revenue. In reality, though, it was more a matter of medical necessity. Admittedly, his links with television had not been completely severed and producers were still attempting to persuade him to continue with his series, but the main burden had been lifted.

Morris found that, for the first time, he could indulge in his primary passion. His reaction to the freedom that the success of *The Naked Ape* gave him was to devote himself to painting:

> I went off, I got a studio and painted and painted. I painted so much that, apart from a couple of sequels to *The Naked Ape*, I stopped writing. For years I didn't publish anything and during that time I did nothing but paint. I painted to fill my villa, which had corridors a hundred feet long and walls eighteen feet high. It was huge. I had a marvellous space to fill.

The Human Zoo, which was applauded for having managed to 'shock people into an awareness of our ignorance of ourselves',[16] was published in 1969. For a time during the early 1970s, Morris made frequent visits to Britain whilst keeping his studio in Malta. His scientific work began to increase and between April 1970 and April 1971, at a coastal town near his villa in Malta, he set up research headquarters to undertake an ambitious project to produce a comprehensive classification of all human action patterns, with a view to producing an encyclopaedia of human behaviour. This led to the publication, in October 1971, of *Intimate Behaviour*. Realizing that this research could not be furthered in Malta, he finally sold his villa after seven years in the Mediterranean and went, in February 1975, to live in Oxford. There he took up a research fellowship at Wolfson College and again worked in Niko Tinbergen's animal behaviour research group, continuing his studies of human action patterns.

Many books and several television series have resulted from this work. In 1977 he published *Manwatching: A Field-guide to Human Behaviour*, a popular presentation of his major investigation into human action patterns, and in 1979 he co-authored *Gestures: Their Origins and Distribution*, a survey of the gestural similarities and differences found in forty locations in twenty-five different countries, across Europe and the Mediterranean. The more focused *The Soccer Tribe* (1981) analysed the world of professional

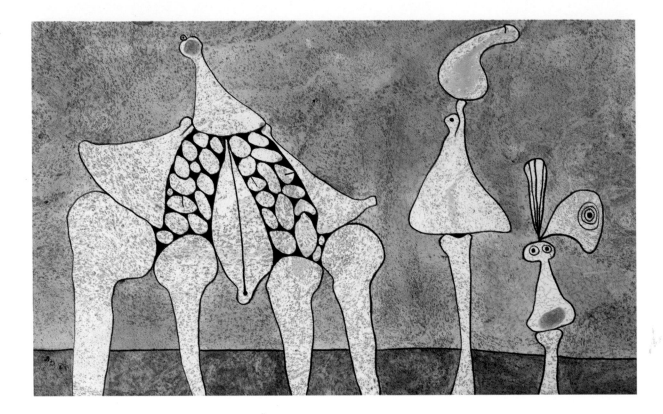

football. In the sphere of television, he presented the series *The Human Race* for Thames Television in 1982 and, starting in 1987, he co-presented *The Animals Roadshow*, a series which lasted for three years. In 1994 he wrote and presented *The Human Animal*, comprising six one-hour programmes for BBC1, which dealt with human behaviour.

Morris's artistic production did not cease, though, and he had made provision for his creativity in the form of a large studio in a converted Victorian stable in Oxford. From there he produced a stream of works which resulted in regular exhibitions. In 1974 he held a solo exhibition at the Stooshnoff Gallery, London, his first exhibition for over twenty years, and in 1976 he held four – in Oxford, London and Swindon. His first main exhibition abroad was held at the Galerie D'eendt in Amsterdam in 1978, and in that year he also showed at the 'Surrealism Unlimited' exhibition in London. In 1982 he was included in an exhibition of British Surrealism, 'Les Enfants d'Alice', held in Paris and in 1986 he had a place in the exhibition 'Contrariwise: Surrealism and Britain, 1930-1986', which toured Swansea, Bath, Newcastle-upon-Tyne and Llandudno.

The year 1987 was a pinnacle in terms of artistic achievement, with a solo exhibition at the Mayor Gallery in London, a BBC television film about his painting presented by Patrick Hughes, an exhibition at the Keats Gallery in Belgium and the publication of a book about his painting called *The Secret Surrealist. The Paintings of Desmond Morris*. This intensity continued in the following year with a solo exhibition at the Shippee Gallery in New York and another at the Keats Gallery. The Mayor Gallery held a second solo exhibition of his work in 1989, and in 1990 Morris exhibited in 'Surrealism:

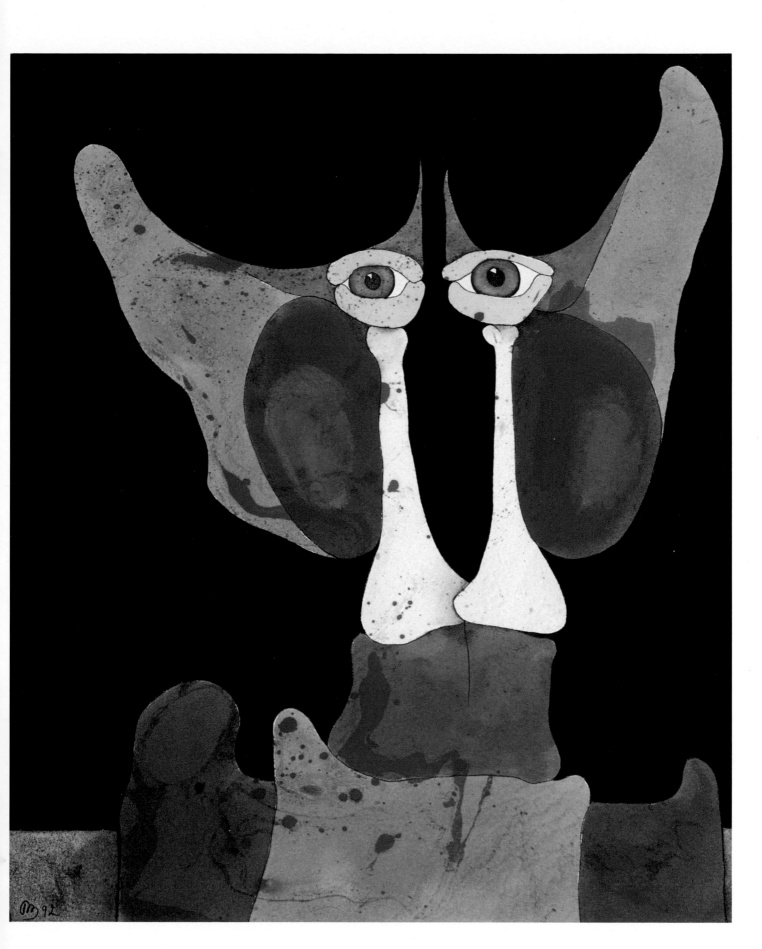

33

'From Paris to New York' at the Arnold Herstand Gallery in New York, as well as in 'Surrealism, a Permanent State of Lucidity' at Bonham and Feely Fine Art in London. In 1991 two events signalled a recognition of his place in the history of the Surrealist movement: a solo exhibition was organised at the Mayor Gallery to mark the publication of the major book *The Surrealist World of Desmond Morris* by Michel Remy, and he was included in the exhibition 'The Birmingham Group' at Bonham and Feely Fine Art, which commemorated the 1949 Birmingham Artists' Invitation Committee exhibition which, forty-two years earlier, had coincided with his initial entry into the Surrealist circle.

Desmond Morris continues to be prolific as a painter, and his subsequent exhibitions have included several solos and two major retrospectives of his work, 'Desmond Morris, Paintings 1946-1993' (1993) at Swindon Museum and Art Gallery, and 'Desmond Morris: 50 Years of Surrealism' (1996), shown at Stoke-on-Trent and Nottingham.

Whilst acknowledging that his career has taken three diverse directions, Morris points out that these ostensibly incompatible activities have, on one occasion, harmonized:

> There is the Surrealist, then there is the academic zoologist . . . and the third me is the television me, which makes me interested in communicating ideas to a general audience – the popularizer. I do like communicating to a large audience, even if I can't communicate very much. In a scientific paper it is possible to include dozens of ideas, whereas in a television programme you can probably only get across one or two. That is real dilution. My academic work was undiluted. My Surrealist work is undiluted. But, when I moved into television and, later, into writing popular books, I was diluting deliberately and calculatedly to communicate ideas to a very wide audience, even if it meant simplifying those ideas . . .
>
> What happened in *The Naked Ape* was that [the three elements] all came together. The cold objectivity of the academic was brought to bear, the popularizer was brought to bear in the way it was expressed and the Surrealist element emerged in the rather outrageous idea of calling people naked apes . . . People were outraged and shocked. So the outrage which only usually greeted my paintings now was greeting my writing. Up to that point all my writings had been perfectly acceptable. Suddenly with the *Naked Ape* people said: 'What's going on here?' . . . I was deliberately shaking people . . . there was objectivity from academic work, easy style of writing from my popular television work and the rebellious shock tactics from my Surrealist background. The three had come together in one product.

The somewhat uncomfortable point that Morris was making in *The Naked Ape* was that humans should no longer consider themselves as 'fallen angels' but, rather, as 'risen apes'. Through this audacious concept the rebellious, 'Surrealist' side of his nature, which had been private and unknown, was suddenly made public on a global scale. It was to take a further twenty years for Morris to be recognized as an artist whose work merited a place in the public consciousness.

2

Prospecting
the Mind

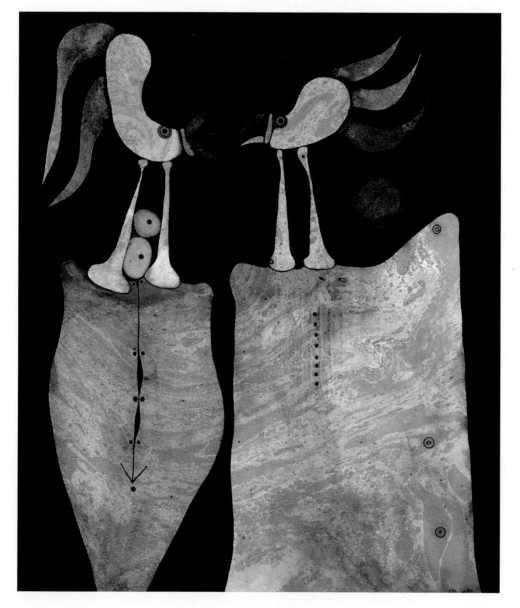

THE ESCORT
1994
Mixed media
12 × 10 in. (30 × 25 cm.)

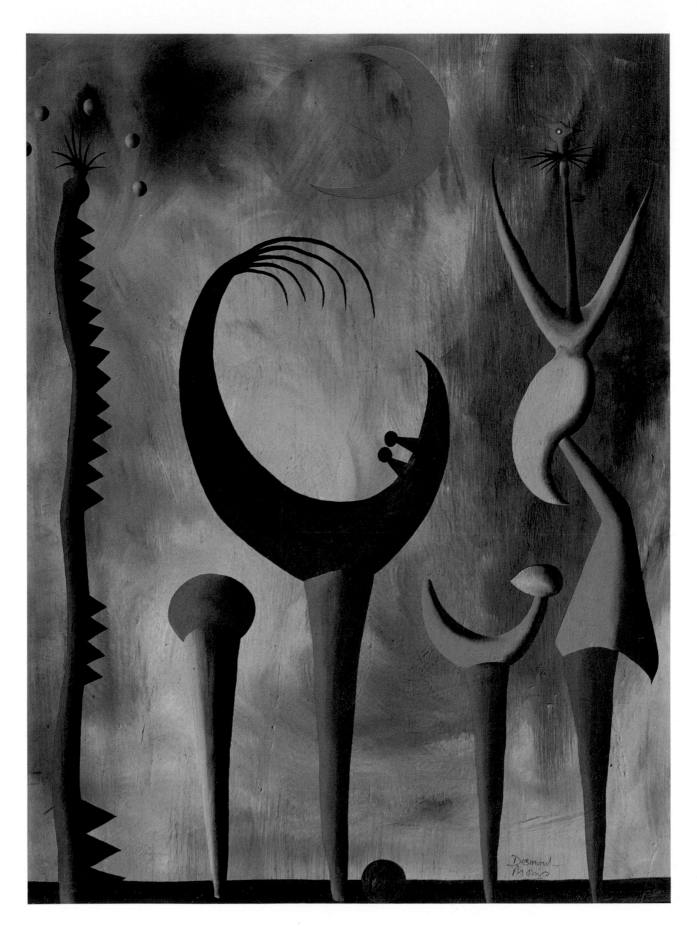

Prospecting the Mind

Tʜʀᴏᴜɢʜ ʜɪs ᴘɪᴏɴᴇᴇʀɪɴɢ sᴛᴜᴅʏ of ape picture-making, *The Biology of Art*, published in 1962, Desmond Morris attempted to establish the extent to which human art can be accounted for in terms of a biological, behavioural phenomenon. During his three-year investigation into the nature of aesthetics he discovered that without guidance, example or reward chimpanzees, gorillas, orang-utans and certain monkeys were capable of graphic pattern formation and simple visual control. None truly reached the stage of even simple representation but, over time, the patterning demonstrated signs of development and of increasing compositional precision.

What was clear was that apes possessed a sense of design and composition. Congo, for instance, showed a marked preference for the colour red. Moreover, Morris maintains, the products of ape picture-making were remarkably similar to the contemporary abstract human art of the early 1960s. He attributes this affinity to the fact that, ever since art lost its primarily representational and communicative function – these having been taken over by mechanical techniques – and was justified by aesthetic concerns, its motivation has been analogous in both species. In this sense there has been a 'pictorial convergence . . . between man and the apes'.[1] What is significant about the study of ape compositions is that it has permitted Morris to describe a small number of biological principles of picture-making, which apply to the compositions of 'everyone from Leonardo to Congo' and which therefore group them in a common camp.

One of these principles is 'compositional control'. The studies found that the sense of rhythm and balance was present even in a small capuchin monkey. In fact, the concepts of symmetry, repetition and rhythm appear to be basic and widespread visual determinants. In other words, for both humans and apes there seems to be a universal tendency towards order rather than towards chaos. Indeed, Morris found that visual sensibility in

Tʜᴇ Lᴀsᴛ Sᴇʀᴇɴᴀᴅᴇ
(opposite)
1959
Oil on board
25 × 19 in. (62.5 × 47.5 cm.)
Collection Mr and Mrs Charles Palfrey, East Barnet

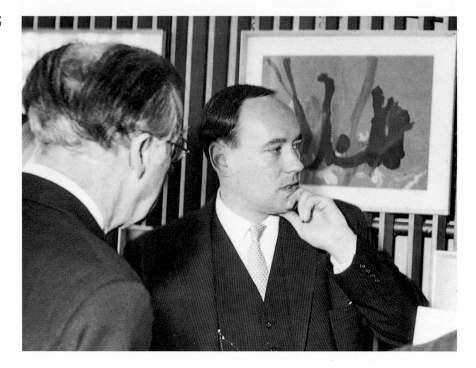

Desmond Morris with Julian
Huxley at the 'Lost Image'
exhibition at the Royal
Festival Hall, London in 1958

primates tends to produce organization rather than confusion. Apes were noted to have shown, with experience, a tendency to develop marks and lines into distinct shapes. One of the features of the compositional control exercised by Congo was the matching of a design to the space available: he would fill the paper surface but would never work beyond it.

The ability to differentiate and to modify is, according to Morris, underpinned by an innate ability to manipulate thematic variation in picture-making. He noticed that Congo would experiment arbitrarily until he identified a theme or pattern, and would then set about finding variations of it. Sometimes the original theme would be abandoned and replaced. At other times he would find a way of making slight changes which would vary rather than obliterate the initial pattern. To his basic theme, the fan shape, Congo would make a number of modifications which varied his preferred shape without rendering it unrecognizable. A point that Morris makes is that it is not unusual for a human artist to base a whole career on a single theme, which undergoes periodic adaptations.

Another universal principle defined by Morris is that of 'optimum heterogeneity'. As already mentioned, Congo's method of working did not involve endlessly adding marks to the paper so as to produce a profusion of detail. He would never carry on painting until he had reached the point of 'maximum heterogeneity', which would have produced a mass of mutually obliterating scrawls. He was conscious of a critical level of marking beyond which the work ceased to be acceptable. At this point he would consider it to be finished. 'One mark or line less,' he explains, 'and it would have been "incomplete" – one more and it would have been "overworked".'[2] The principle of 'completion' was found to be so fundamental that it was thought to be common to all apes. With Congo it was particularly marked:

With Mervyn Levy at the
'Lost Image' exhibition

On the rare occasions when attempts were made to encourage him to continue
working on a picture that he considered 'finished', rather than on a new one,
he lost his temper, whimpered, screamed or, if actually persuaded to go on,
proceeded to wreck the picture with meaningless or obliterative lines.[3]

It would seem, then, that the imagery that appears in picture-making has an
intrinsic universality. Morris notes that in apes as in human infants certain
basic characteristic arrangements and designs not only recur but do so quite
automatically. Throughout the world child art would appear to be
amazingly uniform and consistent in its subjects and presentation.

The key point that Morris makes in *The Biology of Art* is that there exist at
a fundamental level shared psychological principles of picture-making
which apply to both man and apes. He reveals 'rules that are basic enough
to apply to several related species, rather than to one species or (as is more
often the case in art theory) to one epoch of one species'.[4] Like humans,
chimpanzees make pictures in which there is a control of composition, a
filling of the available space, a creation of visual themes, balance, and a
development or variation of stated themes. These productions have been
considered to 'attest to a nascent ability in the great apes to arrange colours
in patterns which we immediately recognize as harmonious and normally
associate with works of art'.[5]

What Morris had extrapolated from chimpanzee art were generalizations
that provided an insight into human creativity: 'What I was learning from
the chimpanzee has repercussions on art in general. The chimp was teaching
me about creativity. I knew these things intuitively as a painter, but I was
now seeing them expressed by another species and therefore I was beginning
to realize just how fundamental these patterns are.' By advancing in this way

the idea that aesthetic creativity is a communal facet of the primate mental apparatus, Morris is also implying that the essence of picture-making is inherent and instinctive. Such an intrinsic part of the human make-up, his book would seem to imply, necessarily communicates something about the very essence of our thinking. He reasons that the process of artistic creation is so inextricably linked with rudimentary and primal thought that picture-making cannot but be regarded, consciously or unconsciously, as a way of fathoming the hidden, primordial depths of cognizance itself. It is for this reason that Morris places enormous faith in the capacity of pictorial expression to reveal latent and, perhaps, repressed thought. For him, the artistic process becomes a means of liberation from the constraints of social conditioning. He sees it as a link with our unthinking essence – a potential which, as the following chapters will outline, makes it the indispensable tool of Surrealism, the movement and philosophy with which Morris has ceaselessly identified himself. By virtue of its elemental place in the evolution of the primate species, creativity is a way of prospecting the mind and, therefore, a way of tapping its resources, however dangerous and subversive these may turn out to be.

3

Creatures Called Biomorphs

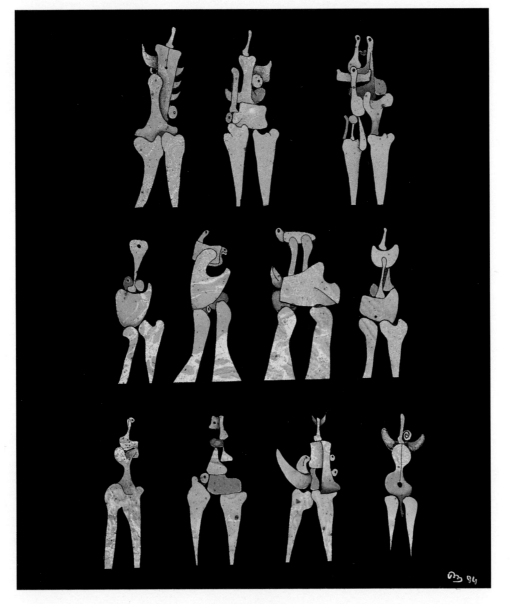

WAITING IN LINE
1994
Mixed media
12 × 10 in. (30 × 25 cm.)

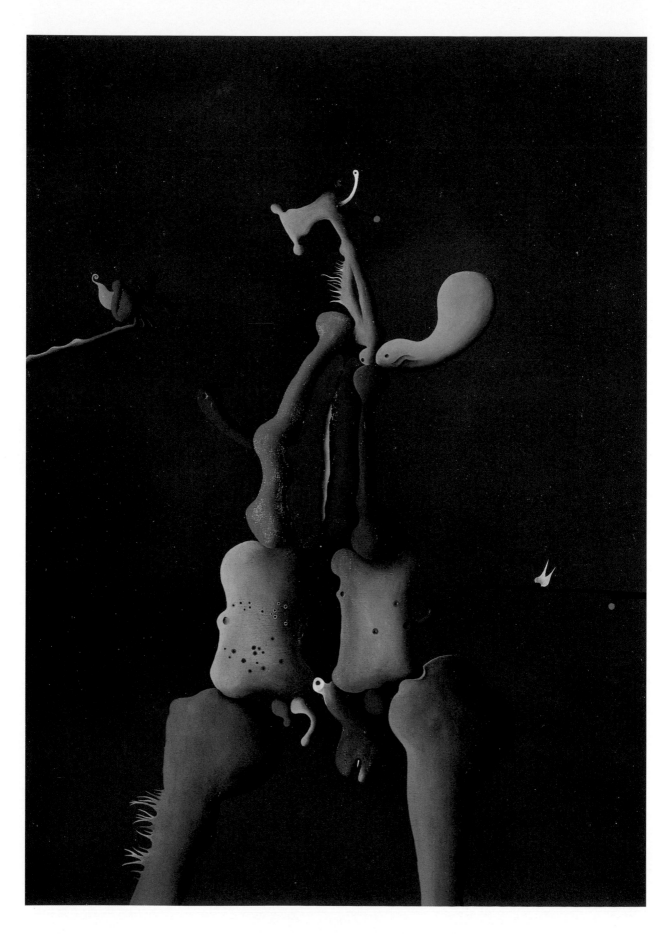

Creatures
Called
Biomorphs

O F THE ARTISTIC PROCESS Desmond Morris has said: 'It has to be kept pure. It has to be kept apart.' The extent to which this is entirely applicable to his own paintings is open to debate, however. Certainly, it would be naïve to regard his work as no more than a fanciful extension of his scientific observations. 'I never thought of myself as a zoologist who painted,' he has remarked, 'or as a painter who was interested in zoology.'[1] Yet there are, undoubtedly, inescapable parallels to be drawn between his zoological observations and his representations of quasi-creatures. These entities, which are 'biological in concept but not representing a specific animal', make compelling allusions to the procedures, shapes and organisms of biology.[2] They perform inescapably organic and biotic movements and functions. 'All my behaviour studies relate to my paintings,' Morris states; 'The exact juxtaposition of two objects on a canvas becomes another study in personal relationships.'[3] Like living creatures, moreover, these forms are dynamic and autonomous, 'developing and changing according to some strange subjective rules'.[4]

The small, globular, amoeba-like beings which populate Morris's paintings have been christened 'biomorphs' by their creator. They take the form of brightly coloured, fleshy creatures which inhabit a desert-like landscape or float in a homogeneous, translucent space. No two biomorphs are alike, but they all have something in common. It is as though they belong to the same 'family' of beings. Viewed through Darwinian eyes, they would almost certainly be classed as sharing a common ancestry.

To regard the biomorphs as being representations, albeit modified, of the lower forms of life is certainly a temptation. They were, after all, conceived by a zoologist who has professed his obsession with animals. In addition, most of the biomorphs were painted at times when Morris was either working closely with animals or engaged in academic research into their behaviour. They can be said to resemble the corpuscles, neurones and

THE EXQUISITE CORPSE

(opposite)

1993

Oil on canvas

22 × 16 in. (56 × 40 cm.)

dendrites that he would have analysed under the microscope. 'I can understand,' he once said, 'that the average person who looks at my paintings would conclude that they are a direct visual response to my work with animals.'

Although Morris has insisted that the biomorphs are not biological illustrations, it is indisputable that there is a strong link between his invented creatures and the forms of life that he has observed as a scientist. This link, however, is not a direct one. There is no simple mimetic relationship between the forms on the canvas and those under the microscope, in the aquarium or on the dissecting table. His indefinable, sometimes clumsy, beings are reflections of, but never direct references to, extant living forms and creatures. He never directly borrows specific elements from known animals or plants. Rather, his visions arise from 'the invention of images'. As he maintains, he has always 'attempted to evolve [his] own world of biomorphic shapes, influenced by but not directly related to the flora and fauna of our planet'.[5]

According to Morris, the genesis of the biomorphs is twofold: they arise, firstly, from a childhood experience; and, secondly, from a desire to emulate the quintessence of evolution itself. Since his early teens he has been fascinated by all that appears sinister and, in particular, by 'monsters'. One day the young Morris resolved to see a horror film at the local cinema, but because of his age he was not allowed entrance through the doors. This infuriated him so much that he vowed to find a way of 'rebelling against the refusal'. His solution was imaginative, to say the least: 'I arranged to get into the local mortuary.' Through a friend whose father was a local undertaker he managed to gain access to a place where soldiers who had been killed in the war were embalmed and, quite literally, pieced together. Understandably, the teenage boy found the experience far more unnerving than any horror film: 'There were a lot of soldiers who had been injured and I remember going into this mortuary and being really shaken up. I can remember the images to this day although it is more than half a century ago. It shook me rigid.'

The experience was all the more poignant in that it externalized the distress and anguish that he had undergone during the drawn-out death of his father. The anger that he had felt towards a war which had poisoned and ravaged his father's body materialized during that visit to the mortuary. 'I was suddenly aware of the monstrous way in which the human species was behaving towards itself,' he recalled. The visit to that room full of corpses made a lasting impact: 'Psychologically, it had a major effect on me.'

There was a more positive side to this morbid experience, though. The sight of lacerated and severed bodies somehow aroused an aesthetic fascination: 'I remember that I was intrigued by the internal organs of the human body which I had never seen before, of course. They were so beautiful, with wonderful structures and extraordinary shapes and colours.' He was captivated by the forms and patterns of the livers, pancreases, kidneys, entrails and so on: 'I had never seen anything like it before. It was pretty stunning.'

So overwhelmed was he by what he saw in the mortuary that it was to have a direct bearing on what he began to paint a year or so after the war. As early as 1946 in a work entitled *Over the Wall* there are echoes of the internal human organs that he had encountered as a boy.

But the biomorphs also derive their existence from another source. Morris has explained that his artistic work, like that of other painters, has its foundation in the concrete reality of a more immediate context:

> If an artist is an imaginative artist, rather than a representational artist, he draws his material from some source or other. Magritte drew his sources from the urban world in which he lived, Delvaux was strongly influenced by the art-class world of the model. A lot of his early women are just art-class models. Some of the bad abstract painters, for me, have no input like that.

As an example of a successful abstract painter Morris has cited Mondrian, who, despite the unrepresentational nature of his work, founds his vision on objective reality. In lectures given during his military service Sergeant Morris used to make this point. He would recount the accepted explanation of Mondrian's work, which centres on the analysis of the appearance of trees; then he would go on to speculate that, in addition, Mondrian's work shows a sensitivity to the microscopic structure of wood fibres:

> A cross-section through the tissues of wood looks exactly like a classic late Mondrian. In some mysterious way Mondrian had been unable to escape the tree and had chopped up the tree in his paintings until he had gone inside the tree. It looked abstract to everyone else, but it was not abstract to me. I knew that what he was looking at was the design of the tissues inside the tree.

The point that Morris is making in this rather reductionist manner is that, no matter how hard one tries, it is impossible to escape from natural patterns and shapes.

He became particularly aware of this during a visit by Joan Miró to London Zoo in the 1960s. Miró wanted to see some chameleons and so was duly shown one, with its long prehensile tail. When he subsequently set to work on a drawing he drew a figure, Morris explained, with a prehensile tail.

> He had seen a chameleon a few hours before he made the drawing and, although I don't think he was consciously aware of the fact that he was drawing a prehensile tail on the figure, he clearly had been, unconsciously, I suspect, influenced by what he had seen. You can't keep out those kinds of influences. When I asked him to sign the zoo's visitors' book he included two huge tusks. He had just seen and touched a pair of tusks in the entrance-hall of the zoo. I don't think he did them consciously but the input is going on all the time, even with someone like Miró.

Morris acknowledges that the same principle applies equally to his own work. He feels that, just as much as Magritte's, Delvaux's and Mondrian's,

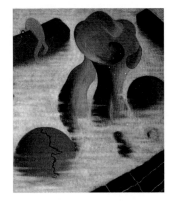

OVER THE WALL
see page 116

his created world has some foundation in the world of experience – in his case, the 'external' influence is that of his scientific research. According to his own theory, his creative thinking would have been constantly touched by images of a biological origin. Indeed, his obsession with animals in general and, particularly in the 1940s, with microscopic creatures, is incessantly echoed in the scenes that he paints. Even though, as he insists, he does not duplicate the appearance of living animals, it is not difficult to detect biological allusions in his work. Claws, teeth, glands, intestines and limbs are frequently appended to otherwise 'unbiological' forms.

The reference back to the biological is, however, far more wide-reaching. Morris's work does not simply make visual borrowings from the world of animals. As well as mirroring the external and internal shapes of living creatures, his paintings appear to parallel a deeper organizational principle to which animal life adheres. His extensive zoological work has made him acutely aware of the evolutionary forces that have generated all life. Over the years he has become sensitized to the ways in which growth, pattern, form and colour have developed in different animals:

> If any shape or pattern or any structure or organ or tissue or visual element appears in a microscopic animal or in an elephant it is there as a result of millions of years of evolution. It has been tested and it has been successful and the result is that you are looking at the distillation of millions of years of natural selection. So it has about it a genuine authority because it is a survivor. Every species is the end point of millions of years of evolution.

Such changes, Morris argues, are by no means arbitrary but, rather, determined by underlying laws and principles. 'Certain kinds of patterns and structures,' he explains, 'have about them an authority tested and tried over millions of years.'

In fact, his awareness of differentiations and demarcations between the various forms which life has taken far exceeds the acumen of the untrained eye.

> I would study under my microscope the tiny details of a claw, or an eye or a spine. I would be able to distinguish, say, the lobe of a certain species and to say that it is slightly more bulbous than the lobe of another species. The difference between the lobes of two species would amount to just a degree of bulbosity, but I knew that a slightly more bulbous form meant the difference between species. I got to the point where I could appreciate the difference between this red spot and that red spot. They were not the same red spot. To most people a red spot is a red spot but to me there may have been a thousand different types of red spots. I also started to study allometric growth patterns and discovered that when a tail grows longer then the part of the body to which the tail is attached also gets a little longer but not quite as much as the tail. I discovered differential growth patterns.

It is precisely such expert knowledge and discernment that have gradually seeped into Morris's artistic world. Unconsciously, he began to draw on

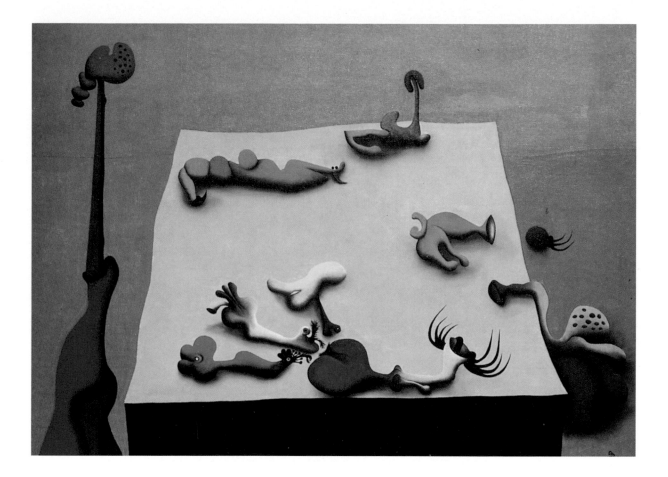

FOR INSIDERS ONLY
1973
Oil on canvas
16 × 22 in. (40 × 55 cm.)
*Collection Professor E.V. van
Hall, Noordwijk, Holland*

what he had discovered about the principles underlying the hierarchical organization of living creatures. It is as though all the different rules that determine the evolution of animals and their shapes have exerted an influence on the forms that Morris has committed to paint. As he has admitted, 'As a scientist I was understanding these analytically, but as an artist, too, I was inevitably getting a very rich input. I began to understand the way in which things changed and evolved, grew and developed.'

Before long he became aware of this phenomenon, and decided to exploit it to the full. He resolved to find out whether, through his paintings, he could construct an artificial world which would function in a way that mirrored the processes at work in the natural world: 'What I set myself as a challenge was to develop images which also had their own authority. When they changed and developed from painting to painting, they changed according to rules which were unspoken.' The process was by no means systematic, however – it involved an intuitive, rather than an academic, method. 'I did not have a rule,' he explained, 'but the paintings more or less made their own rules as I went along.'

Rules of a sort did operate, certainly. Even though the way in which Morris implemented his methods was far from calculated or premeditated, the decision to adopt a pseudo-natural process of development was a conscious one. The biomorphs changed and progressed according to what

could be termed a spontaneous unnatural selection. He says as much when he describes the process:

> If you saw me painting a biomorphic painting I would add another biomorph and I would sit and look at it. Then I might suddenly rub it out and get rid of it. I would get some turpentine and erase it because it would be wrong. But I don't know how I know when something is wrong or right. I can tell straight away if I have painted spines or hairs or lobes in the wrong place. But I don't know how I know.

According to Morris, there is nothing extraordinary in this formula and it can be observed in the work of other painters: 'These rules are developing, and of course this is what happens with most artists.' In fact, he considers the process of varying a particular theme as 'the basis of all human creativity'. What is peculiar to Morris, what marks his originality, is that these 'rules' on which his thematic variation is based are very close to biological evolution. 'It is parallel evolution,' he has remarked, 'it is pseudo-natural selection.' Somewhat fancifully, he once went so far as to attribute to the biomorphs the capacity of autonomous regeneration: 'They seemed at last to have become completely independent of the outer world and were virtually painting themselves. Sometimes, on entering the studio, I quite expected an unfinished canvas to have gone on peopling itself with new biomorphs during the night, as if they had finally developed their own power of reproduction.'[6] What adds to the fascination is that, as a scientist, Morris has been in a position to observe biological shapes which most people never encounter or which are invisible to the naked eye. He would, for instance, have scrutinized interior organs and microscopic organisms. When these taxonomically unidentifiable forms of life exert an influence on a painting the impact on the observer is disorienting and, consequently, all the more poignant.

Morris considers that his most significant activity is that of 'exploring' this fabricated microcosm – his 'private and personal natural history'.[7] Quite outside his conscious control, these forms, once painted, invariably suggest certain possible mutations and developments, which he goes on to record in further canvases:

> I started to evolve a world of private creatures of my own. They mutated from canvas to canvas, growing, developing and changing. Some sort of general biological principles seem to be operating which guide me, but the results have nothing to do with the specific fauna of the outside world . . . The goal is to invent a new fauna and to nurse it gradually through a slow evolution of its own, from picture to picture.[8]

The visions which are presented in individual paintings can be considered as stages of a gradual development. Together they map out a whole evolution which, Desmond Morris has said, mirrors the processes at work in the natural world:

In portraying an imaginary organism I can manipulate emphasis by exaggerating some elements and suppressing others. A similar process occurs in nature – the ant-eater's nose and the porcupine's quills become exaggerated during evolution, while the limbs of the snake and the tail of the ape become suppressed. As a painter, I can follow this same general trend, while making my own special rules in each case. In this way I can evolve my own fauna.[9]

So the biomorphs are the protagonists in a fictitious, or artificial, evolutionary process. Just as evolution screens the different species, making some extinct and allowing others to survive, so the biomorphs undergo a development through time which results in the discontinuation of some and the 'survival' of others. Indeed, some forms in Morris's work have persisted and have developed and been modified over decades. He has said that, once he has devised a particular shape or organism, that organism 'begins to make its own rules'. These rules may herald its extinction or its endurance.

The idea that the make-up and physical appearance of a specific biological feature can differ from creature to creature, and that it can undergo modifications as it develops through time, was impressed upon Morris from a young age. As a boy he had been captivated by Grew's *The Comparative Anatomy of Stomachs and Guts Begun*, which placed differing configurations of internal organs side by side on the same page. This method of 'comparing' anatomies and thereby establishing an 'evolutionary' maturation sequence left its mark on Morris's imagination, and it is occasionally echoed in his own work. For instance, in *Rank and File* (1949) he abolishes all ideas of composition and pictorial space in order to concentrate on a comparison of

CREATURES
CALLED
BIOMORPHS

COMPARATIVE ANATOMY
1948
Mixed media
8 × 13 in. (20 × 32.5 cm.)
Peter Nahum Gallery, London

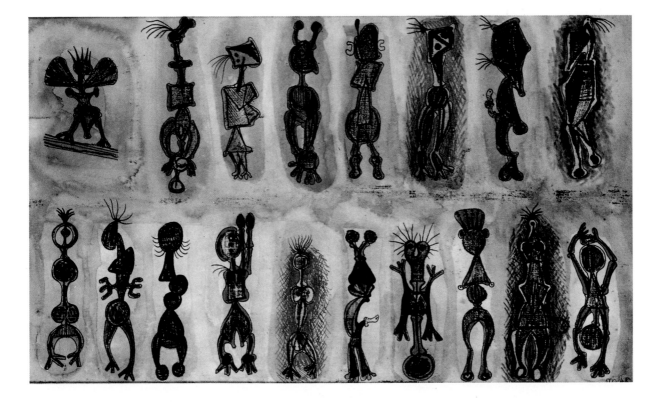

THE PARADE OF MEMORIES

(pages 52–53)

1972

Oil on canvas

20 × 30 in. (50 × 75 cm.)

Collection Dr David Blest,

Canberra

RANK AND FILE *(opposite)*

1949

Mixed media

10 × 8 in. (25 × 20 cm.)

an array of biomorphic figures. A series of shapes are placed side by side – as the guts in Grew's book had been – and are seen to be 'evolving'. It is as though a figure were being altered in stages. Nor is the variation process an arbitrary one. Although not immediately apparent, the 'rule' which Morris adheres to in *Rank and File* is that of increasing or decreasing the number of lines that constitute the outline of the torso of each figure. From a five-sided figure arises a rather asymmetrical trunk, for example. Four sides produce an essentially squat and square variant, whilst three lines emerge as elegant, slender triangular forms. He also experiments with two-sided figures, which turn out as 'rugby ball' ovals, as well as with single lines, which form circular torsos.

Morris has insisted that the process is not a conscious one. 'I start with one shape, and I allow the lines to alter gradually and more or less automatically.' There is no preconceived or calculated progression. Yet the indisputable, albeit latent, order and patterning that can be discerned in these works makes them, to a degree, the products of his 'scientific' inclination. These 'comparative anatomies' could well be regarded as instances of 'Morris the scientist' setting to work and analysing the products of his own imagination. Indeed, the very term that he uses to describe the works is derived from scientific terminology. They are surveys of potential for development. In fact, the comparative anatomies can be viewed as condensed expressions of the processes which more often span long sequences of paintings.

These processes mimic the development of life itself. But to identify specific living forms as the source of particular biomorphs is an impossible task. Morris draws on the full spectrum of both fauna and flora: within a single biomorph it may be possible to detect allusions to parts of the human body as well as to details of flowers. Some biomorphs are rooted, and some float and fly in an avian fashion. Morris draws a comparison with fungi, which 'are neither animals nor plants'. And just as these organisms are set apart, he regards the biomorphs as belonging to a separate phylum. They form a class of beings which exists in parallel to all others, rather than in relation to them. 'Bacteria, fungi, plants and animals are major categories of living things,' he specifies, 'and biomorphs do not belong to any of those.'

Biomorphs are separate from life as we know it. They are not biological in the strict sense. Nor, as already noted, are they representations of biological organisms. Yet, whilst remaining distinct, they cannot be divorced from a human subtext. The relationships between them as well as, very often, their anatomy mirrors elements from the human world. One commentator has remarked: 'Morris has created a marvellously vivid "parallel world", a biomorphic society whose sensual creatures engage in rituals and relations different but not distant from our own.'[10] In some cases, they can even be said to dramatize human preoccupations, instincts and fears. It is, in effect, through his portrayal of the biomorphs that Morris confronts some of the taboos instituted by human society. One of the most enduring of these is death, and it is this particular proscription that is treated in *The Parade of Memories* (1972):

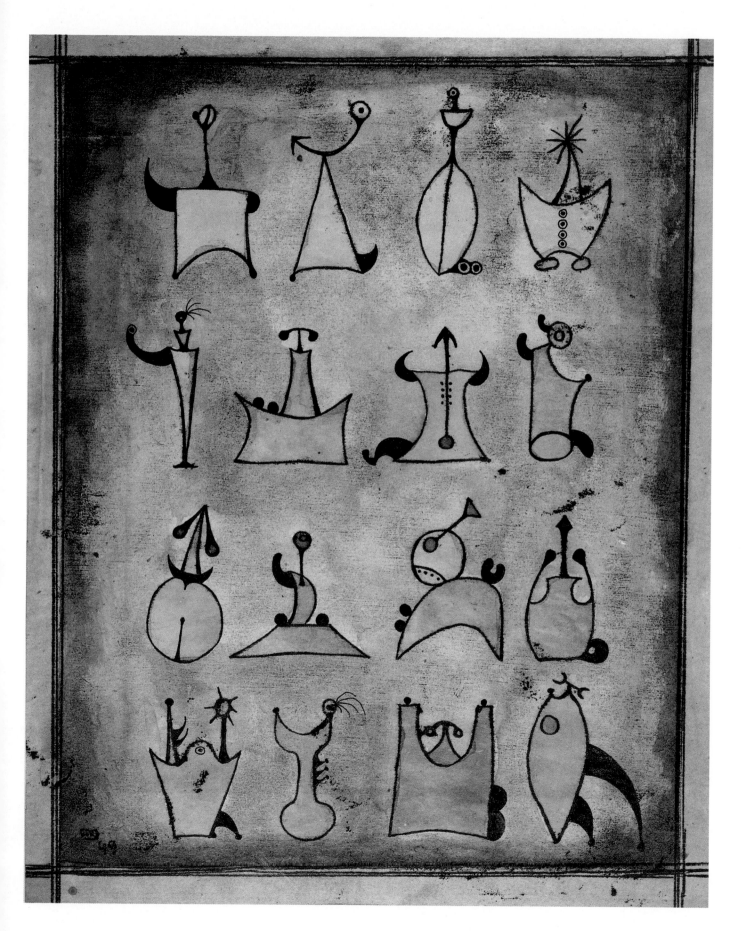

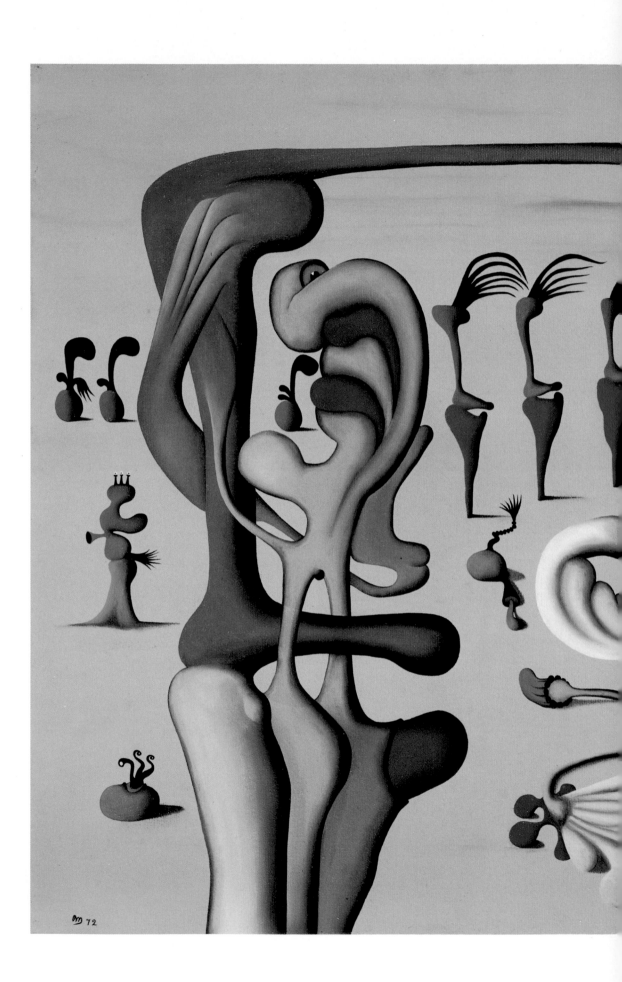

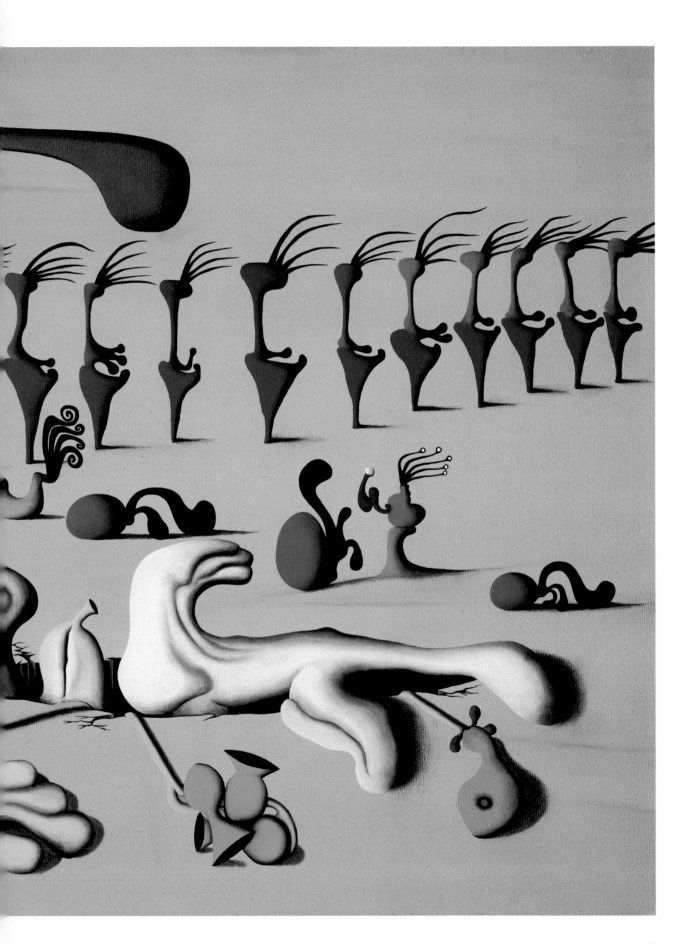

CREATURES CALLED BIOMORPHS

This painting contains a miniature parade of figures with various little onlookers and a major figure in the foreground. Then there is a hole in the ground out of which are coming some figures which look rather like internal organs. Coming out of the ground are all the organs, tissues, bits of bodies and eyes which we bury in the ground so that we don't have to look at them. When somebody dies the first thing we do is to cover the face with a cloth because we don't like to look at a dead body. The next thing we do is to whisk it away as quickly as we can to a mortuary, where it is then put into a box and put in the ground or burnt. We cannot bear to be in the presence of dead human beings because it reminds us of our own mortality, which is one of the things we fear.

We fear death much more than any of us will ever admit . . . This is the reason we have invented an afterlife. This is the reason why we invented God and the religion/superstition system. It is because we have to have some protection against the thought of dying. The whole thing is built to calm our anxieties. We are incredibly neurotic about death. What is happening in this painting is . . . an 'unburial' ceremony. The point is that we are being reminded here that this is what we are made of.

In other words, the world of the biomorphs captures and agitates the most basic of the apprehensions of human existence.

For this reason the interactions between the biomorphs take place on a stage set for the elementary and inescapable activities of life and survival – fighting, playing, mating. These creatures have simple needs and aspirations and they function according to clear-cut, although extreme, passions and sentiments. Existence is portrayed in black-and-white terms: it is sometimes violent and confrontational, sometimes ludic and garrulous, sometimes sexual. At the same time, the world created by Morris depicts a broad spectrum of social interaction: we see hierarchies, contests of strength, courtships and copulation. Because of this, he concedes, 'perhaps some of [the biomorphs] are very human'. Indeed, as with human relationships, the interactions between them, whilst falling within the basic categories of behaviour, are often subtle and ambiguous:

I don't think that there is any reductionism in these paintings . . . What is happening in every biomorphic group is a whole complexity of relationships, because that's how we relate to one another. That's how animals relate to one another. At any given moment there may be a simple relationship, but most of the time most relationships are complex and are based on a whole complexity of different considerations and influences. We very rarely have moments of pure, simple relationship. Most social events involve many different elements of relationship all at once.

When the biomorphs meet they express the complexity and ambiguity of social relationships . . . They are not just invented little cartoon figures: they carry with them more serious messages. They contain within their relationships messages of violence, of death, of playfulness, of envy, of jealousy, of hatred, of love, of passion, of lust. That's what makes them serious.

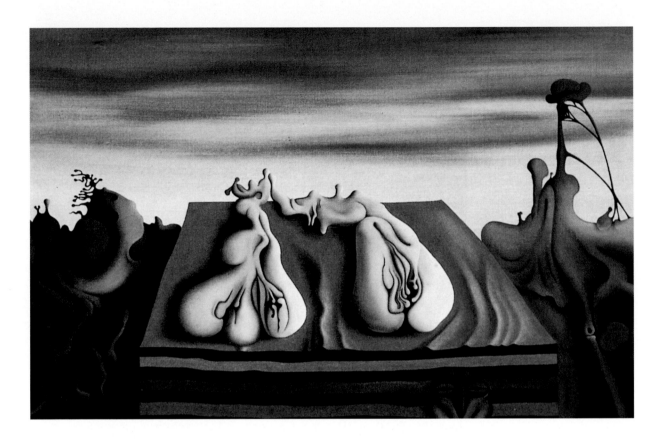

In other words, Morris conveys through the biomorphs a sense of the most primordial and instinctive aspects of human thinking, and goes on to contextualize these within the complexity of social interaction; he unwittingly encapsulates the very mechanism on which life is based. In an elementary, but subtle, manner he taps into the primitive psyche, that of *Homo sapiens* before reason, social decorum and a moral code tempered him into a product of civilization.

Moreover, the manner in which Morris achieves this critique is rarely blinkered by subjective interventions or personal dilemmas and preoccupations. In many paintings there are references to a state of detachment from the scenario depicted. There is the sense of an intrusive observer having access to a hidden or imperceptible world. The recurring theme of the conjugal bed, for instance, would not be accessible except to a voyeur or a scientist. 'In *The Sentinel* [1976],' Morris says, 'there is a presence other than that of the active participants.' It is as though the frame were a peep-hole. Indeed, very often he depicts a figure within the painting who is watching the rest of the scene. 'There are insiders and outsiders,' he explains. The real, at times obsessional, watcher is, of course, Morris himself. He never quite relinquishes the role of observing scientist. It is as though he examines, records and transliterates there his observations on life and humanity. But, because he unconsciously transposes the objectivity and meticulousness of the scientist into his paintings, his conclusions on the 'human relationships' which he implicitly explores carry all the more significance.

THE SENTINEL
1976
Oil on canvas
24 × 36 in. (60 × 90 cm.)
Collection Mr H. Slewe,
Laren, Holland

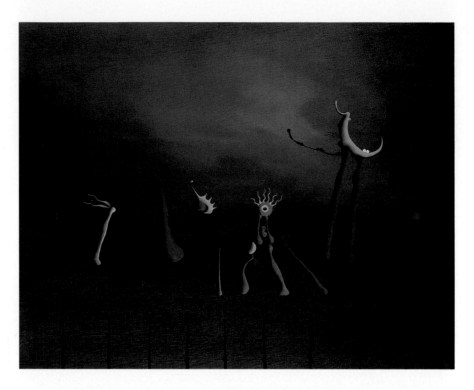

MEMORIES OF TOMORROW
1989
Oil on canvas
24 × 30 in. (60 × 75 cm.)

As well, Morris makes no attempt to reproduce or represent the fauna and flora, however fantastic, found in nature: 'If it is possible to relate one of my biomorphs to a specific animal or combination of animals in real life, I consider I have failed.'[11] Instead, he gives physical corporeality to essences which inhabit not so much the evolutionary kingdoms as the deepest regions of the mind. Mervyn Levy regards Morris's work as a search for 'the intangible kernel which is to be found within'.[12] The visual world is alluded to in his work, but it is simply a starting-point. From it he 'distils his own universe of shapes and pattern, colours and feelings'.[13] By means of spines, protuberances, lobes and vegetal hair he gives form, substance and colour to such sentiments as aggression and terror, to eroticism, joviality and sensuality. With their newly created physiques, these psychological rudiments confront one another, fondle one another, snarl, hunt, play, become victims. This is an interior world in turmoil.

Ultimately Desmond Morris sees his work as a means of subversion. His biomorphs, and the repressed and taboo instincts and desires to which they give material form, are instruments of sabotage. With their attention-seeking iridescent colours the biomorphs compel the observer to confront his or her most uncomfortable and disturbing thoughts:

> To this day, painting has remained for me an act of rebellion, a private pursuit which I indulge in despite the fact that there are many good reasons why I should not do so . . . [Painting] is at once humble and yet egotistical; innocent and yet based on the sum total of personal visual experience. It can act, for an adult, as a gesture of defiance against the increasing intrusion into everyday life of good, sound, common sense.[14]

4

The Black Dream-room

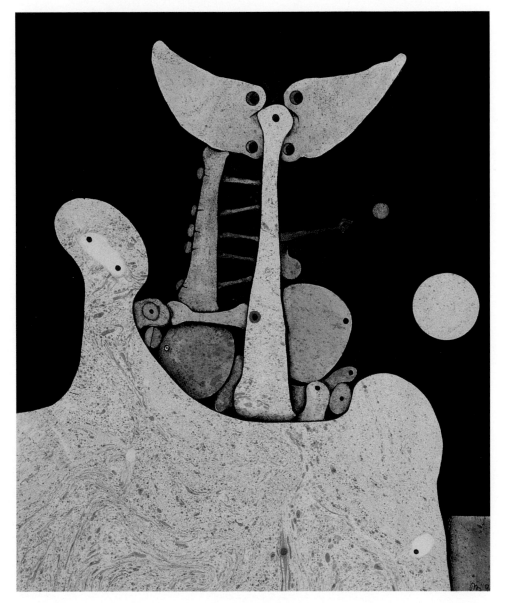

THE LAST GAME
1994
Mixed media
12×10 in. $(30 \times 25$ cm.)

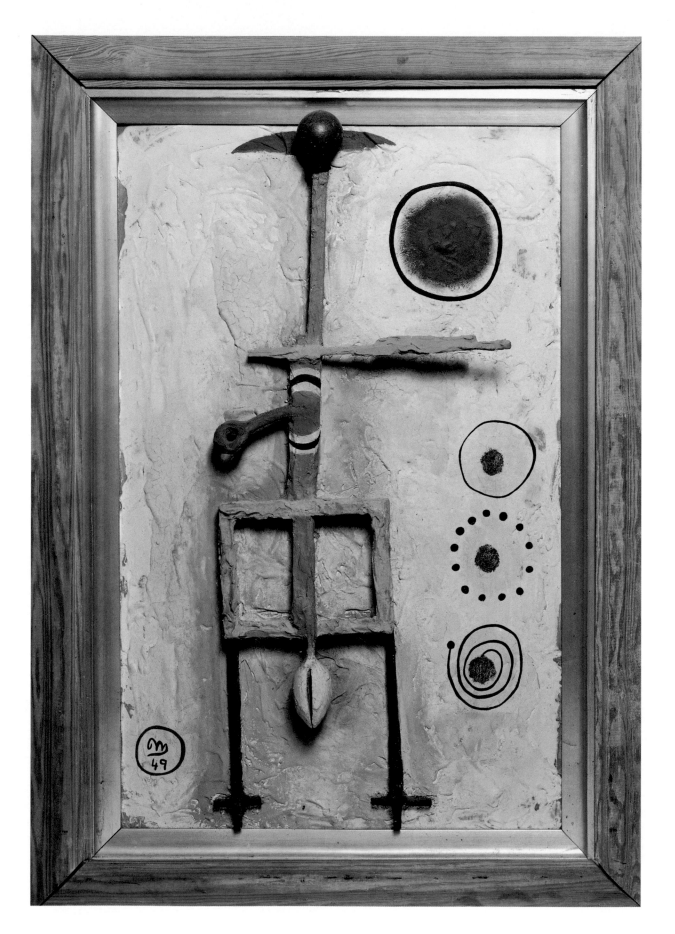

The Black Dream-room

WAR WOMAN (*opposite*)
1949
Mixed media on board
28 × 17 in. (70 × 42.5 cm.)
Collection Mayor Gallery,
London

EVER SINCE THE IDEA of a biomorphic world was formulated, Desmond Morris has had a 'nagging frustration', as he puts it. He has constantly been fascinated – even obsessed – with the notion of somehow attaining a more immediate experience of the scenarios and characters that inhabit his imagination. His ambition has been to 'leap through the picture-frame'.

Over the years he has tried several tacks. For instance, he had himself hypnotized, having instructed the hypnotist to urge him into the biomorphic world. This failed to produce the desired result, even though the hypnosis did result in rather crude biomorphic paintings. Equally fruitless was the suggestion by some scientific colleagues that he should take hallucinogens. Morris's 'mortal fear of all drugs' prevented this course from being even a possibility.

Another attempted solution, which, somewhat unjustifiably, he dismisses as 'a failure', is his novel *Inrock*, which started as a reverie on a Cypriot beach in 1967. He started seriously writing it while living in Malta in 1970, eventually finalizing the text in Monaco in 1982. He regards this fantasy, in which the hero, Jason, enters a parallel world through a gap between two rocks, as no more than an 'entertaining' prose. Yet this unique vision of life that is presented is analogous with the one seen in his paintings. Inside the rocks Jason encounters a bizarre realm inhabited by creatures with biomorphic qualities, whose existence is governed by a rationale quite distinct from our own. Here Morris creates a fantastic alternative reality and, moreover, one which satirizes the world of reason and common sense. His reservations about his novel stem from the fact that, in order to forge a narrative, he was drawn towards a certain anthropomorphization of otherwise 'unhuman' biomorphic characters. For him, this Disneyesque technique, as he sees it, destroys the 'deeply serious intentions' of the world created in his paintings.

THE BLACK
DREAM-ROOM

Desmond Morris in the
Swindon studio in 1948

By far his most ingenious attempt to plunge into the biomorphic world
was begun much earlier, though, in the 1940s, while he was still doing his
military service at Chiseldon Army College. During periods of leave he was
making regular home visits to 58 Victoria Road in Swindon, and gradually
advancing a creative scheme. By the autumn of 1947 he had established a
conservatory – studio which effectively became a three-dimensional version
of the world created in his paintings. Using any materials that came to hand,
such as string, wood, rubber, wire and cork, he produced a rambling
continuum of coloured abstract shapes, mobiles and web-like filaments
which threaded their way across the space inside the conservatory. Here,
within a tangle of forms drawn from his paintings, Morris encapsulated
himself. A photograph taken in 1948 of a corner of this fabricated world
shows the degree to which the constructions are an extension of the
scenarios painted on canvas: were it not for the easel, the strings and
hanging forms in the background could well be taken as a continuation of
the biomorphic scene in the painting *The Schoolmistress* (1947) which is in
the foreground (see page 63).

On rare occasions this concept of giving solid substance to the two-
dimensional has found its way back inside the picture frame. In *War
Woman* (1949) Morris combines painted images with sculptural forms in
wood, cork and plaster. He transgresses the confines and accepted
limitations of the flat image to offer a challenge to the spectator's
expectations. Firstly, his treatment of the subject 'woman' is contrary to
most representational norms: the female figure is presented as angular,
sharp-edged and aggressively robust instead of feminine and sensual. Also,
the 'war woman' is equipped with clubs and various other weapons.
Secondly, the context of a board surrounded by a frame is normally

Desmond Morris in the
Swindon studio in 1948

associated with a work executed in two dimensions. As though attacking the very conventions of painting, Morris forces a treatment normally associated with the sculptural into a flat, two-dimensional mode of depiction. The work forms an aggressive and belligerent statement on various levels. The subject alone is that of a figure which appears to be stepping out of the frame to confront the external reality of the spectator.

The idea of converting a mundane, domestic setting into an expression of an imagined world was extended to another room in Morris's maternal

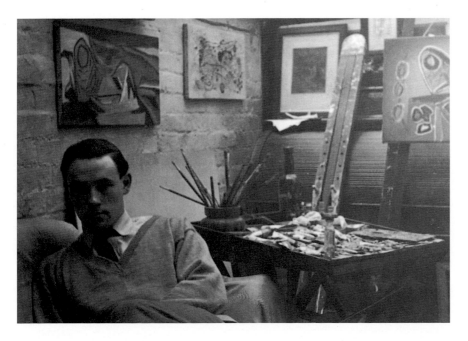

Desmond Morris in the
Swindon studio in 1948

A still from 'Time Flower'
(1950)

home. This time he appropriated the attic, with the intention of
constructing a still more intense three-dimensional biomorphic setting. He
obliterated the 'external' world by painting out the glass skylight, and
covered the floor with mattresses to make an undulating surface. This
turned out, over several years, to be an extremely fruitful focus of experi-
mentation.

The biomorphic ambience was completed with a long mural, making a
private and isolated microcosm. Morris would lie there for hours,
contemplating and planning the world that he was in the process of creating.
It was probably in this environment that the adventurous film *Time Flower*
was conceived. Indeed, the mural provided the stage set for its bizarre
sequence of events – the scenario did specify 'a strange room' – and it is
clearly seen in several of the shots. It may well have been the unorthodox
nature of Morris's preserve that inspired such cinematographic occurrences
as the hedgehog turning into a bullock's skull, the third eye appearing from
inside a man's mouth, and the clock that has letters and symbols on its face
instead of numbers and that bleeds when pierced by a dart. Just as the attic
became a retreat from external reality, so the events that it engendered
relinquished the rationale of that reality: space and time are disrupted in the
film, as is the normal sequence of cause and effect. Morris has recalled that
when, in the 1980s, he revisited his attic sanctuary for the first time in forty
years, just before it was due to be gutted for renovation, he was struck by its
evocative power.

So compelling were his two biomorphic environments that he once had a
vivid nightmare that was set in his studio. He had been suffering from a
fever, and his unusually high temperature induced a delirious dream in the
course of which he found himself in the presence of one of his biomorphs.

He dreamt that, as he happened to look up through the glazed roof of the studio, he suddenly caught sight of an horrific creature in the tree above. Upon waking he frantically scribbled down his experience:

> There's one enormous creature I can just see out of the corner of my eye perched on one of the highest branches of the tree that hangs close over this glass roof . . . It has a single claw and a red head with big teeth fixed all around it which strangely enough seem quite sad . . . I was wrong; it is in fact a circle of very pointed breasts . . . They start circling, a swarm of little sexual buds, around the creature on the branch which sways precariously.*

The nightmare unfolded in a very alarming manner. Morris became aware of gazing up at the monster and, as he did so, it began to sway and topple, then, in slow motion, fell on top of him. The moment of impact was accompanied by an apparent loss of consciousness. In an immediately succeeding episode he dreamt that he had regained his senses but that, in the process, he had also undergone a sinister transformation. He suddenly realized that he was no longer the university student who had fallen asleep that night, but that his body had merged with, and had taken on the appearance, of the falling ogre:

> My legs are also tight together and I find on looking down that they are now a single hard claw and the grass is a long way below and I am eating leaves . . . I wonder if the fleas I can feel running through my feathers are as red as my head must be by now? I wonder if the rain will loosen the skin on my skull? I wonder if I could copulate in flight? . . . Now I feel all sticky.

* The complete text, known by the title 'The Day the Animals Came', was written as a letter and sent to Conroy Maddox on 28 June 1949.

THE BLACK DREAM-ROOM

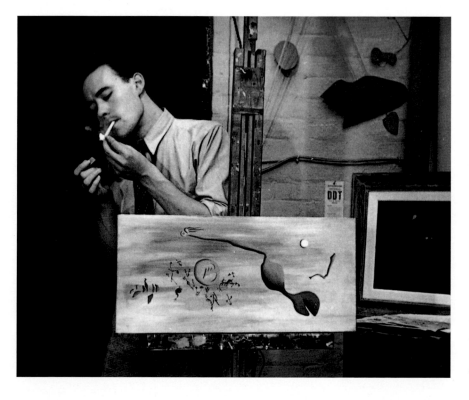

Desmond Morris behind *The Schoolmistress* (1947), oil on canvas, 12 x 26 in (30 x 65 cm) (destroyed) The Swindon Studio, 1948.

Desmond Morris at his desk in
the Black Dream-Room, 1948

He woke up in a panic. In his dream he had become one of the biomorphs
– a turn of events that he found deeply unsettling. He felt that his quest 'had
gone a step too far'.[1] Yet, for all its disturbing repercussions, this
confrontation with the world of the biomorphs had the effect of impressing
upon him the fact that his painted vision could indeed exert a significant
impact on everyday reality.

Morris's endeavours 'to live inside a picture' were not limited to his
claustral attic and his conservatory—studio. To accompany these
constructed domains he decided to create a third, separate setting, which he
conceived in a diametrically opposed way. To the consternation of his
mother and his friends, he set about painting his entire bedroom in matt
black. Nothing was spared: the walls, the doors, the windows, the ceiling and
the floor disappeared into a shadowy homogeneity. Such was the impact of
this transformation that the family doctor, who happened one day to visit
him on account of a minor illness, was quite unnerved by it: on entering the
Black Dream-room the medic immediately assumed that his patient had
died and was lying in state.

But Morris saw nothing funereal in the colour black. Certainly, his
painting of the room had nothing to do, as is sometimes suggested, with the
fact that this was where his father had died in 1942. It was only much later
that he had learnt of this. The only significance that he placed on painting
his room black was that it was a way of creating 'a non-existent surface'. He
wanted to destroy the contours, the surfaces, the tangibility, the very
domesticity of the space in which he found himself. He was, as it were,
effacing the real, external world. 'By being black,' he explained, 'the features

of the room ceased to exist.' He painted himself into a void: 'The black did not exist, it was an empty space, the walls just disappeared.' When Morris later learnt that outer space is itself black, a fact that was little appreciated in 1948, he came to the realization that he had been 'creating space, in the cosmic sense'. This was his first step towards the world he was seeking.

The next came when he started to use the blackness as a setting for his biomorphic vision. On the black background he painted vivid images in bright yellows, reds, blues and greens – several coats of paint were required, he remembers, to create the luminous effect. He constructed what he termed 'a stellar surface', and within it he brought to life scenes and creatures which had, until then, existed only in paintings that took a more conventional form. Once the walls had vanished, the voids became populated with floating spheres, with flying globules trailing spindly tentacles, with geometric, angular creatures hovering or sliding on unsupported filaments. Sexual allusions were never far away and ovular and spermatozoic activity abounded. In places the unmistakable outlines of genitalia – 'symbols floating in space', he called them – appeared to be flitting hither and thither around the room. These were the building blocks of his biomorphic vision. Unlike his other paintings, however, this was a three-dimensional canvas: he could be surrounded by it and exist within it.

Once the painting was complete, he set his bed in the middle of the room, and at night would spend long periods studying his newly created universe

THE BLACK
DREAM-ROOM

The decorated walls of the
Black Dream-Room

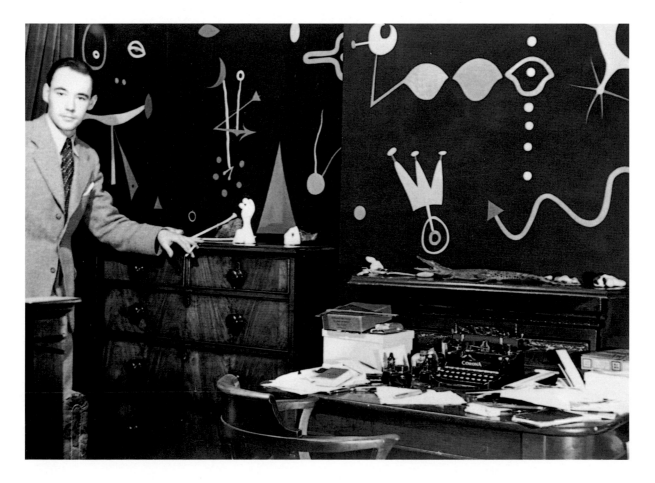

The Black Dream-Room

The Black Dream-Room

before falling asleep. On some nights he would not sleep at all. Having literally placed himself at the centre of his painted world, he wanted to be subsumed by it. All around him were the creatures that had hitherto been kept at bay by the picture frame. He had concocted 'a dream-room, a room for intensifying dreams'.

In this new environment Morris hoped that he would not only develop a closer affinity with his imagined world but that he would be infiltrated by the biomorphic aura: 'I contemplated the scene before falling asleep . . . in the hope that it would induce dreams that would transport me to my private world . . . I wanted to sleep inside my own paintings . . . it was an intense obsession.' But, in a strict sense, his success was limited. With the exception of the dream that led to his writing 'The Day the Animals Came' (*page 181*), he has no recollection of dreaming of biomorphs. He was later even to dismiss the experiment as a failure.

In a wider sense, however, the Black Dream-room period was far from infertile. It undoubtedly generated intense creativity: between 1948 and

The Black Dream-Room

1951 many poems, two films and a stream of paintings emerged. In the year 1948 alone Morris produced eighty-nine paintings, and it was in that year that he staged his first exhibition. 'It was a time when I was intensely involved in Surrealism to the exclusion of everything else,' he has recalled. The significance of the Black Dream-room, which has unfortunately now been totally obliterated by refurbishment carried out by new proprietors, cannot be underestimated. Its baroque, three-dimensional extravagance is comparable to Kurt Schwitters' abstract room-sized assemblage, *Merzbau*.* Both represent an eruption of their respective creators' visions into tangible reality.

The concept of 'entering the world of the biomorphs' has been such an enduring aspect of Morris's personal artistic visuality that in 1996, some fifty years after the construction of the Black Dream-room, he began to devise a room-sized, three-dimensional biomorphic scenario. His long-held ambition has been to create a *magnum opus* consisting of painted bronze or plastic biomorphs, of human dimensions, which would occupy an undulating sandy terrain and be movable at will, like giant chess pieces. The intention is that the spectator should view the installation from its centre and thereby experience an effective 'entry' into the biomorphs' world.

Such an experience would inevitably reveal the fundamentals of existence into which Morris has distilled consciousness itself. It has been said that 'the biomorphic forms inhabiting his paintings are humorous, joyful, often sexualized, sometimes even violent'.[2] Another critic has described them as 'malevolent, amusing, erotic, fierce'.[3] In an interview in 1991 Morris himself upheld this evaluation, describing his paintings as overflowing with 'sexuality, humour, jollity and violence'.[4] The three perspectives of playfulness, aggression and sexuality are, in effect, pivotal constituents of any fruitful examination of his artistic production. The following chapters explore how and why these motive forces energize the world of the biomorphs.

* In 1920 Schwitters began to build a room assemblage, known as *Merzbau*, from discarded ephemera and rubbish. It was destroyed in 1943. He built another in Norway, which was also later destroyed. When he escaped to England from Norway during the war, he began a third *Merzbau* in Ambleside in the Lake District. This incomplete version survives as one wall, which has been transported to the Hatton Gallery in Newcastle-upon-Tyne. One of Schwitters' early collages included an advertisement for the Commerz und Privatbank, from which the fragment 'merz' remained visible in the finished composition. Ever since, his brand of Dada/Surrealism has been known as 'Merz'.

5

Playful Impulses

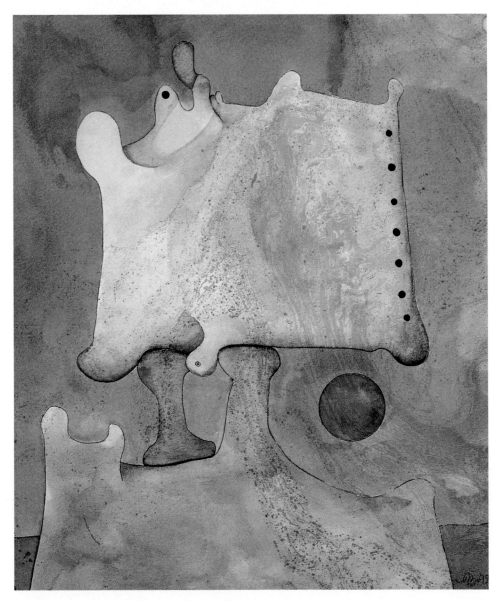

THE OBSESSIONAL
1992
Mixed media
12 × 10 in. (30 × 25 cm.)

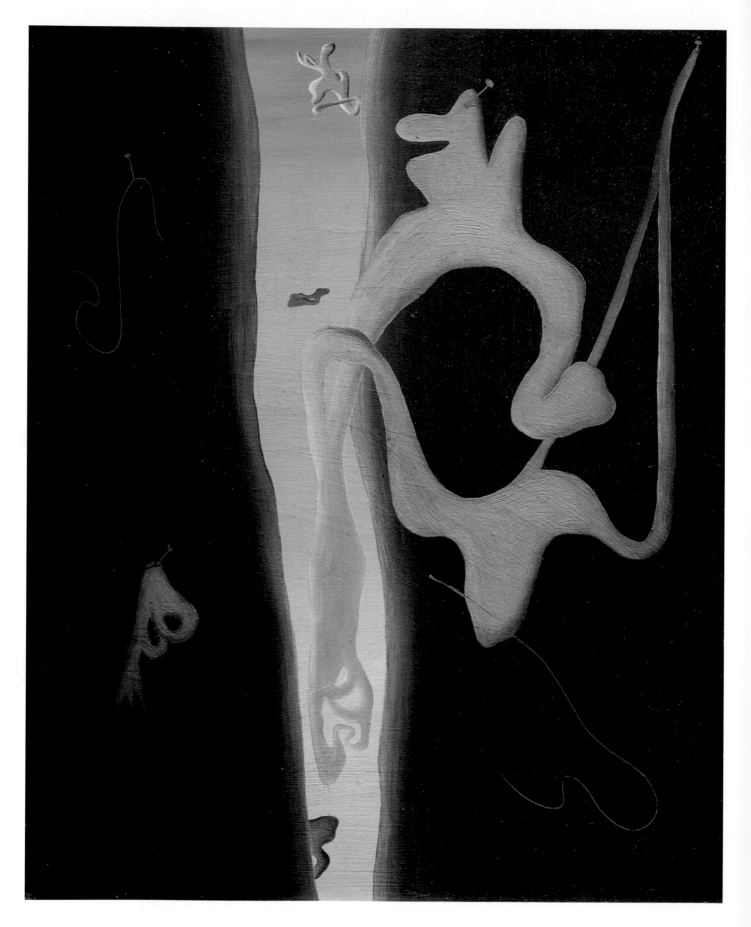

Playful
Impulses

AT FIRST SIGHT Desmond Morris's private world of brightly coloured quasi-biological forms and organisms may appear as innocent and innocuous as the characters in a Disney cartoon film. However, the biomorphic scenes arise from a totally opposed objective. Disney sets out to amuse by his depiction of events and individuals. Morris, on the other hand, writes of 'the deeply serious intentions of my paintings'.[1] For him, painting is no less than 'an act of rebellion'.

This trajectory, which has produced over one thousand works to date, can be said to have been set in 1947 by a work aptly entitled *Entry to a Landscape*. This painting shows a cleft between two dark rock faces through which a strange, seemingly secret, domain can be glimpsed, like 'an existence within an existence'.[2] On the far side of the apparent doorway can be perceived light, a cheerful sandy expanse and, above all, a sense of freedom. The broad terrain and unobscured sky offer a liberating space. Moreover, the small, animated biological shapes which populate it are engaged in emancipated activity. One shape moves, unchallenged, across the lower sandy surface, another lazily basks and, perhaps, dozes, outstretched in the horizon's sunshine, while a third floats with sheer enjoyment in the light of the bright-blue sky. This is a vigorous, brightly lit world of recreation and relaxation – a carefree, expansive world of unrestricted hedonism.

On the near side of the rocks the mood is totally different. In the semi-darkness the forms appear dull, colourless. In contrast with the other, sunlit, shapes, these figures are motionless. They are, in fact, prevented from moving by aggressive red nails driven into their bodies and by red wire which either lies ready to ensnare them or has already pierced and entered their softer parts. One shape, comprising two holed lobes and a fanned tail, droops inanimately from a nail; it seems to have been hammered into the rock and left to perish. Another, which is attempting to escape a similar fate

ENTRY TO A LANDSCAPE
(opposite)
1947
Oil on board
20 × 16 in. (50 × 40 cm.)
Collection Peter Nahum
Gallery, London

MASTER OF THE SITUATION

(opposite)

1947

Oil on canvas

16 × 12 in. (40 × 30 cm.)

Collection Mrs Elaine Fraser,

Ealing, London

by straining into the sunlit domain, is pinned down by two nails and a wire. The dark side of the rocks signifies incarceration and lifelessness.

Desmond Morris has explained that the distinct realms in this painting are allusions, respectively, to death and life. Life, he implies, lies through the opening, away from the world of the spectator, away from the actual world – which at the end of the Second World War must have seemed a very gloomy place indeed to the young Morris. At the age of fourteen he had seen his father slowly die, his health having been destroyed in the trenches of the 1914-18 war, and during his later teenage years he witnessed the horrors of wartime bombing raids. All this had impressed on him just how barbaric the adult world could be: 'I decided that the human species was pretty awful . . . I talk in some of my school essays about this "monstrous species" *Homo sapiens* and how disgusting it is, because, as a child, all I saw was people blowing people up.' In one such essay he described people as 'monkeys with a diseased and festering cranium'.

For Morris, this monstrous real world of atrocity and dark thoughts could be countered by an escape into an exciting, happy, playful world, a world that could be reached through the imagination. There he perceived a vivacious, enchanted state of existence, to which he had offered himself access and that had nothing to do with the morbid reality that surrounded him. 'I slipped through this crack in the rocks and there I was, suddenly surrounded by a whole array of bizarre inhabitants.'[3]* It was the description of these inhabitants and their activities that was to preoccupy him for years to come.

The newly entered landscape immediately gives an impression of playfulness. The often simplistic shapes are reminiscent of children's paintings and of infants toys. It has been said that Morris's paintings are 'imbued with a child-like love of brilliant and contrasting colours'.[4] Just as in child art, the colours are bold and arresting and the shapes tend to be smooth and uncomplicated. It would not be difficult to imagine the characters that he paints as solid, plastic forms quite at home in a nursery.

That Morris should choose to formulate his vision through an ostensibly infantile imagery is not in the least surprising. According to him, 'the artist . . . must remain a mature child'.[5] Creativity, art and culture, he says, are all forms of adult play: 'We take this playfulness, mature it and call it creativity.'[6] Like a child, he invents an essentially playful universe. In *Master of the Situation* (1947), for instance, the subject is a game. A complicated sport is engrossing some seven players. Each is busily reaching out a prehensile limb, as though to catch a trophy. As they jostle for position, floating freely in all directions and twisting their bodies in various attitudes, only one contestant has ensnared the apparent target of the competition, a hoop. As if gloating and revelling in its success, this larger biomorph is jealously guarding its prize with its long tentacles. There is the suggestion that the victor is warding off the other players with gentle nudges.

Whether or not this is some primitive game of rugby, the overtones of the work are essentially ludic. The biomorphs float relaxedly through the air,

* At the beginning of the novel *Inrock* the protagonist, Jason, enters the world of the biomorphs through a crack between two rocks at Avebury.

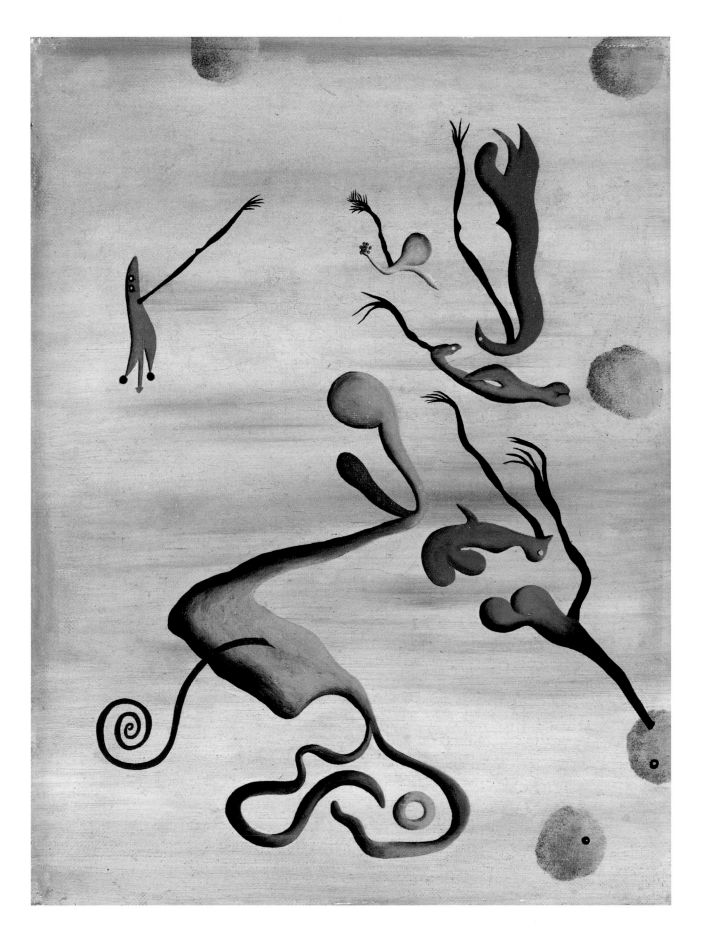

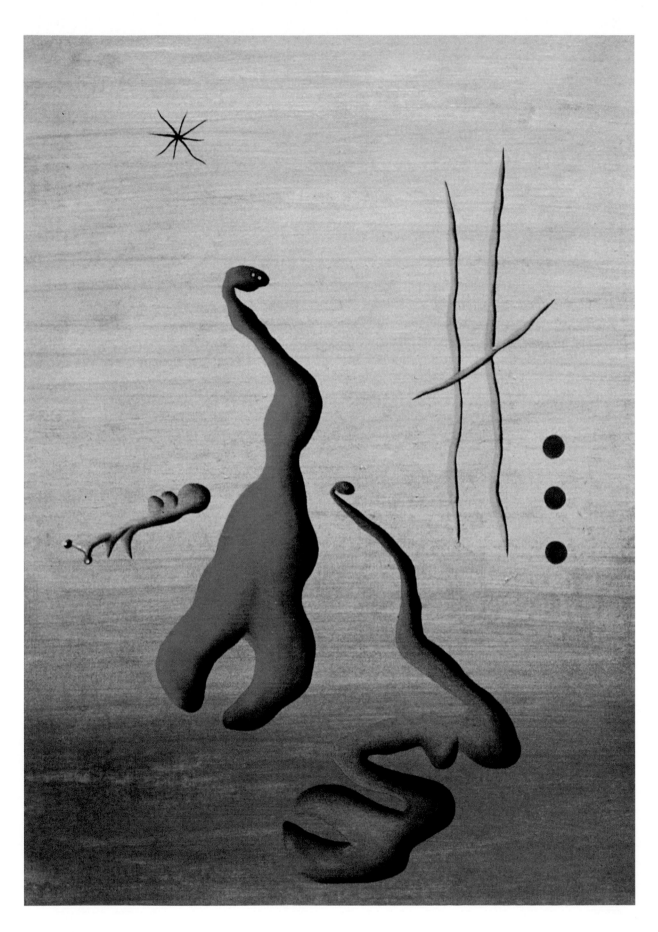

74

giving the impression of a giddy frivolity. The implication is that this is a pleasurable, infantile pursuit. It is significant that Morris places much importance on such a frame of mind: 'For me, the most important pleasure in the life of a human being is that of having the vision of a childlike adult, or an adult—child, of retaining the inquisitiveness and inventiveness of the child.'[7]

Another, and different, type of contest is engrossing the characters in *Confrontation* (1948). Although less athletic than their counterparts in *Master of the Situation*, the two main protagonists here are intensely studying some crossed cocktail sticks and three round counters. There would seem to be a problem or a puzzle to solve. Perhaps it is a matter of positioning the counters in some way on the grid formed by the sticks. Whatever the rules of this game of pseudo noughts and crosses, it has so absorbed the characters, with their tiny staring eyes, that they completely ignore or fail to notice a third individual scuttling past in the middle distance. The disinterest in the proceedings shown by this third biomorph only adds to the intensity of the event in which the competing couple are engaged. We are, as it were, between moves.

The wooden grid in *Confrontation* reappears in *The Jumping Three* (1949), but with a different significance. Instead of being a device extolling the virtues of the animate beings by, in that instance, demonstrating their capacity for mental application and concentration, here it serves simply to ridicule them. The delicate shafts, with their carefully balanced geometric arrangement, are, in fact, a foil to the clumsiness and lack of coordination on which *The Jumping Three* centres. Three biomorphs demonstrate ineptitude and enact confused manoeuvres. As in *Confrontation*, there would seem to be some sort of challenge or trial at issue. The posts rising high above the sandy ground may be an obstacle to be surmounted or a target to be aimed at in, as the title suggests, a test of jumping skill. A rudimentary game of hurdles or pole-vault, perhaps? The contestants are moving towards the gymnastic apparatus at speed, their limbs not touching the ground. However, it would be inappropriate to say that they are 'running' – their movements are far too clumsy. It would, perhaps, be more accurate to describe them as being in the process of 'tumbling' through the air.

The portrayal of these figures is, essentially, comical. We are presented with a slapstick scene in which a demanding athletic feat is being executed with laughable incompetence. As if to emphasize the maladroitness of the 'jumping three', Morris places comparatively graceful avian creatures in the distant sky. These hover and swoop with agility and display a natural flying skill, which accentuates the ungainliness of the movements in the foreground. The three are pictured as tumbling out of control and about to fall on their heads. Their awkward, rangy legs trail above them in the air, more like those of rag dolls than of athletes. Their apparent efforts to jump into the air are so clumsy that they cannot but be about to collide indecorously with the pole contraption. *The Jumping Three* depicts amusing failures. Clownlike, its characters are seen to be bungling their performance.

CONFRONTATION *(opposite)*
1948
Oil on canvas
18 × 12 in. (45 × 30 cm.)
Eric Franck Gallery, London

THE JUMPING THREE
(pages 76–77)
1949
Oil on canvas
30 × 50 in. (75 × 125 cm.)
*Collection Birmingham City
Museum and Art Gallery*

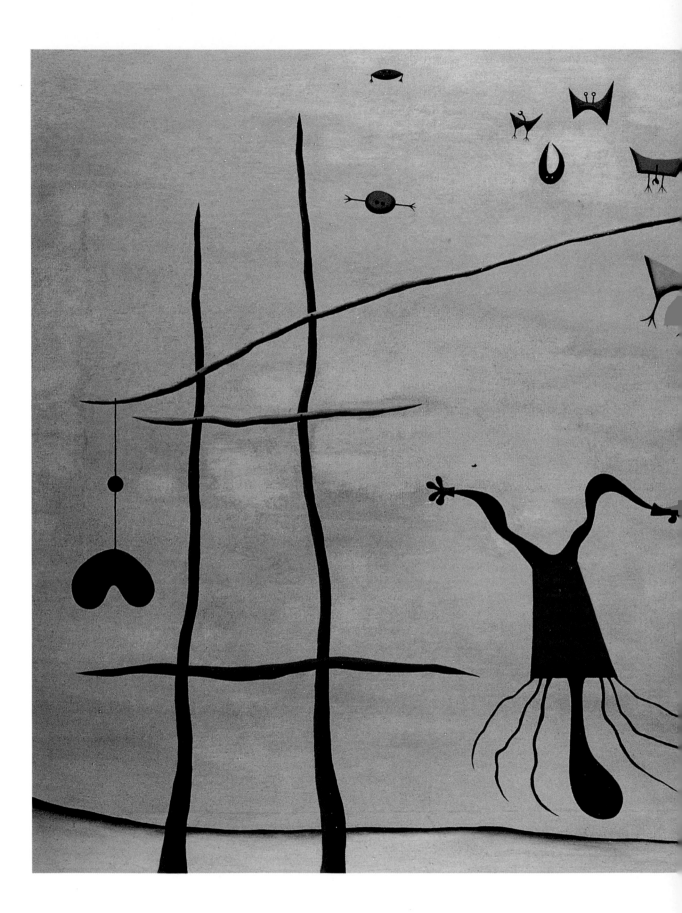

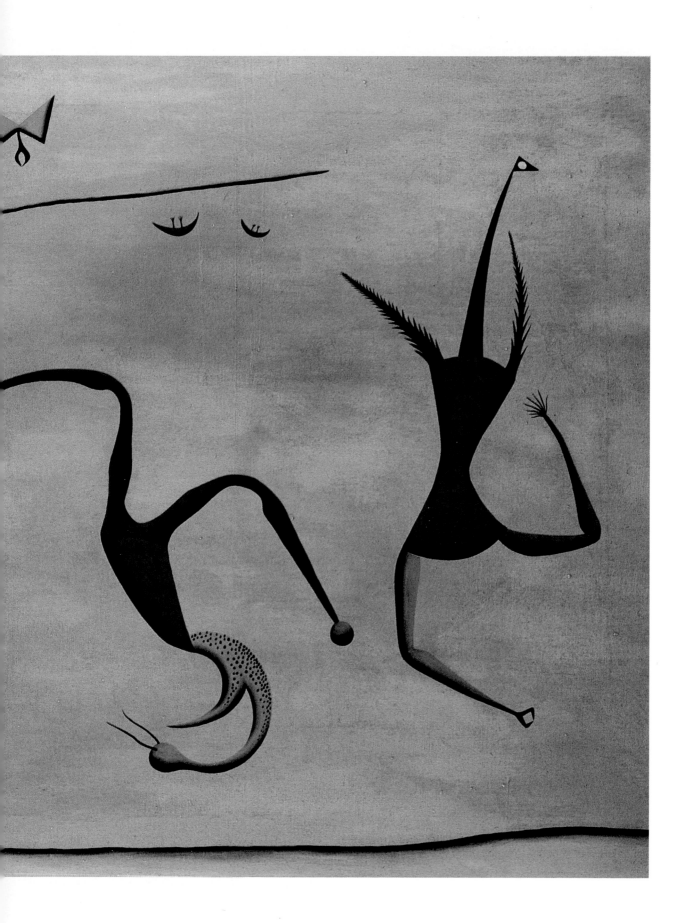

The Serpent's Choice
1958
Oil on canvas
7 × 14 in. (17.5 × 35 cm.)
*Collection Dr. Jeffrey Sherwin,
Leeds*

The tone is one of animated levity and humour at the expense of the three buffoons.

Morris also manages to introduce a humourous tone in paintings that focus ostensibly on the themes of conflict and danger. For instance, *The Serpent's Choice* (1958) represents a predatory scene in which a fork-tongued snake has successfully stalked and surprised a bird-like biped leading her four young along the ground. The moment depicted is that at which the carnivore has just raised its head above the camouflaging tall grass to confront the startled and helpless prey. The creatures have stopped dead in their tracks, staring in trepidation at their imminent assailant. As Michel Remy has written, 'The small defenceless group of little animals – eyes wide with fright and fascination – seems to be wondering which of its number is to be the victim'.[8] In a matter of seconds, the image suggests, the serpent will strike and kill one of the five paralysed creatures.

But the way in which this grisly subject is treated is not in keeping with the gravity of its forbidding implications. Although, ostensibly, this is a life-or-death scenario, it emits the contrasting overtone of jovial buffoonery. The snake, with its decoratively spotted ice-cream-pink body and clashing black dorsal spines, is more a caricature of a villain than a credible ogre. Its gaudy appearance could hardly make it more conspicuous against the green and brown grass, and the idea that it could have been concealed from its surprised prey is as comical and contrived as that of the pantomime 'hidden monster': '*There* he is,' the avian creatures might at any moment twitter. In any case, the apparently stage-struck serpent seems to be more concerned with catching the attention of the spectator than with proceeding with the kill. It is as though, having suddenly realized that it is the centre of attention, the serpent is revelling in an unexpected moment of celebrity: it gives a self-confident sideways glance at its admiring public, perhaps flutters an eyelash.

That something as trivial as vanity should quell the awesome hunting instinct of a normally formidable predator adds to the comedy. The avian creatures, too, inspire amusement instead of, in their case, compassion.

The unnerving predicament of the creatures being preyed upon in *The Serpent's Choice* is generally regarded as one of the less congenial aspects of nature – that the laws of survival demand that animals should kill and devour others is an uncomfortable truth. However, even the most devoted animal enthusiast would be struck by the humorous side of Morris's depiction of the victims in this situation. The big staring eyes of the young and the heavily bearded face of the adult create a comical aura. And it may not be incidental that the black waxed and curled moustache sported by the larger avian is reminiscent of the farcical countenance that Salvador Dalí cultivated. The identical stances of the smaller creatures even suggest a theatrical chorus line. The tone is vaudevillian rather than sobering and tragic. Morris playfully transforms a rather gruesome primal truth into an innocuous and rollicking diversion.

In other works, too, dangerous creatures or ogres are transformed into benign and amusing caricatures. In *The Bull* (1957), a bull with enormous pointed horns is recast as a rather nervously apprehensive creature. From within his enclosure he stares aghast at something just out of sight. The beady eyes and naïve beard with which Morris endows this bovine give it a comical air, effacing any sense of the brutish, quick-tempered animal with which we are familiar. Equally emasculated by Morris is the normally terrifying personage of the dragon. *Dragon Patrol* (1957) presents this 'monster' as an assemblage of somewhat incongruous components. Its body comprises alternate striped or dotted oval segments, and its head is cubic. The avian creatures watching and inspecting their visitor seem far from alarmed. One bends down to take a closer look, and two others perch calmly

THE BULL
1957
Oil on canvas
7 × 14 in. (17.5 × 35 cm.)
Collection Ms H.McKeown,
London

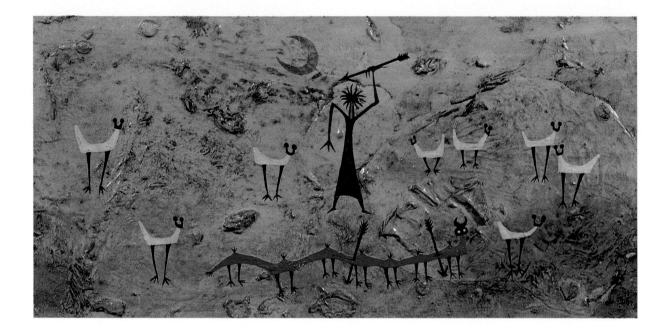

THE HUNT
1957
Oil on canvas
7 × 14 in. (17.5 × 35 cm.)
Collection K.J. Lyras,
Loughton, Essex

within its path. Here Morris depicts another harmless, unthreatening being. Indeed, he does not even give it a mouth, the dragon's traditionally most intimidating and lethal attribute.

It is not infrequently that Morris treats scenarios of carnage and cruelty in a jesting, light-hearted manner. In *The Hunt* (1957) a human figure is taking aim while another guileless biped stands passively in total ignorance of its impending fate. In an instant the spear will have transfixed the animal, and the other members of the tranquil herd will have been traumatized with panic and fear at the sight of spilt blood.

It is the essentially burlesque and exaggerated naïvety with which the animals are endowed that undermines the gravity of the situation. The style in which the event is depicted transforms it from one of potential tragedy into one of lampoonery. In this farcical portrayal of a hunting scene the hunter himself with his rigid tufts of green hair and puzzled expression, is whimsically represented. He looks more like a buffoon than a dangerous killer. No less caricatural is the legged serpent that has just been mortally wounded. Even though this creature has been pierced right through by two stout spears, launched with such force that they have penetrated the ground, its comically blank stare and its pairs of ungainly legs conspire to make its plight laughable. The creature looks perplexed rather than distressed and fearful. Morris has divested this scene of carnage of its potentially calamitous significance.

A similarly deflated drama is depicted in *The Killing Game* (1960). No less than five hunters are rushing towards their airborne prey, a red angel-like winged creature, which has just been transfixed by their lances. In a gesture of helpless submission the avian figure has stopped beating its wings and is now floating down to ground level in an almost vertical attitude. Its torso has taken the full impact of the five lances and, clearly, it is soon to die. As in *The Hunt*, however, the tone is in no way pathetic. The hunters are

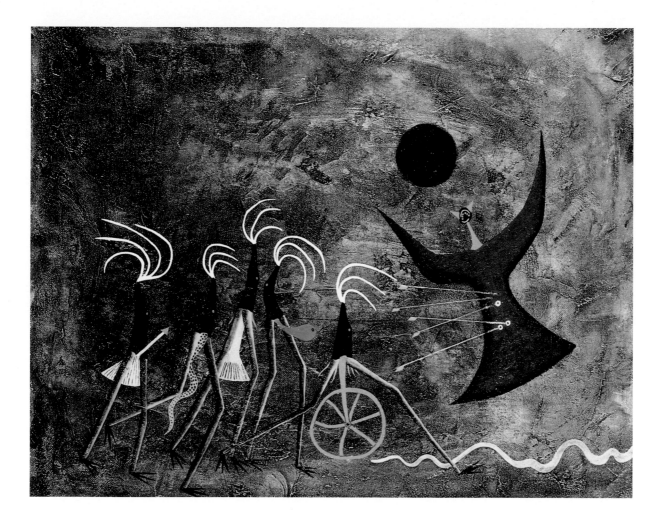

THE KILLING GAME
1960
Oil and plaster on canvas
16 × 20 in.(40 × 50 cm.)
*Collection Mr Alan Durham-
Smith, Dallas, Texas*

represented as stick-like figures with comic phalluses: one figure sprouts an arrow from its pelvis, another dangles a balloon-like protuberance, whilst the phallus of a third terminates in a wheel, thereby providing it with the added bonus of locomotion. To all effects, these are figures of fun. The whimsicality also extends to the winged prey, which appears to be grinning at its assailants: it is as though, far from being a mortal victim, it is engaged in a painless romp. In neither this painting nor in *The Hunt* is there any indication of blood flowing. Hunting and killing are portrayed here as games.

The tone of these works extends to the object, *Good Morning Miss Smith* (1969). An antelope skull which Morris had procured following a dissection at London Zoo, is garnished with a pair of ruby-red plastic lips. What he is doing here is defusing the morbidity and repulsiveness of the mammalian skull with a playful appendage; he is contradicting the grisliness of decapitation and death, implicit in a skull, by endowing it with a frivolous adornment. Further, the lips suggest capriciousness and a coquettish vanity. It is the macabre reality of a fleshless animal skull, contrasting with an implicit aspiration to embellishment, that gives this object its paradoxical humour. Since no form of decoration, particularly

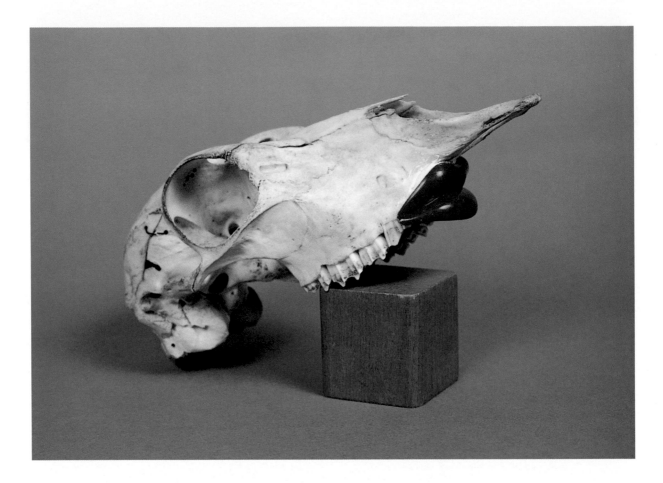

Good Morning Miss Smith
1969
Skull and plastic lips
Length: 8.5 in. (22 cm.)
Collection Dr Jeffrey Sherwin,
Leeds

one as minimal as plastic lips, could possibly override the grimness of the dead skull with its grinning row of teeth and hollow eye-sockets, a comic effect is inevitable.

Morris has explained that the origin of this object lies in his occasional tendency to perceive living humans in anatomical terms: 'I have terrifying moments when I can be looking at a beautiful young girl and suddenly see her as a skull. I can see what is beneath the skin. These are uncomfortable occurrences.' But *Good Morning Miss Smith* expresses this contradiction between living fleshiness and moribund ossification in a far from morose manner. The incongruity between the vividly coloured, perhaps passionate, lips and the ashen skull emerges as more of a joke on a par with, say, mechanical false teeth or a false moustache. Death and all its dolorous implications are abated in light-hearted jest.

Playfulness is a persistent theme in Morris's work, extending, as we see here, to his plastic creations. The tenor of, say, *Good Morning Miss Smith* and *The Serpent's Choice* extends also to his novel *Inrock*, in which many incidents are also portrayed in a flippant and glib manner. The world of *Inrock* is one of apparent innocence and naïvety. When serious concerns are raised their consequences are understated, however grievous they may, in fact, be. When the Mha-kee, the taskmaster of the hand slaves, describes a gruesome hand-lopping practice to an intended victim, he does so in a comically matter-of-fact manner:

'Usually we simply cut off their hands and send them to the Hand-stitcher. He tests the fingers and, if he approves, he sews up the wrists and moulds on a pair of claws.' . . . 'What do you do with the rest of the body?' 'We feed it to the old hands, . . . it is all very economical. No waste. No mess. All very neat and convenient.'[9]

The Mha-kee dismisses the apprehensions that Ludo, in friendly character, expresses about this inhumane means of acquiring 'hand servants', insisting that 'they have very poorly developed systems . . . they hardly feel any pain at all'. He discounts the suffering of humans in much the same way as we would make light of the cruelty of, say, squashing an insect.

This tendency to rob situations of their gravity and to transform them into childish distractions has frequently led Morris to make allusions in his paintings to the ultimate form of playful recreation, children's games. In *Totemic Decline* (1976) the phenomenon is evident. A horde of biomorphs are gathered in seeming disarray. No less than thirty figures, apparently engaged in disparate activities, appear to be scattered haphazardly over an open expanse. However, a closer look reveals that this is, in fact, an ordered and coordinated group of individuals. The tallest, conspicuously waving two limbs in the air, represents a focus for the others in the scene. A collection of smaller, rounded biomorphs have arranged themselves in a circle around the tall one. The impression is that of a game involving dancing in formation. The tall figure is maintaining a pose not unlike that of a ballerina, with raised

TOTEMIC DECLINE
1976
Oil on canvas
24 × 36 in. (60 × 90 cm.)

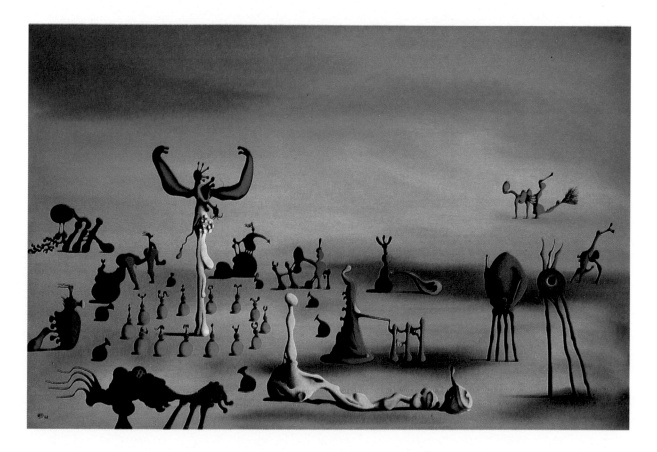

arms and inward-pointing fingers – indeed, it could be that this individual is standing in the ballet fifth position on point. And it could well be, also, that the biomorphs in the circle are dancing around to chants of 'Ring-a-ring-o'-roses'.

That there is some type of performance in progress is corroborated by the fact that with only a few exceptions, all those present seem to be observing or are turned towards the spectacle. The bulbous forms just outside the circle all point their ear-like protuberances towards the scene – in order, perhaps, to hear the singing more clearly. In the right foreground a biomorph with a large eye similarly strains towards the dancers.

It is as though Morris places us in a school playground at playtime. Most of the 'children' are engaged in communal play; some observe the activities and others, such as the three match-like biomorphs in the centre, are held by the hand by a parental figure. Even though this scenario is full of rather more adult, sexual, references, the tenor remains playful. True, the 'ballerina' sports a drooping breast and one figure in the distance presents a pair of rounded buttocks to another biomorph, and yet, as in *The Serpent's Choice*, serious considerations remain secondary to the infantile preoccupations.

The allusion to a children's playground could not be more explicit than in *Angels at Play* (1951). Four figures appear to be playing with yellow

ANGELS AT PLAY
1951
Oil on canvas
20 × 25 in. (50 × 62.5 cm.)
*Collection Mr Norman
Goldstein, Canada*

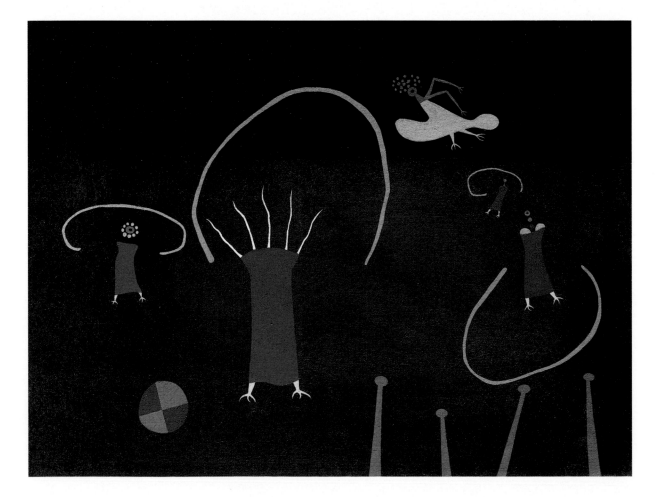

skipping-ropes, which form arcs either over their heads or under their feet. In other words, it is implied that the ropes are in motion and the 'children' would seem to be jumping through them as they rotate. They are engrossed in the childhood pastime of skipping.

That this is an infantile play situation is also indicated by the presence on the ground of a colourful sphere. Its size and beach-ball qualities clearly place it in the domain of infant play. What the ball also indicates is the existence of another playing group somewhere out of sight on the left. The ball is extraneous to the central activity depicted, and would seem to have inadvertently rolled into the scene from a neighbouring game. We are witnessing, therefore, not just play but play taking place in various little groupings, as so often occurs when large numbers of children are brought together. This impression is consolidated by the skippers, who are performing in close-knit formation.

Such regulated activity is symptomatic of a school environment and, indeed, there are various indications in the painting that this is what is being alluded to. For example, the blue-grey ground area is not unlike a tarmac playground, and the playing figures are all attired in matching bright-orange smocks which resemble school uniforms. In addition, there is a figure in the background watching over the activities with a single staring eye. The notion of an overseeing schoolmistress or some other adult in a supervisory role comes to mind. Given this suggested need for regulation, it may well be that the reference to 'angels' is made with ironic humour.

The unseen ball game suggested by the extraneous beach-ball is represented in a work painted not long after *Angels at Play*. In *Ball Game* (1952) Morris depicts the upper torso of a figure, both of its arms stretching upwards in order either to catch a descending beach-ball or to launch it into the air. The head, eyes and face of this figure are suggested in a stylized and, even, confused manner. The left eye is perched on the edge of the figure's face, but the right eye is displaced to the pectoral region. The head itself, only recognizable as such because it appears above the figure's head and shoulders, is wholly schematic. These deviations from a more literal representation are inconsequential, though. What really matters in this work is that it conveys a dynamic, playful gesture. We see the act of stretching to manipulate a fast-moving ball. We see coordination, spryness, agility. We see gymnastic play.

Play, in group form, again appears as a subject in *The Collector's Fallacy* (1972). Here biomorphs of various shapes and colours have attached themselves to wires suspended between 'telegraph posts', which are being used as playground apparatus. The small creatures hang upside down and swing or inch their way across the wiry stretches. One figure swings a long tentacle-like tail as though it were a pendulum. Another has, comically, tangled its limbs into knots, presumably as a result of inept acrobatics. The same tightrope 'game' is being played by a tripodal creature in *The Protector* (1972), and in *The Sacrifice* (1957) five avian creatures take advantage of the horizontal arms of a figure lashed between two posts to indulge in a balancing game. The tragic connotations of this scene are completely

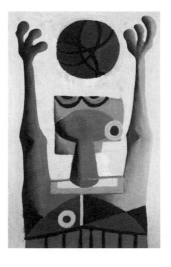

BALL GAME
see page 2

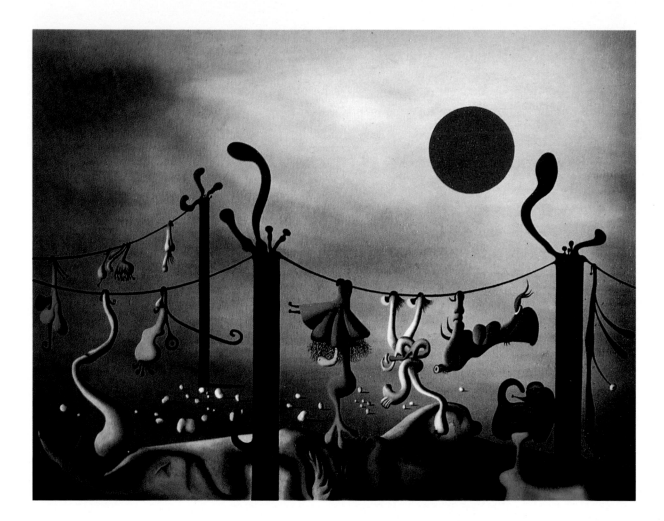

THE COLLECTOR'S FALLACY
1972
Oil on canvas
24 × 30 in. (60 × 75 cm.)
Collection Mr Gavin Rankin,
London

THE JESTER *(opposite)*
1951
Oil on canvas
24 × 18 in. (60 × 45 cm.)
Collection Jens Birger
Christensen,
Klampenborg, Denmark

overridden by the frivolity of the small creatures at play. As a whole, these gymnastically playful biomorphs convey the idea of communal recreation. We see a spirited group of figures enjoying light-hearted diversions. Again, these are childlike pursuits, and the underlying tone is one of levity and humour.

Humour of a very ingenuous type is contained in *The Jester* (1951). The subject indicated by the title is already that of an overtly comical figure; in addition, Morris treats this medieval character in a way that is itself entertaining. Remaining in the realm of puerile amusement, he has painted here what amounts to a child's toy. The figure is awkwardly jointed and stands in a passive, lifeless pose like a wooden doll. Indeed, the bright and highly decorative ice-cream colours and painted patterns bring to mind the type of adornment found on Russian dolls. Like a doll, this jester could be imagined to have swivel arms and legs that could be moved into any position. As it is presented, the 'toy' appears to have been manipulated into a humorously ungainly posture: the unstable position of the feet suggests that it is in danger of toppling indecorously from the narrow ledge on which it stands.

By far the most comical feature of the jester is its face. Its bulging, staring eyes and exaggeratedly opulent lips give it an obtuse and, perhaps, asinine

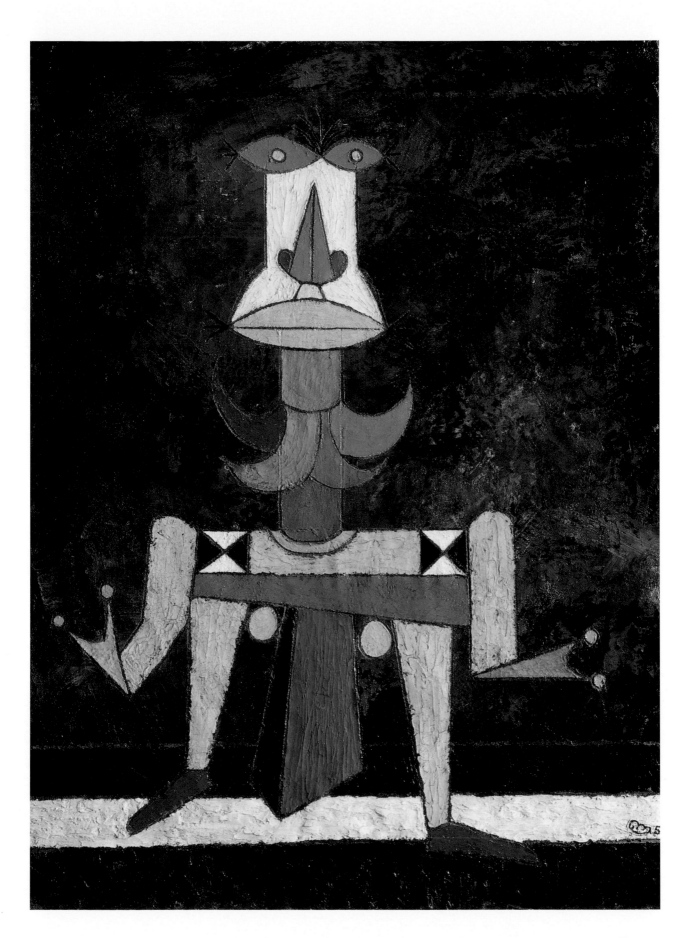

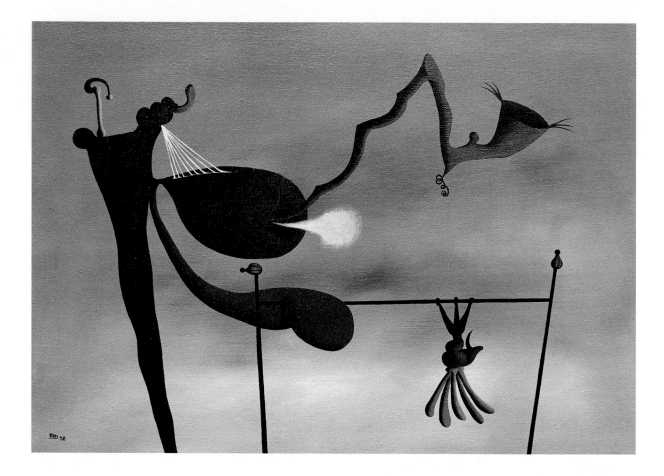

THE PROTECTOR
1972
Oil on canvas
16 × 22 in. (40 × 55 cm.)

THE NIGHT-WATCH *(opposite)*
1993
Oil on board
16 × 12 in. (40 × 30 cm.)

expression which any infant would find irresistibly amusing. The jester has the appeal of a clown, thus highlighting again, the insistent playfulness in Morris's work.

Playfulness can be said to have been elevated to a philosophy of life in Morris's novel *Inrock*. Looge, a pupil in what he terms 'the school of unlearning', graduates from his studies knowing nothing other than the single axiom, 'Work is the failure of play.' Only by constantly focusing his thoughts on this notion can the character survive in the environment in which he finds himself. The idea behind the school of unlearning is to purge the mind of all the education and attitudes associated with maturity and experience. The 'registrator' of the school comments: 'You are supposed to be educated when you come here – you must be, or you wouldn't be so anxious to become uneducated.'[10] In other words, all that is serious and erudite must be discarded in favour of the cheerful and trivial. Mr Rippleflog, an 'unteacher', explains the unteaching procedure to Jason, the hero: 'Well, this class has now completed its three-year course of unlearning. They have carefully and painstakingly written out all they knew – written it right out of their systems, we trust, and totally uncluttered their brains. They should now, with any luck, have reduced it all to a single sentence.'[11]

The products of this method are such dictums as 'The articulate fool is doubly blessed', 'The short and rich must pay the tall and poor to go on their knees', 'He who stands still has time to itch.' In all of these, reason is

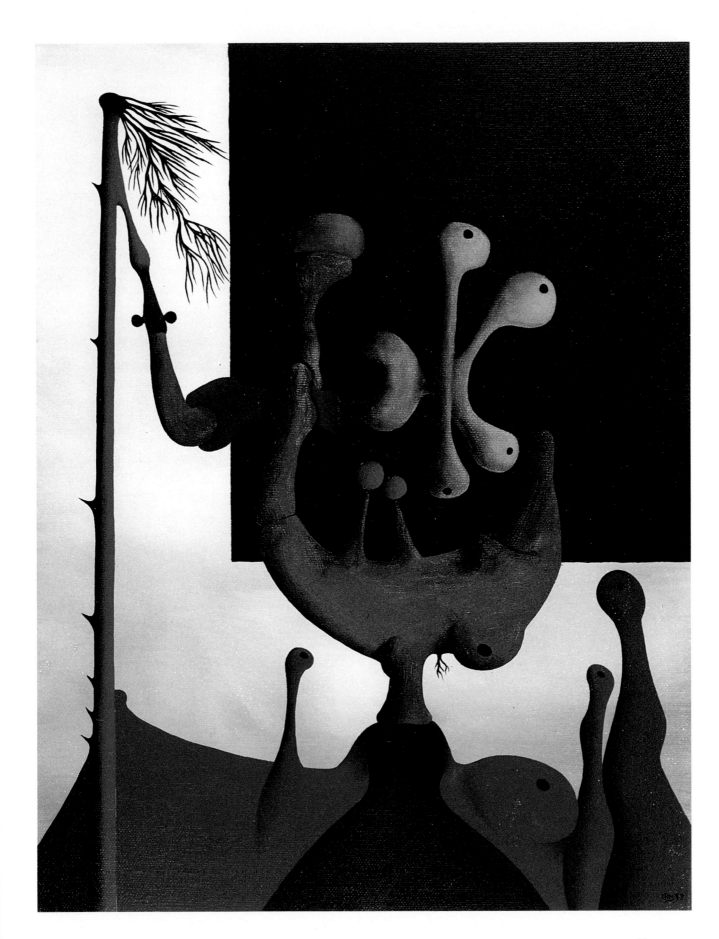

overridden by an insistence on the nonsensical, even the absurd. Whenever the master senses a hint of profundity or philosophical insight, the pupil is reprimanded. When one of the pupils proposes 'It is dark inside my head' and another 'The fading of a smile tells more than the smile itself', the inept individuals are asked to stay behind after the class, no doubt for further untraining.

Unfettered by serious concerns, the world of *Inrock* is free to indulge in frivolity and games. Even apparently gruesome and dangerous public entertainments such as 'the Bonfire Race' and the performances held in 'the Rock Arena' turn out to be elaborate hoaxes. In an athletic event which appears to be about to terminate in the incineration of the contestant, at the fatal moment there is a cleverly manipulated substitution with a dummy. Another feigned mode of death characterizes a performance in which actors' heads are beaten with bones until blood is drawn. What, in fact, receive the apparently mortal blows are false heads containing 'redberries', which burst and ooze imitation blood. Jason concludes that 'it was all some sort of gruesome charade'.[12]

According to Morris the theme of playfulness, so intrinsically linked to the child mind, is an inherent part of all painting. 'The simple, direct creative act of painting a picture,' he has written, 'is a childlike ritual of exploration.' But the repercussions of this state of mind, he insists, are felt beyond the context of childhood. For him, playfulness pursued in art amounts to an expression of contempt for the web of values upon which convention and society as we know it rest: childlike painting, he maintains, 'can act, for an adult, as a gesture of defiance against the increasing intrusion into everyday life of good, sound, common sense'.[13] Indeed, he goes further, establishing 'playfulness' as an intrinsic quality of the human psyche:

> Like Japanese seaweed, reasonable, rational, logical, well-balanced thinking has spread rapidly over our daily lives until it has choked almost to death our quirks and obsessions, our compulsively inspired eccentricities and our wayward intuitions. Almost, but not quite, for the human animal is a resilient creature and our inherent playfulness, our creative neophilia, is hard to stifle.[14]

Morris perceives rationality as potentially inconsequential. For him, it can oppose the fundamental creativity of the human mind. In the 1924 *Manifesto of Surrealism* André Breton specified that the 'pure psychic automatism' which formed the cornerstone of his movement depended on 'the dictation of thought in the *absence of all control exercised by reason*'. Morris's thought is thus essentially Surrealist.

6

Predatory Instincts

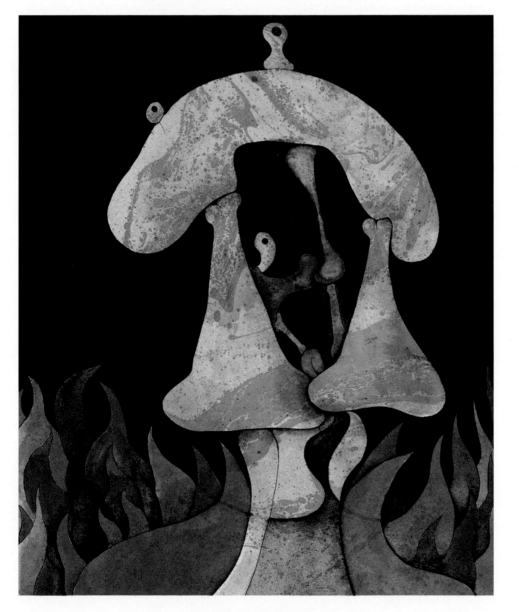

LAST OF THE LINE
1992
Mixed media
12 × 10 in. (30 × 25 cm.)

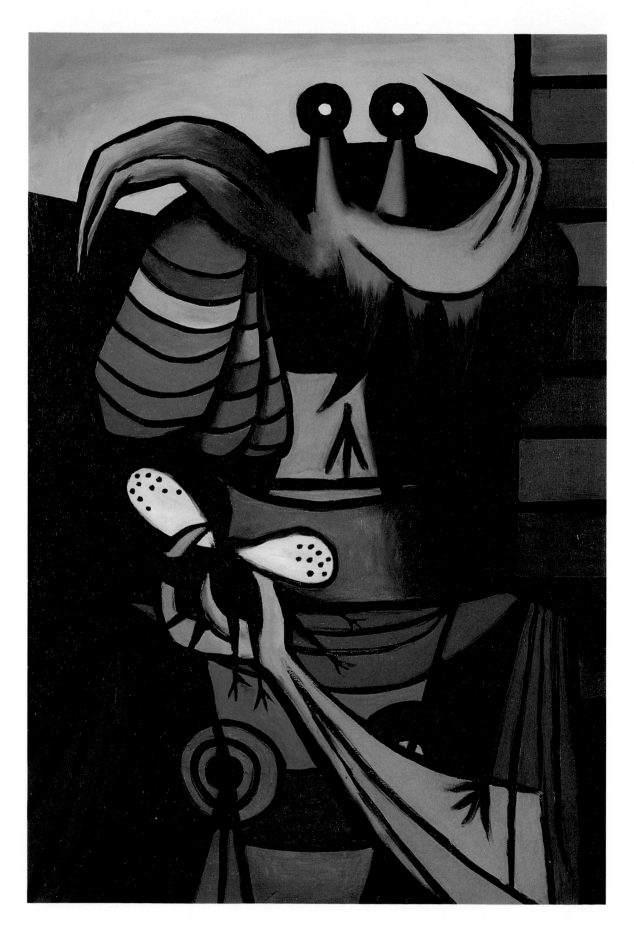

Predatory
Instincts

THE ENTOMOLOGIST

(opposite)

1951

Oil on board

28 × 20 in.(70 × 50 cm.)

Collection Dr John Godfrey,

London

DESMOND MORRIS'S NIGHTMARE in the Black Dream-room demonstrated the intimidating and unnerving potential of the biomorphs' world. Under their playful and jovial veneer they can conceal a darker side, which took even their creator by surprise. In addition to their appealingly frolicsome nature, his creatures display traits that tend towards the grotesque and the invidious.

This less affable facet of Morris's protagonists emerges in *The Entomologist* (1951), a painting that affirms a simple, perhaps brutal, biological fact – animals eat one other. A living winged insect – a dragonfly, perhaps – its six tiny legs stretched out in terror, is about to be devoured by a larger, anthropomorphized creature. The scene is one of uncomfortable apprehension: we know that within seconds the small writhing creature is to be ingested. But the scenario should not surprise: it has been a fundamental part of the natural cycle ever since life has existed on the planet.

The painting accentuates the ferocious essence of this inevitable truth. Morris is not simply depicting here an animal feeding, but, rather, seems to want to show the torment and anguish inherent in this vital function. The living prey is shown helpless and impotent in its last moments, whilst the massive captor is presented as terrorizing. Conroy Maddox has drawn an analogy between this creature and Rhadamanthus, a mythological judge characterized by his inflexibility, severity and brutality.[1] Morris's fiend has stalked red eyes that stare menacingly from a toad-like head. What makes this carnivore-hunter distinctly terrifying is its formidable row of fangs, which the small creature is about to encounter. It is clear that the firm grip of the ogre's hand is only a prelude to the more fatal grip of its teeth. With no hope of survival, the insect is on the verge of being gnashed to its death.

This same fate is even more explicitly conveyed in *The Zoologist* (1951) An almost identical small winged creature is being similarly clasped by another, equally grotesque, monster. The insect – which, curiously, appears

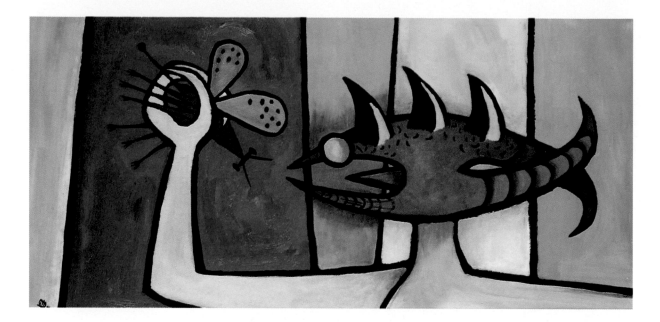

THE ZOOLOGIST
1951
Oil on board
12 × 24 in. (30 × 60 cm.)
Collection Dr John Godfrey,
London

to have seven instead of six legs – is being drawn towards an opening mouth. The predator sticks out its pointed tongue in anticipation of its imminent meal, totally engrossed by the creature that is flapping and writhing at a small distance from its waiting jaws. Morris presents a scene of unsparing rapacity at its most barbarous.

Through his graphic accounts of this most common ordeal – which nature imposes on its creatures as a matter of course – Morris reveals the brutality of basic animal instincts. The capacity to subject other creatures to horrific distress, he implies, is a natural predisposition. Moreover, by presenting the hunter in *The Entomologist* in the guise of a human-like form, a cloaked figure with two eyes and a flesh-coloured arm and hand, he may be hinting here that such tendencies are an integral part of our own psyche. Our own nature, he suggests, may well be latently predatory: 'The ancient human energy to pursue prey . . . can all too easily be channelled into destructive outlets.'[2] This may suggest why, as Morris concedes, 'there is quite a lot of violence in the paintings . . . there are a lot of challenges.'[3] For him 'true aggression' is an all too common part of human behaviour. In the aptly titled painting *Aggro* (1981) the relationship between the two protagonists is explicitly one of open hostility. One biomorph wields a menacing portion of intestine, while its adversary retaliates by threatening to lunge with an oversized defensive limb in the form of a boxing glove. Both aggressors also brandish truncheons with weighted ends. Robin Dutt has gone so far as to suggest that a large proportion of Morris's paintings comprise 'confrontational images on a battlefield background'.[4]

In *The Naked Ape* Morris devoted a whole chapter to the subject of human 'fighting'. He regards the human species as being 'preoccupied with mass-produced and mass-destroying violence'.[5] In *The Human Zoo* he equates human social behaviour with that of baboons seeking dominance in their groups. In both cases, he advances, violent codes of conduct underlie everyday behaviour: 'In moments of active rivalry you must threaten your

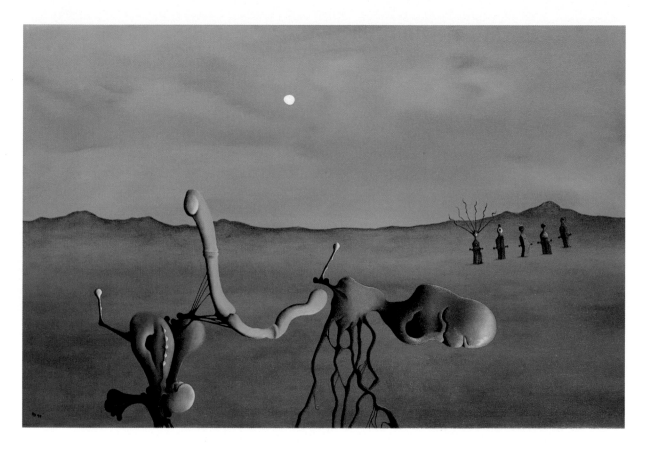

AGGRO
Dated 1979, completed 1981
Oil on canvas
24 × 36 in. (60 × 90 cm.)
*Collection Dr and Mrs Peter
Marsh, Oxford*

subordinates aggressively . . . In moments of physical challenge you (or your delegates) must be able forcibly to overpower your subordinates.'[6] Humans are seen as essentially feral and belligerent. As with hostile animals, whenever a position of advantage is contested 'a physical attack must follow'.[7]

The Playground of Power (1957) not only illustrates this aggressive tendency, but does so within a human context. The five figures depicted have human legs and feet and are engaged in what appears to be a ritualistic form of carnage. Three dominant figures sporting crown-like headgear preside over the humiliation and persecution of the other two. One of these kneels subserviently, perhaps awaiting decapitation. The other has been placed, head first, into a boiling cauldron. All that is visible are two writhing legs displaying bloody lacerations. It is not difficult to imagine the agony and terror being experienced inside the black receptacle. This is a scene of cold-blooded torture, of violence at its most barbaric. It could even imply a prelude to one of our deep-seated taboos, cannibalism. The tormented screams of agony and terror can easily be imagined.

Another work from the 1950s' 'zoo period', during which Morris painted thirty-six canvases measuring 7 by 14 inches (17.5 × 35 cm.), is *City Games* (1957). This work, which was prompted by an horrific contemporary mugging in the streets of London, is a rare example of a literal pictorial response to a specific occurrence. Close to Regent's Park, where Morris was then living, a knife attack took place which ended up as an episode of multiple carnage. When a passer-by attempted to rescue the struggling

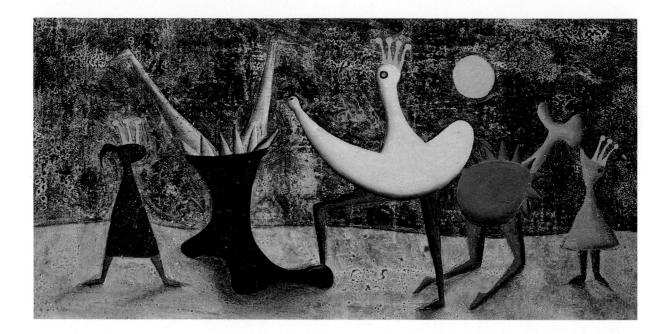

THE PLAYGROUND OF POWER
1957
Oil on canvas
7 × 14 in. (17.5 × 35 cm.)
Private Collection, Berkshire

CITY GAMES
1957
Oil on canvas
7 × 14 in. (17.5 × 35 cm.)
Collection Mr John E. Nadler

victim, the assailants turned on him and proceeded to castrate him in the street. The viciousness and horror of the incident could not but have appalled and shocked Morris, particularly since the unfortunate would-be rescuer was his own grocer.

While insisting that *City Games* is not a representation of this attack, Morris has remarked that 'the horror seeped through on to the canvas'. Uncharacteristically, he offers here a reasonably faithful representation of a street setting in which he depicts a figure being attacked by three violent individuals. Surrounded by this menacing trio, the victim is clearly unable to escape. His stare is blank and terrified, his hair stands on end, and his mouth is wide open as if he were calling out. His distress signals are not heeded,

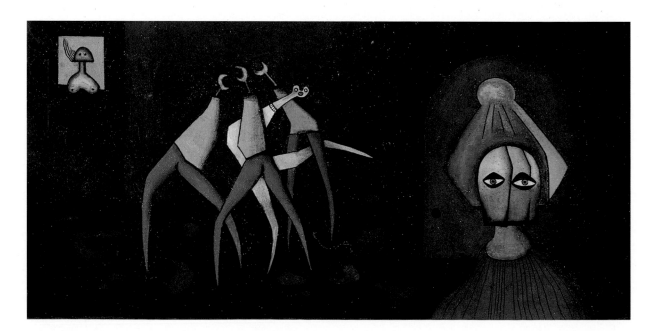

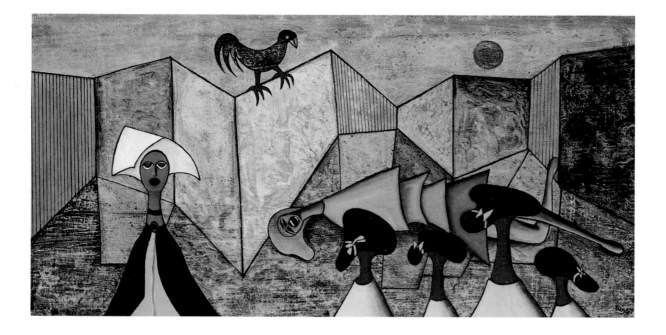

though, and the two other figures in the scene stand idly by. While the masked character in the foreground looks away, the female at the window, whose face appears to be changing into the severed genitals, stares out impassively. As in *The Playground of Power*, patches of blood attest to the brutality implicit in the work: red pools lie all over the black road surface, making this a particularly gruesome spectacle.

Human torment also figures in *The Indelible Incident* (1957). A young woman lies supine in a street, screaming. Her tortured expression, close to tears, suggests a pain resembling that of childbirth. The cause of the agony, which makes her writhe helplessly, is clear: her torso has been divided into slices – Morris has talked about a process of bodily 'segmentation' here. He

THE INDELIBLE INCIDENT
1957
Oil on canvas
7 × 14 in. (17.5 × 35 cm.)
Collection Mr John Nadler

RITE DE PASSAGE
1957
Oil on canvas
7 × 14 in. (17.5 × 35 cm.)
Private collection, Berkshire

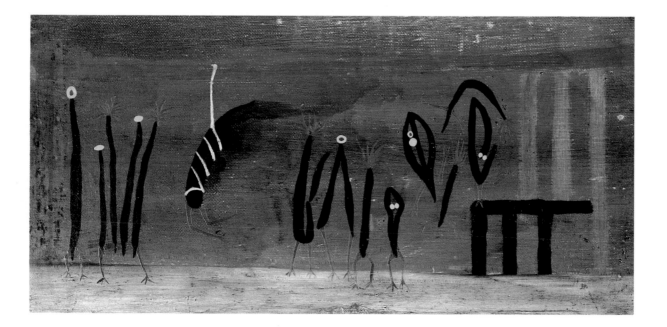

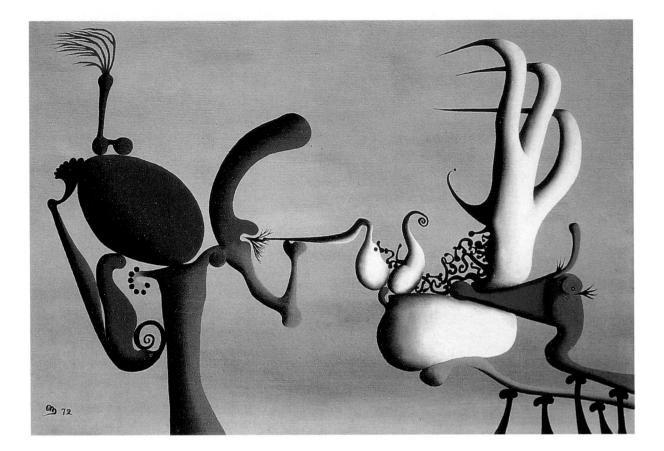

THE TITILLATOR
1972
Oil on canvas
12 × 18 in. (30 × 45 cm.)
*Collection Dr Richard
Dawkins, Oxford*

views his protagonist as undergoing a painful division process. It is as though she had suffered a sadistic attack or rape. Her plight, in any case, appears to be beyond redemption and she is left to her agonizing fate by a whole audience of passive and impotent onlookers.

In *The Titillator* (1972) the notion of an assault is far from being a mere suggestion. Morris presents a situation of imminent attack in which two mutually hostile figures confront each other. Each is brandishing a weapon. The aggressor on the left menacingly waves a heavy brown truncheon in the air as though awaiting an appropriate moment to deal the blow. The biomorph on the right employs different tactics. It has bared a series of feline spikes, which are poised to claw and stab at the fleshy parts of its adversary. The moment depicted by Morris is one of tense anticipation. It is uncertain whether the tensed 'clawed' hand will lunge forward first, or whether the truncheon will swing round to pommel the rival. In an instant the impending aggression will materialize.

Imminent threat is equally implicit in *The Survivors* (1950). The three foreground figures display all the characteristics of fear: they are standing rigid and motionless, they stare intensely in the same direction, they appear apprehensive. It is as though they are fixated by a peril to the right, which we cannot see but which is apparent to them. One of the trio appears so startled that its hair is standing on end. The figures are waiting, in silence perhaps, and evaluating their predicament. They may well be trying to determine whether the menace is about to approach and attack them and

whether, therefore, they ought to take flight. Hunted creatures are about to confront their ultimate fear. The tone of the painting is one of tension and anxiety.

The predatory menace which is implied in *The Survivors* becomes the explicit subject of another work, *The Intruder* (1949). In this subaquatic scene various marine forms, resembling tadpoles or jellyfish, appear to be swimming aimlessly and sedately around in the clear blue water. At a second look, however, it becomes clear that they are all steering themselves in a single direction, upwards and leftwards. With their black tentacles fully outstretched, they are swimming hard. The tentacles of one are pointing slightly forwards, as though beginning a stroke; another's limbs are outstretched but beginning to turn backwards; a third is at an intermediate stage; and a fourth is pushing right back, in the final stages of a breast stroke movement, and gliding forwards. From the progressive stages of this swimming action, shown in the various postures of the sea creatures, the impression is of a group swimming in unison and at speed.

The lower right of the painting reveals that this quartet is not simply exercising as a group but, rather, that it is attempting to escape. The swimmers are, in fact, all racing away from a gruesome predator, a formidable hunter armed with snapping jaws and two articulated limbs which terminate in sharp pincers. Intent on ensnaring a likely prey, these offensive appendages lurch menacingly in front of the lobster-like being.

THE SURVIVORS
1950
Oil on canvas
10 × 14 in. (25 × 35 cm.)
*Collection Mr and Mrs Paul
McCartney, Sussex*

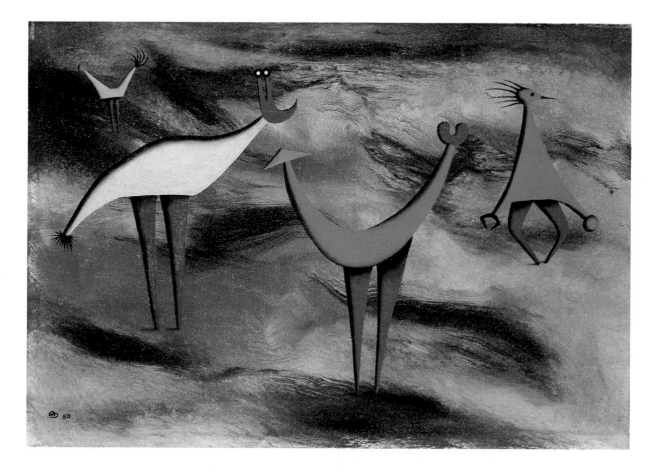

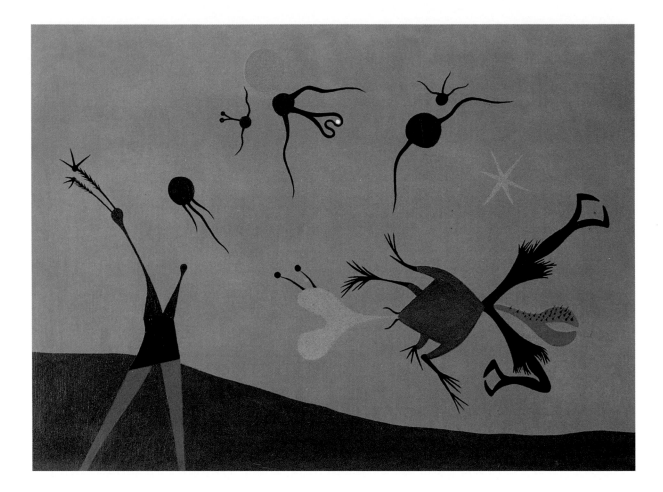

THE INTRUDER
1949
Oil on card
12 × 16 in. (30 × 40 cm.)
Collection Mr Ron Crider,
San Francisco

More deadly still is a third pincer claw which stretches out between the first two. This more substantial clasping and crushing apparatus, its uppermost articulation covered in sharp spikes, would certainly be fatal to the frightened creatures above. Even the plant-like being embedded in the sandy sea floor appears to be exhibiting signs of trepidation: bending to the left, it is visibly straining away from the sea monster.

However convincing, the snapping jaws in *The Intruder* are, to an extent, suggested by the forms that Morris delineates rather than directly represented. In *Celebration* (1948), though, we are left in no doubt about the nature of the creatures depicted. The work shows fangs, sharp points and incisors in graphic detail. An evil-eyed reptile opens a pair of jaws equal in size to the remainder of its body. Inside its mouth are two rows of white, nail-like teeth. It is not difficult to visualize these fangs crunching bones and tearing flesh. With its tongue also visible, this creature appears to be lying in wait for its next meal. An equally forbidding animal, displaying bright-red knife-like members, floats aloft. Pointing forward like tusks, these excrescences look capable of piercing anything in their way. Morris presents here the ultimate hunting tool: in addition to the rapier-like points and razor-sharp blades, these 'tusks' bear serrated edges. The small creatures in the centre of the painting which are being stalked by this hunter have an horrific fate in store: they are about to be transfixed, slashed and sawn up.

Despite the unequal match in size and pugnacity between the predators and their potential prey, the hunted creatures in *Celebration* do have the possibility, however minimal, of escaping the danger in which they find themselves: when the jaws start snapping it may just be possible for the small biomorphs to dart away out of reach. In *The Revolt of the Pets* (1959) even this remote prospect of deliverance is absent. Three different types of creature, one two-legged, one four-legged and one ten-legged, have been herded together in an enclosure bounded by rope fencing, from which they are clearly incapable of escaping. Their predicament alarms the trio, who rush in panic towards their captor on the left. It is as though they are pleading for their release or, perhaps, for relief from the blazing sun. The biped victim is stretching out its forked tongue between the ropes in an effort to test the air for possible signs of aggression. Morris has explained that this is normal behaviour for reptiles, who are able to 'detect the smell of aggression' through sensors in the tongue. The gesture in *The Revolt of the Pets* is one of apprehension and fear – it could even be seen as a supplication.

But the display of nervousness fails to sway the gaoler, and the appeal for clemency falls on deaf ears. Clearly, it is intent only on repulsing the surge towards it and on suppressing the turmoil. Moreover, this captor is presented as a daunting creature. It towers intimidatingly over its prisoners, displaying an array of monstrous features: its thin green legs support a

CELEBRATION
1948
Oil on board
28 × 37 in. (70 × 92.5 cm.)
Collection Eric Franck Gallery,
London

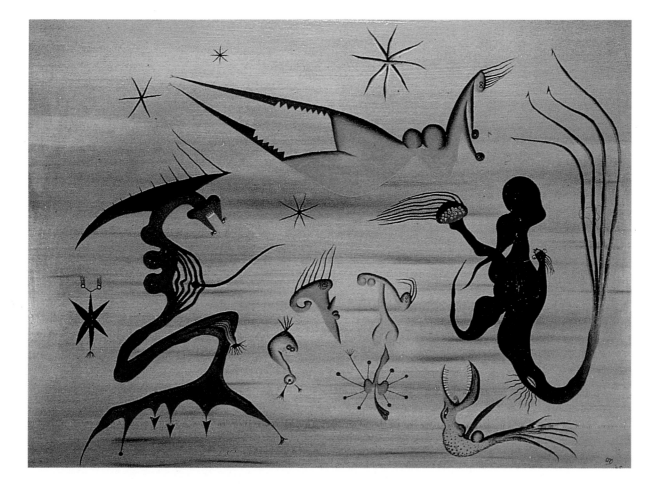

deformed, blubbery torso from which three claws sprout, and a long thin neck supporting a square head. Its grotesqueness arises from an aberrant proliferation of bodily attributes: it sports four staring eyes and a fearsome array of proboscises. But its malevolence is demonstrated, above all, by the fact that it is aiming an arrow-headed spear at the harmless trio, who are apparently oblivious of the imminent peril. Once again, the larger creature overwhelms the smaller ones with naked aggression.

This painting, Morris has explained, is an allusion to the 'pathetically ineffectual nature of rebellion'. It indicates the formidable difficulties encountered in any revolt against authority. All ordinary people, he feels, are trapped by a dominating authority, as are the 'pets' that he depicts here. He regards most instances of rebellion as feeble and ineffectual since, as he puts it, 'authority absorbs rebellion, authority can dampen any rebellion'. Whilst pointing out that *The Revolt of the Pets* was not executed as a conscious statement about oppression, he concedes that 'the painting is about the fact that rebellion against a controlling influence is generally pathetic'.

Equally impotent are the victims in *The Egg-thieves* (1960). A nesting avian being has just been startled into exposing the pair of eggs that she has

REVOLT OF THE PETS
1959
Oil on canvas
10 × 12 in.(25 × 30 cm.)
Collection
Mr Gerald Grinstein,
Fort Worth, Texas

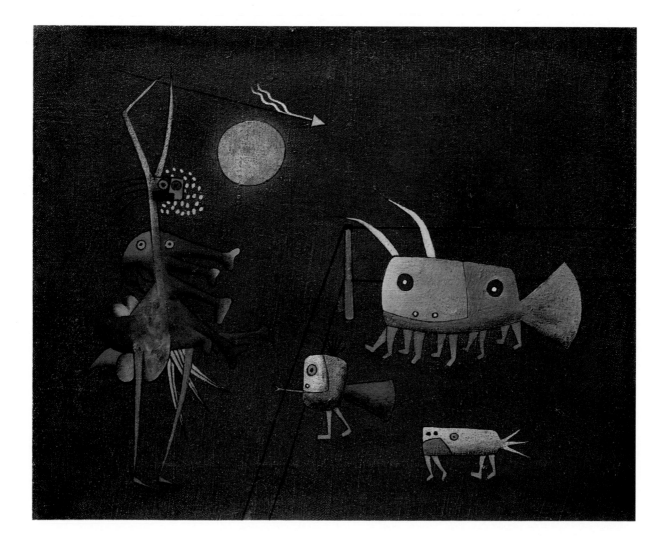

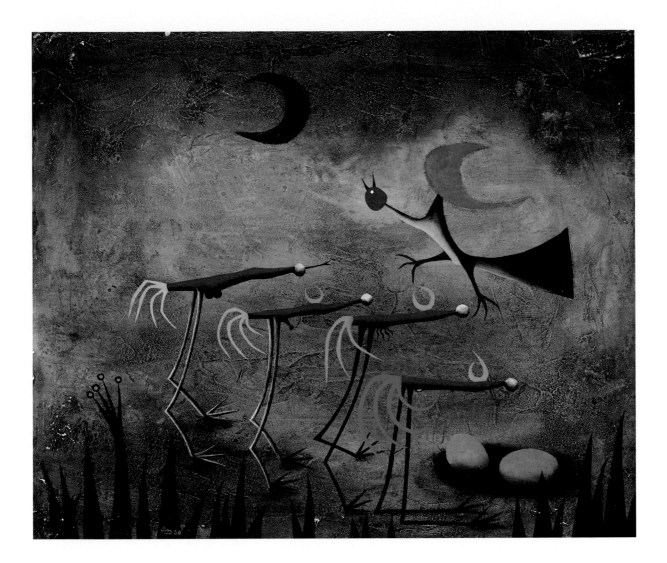

THE EGG-THIEVES
1960
Oil and plaster on canvas
14 × 17 in. (35 × 42.5 cm.)
Collection Mr Tom Maschler,
London

been incubating. The female flies up in panic and flaps distractedly over the heads of the intruders. She lashes out with her claws, but these efforts to defend her young are to no avail. Ignoring her, four predatory bipeds advance intimidatingly towards the vulnerable pink shells that are protected only by their downy nest. With an undeterred confidence, and seeming to gloat over their unquestionable triumph, the 'thieves' carefully crouch down to examine the prize they have stalked and are soon to steal. To the mother about to be deprived of her treasured and defenceless unhatched offspring, the bipeds are callous fiends.

With hindsight, Desmond Morris has described the nest-raiders as 'walking phalluses'. For him their protruding intrusiveness is an allusion to the clash between sexuality and maternity: 'The harassment of the female while she is rearing her young is symptomatic of the jealousy of the father.' Eggs, as with any newly arrived offspring, represent a new love bond which excludes the father. In this painting the male presence is portrayed as a terrorizing brutishness.

The overbearing and terrifying monster is, as already noted, a fundamental and frequently recurring theme in the pictorial work of

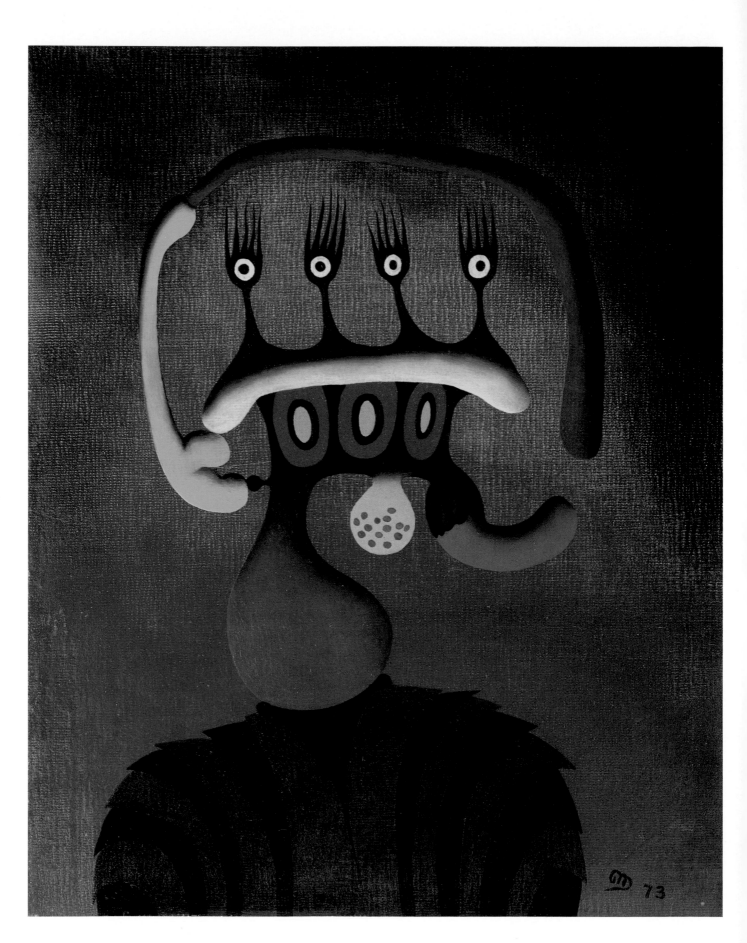

Desmond Morris. A demonic figure is the exclusive subject of *The Agitator* (1973). A hideous head, and nothing but, occupies the whole canvas. Four stalked eyes stare out from a face that is a mass of deformities. Its lobes, protuberances and tubes have more affinity with internal organs, which once mesmerized the young Morris, than with a head. During his macabre and illicit visit to a wartime mortuary mentioned in Chapter 3, he had been captivated by 'the shiny organs inside the human body'.[8] The 'strange, voluptuous beauty' that he sensed in these gruesome revelations is echoed in this painting. The intensely red background may well be an allusion to the blood-stained lacerations displayed on the corpses.

On several occasions Morris has conveyed the concept of the monstrous quite literally, by incorporating actual relics of ferocious animals in his works. *The Visitor* (*The Uninvited Guest*) (1948) comprises a horned goat skull mounted in a menacingly upright and confrontational posture. It appears to stare with a fixed blank gaze and almost to threaten an imminent head butt. As if to suggest that it has only just emerged from just such a recent tussle, Morris has painted its horns the colour of fresh blood.

Even more menacing is *Moratorium* (1969), in which a mannequin torso supports not a human head but the skull of a full-grown tiger. Morris has mounted the skull upside down, with the result that the upper row of sharp teeth points upwards, towards the spectator. In this way the object becomes positively dangerous; the aggressive canines are especially hazardous – they could pierce the eyes of an onlooker who ventured too close.

THE AGITATOR *(opposite)*
1973
Oil on canvas
10 × 8 in. (25 × 20 cm.)
Collection Mr Roy Heenan,
Quebec, Canada

THE VISITOR *(below, left)*
1948
Painted goat's skull
9½ in. (24 cm.) high,
including base
Collection Faggionato Fine Arts,
London

MORATORIUM *(below, right)*
1969
Mannequin, skull, plastic
ornaments
Height: 35 in. (90 cm.)

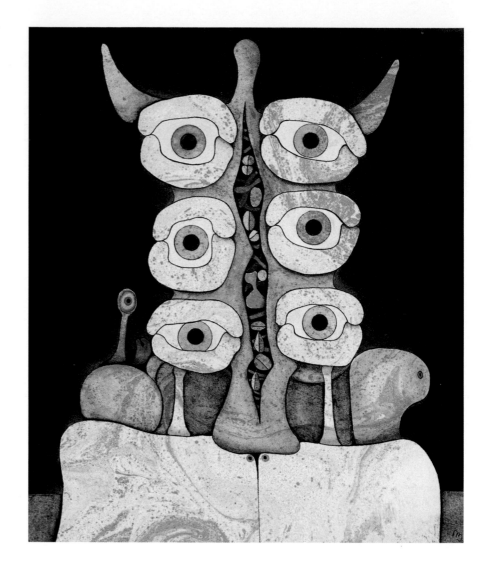

THE WITNESS
1994
Mixed media
12 × 10 in. (30 × 25 cm.)

THE PROTÉGÉ *(opposite)*
1972
Oil on board
10 × 8 in. (25 × 20 cm.)

Another monstrous head appears in *The Witness* (1994). No less than six eyes glare back at the spectator from a deformed mask-like face. The intensity of the eyes, with their dilated pupils, is disconcerting. The expression is threatening, not watchful. As the title suggests, there are accusatory and menacing undertones in the expression of this figure. The triple gaze cannot but be seen as malevolent, particularly since two demonic horns sprout from the temples of this biomorph.

The 'strange beauty' which mesmerized Morris in the mortuary is equally present in *The Protége* (1972). So deformed is this 'face' that it is barely recognizable as such. There is merely a mass of soft, bulbous forms, compressed and contained within outer layers forming a rough circle. What animates these amorphous shapes is a small, rather sinister, eye which peers from a dark recess. By virtue of its penetrating gaze, the amalgam of tissue assumes an ominous quality. It appears to be watching through the distortion of a repulsive elephantiastis in order, perhaps, to spy a likely prey. It has a knowing look that betrays a potential for aggression, albeit a dormant one.

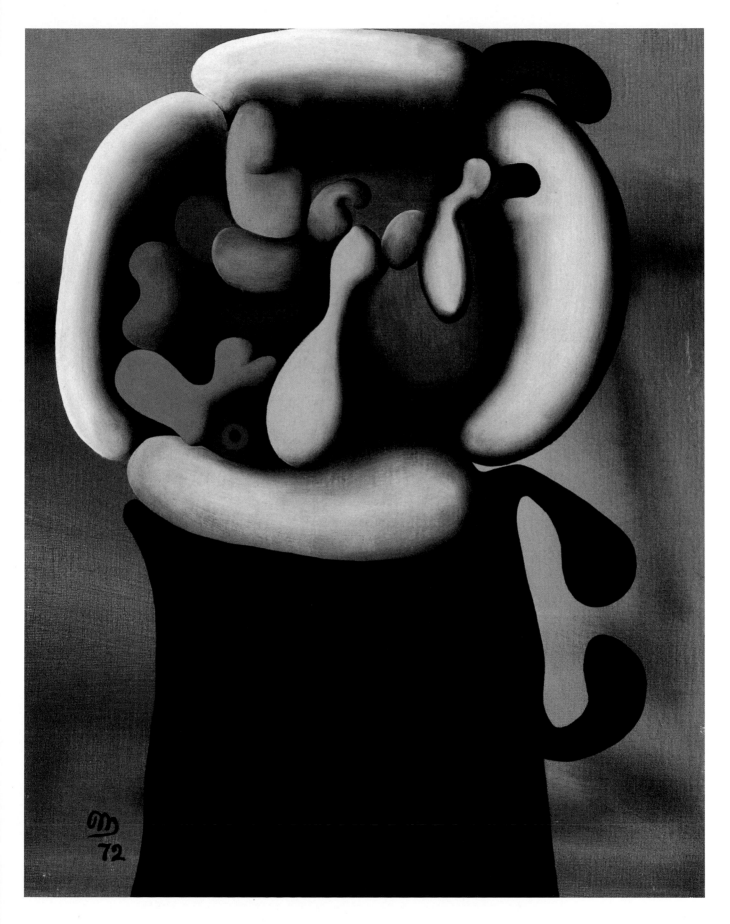

PREDATORY INSTINCTS

That violent references and images should pervade Morris's *oeuvre* is not incidental. His initial gravitation towards painting at the age of sixteen was, in fact, sparked by no less gruesome a visual experience than Goya's *Desastres della Guerra* (*The Disasters of War*). 'Previously,' he concedes, 'I had thought of art as effete nonsense.' In these etchings, found in a volume in Dauntsey's School library, he would have seen a vivid rendition of the grotesqueness of human conflict: 'The human cruelty they depict makes a violent impact on me.'[9] Goya's works, as it turned out, were to leave a firm imprint on Morris's painting for well over half a century. As he was later to acknowledge, 'At the time I make no conscious connection in my mind between the impact of Goya and the start of my own picture-making. But the link is glaringly obvious.'[10] In his implicit commentary on the latent workings of the human mind he reserves an unequivocal prominence for the aggressive impulse.

In fact, he regards aggression as an indelible facet of the human intellect. 'We are all carrying in us a certain anger,' he has observed, 'and we all have the potential for delayed revenge – we store it away and eventually it is used.' In his view, everyone has the potential for violence. The anger that he himself had felt as he watched his ailing father die re-emerges incessantly in his paintings and writings:

> The death of my father made me a young rebel. My rebellion took the form of painting pictures and writing poems into which I poured violent imagery. Sex was taboo at the time so sexual elements were a rebellion against authority, as were non-representational methods and the use of violent images. Using a warped humour and playfulness was a rebellion against the solemnity of the disgusting authorities and beliefs which I saw as decrepit.

It is not surprising, therefore, that, even within the broader conceptual framework of the titles with which Morris has identified his paintings, violence appears as a recurrent theme. With remarkable regularity, he has made such overt allusions to belligerence as *Confrontation* (1948), *The Hunter* (1948), *The Suicides* (1949), *The Assault* (1949), *Warrior I* (1949), *The Warrior* (1950), *The Antagonists* (1957), *The Hunt* (1957), *The Killing*

UNTITLED DRAWING
(below left)
biped with 5 arrow penises
1961
(See page 111)

UNTITLED DRAWING
(below right)
quadruped with Viking helmet
1961
(See page 111)

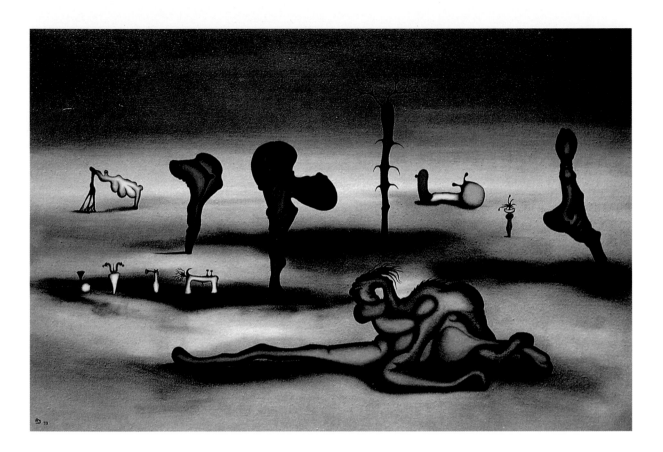

Game (1960), *Boundary Dispute* (1964), *Warrior Waiting* (1966), *The Antagonist* (1968), *The Agitator* (1973), *The Kill* (1973), *Contestants* (1976), *Aggro* (1981), *The Warrior* (1986), *Warrior Angel* (1988), *War Hero* (1988), *The Warlords* (1988).

Violence is equally prominent in many of Morris's poems, and it invariably finds its conclusion in bloodshed and death. We are told, for instance, that 'a barrister shot himself in the mouth'. In another poem the quiet, pastoral setting of a golfing session develops into a series of events that have fatal consequences: 'The plane crashed in a bunker/ His blood did not mix well with the sand . . . heading for the hospital, he died.' Elsewhere there are references to a 'dying' monster, to 'bombs falling' and to 'a small corpse'. In an anxiety-stricken piece recounting a dream, a group of ferocious alligators relentlessly chase the protagonist with the result that 'they kill me and I sink/ I sink into blackness.'

But the innate violence of the human psyche, which these examples demonstrate, cannot, according to Morris, be divorced from another primordial motive force, that of sexuality. The ambivalence perceptible in the interaction between the many biomorphs demonstrates this. The two figures in *The Kill* (1973), for instance, are mutually hostile while simultaneously engaged in a glutinous sexual huddle. 'What one has here,' he explains, 'is a statement about the ambiguous relationship between sex and violence – very often there are elements of violence in sexual interaction, or vice versa.' Entwined bodies could be interpreted as a

THE KILL
1973
Oil on canvas
20 × 30 in. (50 × 75 cm.)
Collection Christopher Moran and Co. Ltd, London

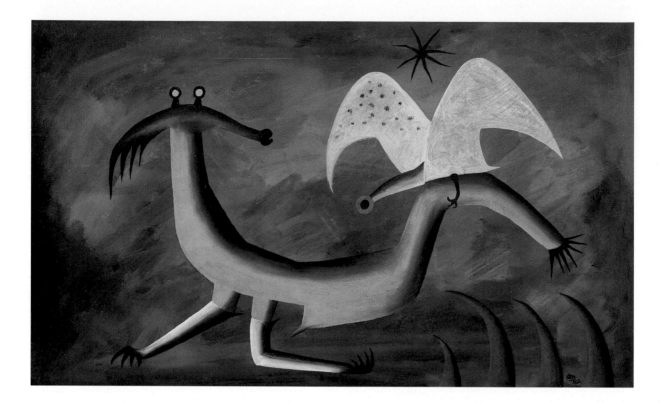

THE ATTACK
1952
Ink and water-colour on paper
8 × 13 in. (20 × 32.5 cm.)
*Collection Professor Aubrey
Manning, Edinburgh*

predatory situation, where a hunter has floored its prey and is about to take its life. Alternatively, the couple could be seen as being in an intimate, amorous embrace. What Morris appears to suggest is that this is not so much an ambiguous phenomenon, where the two alternative readings are mutually exclusive, as an ambivalent scenario in which one level of signification extends into and is compatible with the other. The violent attack and the sexual intimacy implied in *The Kill* are, it would seem, two sides of the same coin:

> The act of penetration of one body by another is an act of intrusion, of invasion. There is no way in which a male and female can copulate without an act of intrusion. Even in its most gentle form, it is still one body entering the interior of another body. There is an inherent violence in this. It is a violation of another person's space, even if they are not violated in the strict sense of the word. It is impossible to go any further unless one is a surgeon or a murderer. When sex reaches its climax, it becomes vigorous to the point of violence. The extreme moments of passion at its most intense become almost brutal. When that happens the man is almost stabbing his loved one.

The Attack (1952) is a clear example of one individual being assaulted by another in such a way that a sexual interpretation of the encounter cannot be precluded. One creature has landed on the back of another and is attacking it, but the scenario is not unlike that of one animal mounting another to mate. Commenting on this painting, Morris has pointed out that 'any relationship in which one creature is attacked by another has a sexual as well as a predatory connotation'.

In some works he has, in fact, equated the phallus with an offensive weapon. In the novel *Inrock*, for instance, aggressive characters known as Polizesti, who guard 'the main assembly area', have spear-like penises. Each Polizesti has an 'armoured spike . . . on a long stalk' which grows 'out of the middle of his stomach'.[11] The purpose of these phallic weapons is to spike those who contravene certain regulations, a fate which the hero Jason is forced to endure. Morris's description of this ordeal exemplifies the metaphorical equation of the sexual function of the penis with aggression:

> The tentacles stiffened and reared up to their full height. 'In the name of the Sculptor, I spike you,' and thrust out his armoured point. As it touched Jason's body it hissed and rattled more violently than ever. He felt himself begin to shake with it. His arms and legs shot out straight and stiff and his teeth started to chatter. He was quivering all over now, uncontrollably . . . He collapsed to the ground.[12]

In the paintings, too, we find this form of phallic mutation. Like the Polizesti, the male figure in *Warrior in Love* (1961) has sprouted a menacing phallus. It is true that this character appears quite innocuous, even comical – he sports a stylized heart in the centre of his chest and waves amicably at the spectator – but the portrayal of his phallus as an arrow-headed spear hints at the other component of the libidinous urge. In spite of the apparent levity in this painting, Morris is using it to reflect on the way in which some aggressive men use sex violently: 'The ease with which the phallus can become a weapon in so many instances is part of the story of human sexuality. This is the hated violence of rape and assault. There is that ambivalence about the human male.' This implication is more explicit in an untitled drawing of 1953 in which the spear-penis has taken on enormous proportions. Extending further than any other limb, it protrudes in a menacingly erectile state from a gesticulating horseman. The phallus becomes a lance, an instrument of confrontation, even carnage.

A quadruped drawn in 1961 is endowed with no less than five such lances, projecting brutally from its equine torso. That this is a hostile figure could not be more blatant: not only is its human head fully encased in a horned helmet – evoking the Viking warrior, noted for his barbaric ferocity – but the creature's tail takes the form of a mace equipped with deadly spikes. A formidable adversary indeed! If an opponent is not mutilated by the array of phallic spears he will inevitably be crushed by the creature's bovine bulk or fatally dashed by a swing of the tail-mace. Every aspect of this biomorph converges on the bellicose. Morris attributes this focused violent potency to the male: a penis protrudes from the creature's underside.

The notion of multiple lanced phalluses 'evolves' into a veritable war machine in a further drawing of 1961. Here the five pelvic protuberances of the biped depicted are so elongated that each needs a mechanical support. And such is the implied weight of the extended bodily spears that they are shown to be manoeuvrable solely by those supports – individual wheel props. The penis here becomes a corporeal battering-ram.

WARRIOR IN LOVE
1961
Mixed media
8 × 4 in. (20 × 10 cm.)
Collection Jack Emery and
Joan Bakewell, London

UNTITLED DRAWING
1953

PREDATORY
INSTINCTS

MOTHER GODDESS *(opposite)*
1969
Painted metal and stone
Height: 10 in. (25 cm.)
Collection Anders Malmberg,
Sweden

THE WARRIOR
1950
Oil, ink and watercolour on
paper
13 × 8 in. (32.5 × 20 cm.)
Collection Mr Arnold B.
Kanter, Evanston, Illinois, USA

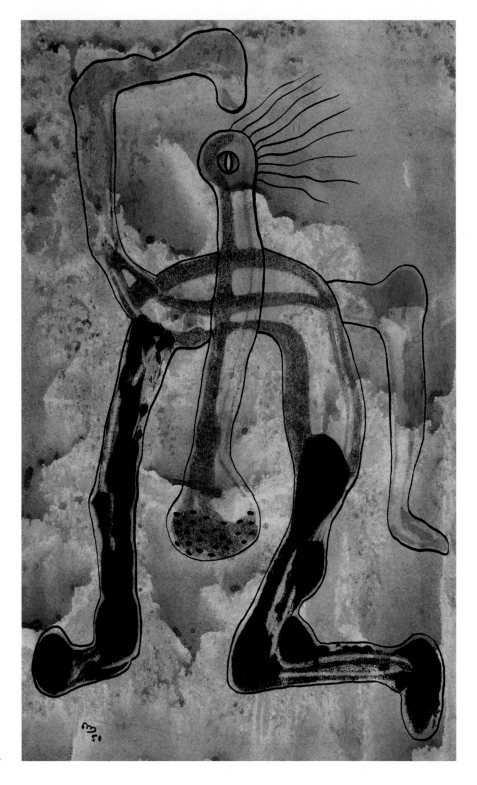

Another 'warrior', painted in 1950, wields a heavy club in the place of a phallus. And this anatomical feature is so prominent that it replaces the whole torso. The figure designates the male in the guise of a sexually violent/violently sexual being. No other attributes seem to be deemed important. Even the head is reduced to a fraction of the size of the bulbous end of the phallus-club. Again Morris equates sexuality with violence: in this

this alarming portrayal of masculinity he thereby draws attention to the more distasteful aspects of lustful degeneracy. We are so horrified by the idea of rape and sexual assault he says, that we tend to overlook 'the fact that loving sex can also be pretty brutal'.

But the equation of violence with sexuality is not limited to allusions to masculinity. In *Mother Goddess* (1969) Morris portrays an even more acutely aggressive sex, although, at first glance, the inverted meat mincer from which the Mother Goddess is modelled seems to suggest an acquiescent, welcoming gesture, a benign enticement to sexual intimacy. The mincer's clamp has become two outstretched arms beckoning, almost supplicating. As Morris is well aware, the extended arm displaying an open hand is a way of communicating cordiality and an absence of hostile intention. But the precise nature of this invitation is indicated by the hollow barrel of the mincer. Morris has removed the screw mechanism to leave a compelling reference to a gaping vulva. The figure is an unrestrained evocation of receptive fertility and of sexual arousal. But the allusion to the erotic has an alternative connotation. Having succumbed to this temptress, the avid male lays himself open to the most vicious fate, Morris's object seems to imply. For consummation would also entail the perils implicit in the workings of this metallic implement. The phallus is being enticed into a mechanism designed to crush, lascerate and pulp flesh. Violence at its most sadistic may be closely associated with passionate intimacy.

It would seem, then, that a consideration of aggression in Morris's work would not be complete without an examination of its complementary vital urge, the sexual forces emanating from the libido.

7
Passionate Intimacy

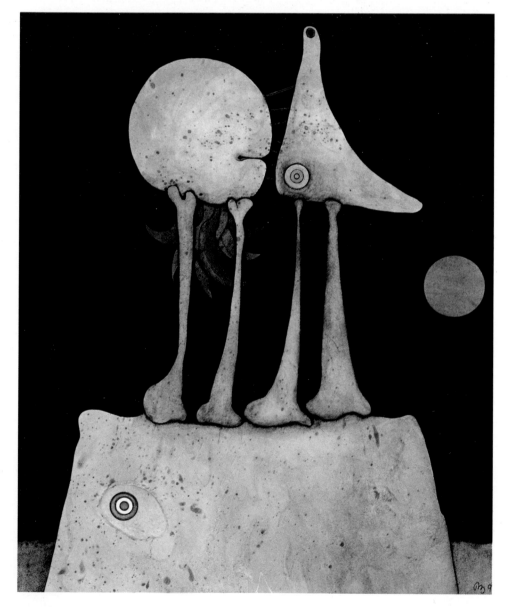

THE SURVIVOR
1988
Mixed media
8 × 13 in.(32.5 × 20 cm.)

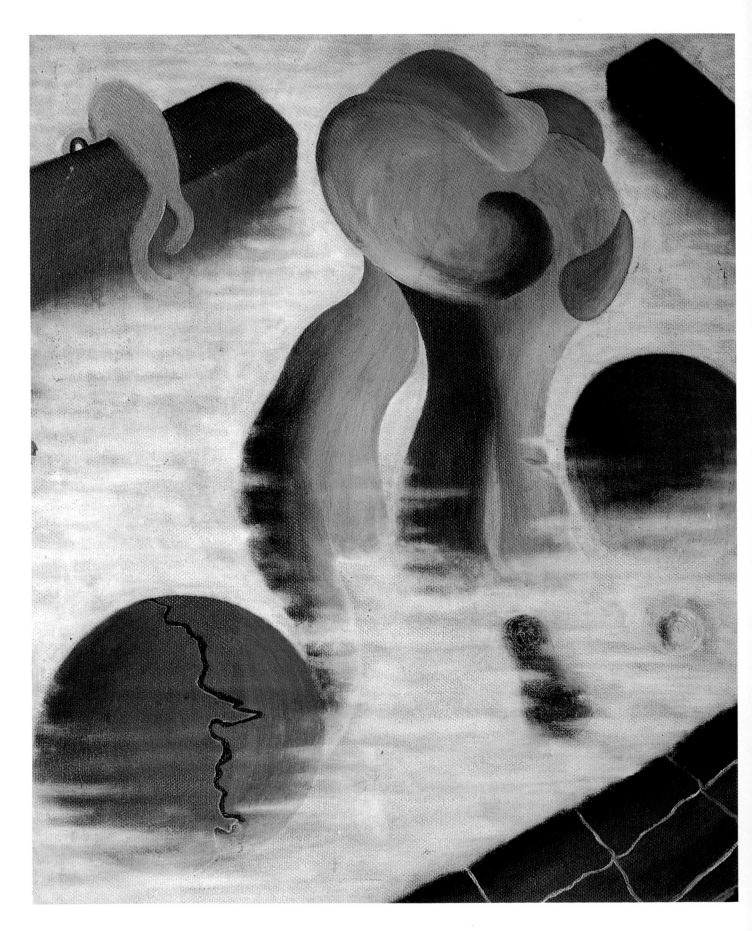

Passionate Intimacy

I F, IN *ENTRY TO A LANDSCAPE*, Desmond Morris announced his artistic trajectory towards a new, separate, liberated vision, in *Over the Wall*, painted a year earlier in May 1946 in the studio of the Swindon artist Walter Poole, he had already highlighted one of the key constituents of that vision. An essential feature of many biomorphs – indeed, in some cases, their sole function – is their insistent gravitation towards the expression of sexuality. *Over the Wall* not only foregrounds such libidinous concerns but it also establishes sexuality as a pivotal preoccupation for Morris. The tone of the painting signals what was to become a lifelong engrossment in and fascination with sexual desire. It is worth recalling that what most fascinated Morris about the art of his avowed preceptor and model, Joan Miró, was his practice of 'often imbuing his paintings with a wild, sexual violence'.[1]

To regard *Over the Wall* as epitomizing this theme may, at first, seem somewhat surprising. Its initial message would seem to be far from salacious: the painting represents nothing overtly erotic or, even, remotely sensual. The two figures depicted cannot be said to display anything resembling lust. On the contrary, the scene is evocative of tenderness and emotional attachment: the stylized couple appear to be engaged in an extremely affectionate embrace. And such is their fondness for each other that their heads and shoulders are intertwined to the extent of appearing mutually indistinguishable. The mauve figure has clearly wrapped its two arms around its partner and is clasping the back of the green one. A third limb caresses the back of the green figure, but it is not clear whether it belongs to the mauve figure or to its mate. But establishing the precise configuration of the various limbs is of little importance. All that really matters is the overall impression of intimacy. Merged as they are in a continuum of sensuality, the couple gives the impression of being so emotionally attached that they have become physically inseparable.

OVER THE WALL *(opposite)*
1946
Oil on board
29 × 24 in. (73 × 60 cm.)
Private Collection

It is significant, moreover, that the lovers make contact only by means of their heads, arms and shoulders. Their lower torsos remain well apart – Morris even allows daylight to shine through the gap between them. The 'coupling', the painting suggests, takes place on an emotional rather than on a carnal level: the two are kissing, not copulating. Thus, the underlying mood would seem to veer towards the 'romantic' rather than the erotic. Indeed, in a rather endearing, if somewhat clichéd, manner – possibly not unrelated to the techniques of escapist wartime film-making – wisps of mist create an idyllic aura in *Over the Wall*. One can almost hear the faint sound of strings, so typical of the Hollywood happy ending, playing in the background.

However, the mist also encapsulates an alternative, less quixotic, significance. On either side of the lovers two large spheres seem to be emerging from the haze. Halfway between them is a third element, reasonably distinguishable as a phallus. This protuberance, which tapers to a blunt point, hovers just below the mist's surface, almost as if it were in the process of rising out of it. Viewed in this way, the shapes surrounding the couple take on the aspect of male genitals.

If, then, Morris's allusion is to genitalia and the blood-red spheres are to be regarded as testes, a review of the relative size and significance of the other elements in the painting is called for. Clearly, the 'embracing couple' assumes a new meaning not independent of the adjacent male organs. And it would not be inconceivable, therefore, to infer a veiled reference to the female pudenda in the vulva-like space between the figures. A cleft is clearly delineated at this point.

Equally, the suggested incipient erection emerging from the mist can be seen as a response to the allure of the adjacent 'female' presence. Morris appears to be representing male arousal here. Viewed as a whole, these various sexual connotations point to an interpretation quite distinct from the initial impression of sentimentality. It could even be said that the overriding significance emerging from the painting is tantamount to a portrayal, albeit in metaphorical terms, of imminent coitus.

This further significance of *Over the Wall* is by no means definitive, though. Yet another level of meaning can be gleaned in the title itself. The wall surrounding the intimate activity in the centre of the picture, be it an embracing couple or giant genitalia, acts as a barrier or screen providing privacy and isolation. However, an intrusion into this secluded domain may be observed 'over the wall': what is happening here is a surreptitious but deliberate violation of the couple's desire for covertness. In voyeuristic manner, a single prying eye peeps over the wall. This third presence in the painting appears so engrossed in and captivated by the scene that it is witnessing that it has, inadvertently perhaps, allowed its tentacle of an arm to reach towards the couple in a gesture of envy. It is as if an overwhelming covetousness has drawn the concealed figure out of its hiding-place. The gesture conveys a yearning for an inaccessible and exclusive state.

Morris has said that this painting 'is an expression of the sentiments of the outsider confronted with a situation from which he is excluded, that of the

insider'. 'It is,' he notes, 'another "entry to a landscape" but more so in that the feeling of exile is all the more acute.' It is not surprising, therefore, that, although for several decades he regarded this painting as unrepresentative of his increasingly refined style and technique, he did not submit it to the ritual destruction which has been the fate of a significant number of 'rejected' works. Even though *Over the Wall* was invariably relegated to an undignified corner of the studio, causing it to be catalogued as 'whereabouts unknown' in 1991, and its reverse had even been used as a palette, Morris has unconsciously always accorded it a degree of significance within his *oeuvre*.[2] It was only in May 1996, exactly fifty years after its execution, that he came to realize the true consequence of this work: it suddenly dawned on him that it marked a turning-point in his 'explorations'. 'Clearly,' he has subsequently acknowledged, 'it is *Over the Wall* and not (as I usually state) *Entry to a Landscape* that is the *true* first depiction of my private biomorphic world.'

In *Over the Wall* he had distilled his teenage preoccupations and anxieties about social intercourse and sexuality, themes which may well have been echoed in the numerous destroyed works of this period. Certainly this is true of a lost painting executed in about 1946 titled *Landscape for Three*, which again depicts an entwined couple in the foreground being watched by a small solitary figure in the distance.

In 1946 when he was eighteen the idea of marginalization, in a general sense, was prominent in Morris's mind, and it formed the subject of a poem written in that year entitled 'To Live Alone'. The original version, which has probably been destroyed, ran to thirty-two pages, but at some later point he edited it down to a shorter length. In this text he set out his juvenile resolution to shun social interaction and to devise a way of living in isolation from others. So poignant was this phase of his development that, after some fifty years, the line 'I have to live alone on the third side of the fence' still persists in the artist's memory. The implication of this fragment of the poem is that the normal alternative social stances, the 'two sides of the fence', are not perceived as valid options in his hermetic scheme of things. Rather, he has situated himself beyond customary social parameters at an impossible 'third' side. In other words, he views his rapport and interaction with others as paradoxical and, perhaps, futile.

The distant figure in *Over the Wall* is clearly 'on the third side of the fence'. It is excluded from the attractive predicament of the lovers and appears to have no prospect of participating in such social intercourse. To an extent, this was an autobiographical statement. During his teenage years Morris regarded himself as a solitary figure, convinced of what he called 'the impossibility [for him] of social interaction'. 'The little figure longingly looking over the fence,' he once revealed, 'is me.' Arguably, it is this third figure that is the true subject of the painting.

The parallels between the poem and the painting are striking. 'To Live Alone' refers to 'these grey walls' and to 'steam, fog, mist'. Together these features accurately describe the setting of *Over the Wall*. As in the painting, the poem expresses the view that 'the fence has three sides'. Also, just as much as *Over the Wall*, the poem foreshadows the biomorphic world that

LANDSCAPE FOR THREE
(CHRISTMAS PAINTING)
1946
Oil on board
24 × 32 in. (60 × 80 cm.)

was to arrive fully with *Entry to a Landscape* in April 1947. In a premonitory manner 'To Live Alone' gives a vivid description of the private world that Morris was to start painting from the following year. 'I had completely forgotten this,' he recently remarked, 'and I find it extraordinary that I should have pictured the world of the biomorphs in such detail so long before I actually portrayed that world.'

Over the Wall is considered by Morris to be his 'first original painting'. Before it he was producing works such as *Girl Selling Flowers*, *Seated Woman*, *The Kiss* and *Woman Reading* (all 1946), which show a strong Picasso influence and result from visits to Picasso and Matisse exhibitions at the Victoria and Albert Museum after the war. Spurred on by Walter Poole, in whose studio he was working at the time as an 'apprentice' and with whom he was to exhibit in 1948, Morris produced in *Over the Wall* a charged, personal manifestation on which he 'worked very hard and struggled'.

'To Live Alone' may be regarded as equally pivotal; in a variety of ways it anticipates many aspects of Morris's *oeuvre*. For instance, the landscapes which appear in many of the paintings are paralleled by the vast vistas evoked in the poem. He writes of 'boundlessness', of 'immense space', of an 'edgeless plateau' that 'extends endlessly'. The immensity of the sky depicted in the paintings is also reflected in the writing: 'To Live Alone' describes 'firmamental space, stretching to infinity' and a 'celestial expanse, a million million times beyond my reach'. Between the earth and the sky 'horizons there are none', the poem goes on thus echoing the indistinct merging of the horizontal and of the vertical found in the images. Indeed, in many paintings the background conveys neither the idea of *terra firma* nor that of an atmosphere. Instead, the painted scenes give the impression of the 'desert' and 'undulating sands' to which 'To Live Alone' draws our attention.

Within this unearthly panorama Morris's poem, as do his paintings, excludes the human presence: 'No man comes,' he writes. Throughout the poem it is 'solitude' and 'elemental emptiness' that are emphasized: 'I sing the praises of my isolation.' The setting in both poem and paintings is often one of 'spacious quiet', of 'silent stars'. Even the air is described as 'windless'. The solitary 'female figure' in the poem, described as waiting 'on the far side of the fence' – that is to say, in an inaccessible place – is out of reach.

What appears to replace human presence in 'To Live Alone' is an alternative life form that can be said to prefigure the multiform biomorphs of the paintings of the seventies. Morris writes of 'chattering tree-things', of 'little flutterings' and of 'the spiny fish of fantasy'. It would not be difficult to find creatures in his paintings that fit such descriptions.

The analogy between the paintings and this prophetic poem lies above all in the palette with which Morris's world is depicted. In both he evokes a world of bright and contrasting colours, of intense visual stimulation. The sky is 'orange', waters are 'pink', the beach is 'crimson', smoke is described as 'fine blue powder', mud is a 'yellow-brown mass', and at one point in the narrative we see 'mauve beams'. As though foretelling the style of painting

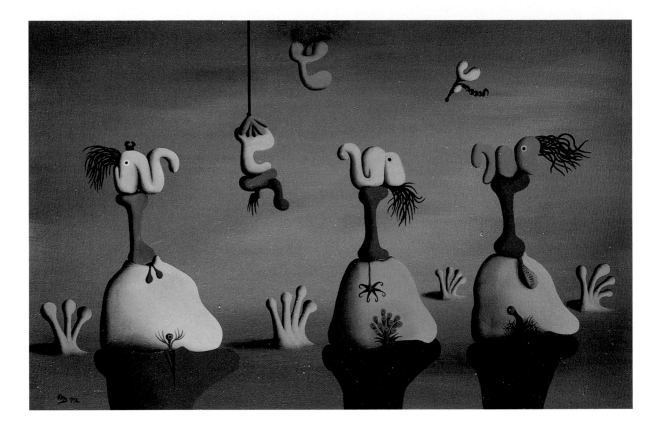

THE THREE MEMBERS
1972
Oil on canvas
12 × 18 in. (30 × 45 cm.)

that he was to develop over the next half-century, he writes of 'clarity' and of a vision that perceives 'cleanly, brightly'.

Beyond considerations of technique and sensual perception, *Over the Wall* remains a touching and heart-felt expression of the hidden insecurities, cravings and fears of a young mind – the first step in a journey of self-exploration, a journey into the psyche. This route, as later paintings were to reveal, was to lead him into an inner domain inhabited by the distillations and materializations of secret and intimate thoughts. The resulting paintings allowed him to set down 'the stupefying photograph of [his] thoughts and his dreams'. A great proportion of those thoughts and dreams, as the paintings testify, centre on the theme of our principal social taboo – sexuality.

With this in mind, it is not difficult to see that in the painting *The Three Members* (1972) Morris makes thinly veiled erotic allusions. He presents three composite figures each of which comprises four sections: an uppermost portion that can be likened to a head and that contains an eye and sprouting hair; a long supporting stem, which acts as neck and upper torso; a bulbous, fleshy area in the form of a pelvic region; and, finally, a supporting trunk, which appears to stretch beyond the confines of the frame and to rest on the ground.

What distinguishes these biomorphs from those considered so far is that the 'pelvis' of each shows evidence of genitalia. The biomorph on the right, for instance, displays a phallic protuberance, complete with a small hole at its tip and a mass of dark 'pubic' hair at its base. The biomorph on the left

possesses a similar appendage but, in comparison, it would seem to be at an earlier stage of maturity, perhaps pubescence: its phallic stalk is less pronounced and the growth of hair is much less profuse. Between these two unequally matched 'males' Morris places what can only be interpreted as a female. The pubis is indicated by a multi-flowered plant, which, as in nature, displays its blooming heads in anticipation of, or as an invitation to, fertilization. As Morris explains, 'Flowers are the genitals of plants and, especially when viewed under the microscope, they have a marked eroticism'. Indeed, as if responding to this enticement, the phallus on the right is beginning to incline towards the 'female'. The situation mirrors a prevalent natural process, the pursuit of a female by competing males. In this scenario it is clear which of the two males is the more dominant and which is more likely, therefore, to achieve its objective.

But there is neither question of a contest in this scene nor of direct steps towards a mating. It is more a matter of display. The three 'members' simply parade themselves and, more particularly, their sexuality. Morris appears to be concerned only with introducing us to yet another behavioural potential of his biomorphs. These creatures, he suggests, have a sexuality, and one that parallels that of the higher animals. The painting might even be said to resemble a natural history display in a Victorian museum, with the carefully labelled specimens presented side by side. Indeed, the 'three members' could well be regarded as a 'comparative anatomy' study contrasting the various manifestations of a specific creature – the male, the female and the immature male.

In *The Budding Force* (1973) it is the female and her sexual organs that are the subject of such a display. Ostensibly, this painting shows a rooted seed sending up a small shoot. The whole of the complicated central form appears to be below the ground, where it is anchored by a hair-like root clump issuing from the bottom right. At the top a budded stem is surging upwards. It appears to have forced its way through the ground by the exertion of immense pressure, and has now emerged into the lighter area of the open air. This is an eruption of subterranean forces. The bulb-like mass is shown in all its elaborate, tensioned detail, and at its muscular heart a well protected kernel appears to throb. The title of the work denotes the idea of vigorous growth from a plant root.

However, as is often the case in Morris's works, the botanical can be transposed into the zoological. The overall formation gives the impression of a soft organic entity growing and developing by division. Cells, protoplasm and nuclei can almost be discerned within the various areas depicted. But the allusion that emerges most strongly is that of the reproductive and sexual organs of a female mammal. The central dark form in its protective envelope, the tube-like shapes leading to it, the spherical forms nestling in crevices – all contribute to the notion of an intra-uterine environment. It would not be difficult to perceive the suggestion of an embryo developing in a womb in the centre of this painting. Similarly, the various ducts connecting with a small globular form to the right of this 'uterus' can be interpreted as fallopian tubes leading to an ovary where an egg is poised to be absorbed on

THE BUDDING FORCE

(opposite)

1973

Oil on canvas

16 × 12 in. (40 × 30 cm.)

Private Collection, Oxfordshire

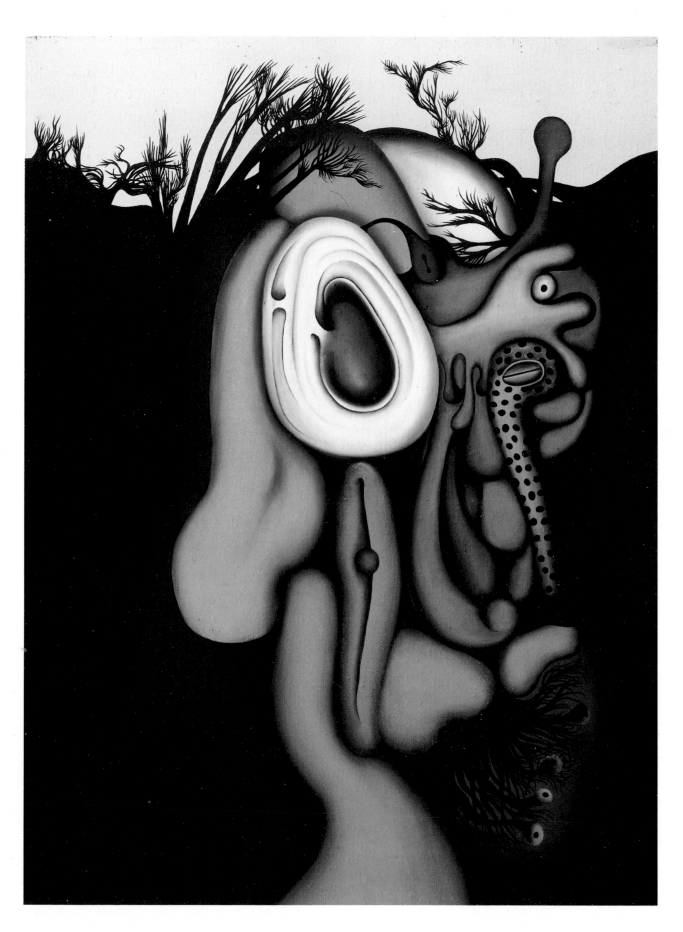

124

its way to possible fertilization. Indeed, such an interpretation would certainly be in keeping with Morris's acknowledgement of the importance of the theme of fecundity in the development of his work: 'Suddenly, with almost explosive force, fertilizations began to take place. Eggs and cells and globules began to swell and divide. In some strange way, and in immense close-up, growth and development were beginning.'[3]

Even more indicative of female sexuality in *The Budding Force* is a long vertical fissure placed between two soft elongated swellings. This orifice can only be regarded as an allusion to a vulva. Obviously, what had appeared to be fibrous roots can, in this light, be reinterpreted as a mass of pubic hair or, perhaps, as fimbriae, the hair-like tentacles which usher eggs along the fallopian ducts. In fact, egg-like nodules appear on stalks within the bushy mass.

The Budding Force conveys sexuality, although not sex. As in *The Three Members*, we find ourselves in front of an informative display. But this painting alludes more to the scientist's laboratory than to the museum showcase. The specimen is cut in half to reveal, by means of a cross-section illustration, the internal working of the female reproductive system. It is almost as if Morris is at pains to prove that his creatures have a sophisticated sexuality. As an investigative scientist, he displays a carefully dissected specimen in such a way that all the vital elements are revealed.

Even more suggestive of the scientist at work is a series of works executed in the early 1960s which echo microscope views of cells and organisms engaged in the process of procreation. Morris has described these paintings as centring on 'explosively reproductive themes of fertilization and ovulation'.[4] As though taking a highly magnified view of his biomorphs, Morris appears to look inside their very workings. In *Ovulation* (1961) he seems to be focusing on the minutiae of egg production. Six small dark, circular, gamete-like forms appear to float in uterine fluid as if awaiting fertilization. *Fertilization II* (1961) takes this process one stage further. A single egg, in greater close-up, hovers in space while an ejaculation of spermatic blobs steers round a phallic shaft and veers towards the centre of the egg. In a further work of this sequence of 'procreational' paintings, the representation of the 'egg' changes from that of a blank, black sphere to that of a globule containing a nucleus.

As the title *Force of Fusion* (1961) denotes, the cycle suggested by *Ovulation* and *Fertilization II* has reached its conclusion. The ovum and the spermatozoon have fused to produce a single zygote. This description is equally applicable to the various floating forms in *The Loved One* (1950). Here the tentacled cellular form contains a vibrant core, which gives it an autonomous 'living' presence. It even appears to be swimming amongst the various elemental entities with which it shares its microscopic aqueous world.

Clearly, in these works Morris seems to be underlining the emphatically sexual substance which underpins biomorphic interactions. A work suitably entitled *Growing Signals* (1966) makes a similar statement. Depicting a blatantly ovular shape nestling within a uterine sphere, it has prompted one

OVULATION *(opposite)*
1961
Oil on canvas
29 × 22 in. (72.5 × 55 cm.)

FERTILIZATION III
1962
Oil on canvas
16 × 12 in. (40 × 30 cm.)

FERTILIZATION II *(page 126)*
1961
Oil on board
39 × 30 in. (97.5 × 75 cm.)

FORCE OF FUSION *(page 127)*
1961
Oil on canvas
16 × 12 in. (40 × 30 cm.)

127

128

THE LOVED ONE
1988
Mixed media
11½ × 8 in. (29 × 21 cm.)

critic to remark: 'Here we have the hermaphroditic vision of uterine organs laid bare and supported by two enormous testicles, between which a blood red area is speckled with black cells, either ovules or spermatozoids'.[5] Morris appears to be focusing on the fundamental forces of generation and vital fusion. Other paintings, with titles such as *The Day of the Zygote* (1966), *Coupling Strategies* (1966), *Fertility Figure* (1969) and *Great Mother* (1969), and two other 'fertilizations' (1961 and 1962), attest to an obsessive concentration on the scientific and gynaecological facets of sexual interaction.

Niko Tinbergen would, however, almost certainly have impressed on his doctoral student that the investigative potential of the laboratory is limited and that animals should be observed in a social situation. Accordingly, the 'clinical' depiction of biomorphs does not preoccupy Morris for long and is by far outweighed by paintings that concentrate on their behavioural characteristics and idiosyncrasies. The sexual qualities with which Morris's creatures are emphatically endowed are more often manifested in paintings that depict a social interaction than in detached, diagrammatic tableaux. He tends to refer to sexuality in terms of sensual or, at least, impassioned encounters between his male and female biomorphs. Sexual intercourse is pictured not from an intra-uterine perspective but from outside the body.

A powerful *sexual*, as opposed to gynaecological, image appears in *Table for Two* (1972). On a platform or 'table' two shapes appear, one of which has plunged into the other. The two shapes, male on the left, female on the

GROWING SIGNALS (*opposite*)
1966
Oil on canvas
21 × 14 in. (52.5 × 35 cm.)

129

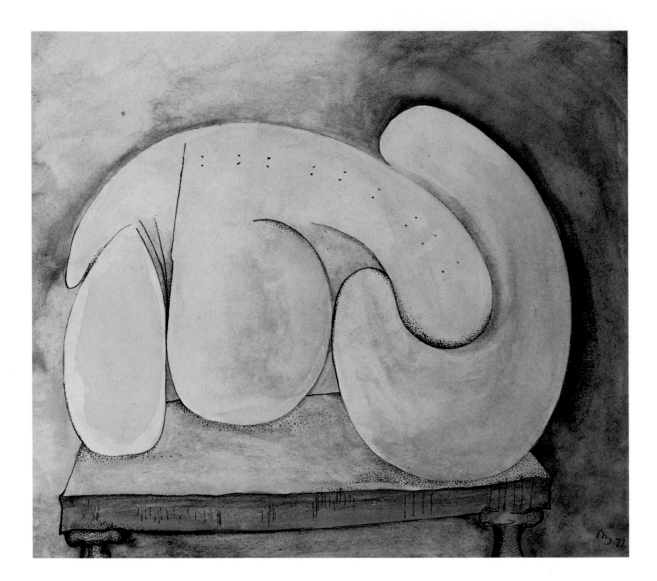

right, are reduced to an absolute minimum in terms of anatomical detail. The focus is placed solely on sexuality. As opposed to the scenario in *The Budding Force*, sexuality is seen in terms of intercourse between the sexes and not simply as unexpended fertility. 'The one on the left is thrusting into the one on the right,' Morris points out, 'in a way that is obviously sexual; I have eliminated anything that is not relevant.' *The Courtship I* (1948), as the title suggests, demonstrates just this. The painting centres on the ritualistic encounter of a coupling pair. A form with an elegant neck and two breast-like protuberances bows towards a larger, more flamboyant being. The allusion is to a female creature, which is beginning to show interest in a male. This second biomorph clearly displays an avid attraction towards his prospective mate. His grotesque frog-like face nudges close to the other figure and his long-lashed eyes beam at her with blind admiration. He is mesmerized, and his half-open mouth could well be uttering throaty enticements. All the signs are that this is a determined suitor: two uppermost antennae, erect with excitement, display multicoloured

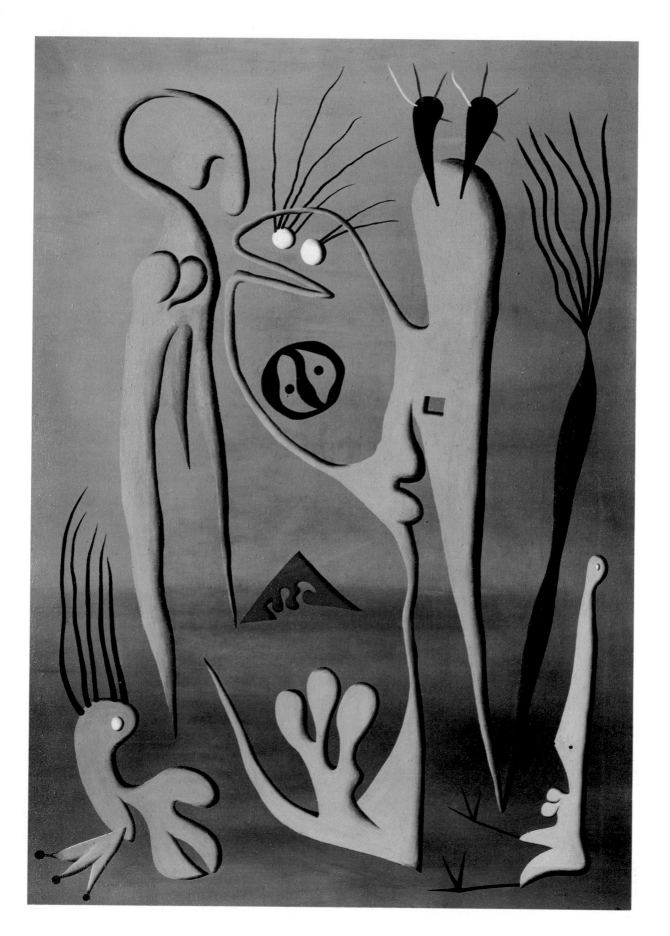

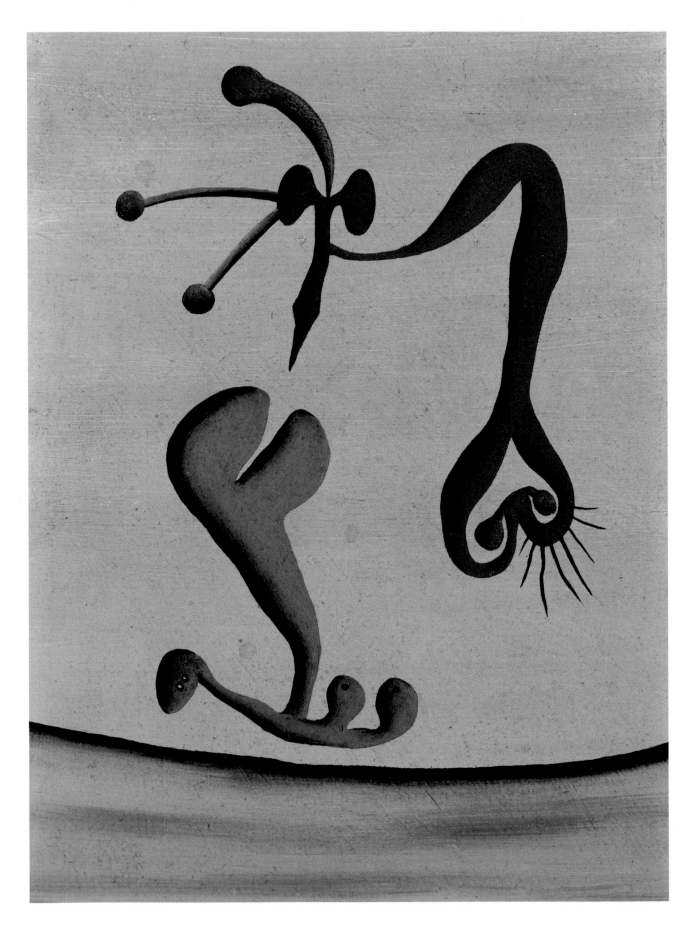

tentacles, and at the opposite end of this male body a pointed member emerges from a scrotum-like appendage complete with spherical bulges. This sexual implement is, moreover, directed at the underside of the female. She makes no effort to evade the advance and her splayed tentacles appear ready to accommodate the impending penetration.

Whilst in *The Courtship I* copulation is merely suggested, in *The Lovers* (1948) it is the immediately recognizable subject. This painting contains no peripheral figures and so centres the viewer's attention on the activities of the two biomorphs depicted. The title leaves no doubt about possible interpretations, and it is difficult not to infer from the various twisted shapes an imminent act of coitus. In the very centre of the painting a penis-like shaft is poised above a vulva-like cavity. So explicit is the connotation that it is only after one has apprehended it that the biomorphs' remaining body parts are perceived. The red 'male' shape has antennae like those of a snail, and lower down its body is a 'pouch' containing shapes resembling testes. The 'female' has what can be regarded as a head, with a pair of eyes, and at the other end of her body two spherical swellings give the impression of breasts, with red nipples.

Yet these further body parts appear incidental to the sexual organs, and certainly secondary to the prominence accorded them. Not only are the vulva and phallus depicted as huge in comparison with the respective bodies, but most of the other parts with recognizable functions are connected with reproduction and procreation: the testes, breasts and antennae all have a direct bearing on sexuality. *The Lovers* focuses on the carnal appetite of biomorphs and ignores all other behavioural or physical attributes. Moreover, Morris makes the point in an unusually direct and candid manner. For him this work, executed during the intensely passionate years of his own courtship, denotes 'a metaphorical distillation of sexuality'. It is, he insists, 'pure sexuality with everything else removed'.

Many works of this period reveal an insistence on the raw elements of sexuality. In *The Assault* (1949), for instance, one form is lunging at another

PASSIONATE INTIMACY

THE LOVERS *(opposite)*
1948
Oil on canvas
8 × 6 in. (20 × 15 cm.)
Collection Mrs Ramona Morris, Oxford

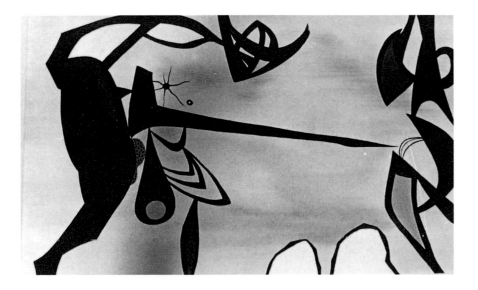

THE ASSAULT
1949
Oil on board
18 × 29 in

THE COURTSHIP II
1948
Oil on canvas
14 × 19 in. (35 × 47.5 cm.)
Private Collection, Vienna

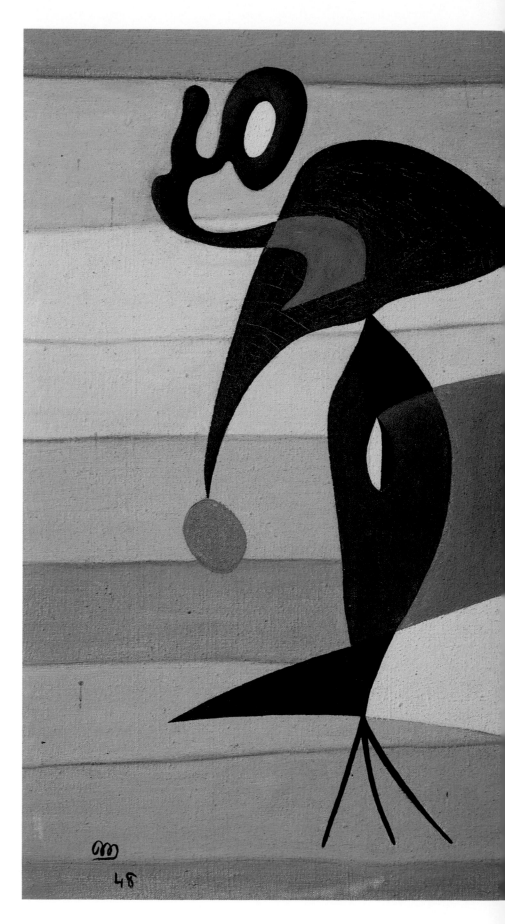

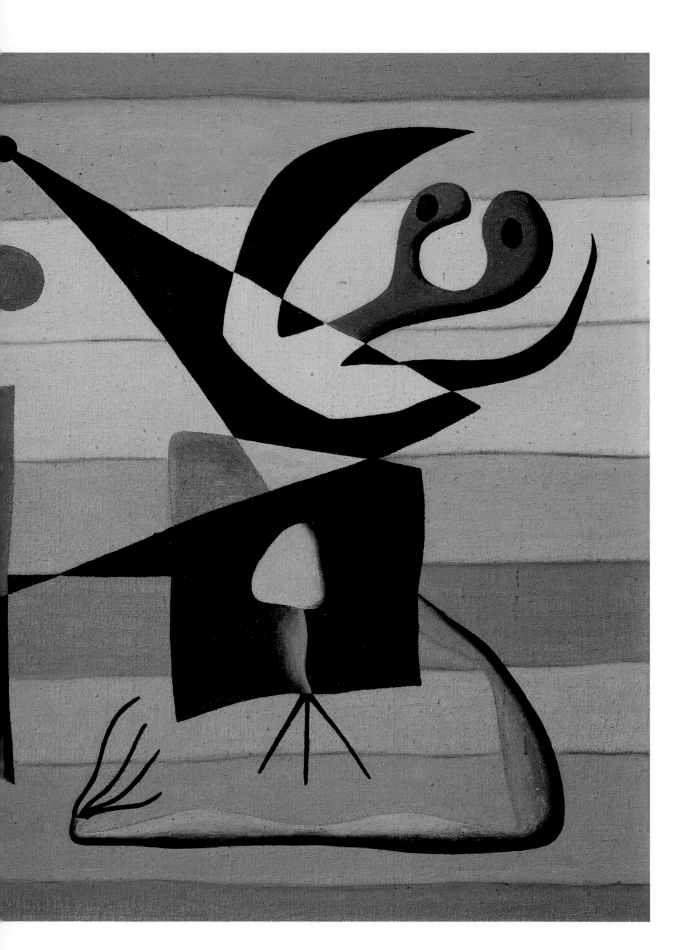

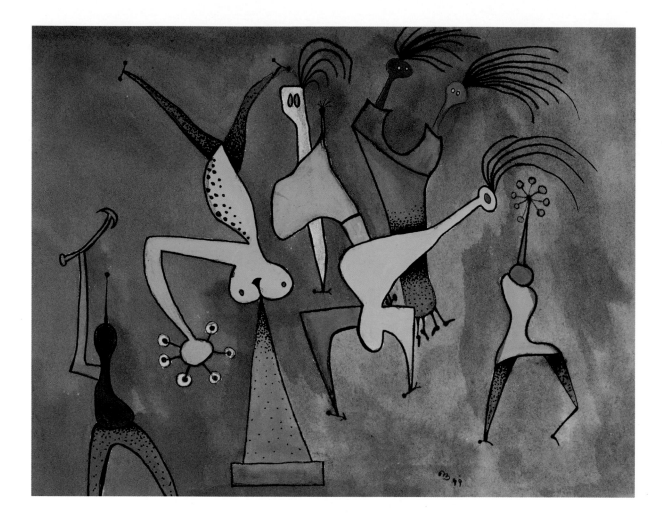

ACROBATIC DISPUTE

1949

Gouache on paper

9 × 12 in. (22.5 × 30 cm.)

with its phallus. The male member is represented as a long pointed shaft that is about to enter the 'female' aperture of an adjacent form. It has already been noted that when, in *Inrock*, Jason encounters just such a spike-like bodily protuberance it takes on the role of offensive weapon. In the aptly titled *The Assault* the aggression implicit in the sexual act is emphasized by the indication of an intact hymen across the orifice that is about to be penetrated. The sexual act is represented here in the cold light of biological pragmatism.

No less of a sexual 'assailant' appears in *The Courtship II* (1948), in which a male figure thrusts a huge phallus towards his female partner. Such is the momentum of this movement that its initiator is almost thrown off balance, waving his arms in the air as though to steady himself. As in *The Assault*, the phallus is presented as a quasi-missile. And its pointed tip needs to be protected, like a fencing foil, by a spherical button. For her part, the female is by no means quiescent: she brandishes her own weapons in the form of formidable breasts. The 'courting' pair are engaged in a joust-like encounter. The amorous convergence is presented here in an explicit and confrontational manner.

A similarly contentious treatment of the sexual encounter is presented in *Acrobatic Dispute* (1949), in which a female form appears to have settled on

an enormous phallic point. The 'dispute' in question could be concerned with possession of this solitary source of fertilization. Natural selection is shown here as a combative process. Indeed, one of the figures wields a hammer-like weapon. In *Two Friends* (1948), although the two females have not resorted to mutual aggression, there is an indication of strife over, or at least competition for, the solitary male genitals aimlessly floating by.

By the early 1950s such concerns were so prominent in Morris's thinking that they developed into a whole series of *risqué* works. This 'obscene phase', as he puts it, later struck him as being shocking enough to merit total destruction. Today none have survived the artist's self-censorship.

Morris refuses to be drawn on the content of these 'scandalous' 1950s paintings, but their tenor can, to an extent, be inferred from later works on this same theme. The insistence on salaciousness is inescapable in, for instance, a painting such as *The Guardian of the Cycle* (1972). Even a cursory glance at this work could not fail to perceive the lower visceral protuberance of the tree form in phallic terms. Not only does its shape and position correspond to this interpretation, but its base is surrounded by a mass of dark

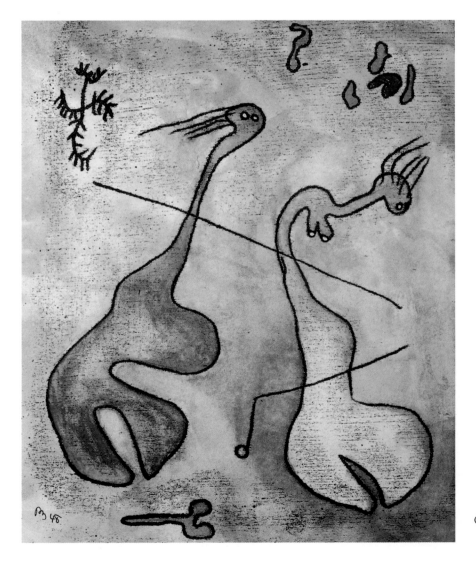

TWO FRIENDS
1948
Mixed media
8 × 6 in. (20 × 15 cm.)
*Collection Mr Joris de Schepper,
Paris*

filaments which strongly suggest pubic hair. Furthermore, the obvious eroticism underlying this painting is accentuated by the perfect horizontality of the swelling. If this form is indeed intended to convey a phallus, then it is depicted in its erectile state. Depicting here a throbbing sensuality, Morris homes in on the human male's perennial phallic obsession – an obsession which may well owe much to the fact that, of nature's 193 species of monkey and apes, Man sports the largest penis. Even the gorilla cannot compete in this respect.

This focus persists in *Inrock*, in which not only is there an extremely thinly veiled allusion to an erect phallus but the narrative picturesquely evokes the state of sexual arousal and then the act of ejaculation in a spectacular, albeit metaphorical, manner:

> The great bird flew wearily back to the mountain with only a small fish clasped in his talon . . . the puny fish was all he could catch. He had failed in his task and now he must tell the Princess, losing her forever . . . As he looked at her, his love welled up inside him and he felt he was going to split in two . . . he felt a strange sensation moving through his body. Looking down he let out a startled gasp for there, between his legs, as if by magic, the small fish was growing into a great, glistening whale. It grew and grew, writhing to escape from him, until it was bigger than any of the whales he had seen in the sea. At this moment the Princess awoke . . . she caressed the whale. She was surprised to find that there was a hole in the top of its head. A fish does not have a hole here, she thought . . . the Sea-eagle said: 'No hunter has made this hole, it is

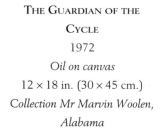

THE GUARDIAN OF THE
CYCLE
1972
Oil on canvas
12 × 18 in. (30 × 45 cm.)
Collection Mr Marvin Woolen,
Alabama

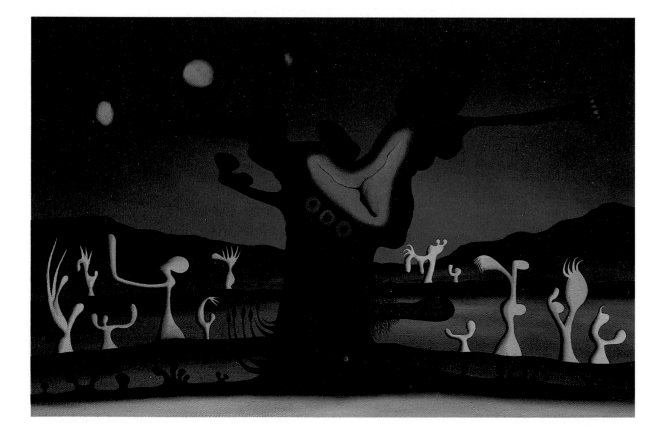

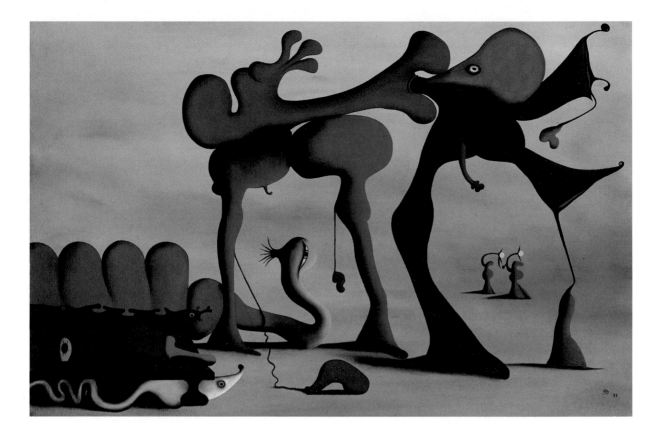

THE OBSERVERS
1973
Oil on board
20 × 30 in. (50 × 75 cm.)

natural to the whale and through it he spouts a great jet of water.' So saying, the Sea-eagle squeezed his legs together against the body of the glistening whale, which spouted a great spout. The water shot into the air like a fountain and drenched the Sea-eagle and the Princess.[6]

An extremely blatant phallus appears in *The Observers* (1973), where from a mass of dark pubic hair it dangles and swings between two elephantine legs. There is nothing covert or ambiguous about this portrayal – Morris even colours the member an eye-catching orange. As opposed to *The Guardian of the Cycle*, however, *The Observers* does not show male genitalia in a detached manner. To the left of the obviously male lower body on the right he has placed another pair of quasi-legs which support a brownish form containing the suggestion of female genitalia. Within the contours of an indeterminate curvaceous mass there is an indication of an aperture.

This 'female' orifice has a rim resembling the mouth of a balloon. And, in the manner of a balloon, the opening appears to have stretched open in order to accommodate a second 'phallic' swelling emanating from the male figure. In a thinly veiled allusion to coitus, Morris demonstrates the power of the sexual impetus possessed by his biomorphs. Their libidinous urges are so compelling, it would seem, that their need for fulfilment overrides all concern for modesty or restraint. In a totally conspicuous and uninhibited manner the pair are coupling under the attentive gaze of various beady-eyed worm-like biomorphs, who have assembled in order to 'observe' the performance.

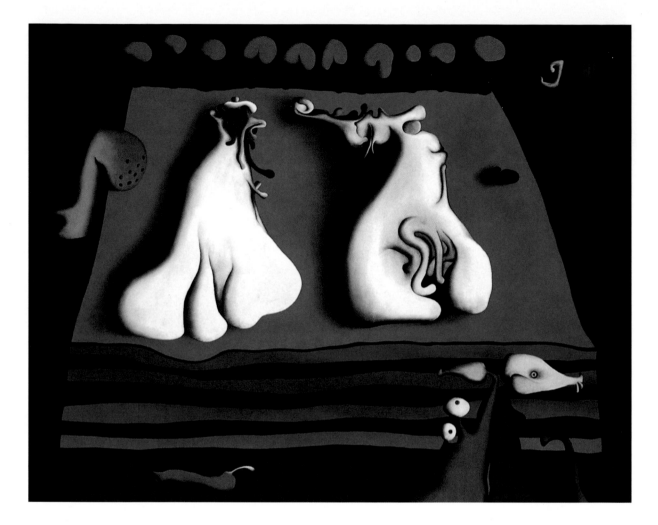

LOVERS' WHITE DREAMTIME
1973
Oil on canvas
24 × 30 in. (60 × 75 cm.)
Collection Mr and Mrs James
Vaughn Jnr, Texas

A 'Starred waxen-vain', from
Nehemiah Grew's book

In the world of the biomorphs the idea of copulation as spectacle extends, even, to the normally private domain of the conjugal bed. The two 'lovers' in *Lovers' White Dreamtime* (1973) lie side by side in apparent intimacy, and yet they are surrounded by a throng of spectators. One critic has remarked that 'upon the bed, they are specimens upon a laboratory table, open and scrutinized in harsh light'.[7] At the bedhead a row of stalked creatures, or fungi, have lined up in anticipation of the imminent spectacle. They appear to be swaying from side to side as they jostle for a better viewing position. Similarly captivated onlookers stand at either side and at the foot of the bed. On the left, one inquisitive bystander has gone so far as to encroach on to the lovers' mattress.

The predicament of the coupling pair in *The Sentinel* (see page 55) is no more private. Their somewhat sentimental petting gestures, not unlike kissing, seem to have captured the attention of the very landscape that surrounds them. As if impelled by a geological voyeurism, the brown rocks around the bed appear to be heaving up towards the recumbent figures. And the 'bed' itself is strikingly similar to a rock-like slab that Morris had seen in Nehemiah Grew's *Comparative Anatomy of Stomachs and Guts Begun*, referred to earlier, which he had discovered as a boy in the attic of the family

home in Wiltshire. On the right, the fluid rock formations have even extended upwards in order, it would seem, to gain a vantage point from which to view the mating spectacle.

Genitalia and sexual organs or attributes appear almost everywhere in Morris's biomorphic domain. For instance, most of the creatures in *Disturbance in the Colony* (1973) flaunt large udder-like swellings. As though to leave us in no doubt about the function of these organs, Morris has added a series of protuberances resembling teats. With these rudimentary reproductive attributes the biomorphs depicted are transformed into mammiferous beings – and scattered on the ground are a dozen or so objects in the guise of eggs. The downcast heads of some of the creatures could well be taken for the protective gaze of mothers towards their young.

Another example of sexual allusion appears in *Brown Figure II* (1985). The painting is dominated by a scrotum-like form enveloping two egg shapes. The obvious reference to male genitalia is further corroborated not only by some dark hair-like stands, which in other paintings have represented pubic hair, but also by an erectile stalk issuing from between the ovoid forms. As though ejaculating, its tip emits an upward jet of yellow fluid.

Testicles are given a prominent role in *The Presentation* (1976), where they are distinctively coloured and elevated on to a tall stalk – almost as if they were being put on display. And this attention-seeking is not ineffectual within the narrative of the painting: a queue of 'female' biomorphs is

DISTURBANCE IN THE
COLONY
1973
Oil on canvas
20 × 30 in. (50 × 75 cm.)
Collection Mr Edward Anixter,
Chicago

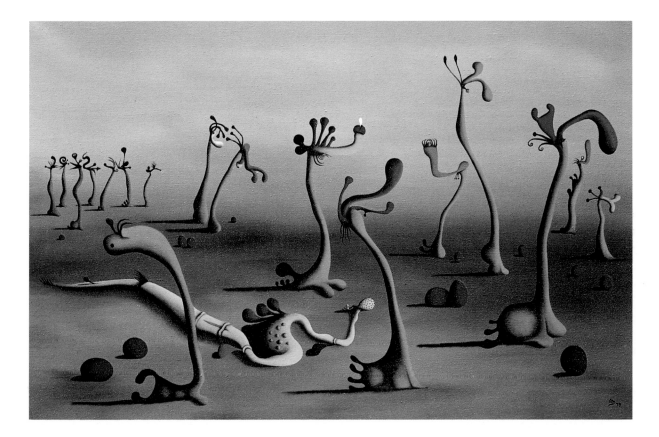

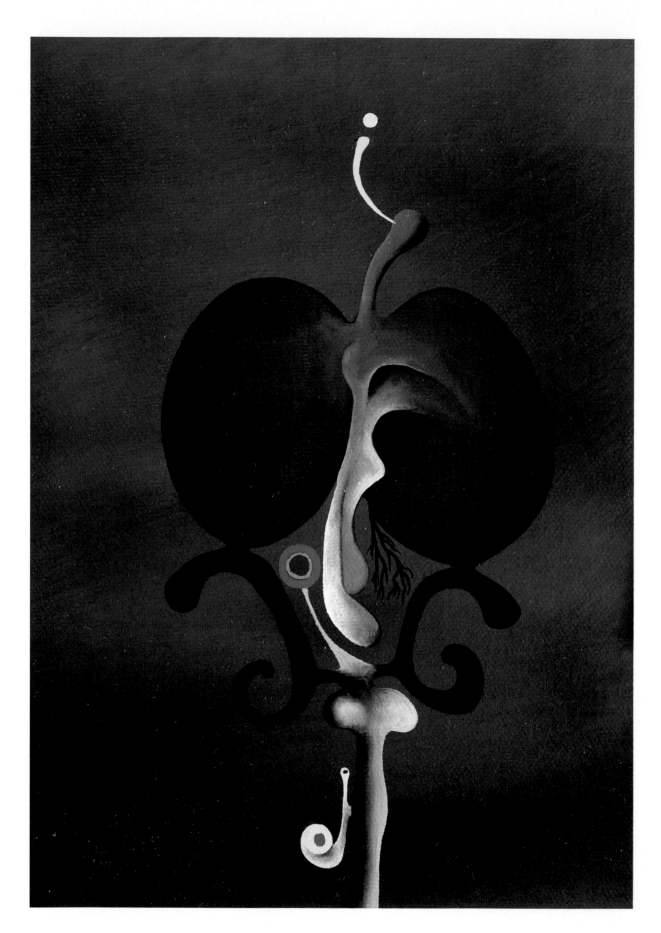

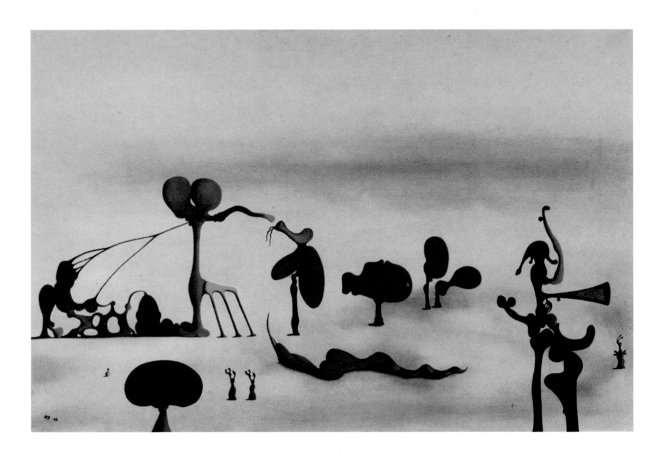

forming, and one is in the process of 'presenting' an orifice which is about to be penetrated by a long protuberance attached to the flamboyant testicles. This mating scenario also figures in *The Guardian of the Trap* (1973), in which the male offers a thorn-like spike to the attentive female. As in *The Presentation*, the testicles are represented as the principal subject of the painting: they are coloured a refulgent red and paraded on a stout 'pedestal' in the centre of the scene. Given the additional role of the genitalia as 'guardians' and, presumably, possessors of the bounteous catch of male genitalia-like forms in the web—trap, this is a statement of male dominance at its most assertive: bulging testicles are seen to preside over several submissive females and over a retinue of other acquiescent biomorphs as well as a valuable horde of captives, who struggle ineffectually in the elaborate 'trap'.

Male sexuality is even more forcefully implied by Morris's portrayal of the phallus itself. The notion of potency is strikingly conveyed by the arm-like members shown in *The Day after Yesterday* (1973), with their blatant rigidity and menacing potential. To the left, one biomorph swings a pair of penises around like a couple of truncheons, and in the foreground another biomorph lunges at a third with a penis. The phallus here is a vehicle of aggression and an assertion of dominance. *The Day after Yesterday* is an arena of male competitiveness. The more substantial figures stand their ground and offer mutual challenges. One stands solidly with splayed legs; two others are anchored by the weight of their swollen buttocks. The weaker and

THE PRESENTATION
1976
Oil on canvas
24 × 36 in. (60 × 90 cm.)
Edwin A. Ulrich
Museum of Art,
Wichita, Kansas

BROWN FIGURE II *(opposite)*
1985
Oil on board
10 × 7 in. (25 × 17.5 cm.)
Collection Mr Ron Crider,
San Francisco

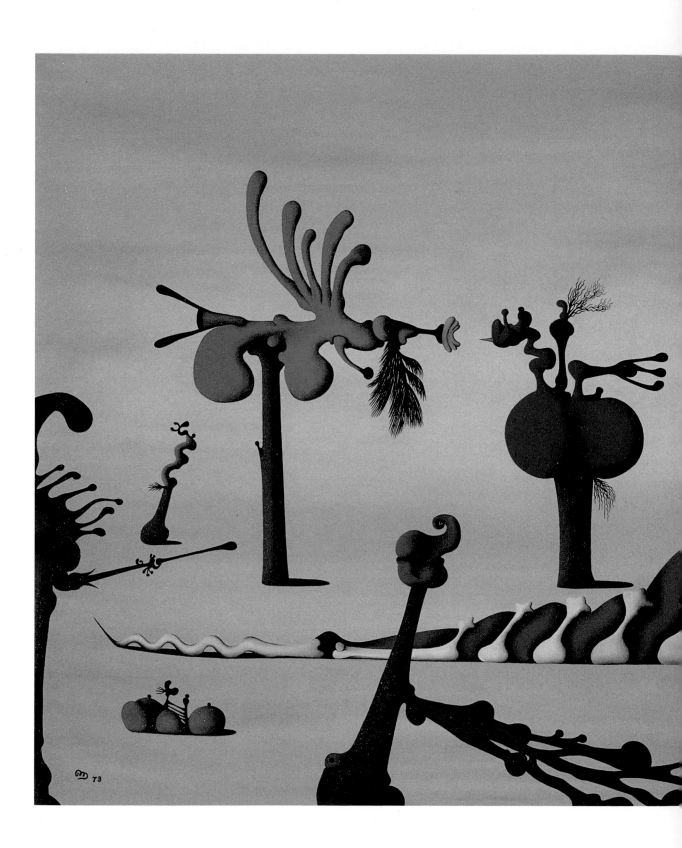

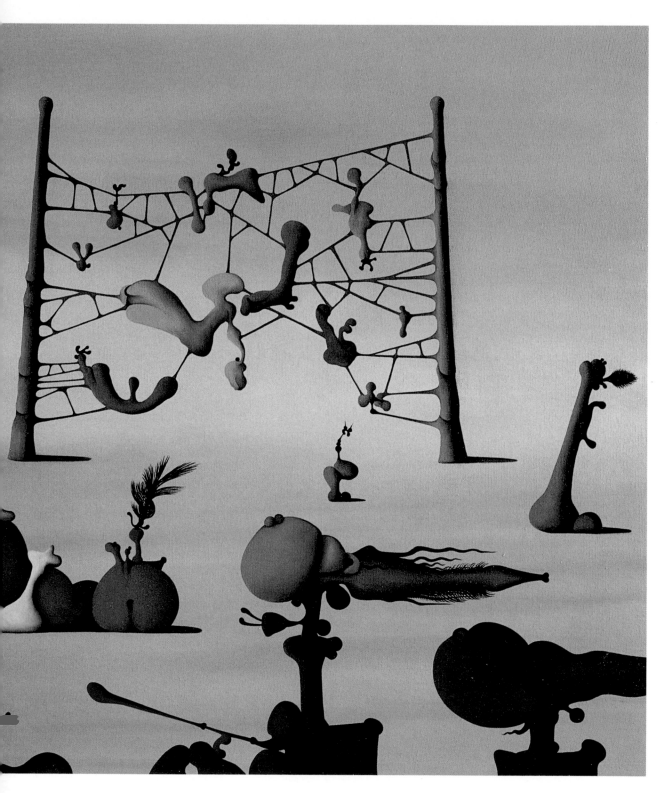

THE GUARDIAN OF THE TRAP
1973
Oil on canvas
20 × 36 in. (50 × 90 cm.)

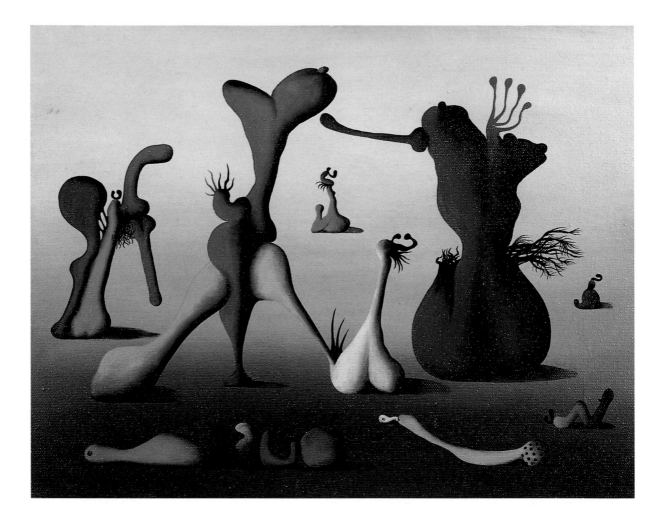

THE DAY AFTER YESTERDAY
1973
Oil on canvas
12 × 16 in. (30 × 40 cm.)
*Collection Mr. Damon de
Lazlo, London*

smaller ones, like the worm-like creature in the right of the right foreground, are forced to wriggle away in defeat.

A more organized kind of contest is depicted in *The Arena* (1976), in which two rivals confront each other. One is a tall, upright, phallic biomorph that stares down defiantly and appears poised to strike, like a snake attacking its prey. The other is a squat, double-headed penis that is waving its terminal bulges like boxing gloves. The combatants fixate on each other, displaying their potential with menacing bravado. It would not be difficult to imagine the duo exchanging verbal challenges and insults. All around, rows of lesser biomorphs are lined up in anticipation of the spectacle, which would appear to be imminent but for the intervention of the referee-like figure. The phallic aggressors are preparing for the fray.

Violence is not a trait of female sexuality in the world of the biomorphs. Indeed, it is in total contrast to the belligerence and pugnacity of male sexuality that Morris formulates his notion of biomorphic femaleness. The figures that possess vulva-like orifices and that can therefore be regarded as the female of the species consistently show a characteristic compliance and submissiveness. Female genitalia generally function as foils and complements to the more domineering male organs. For instance, as

opposed to the assertive competitiveness of her male counterparts, the 'female' figure in *The Sleepwalker* (1976) takes on a yielding posture. In total passivity and apparent subservience, she exposes her softer, vulnerable parts and offers, it would seem, a completely unguarded vulva. Her recumbent pose, too, contrasts with the invariable alert uprightness of the males. She is accessible, exposed and defenceless; her mood is indolent and relaxed. And the overall ambience created in this work, with its moonlit sky and suggestions of nocturnal repose, is one of tranquillity, serenity and languor.

Another indication of the desire to impose submissiveness on the female appears in *The Enclosure* (1957), in which a slender figure is incarcerated within an enclosure similar to the one depicted in *The Revolt of the Pets* (page 102). Like the passive animal captives, this virtually human female makes no effort to free herself. Instead, she stands sedately in front of her ogling audience. She is exhibiting her body as though offering it for the gratification of the supposedly male admirers, who appear riveted by the spectacle. More than any other, this work demonstrates that female sexuality, as depicted by Morris, is inextricable from the idea of the absence of contention, rivalry or aggression. It could be argued that this female submissiveness corresponds with the time-worn, although not always politically or morally palatable, desiderata of male fantasy. What is inescapable is that this approach generates an erotic assessment of femaleness.

The theme of male erotic fantasy could not be more explicit than in *The Middle-class Fantasy* (1949). Two naked female figures are engaged in some

THE SLEEPWALKER
(pages 148–149)
1976
Oil on canvas
24 × 36 in. (60 × 90 cm.)

THE ARENA
1976
Oil on canvas
24 × 36 in. (60 × 90 cm.)

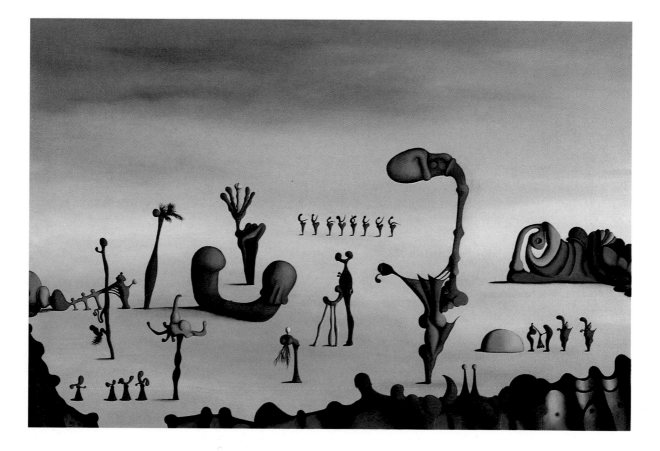

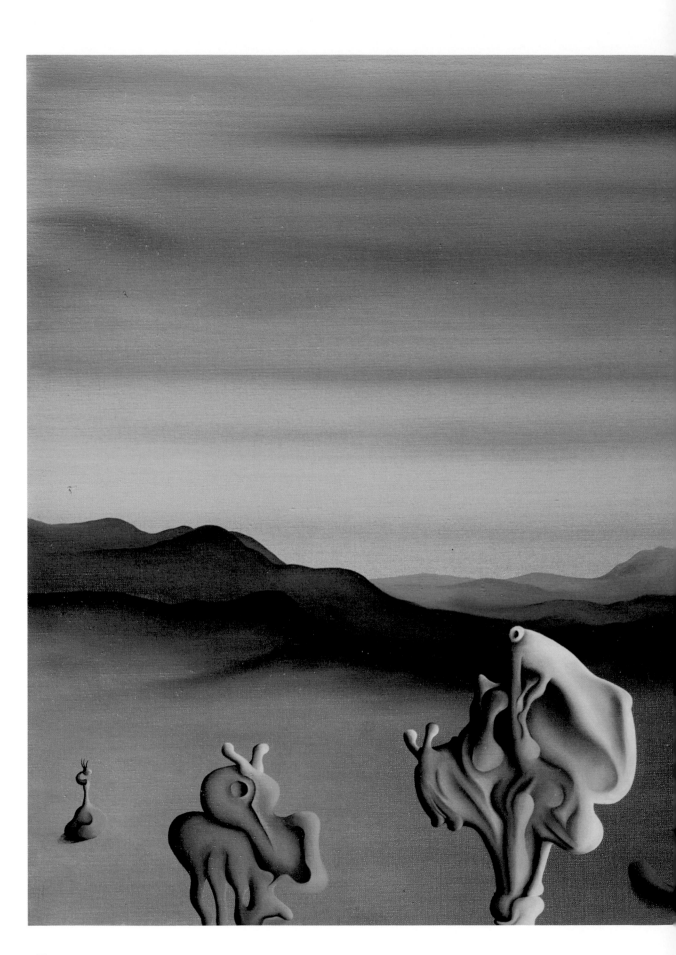

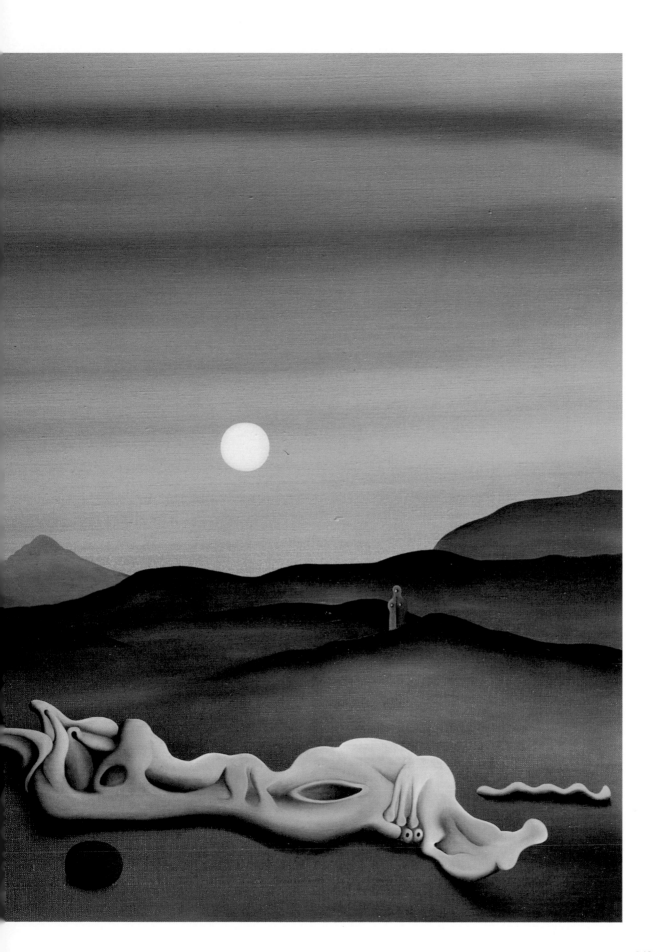

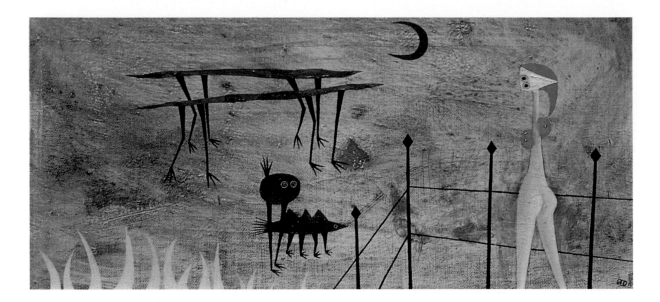

THE ENCLOSURE
1957
Oil on canvas
7 × 14 in. (17.5 × 35 cm.)
Collection Mr Stamatis
Moskey, Hampshire

sort of sexual game. One is lying on the ground, with arms and legs splayed, whilst the other performs a graceful ballet second position *en l'air*. It is as though the dancing figure is about to perform the splits and descend upon the naked torso of the supine one. Both figures display their sexuality to the full: the standing figure clearly displays her vulva, whilst the supine one opens her thighs so far that they almost form a right-angle to her torso. Both poses demonstrate a total lack of inhibition and an apparent revelling in lustful indulgence.

The sensuality of the female body is particularly stressed in the treatment of the lower figure. She has a luscious rounded midriff, a pair of bulging breasts and well formed thighs and calves. As though to emphasize the insistent focus on the body of this female, Morris omits her head. She is an object of desire, and no more. In an almost fetishistic manner, he concerns himself only with the features that are directly connected with sexual arousal. The pose adopted by the female on the ground suggests an invitation to sexual attentions – indeed, the pose is no less than an inducement to ravishment. Clearly, this painting evokes a multi-faceted male fantasy. In a practically literal manner it depicts two naked females exhibiting their genitalia. Above all, it depicts female sexual submissiveness. One of the ways in which Morris views this painting is as 'two females having an erotic relationship with each other'.

The display of female sexuality is the somewhat comical subject of *The Cabaret Message* (1949). Three figures pose on a podium in what appears to be the finale of a cabaret act. The two flanking figures appear to have various grotesque disabilities: the left-hand one leans on a strut to maintain its balance, while the one on the right sports artificial legs. But the central figure, daintily balancing on tiptoes on a rounded object, is suggestive of a prima ballerina. In an acrobatic gesture, she holds out her arms and raises one leg into the air. The style of representation is far from literal but there is a strong suggestion of exposed bodies and parading of sexuality. The central figure certainly appears to flaunt breasts and buttocks. Whatever the

THE MIDDLE-CLASS FANTASY
(opposite)
1949
Mixed media
13 × 8 in. (32.5 × 20 cm.)

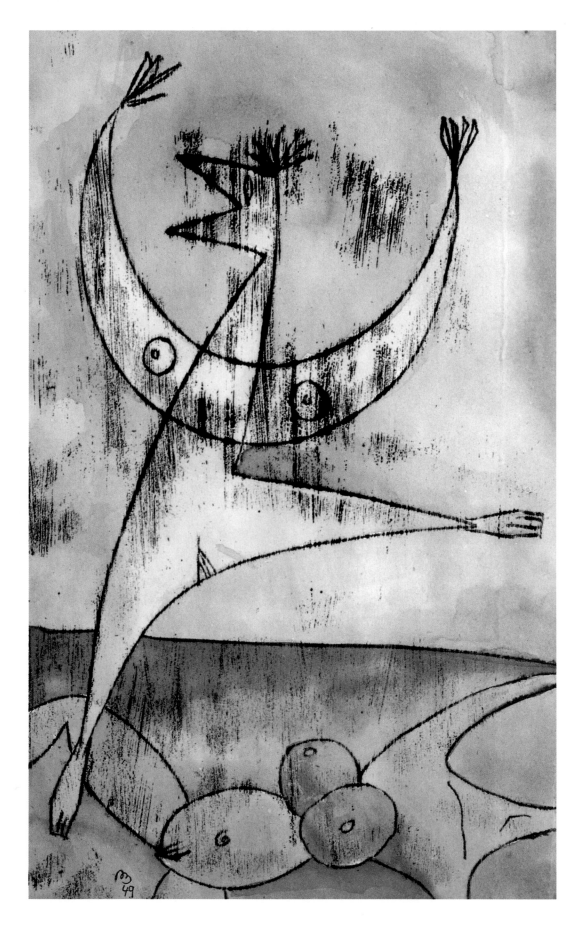

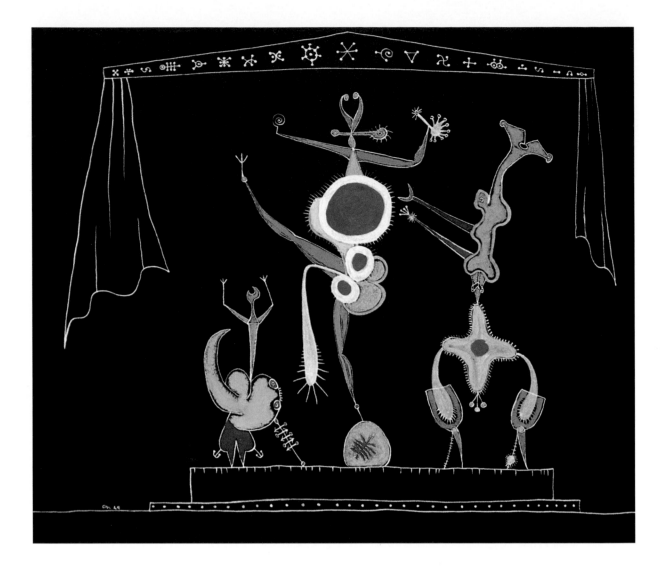

THE CABARET MESSAGE

1949

Ink and gouache on black paper

10 × 12 in. (25.5 × 30.5 cm.)

precise interpretation placed on the shapes depicted, the subject of this painting is undoubtedly that of staged erotic arousal.

Another 'staged' erotic display is the subject of the aptly titled *The Performers* (1957), in which five figures with obviously female attributes perform energetic movements. The figures are arranged in a row, like a chorus line of dancing-girls on a stage. Each is engaged in a different 'routine'. One has its legs crossed, indicating a model-like meander on a catwalk, whilst others dance and skip. One 'chorus girl' is performing a particularly strenuous splits-like movement. But what they have in common is that they are all acting in a sexually provocative manner. Their long, slender legs evoke an intense sensuality, and the poses adopted have implications that range from the erotic to the seductive. In one case, slightly parted labia are strongly suggested.

Perhaps the most blatant display of female nudity appears in *The Gymnastic Surprise* (1959). In the centre of what appears to be a room full of gymnastic apparatus, a female figure stands immodestly on a platform. Her pose is calculated to reveal her nakedness and sexuality to the full. Her

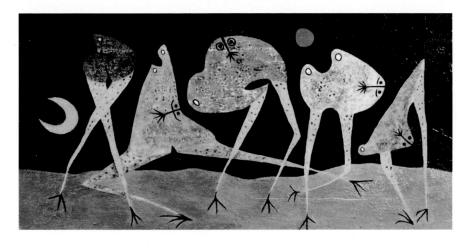

THE PERFORMERS
1957
Oil on canvas
7 × 14 in. (17.5 × 35 cm.)
Collection Lee Materia, Dallas,
Texas

right leg is raised to expose her genitals, and her arm is arched in the air in order to bare her breasts. The eroticism of this 'model' is powerful. Her long, slender legs, her bulging buttocks and her plump breasts evoke an extreme sensuality. Not surprisingly, the entourage of 'male' voyeuristic onlookers is depicted as very attentive. But what makes this *tableau vivant* particularly titillating is a long tapering horn protruding from the model's vulva. The eroticism of this appendage is twofold: it can be seen either as an allusion to a penetrating phallus, or as an exaggerated vagina. In both instances the implication is that of an outrageous, mesmerizing sexuality.

It can be said, then, that Morris's allusions to the human body are almost invariably accompanied by an accentuation of sexual potential. The works in which the erogenous areas are obviously being implied do not just depict

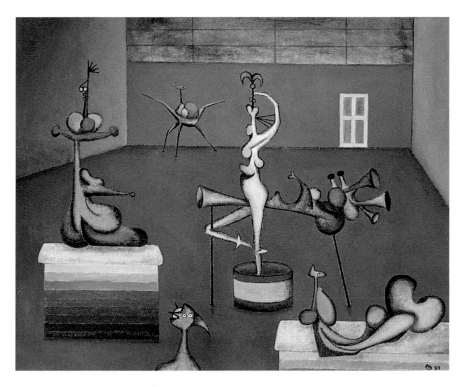

THE GYMNASTIC SURPRISE
1959
Oil on canvas
17 × 21 in. (42.5 × 52.5 cm.)
Collection Mr and Mrs Charles
Palfrey, East Barnet

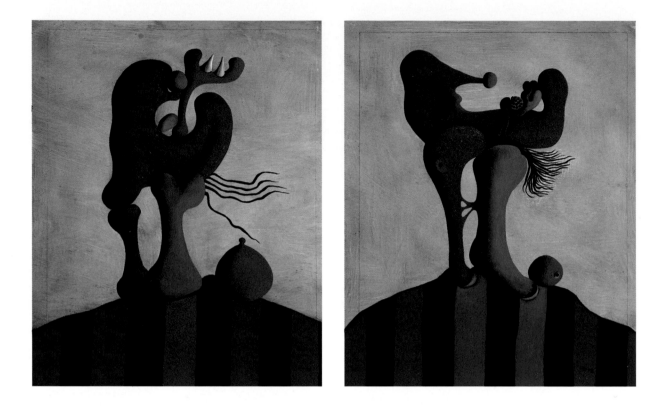

COUPLE. NO. I. (A)
(above, left)
1992
Oil on board
10 × 8 in. (25 × 20 cm.)
Collection Mr John Nadler,
London

COUPLE. NO. I. (B)
(above right)
1992
Oil on board
10 × 8 in. (25 × 20 cm.)
Collection Mr John Nadler,
London

creatures with sexual organs but, rather, create animated genitalia. In most cases the various suckers, glands, coagulated droplets, fleshy membranes and viscera take on the appearance of organs of procreation – and, in addition, they behave like sexual beings. Throughout Morris's work, not only are his slug-like entities, the biomorphs, likely to have progenitive functions, but they are frequently seen to be engaged in some kind of copulative or erotic activity. Clearly, if this degree of explicit and abundant eroticism can pass the test of the artist's self-imposed censorship, one can only begin to guess at what had so shocked him in the paintings that he destroyed in the 1950s.

8

Surrealism or Fantasy?

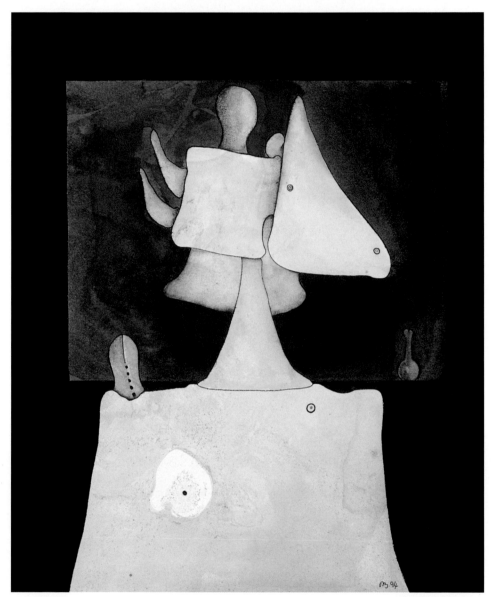

THE WINDOW-GAZER
1994
Mixed media
12 × 10 in. (30 × 25 cm.)

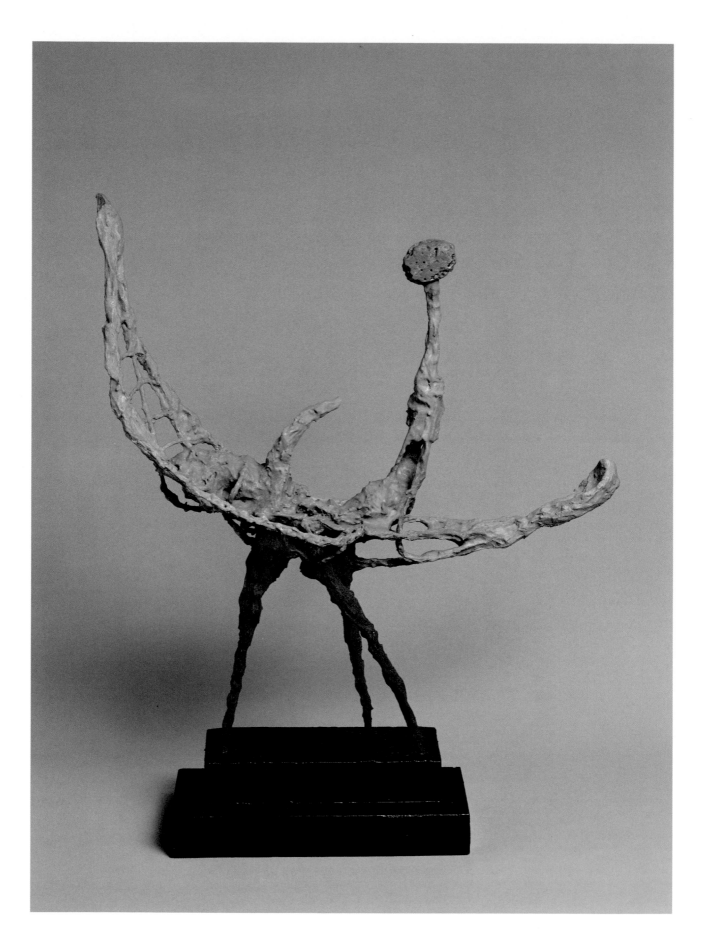

Surrealism or Fantasy?

M ICHEL REMY has highlighted the general difficulty of designating any painter a 'Surrealist'.[1] At the best of times this is 'a risky affair', he remarks. The problem is further accentuated in the case of Desmond Morris by the fact that he has always proceeded in his artistic endeavours in an introspective and solitary manner rather than participating in shared creativity and group ventures. He has never collaborated on creative work, nor has he ever added his signature to collective tracts or declarations.

To an extent, this has been the inevitable consequence of an accident of birth: by the time he was mature enough to make his contribution to the Surrealist quest, the movement in Britain was already losing its formal infrastructure. The year of his arrival in Birmingham, 1948, also marked the effective dissipation of group activity for the British Surrealists. What was to prove to be the final rallying of solidarity by The 'Surrealist Group in England' had been acted out and concluded during the previous year. In 1947 the Galerie Maeght in Paris had staged the exhibition 'Le Surréalisme en 1947', for which a group 'declaration' had been written by E.L.T. Mesens and Jacques Brunius and countersigned by John Banting, Robert Baxter, Emmy Bridgwater, F.-J. Brown, Feyyaz Fergar, Conroy Maddox, George Melly, Robert Melville, Roland Penrose, Edith Rimmington, Philip Sansom and Simon Watson Taylor.[2] Somewhat paradoxically, as events were to show, the declaration asserted that certain of the signatories had, in spite of a climate characterized by militarism, patriotism and censorship, kept the Surrealist flame burning brightly; and that the group was devoted to Surrealist principles, as stated by André Breton in his interview in *View*, his 'Prolegomena to a third manifesto', his 'Position of Surrealism between the wars' and by Benjamin Péret in his *Le Déshonneur des poètes*.[3]

As it turned out, the Surrealists in England were to show themselves incapable or unwilling to maintain any kind of productive cohesiveness. This

TRIPOD FIGURE *(opposite)*
1960
Painted wire and plaster.
Collection Eric Johnson,
California

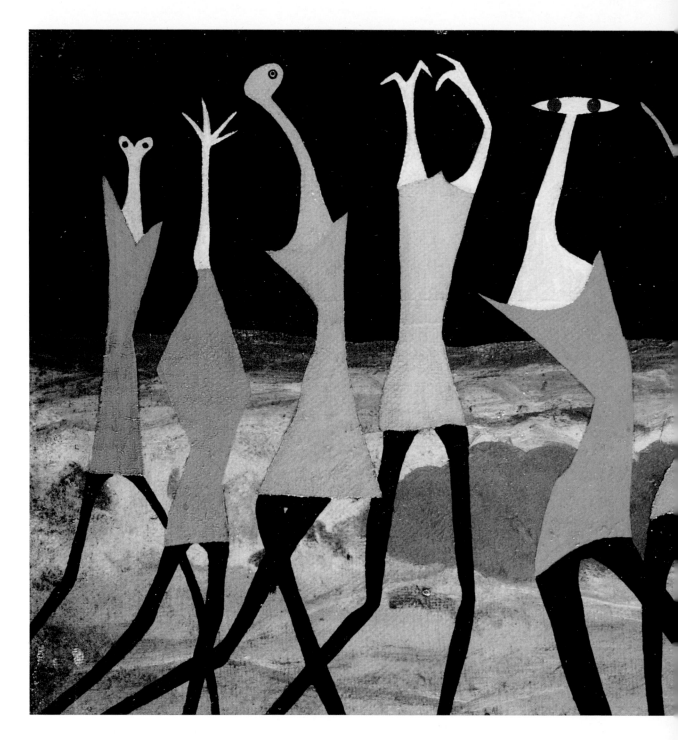

was, perhaps, not so surprising, since the 1947 exhibition had been the first occasion on which they had regrouped since 1945. John Banting, Edith Rimmington, Eileen Agar and Roland Penrose, for instance, who had attended Mesens's London meetings at the Barcelona Restaurant in the early 1940s, had abandoned communal activity by the latter half of the decade. The 'community of aims' had dwindled and there was, in effect, no meaningful grouping to which Morris could have given his allegiance.

What had, however, remained after 1947 was an informal circle focused on the Birmingham home of Conroy Maddox. There was no leader, as such,

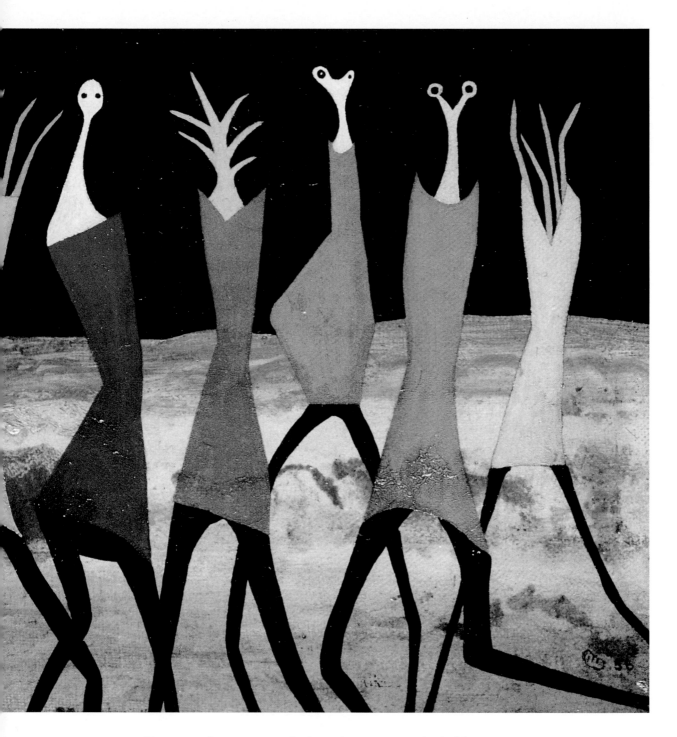

THE PARADE
1956
Oil on canvas
7 × 14 in. (17.5 × 35 cm.)
Collection Mr T.W.P.Herbert,
Caerleon, Gwent

to maintain a collective and consistent ideological position, and Maddox considered Morris as an equal rather than as a disciple. There was, as mentioned earlier, an assembly of like-minded people, such as William Gear, Emmy Bridgwater, Oscar Mellor, John Melville and Robert Melville. Eric Malthouse and the poet Henry Reed would make contact, but they were less closely related to the group. Often, George Melly, who was to work as an administrator at the London Gallery in the early 1950s, would come from London with Mick Mulligan and his band. Mesens, who had been the driving force behind the establishment of a Surrealist group in

London and had stipulated conditions for its membership in the early 1940s, now assumed a less prominent role. He never visited Maddox's home in Speedwell Road, but he did travel up from London occasionally to attend meetings with the group at the home of Robert Melville.

The fact remains that Morris, unlike Maddox, was never affiliated to an 'official' Surrealist group. Moreover, Morris might well have shunned regimented communal activity, had it existed, because he has always deplored the insistence on conformity – regardless of whether it is instigated in the cause of revolt – which the Surrealist movement has traditionally imposed on its official 'members'. He particularly distances himself, on principle, from any sort of political allegiance, an undertaking which, historically, has underpinned Surrealist affiliation:

> I strongly disapprove of the political activities of Surrealism because I hate all politicians and all politics. When some of the Surrealists became associated with communism I thought it ridiculous. Indeed, the fascinating thing about the history of Surrealism is that nearly every major Surrealist left the movement. One after the other they packed it in because the movement was dominated by André Breton, who was a very politically motivated man . . . In the end . . . to have a 'Surrealist group' is almost a contradiction in terms. Although Surrealists are not anarchists, they are anarchic and iconoclastic and, as such, they can hardly be docile members of a committee. Rather, they are individualists. The very nature of Surrealism is that it rebels against rules. The moment people have Surrealist 'rules' you have a contradiction in terms.

But while it cannot be said either that Desmond Morris was a member of a formal Surrealist group – since there was no organized group to which he could have belonged or from which he could have derived an official categorization as 'Surrealist' – or that he acquiesced even in the concept of an official Surrealist clique, he was, nevertheless, very much part of the informal grouping of Surrealists in Birmingham. He was drawn to Conroy Maddox's entourage and participated in its exhibitions; between 1949 and 1951 he took part in the the Birmingham Artists' Committee Invitation exhibitions. As mentioned earlier, in 1950 the London Gallery saw fit to exhibit his works simultaneously with those of Miró. Such was Morris's impact on the Birmingham circle that, even after some fifty years, Conroy Maddox has recalled with perfect clarity Morris's readings from his own poetic writings and his participation in discussions about Surrealist activity.

Moreover, Morris has tenaciously identified with Surrealist artists. Indeed, even from an early age his outlook çan be seen to be very compatible with the spirit of Surrealism. He has made no secret of his admiration for Joan Miró, one of the initiators of the Surrealist movement. 'There is only one person left,' he had said in 1993, with hindsight, 'for whom I can muster a little genuine hero-worship, and that is the Spanish painter Joan Miró.'[4] 'To me,' he later added, 'he is the greatest twentieth-century artist – I rate him above everyone because his imagery is full of all those fundamental passions.'

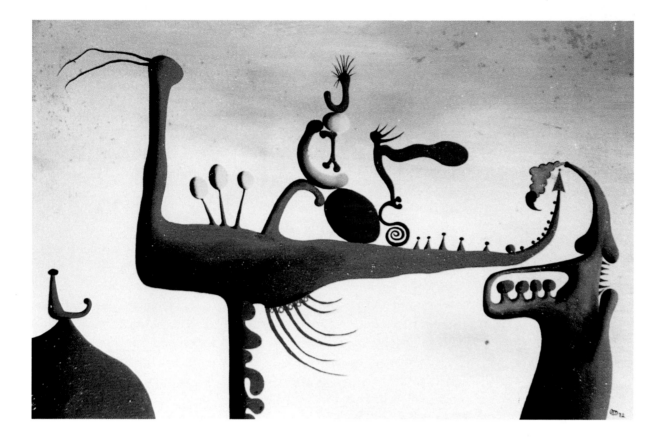

While still at school he had been deeply overwhelmed by the work of Max Ernst:

The Attentive Friend
1972
Oil on canvas
12 × 18 in. (30 × 45 cm.)

> Then I came across some Max Ernst. Immediately I discovered his work Í became obsessed by it and altered my style accordingly. I remember vividly the way in which the art teacher was horrified and tried to stop me. He told me that it was all rubbish and told me to tear up my work. That only strengthened my resolve.

It was primarily Ernst's writings that captivated the young Morris. As mentioned earlier, at the age of sixteen he had read Myfanwy Evans's partial translation of the German painter's 'Comment on force l'inspiration', originally published in the magazine *Le Surréalisme au service de la révolution* in 1933.[5] In this article he would have discovered that the Surrealists aimed at 'excluding all conscious directing of the mind (towards reason, taste or morals) as a primary means of evoking inspiration', and that it was through these 'automatic' means that they felt it was possible to reveal one's 'most secret desires'. The article went on to give accounts of the Surrealist object and the *cadavre exquis* (game of consequences), and of the techniques of '*dépaysement*' (contextual disorientation), collage, frottage and *grattage*, all of which were means of attaining an 'intensification of [Ernst's] visionary faculties' and 'true revelations based on *the chance meeting on a non-suitable plane of two mutually distant realities*'.

SURREALISM OR FANTASY?

The consequences of these dicta could not be more apparent in the direction that Morris's work was to take. Above all, Ernst's article extolled Surrealism for the fact that it 'has made it possible for painting to travel in seven league boots from Renoir's three apples, Manet's four sticks of asparagus, Derain's little chocolate women, and the cubist's [sic] tobacco packet'. In other words, the movement stood for iconoclasm and rebellion against convention. And it is clear that this spirit of revolt against tradition has underpinned all of Morris's artistic work and has virtually influenced his total outlook since his schooldays. According to Ernst, Surrealism's primary virtue was its essential rejection and transcendence of traditional art. He described Surrealism as having 'opened up a field of vision limited only by the mind's capacity for nervous excitement'. These concepts were espoused wholeheartedly by Morris. Not only does his work from the 1940s onwards display a consistent spurning of academic and conventional art, but he has repeatedly articulated his dislike of the so-called 'masters'. On several occasions he has proudly recounted an incident that demonstrates this disdain: 'I once bought a Gainsborough for a shilling. I considered it a good price because it had a good frame . . . My intolerance for representational art of any kind was total. I despised this particular leafy landscape as much as any other.'[6] He had even started to tear the water-colour in two.

Moreover, Morris's initial gravitation towards the Surrealist spirit is not attributable to his intellectual and artistic convictions alone. His rebellious frame of mind arose from a heartfelt disenchantment, as a teenager, with the

THE SEVEN SISTERS
1985
Oil on board
24 × 36 in. (60 × 90 cm.)

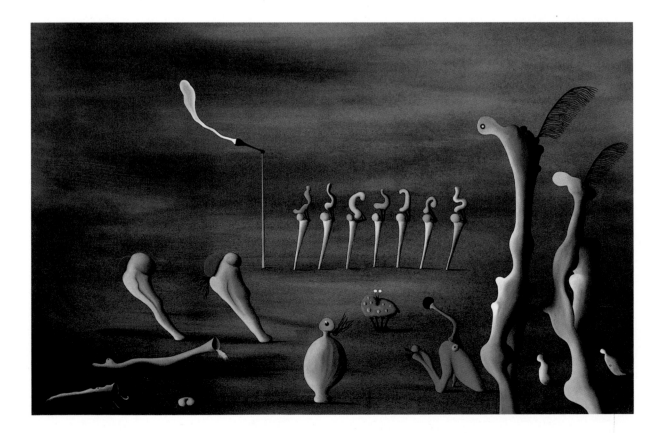

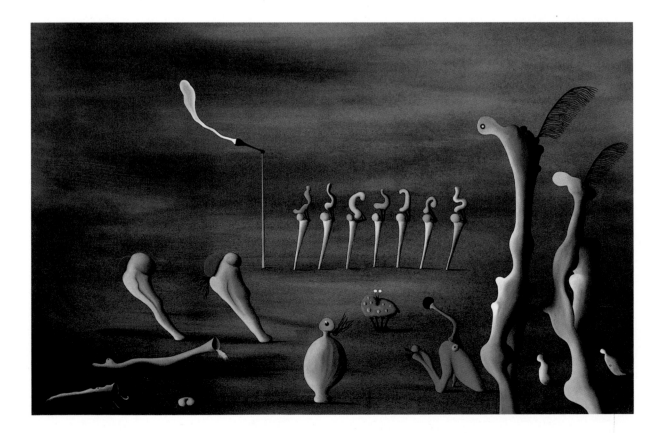

162

reality in which he found himself. At the age of sixteen, having watched his father die as a result of the 'inhumanity and senseless violence of the First World War', as he has put it, and having himself witnessed the equally horrific conflict of the Second World War, he found that he had an immediate and natural affinity with the Surrealists and their defiance of the beliefs and values of so-called civilized society. It was his situation and his reaction to it which drew him into the sphere of Surrealism in the first instance:

> It wasn't as though I had met a group of people, which is what usually happens with Surrealists. Most Surrealists got their strength from groups of other Surrealists. With me it was a solo operation. Without realizing it at the time, what had happened to my father, the stupidity of the politicians and the generals in the First World War, had made me angry, even though I did not articulate or analyse that anger. I came to hate the military, the political world and the religious world. So anyone who had authority in politics, the military or the Church became my enemy. I hated the Church and decided that religion was a complete sham . . . that all politicians were crooked, that politics was rotten, that the Church was rotten and that the species was in a pretty bad way. All I was seeing were preparations for an invasion and people with guns. There were bombs being dropped all around me. As a child I looked at this species and thought it abominable.
>
> All that put together produced a deep rebellion inside me and so, when I found a form of art which was rebellious, I gravitated straight towards it. I instantly felt in sympathy with the Surrealists. What I had not known at the time was that Surrealism and Dada grew out of a kind of disgust with what had happened in the First World War. Here was I, in the Second World War, recreating that disgust for myself and rediscovering it a generation later. What had triggered off the Surrealist movement was triggering me off.

Thus Morris regards his Surrealist motivation as analogous with a desire to rebel against convention and those who uphold it: 'I feel an affinity with the Surrealist movement because it defends the liberty of the artist. It encourages a personal subjective rebellion against the traditional attitudes of the establishment.'[7]

That the Surrealist concept of rebellion was never far from Morris's 'artistic' thinking is reflected in the shocking, violent and iconoclastic nature of his paintings. In *Disturbance in the Colony* (*see page 141*) the theme of rebellion actually becomes the subject. In this work each of the figures in a group is standing erect, with the exception of one, which is lying down. He regards this scenario as a comment on the response of society to nonconformity:

> Here is a colony: the creatures all conform, they all belong to the group. What is being conformed to is verticality, except in the case of one, which has gone horizontal. That has created a disturbance in the colony. It has upset the others and they are all slightly agitated. This painting is about the relationship between convention and rebellion against convention.

**DISTURBANCE IN THE
COLONY**
see page 141

SURREALISM OR FANTASY?

Acts of originality and divergence from the norm, he suggests, are seen as an affront to social convention. Such an affront dominates the social commentary implicit in his works, significantly revealing the latent desires of the unconscious mind in contrast with the actions of the mainstream consciousness.

But while Morris's initial impetus can certainly be attributed to the rejection and contestation of the accepted order of things – that is, to a genuinely Surrealist preoccupation – it could also be argued that the way in which that challenge against the establishment manifests itself may be dismissed as no more than fanciful escapism. In his writings he has, after all, referred to his work as 'my visual fantasies', a phrase that could well be taken to indicate an attitude centred on the frivolous, the capricious and the whimsical.[8] He has also written: 'I flee automatically to the fantastic and to the imaginary.'[9] The art critic Waldemar Januszczak has been severely dismissive of the biomorphic world as an expression of Surrealism.[10] It is only too easy, in other words, to construe Morris's work as no more than a form of aesthetic recreation. Morris himself has made the admission that 'anyone could be forgiven, seeing the public version of me, for saying that Surrealism is a sideline and a minor amusement for me'. What unfortunately appears to add fuel to this depreciating view is the content and execution of the works themselves. Their bright, playful colours and the generally jocular appearance of their subjects tend to prompt an initially whimsical response in the viewer. Their tenor is amusing, capricious and fanciful, which has prompted one commentator to describe his work as 'organic fantasies'.[11]

It cannot be doubted that playfulness is a major theme in Morris's work, but it does not follow that there is anything playful in the exploration of that theme. One critic has pointed out that 'his painting is not what you might think it to be – a sideline to keep the scientist amused. Desmond Morris is a serious artist'.[12] Indeed, for Morris there is nothing frivolous or whimsical about his artistic venture: he is insistent that 'it is a thing that I still wrestle with and a thing that I take most seriously'. It is also the case that for some leading Surrealists the theme of the mind at play has been a lifelong preoccupation. It would take only a brief consideration of the works of Joan Miró or of Yves Tanguy to realize that childlike imagery does not preclude a serious Surrealist intention. In fact, Morris has summed up the most significant achievements of twentieth century art as 'visual play'. For him, those artists who have made the greatest advances have done so essentially through the mechanism of play: 'Via cubism to total abstraction, the twentieth-century artist returned to the basic childhood game of playing with shapes and patterns and colours'.[13] Furthermore, he has written that: 'The table of Surrealism stands on four legs. The first we may call the poetry of chance; the second the joy of exaggeration; the third the shock of juxtaposition; and the fourth the invention of images.'[14] Not only is it with this fourth 'leg' that Morris identifies himself, but it is through it that he perceives his role in Surrealism. The noted Surrealist José Pierre does not hesitate to place Morris firmly within this camp:

THE BLIND WATCHMAKER

(opposite)

1986

Oil on canvas

30 × 24 in. (75 × 60 cm.)

Collection Eric Franck Gallery,

London

164

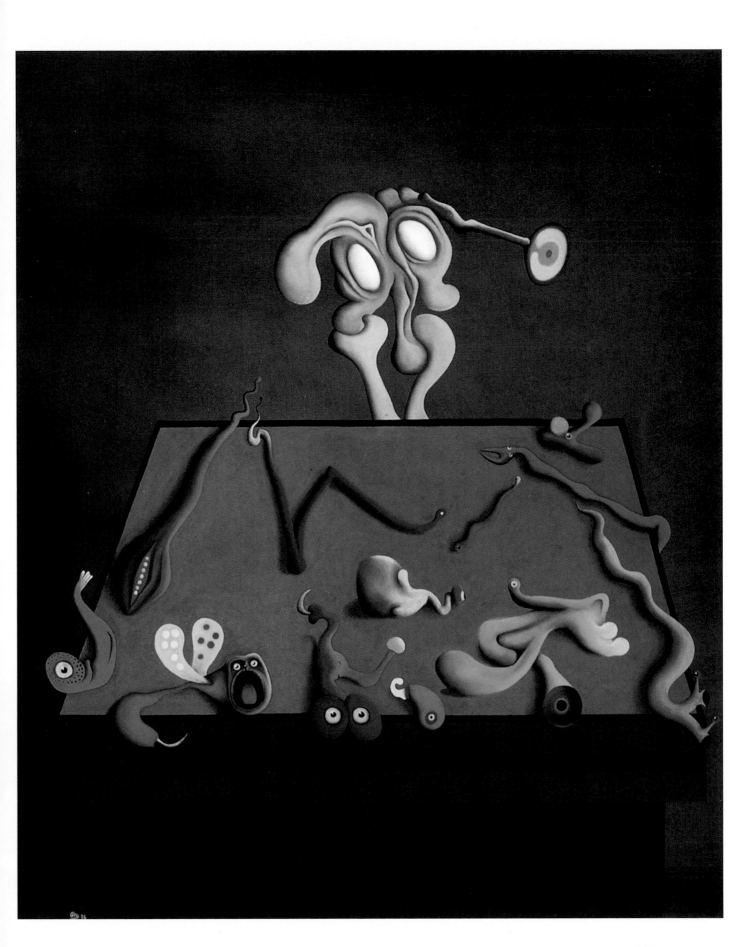

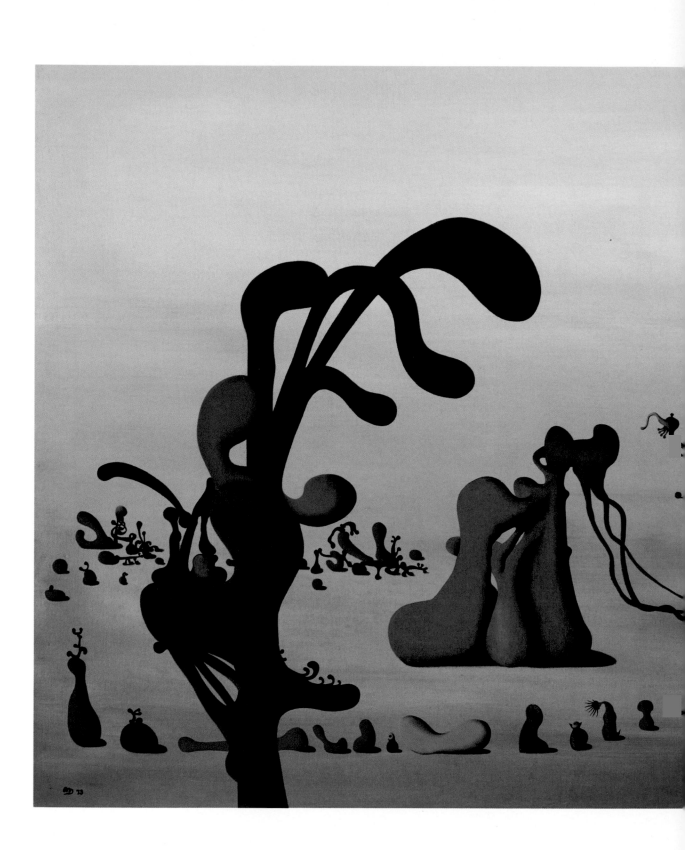

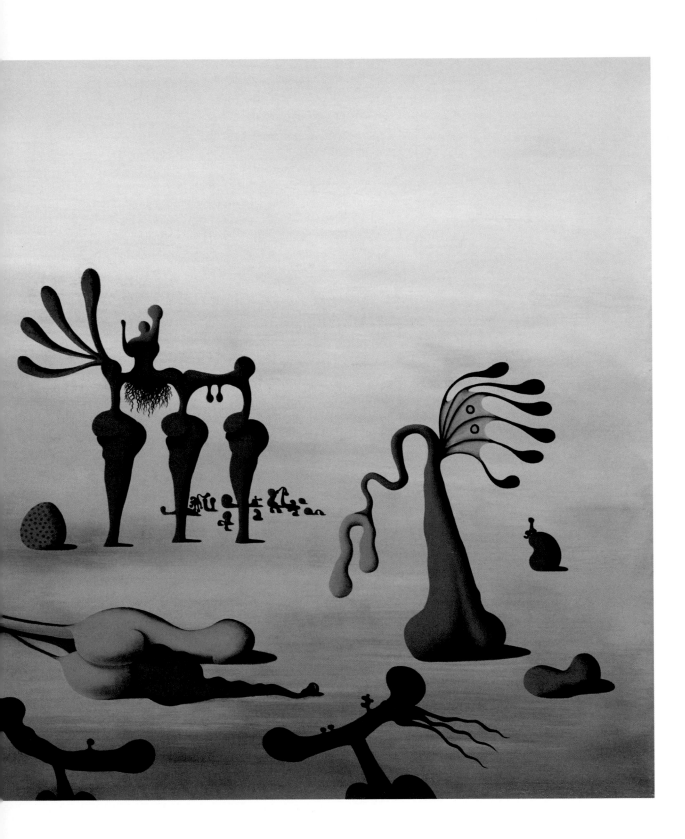

THE MOMENT OF PARTIAL TRUTH
1973
Oil on canvas. 20 × 36 in. (50 × 90 cm.)
Collection Mr Damon de Lazlo, London

SURREALISM
OR FANTASY?

If in poetry the surrealist movement was concerned with the very conception of language . . . in the pictorial and sculptural fields it often addressed itself to the birth of forms, including the most elementary and archaic beings . . . Not all surrealist painters emphasized these organic aspects – aspects that enabled the metaphoric evocation of processes such as fertilization, germination, hatching, burgeoning and metamorphosis. These aspects preoccupied only the most dynamic exponents of surrealism, those most oriented towards life and hope. Among them, as we well know, Hans Arp and Yves Tanguy celebrated this universe of births and embryonic forms all through their lives, influencing Max Ernst as much as Salvador Dalí, Picasso or Henry Moore, Miró or Arshile Gorky.

There is no doubt that Desmond Morris belongs to this same genre, and it is significant that E.L.T. Mesens chose to show his works alongside those of Joan Miró.[15]

In the same way as Miró, Tanguy and Arp, Morris can be said to employ a simplistic artistic vocabulary in order to generate images which launch a challenge against extant reality. This challenge is not a simple one, moreover, and materializes on various levels. In its rebuttal of the methods and content of formal painting it stands for a rejection of traditional art and academicism. 'Traditional art,' Morris has said, 'is in a coma and I doubt whether it will ever recover . . . I am delighted, and I drink to its assassins.'[16] It is significant that to this day he should recall with glee that his first exhibition in 1948 was greeted by public outcry and scandal in the local press. From his schooldays, it would seem, when his art master ordered him to tear up his work and throw it away, he has been bent on defying conventional aesthetics.

Above all, Morris's work represents a head-on confrontation with conventional morality. In direct contravention of traditional concepts of probity and good taste, he confronts us with our innermost psychological turmoils and insecurities. He fathoms the subconscious and dredges up the taboos and prohibitions which we strive to keep locked away. For that reason he has been described as 'the most disturbing of the English Surrealists'.[17] He regards his work as a reflexive and uncensored expression of latent thought: 'The act of painting is automatic, compulsive, an extension of one's visual worries and desires.'[18]

Leaving his scientific procedures and thinking far behind, Morris calls into question the security of external reality in order to delve into a dangerous interior automatism. His forays into our instinctive and primordial mind, into our untaught essence, make his work a communicating vessel which links us with the uncivilized, primeval ape that is within us all. When he states that he advocates 'totally irrational thought processes', he also means that he wants to bring us face to face with the instincts that remain when the superficial apparel of reason has been stripped away.[19]

Michel Remy has rightly identified Morris's 'attitude towards the representation of exclusively and purely interior models' with 'the fundamentals of surrealism as expounded by André Breton'.[20] In conformity

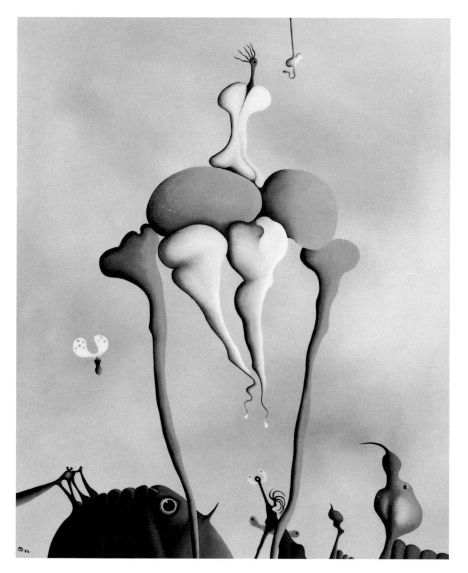

THE BIPEDAL SURPRISE
1986
Oil on canvas
22 × 18 in.(55 × 45 cm.)
*Collection Mr and Mrs Nathan
Shippee, New York*

with the axioms laid down by Breton in his inaugural speech at the International Surrealist Exhibition in London in June 1936, Remy insists, Morris's work confers 'greater freedom to instinctive impulses', and breaks down 'the barrier raised before civilized man, a barrier which the primitive and the child ignore'.[21] To that extent, his approach is said to be 'part and parcel of the Surrealist desire to explore the primitive forces that still inhabit the mind of man'.[22]

Desmond Morris's vision is Surrealist in the most fundamental of ways. In conformity with the primary aims of the movement, his venture is no less than a prospection of the elemental properties of the mind and, even, of the pre-cognitive brain. His work reveals thought in its raw state, in its rudimentary components – violence, lust, playfulness – and thereby divests our psyche of the paraphernalia of social conditioning and of the oppression of rationality. He lays bare the mind and shows it liberated from logical, critical and ethical preoccupations. As Mervyn Levy had predicted in the 1940s, the paintings of Desmond Morris have developed into a record of

SURREALISM OR FANTASY?

'the intangible kernel which is to be found within'.[23] What Morris, in effect, describes and explores in his paintings is a form of psychic automatism which exposes the true mechanisms of human thinking. In this way he challenges traditional knowledge and destabilizes the logic-based paradigm in terms of which we understand and make sense of the reality in which we find ourselves. Morris's lifelong enterprise both in painting and in his writings could not be better attuned to the key principles of Surrealism. André Breton had, after all, defined the movement and its methods in his *Manifesto of Surrealism* as 'pure psychic automatism through which it is intended to express, verbally, in writing or by any other means, the real functioning of thought . . . the dictation of thought, in the absence of all control exercised by reason, and beyond all aesthetic or moral concerns'.[24]

It is not surprising, therefore, that Conroy Maddox, who initiated and welcomed Desmond Morris into the realm of Surrealism, should have identified a persistence of the movement's objectives in the work of his former protégé. Looking back on over fifty years of painting, Maddox remarked that:

> Desmond Morris transforms the amorphous biological life-forms of the microscope and transposes their imagery into a jittery choreography of androgynous misfits that scratch and tease at the very fabric of reason and logic. By resolving the conflict between mental emancipation and logical control, he becomes inextricable from the great uncharted dream-world of Surrealism, which evokes all that is possible from an impossible world. Morris takes us on an amorous adventure between the obsessions of Hieronymus Bosch and the black humour of *Ubu Roi*.* There is no limit to what his vision can generate.[25]

There is no doubt, as Maddox advances, that Morris has created a vigorous and evolving universe out of which emblems and metaphors of our innermost passions have materialized. He has exposed our deepest terrors, obsessions and desires. He has explored the secret and enigmatic nether regions of the mind.

* Alfred Jarry, the author of *Ubu Roi*, was identified as 'Surrealist' in Breton's *Manifesto of Surrealism* (1924). Hieronymus Bosch was favoured and admired by the Surrealists because to them his work represented a counterpoise to the impact of classical art.

Footnotes

1 Zoologist or Artist?

1 Desmond Morris, *Animal Days* (Jonathan Cape, London: 1979), p. 5.
2 In Patricia Scanlan, 'Desmond Morris at home', *SuperReal. The British Journal of Surrealism*, no. 1 (October 1992), p. 48.
3 Morris, *Animal Days*, p. 25.
4 *Animal Days*, p. 25.
5 Gerald Howe, London: 1937.
6 *Le surréalisme au service de la révolution*, no. 6 (15 May 1933), pp. 43-5. Evans entitled her partial translation 'Inspiration to Order' (pp. 74-9).
7 In Michel Remy, *The Surrealist World of Desmond Morris* (Jonathan Cape, London: 1991), p. 11.
8 All unattributed citations are drawn from the author's interviews with Desmond Morris.
9 Morris, *Animal Days*, p. 32.
10 Remy, *The Surrealist World of Desmond Morris*, p. 50. The exhibition which Morris visited and which, contrary to its official duration, was kept open until September 1949 was 'Matta', Galerie René Drouin, Paris (10-31 May 1949).
11 Letter dated 27 December 1995 to the author.
12 In Remy, *The Surrealist World of Desmond Morris*, p. 14.
13 Morris, *Animal Days*, p. 170.
14 Don Bradshaw, 'The biological roots of art', *Modern Painters*, vol. 2, no. 1 (Spring 1989), p. 58.
15 Morris, *Animal Days*, p. 180.
16 Niko Tinbergen in *Desmond Morris* (Jonathan Cape, London: 1971).

2 Prospecting the Mind

1 Desmond Morris, *The Biology of Art* (Methuen, London: 1962), p. 151.
2 *The Biology of Art*, p. 164.
3 *The Biology of Art*, pp. 164-5.
4 *The Biology of Art*, p. 168.
5 Don Bradshaw, 'The biological roots of art', *Modern Painters*, vol. 2, no. 1 (Spring 1989), p. 55.

3 Creatures Called Biomorphs

1 Desmond Morris in catalogue of the exhibition 'Desmond Morris' (Stooshnoff Fine Art, London: 1974), p. 7.
2 Morris in catalogue of 'Desmond Morris', p. 7.
3 Morris in catalogue of 'Desmond Morris', p. 9.
4 Morris in Max Wykes-Joyce, *Some Notes on Desmond Morris – Explorer*, catalogue of the exhibition 'Desmond Morris, Recent Paintings' (Lasson Gallery, London: 1976).
5 Desmond Morris, *The Secret Surrealist. The Paintings of Desmond Morris* (Phaidon, Oxford, 1987), p. 17.
6 *The Secret Surrealist*, p. 53.
7 Morris in catalogue of 'Desmond Morris', p. 9.
8 Morris in catalogue of 'Desmond Morris', p. 1.
9 Morris in catalogue of 'Desmond Morris', p. 30.
10 Bonnie Barrett Stretch, 'Desmond Morris', *Art News* (New York), vol. 87, no. 7 (September 1988), p. 168.
11 Morris in catalogue of 'Desmond Morris', p. 20.
12 Mervyn Levy, 'Desmond Morris, the man and his work', BBC Radio talk (12 January 1948).
13 Mervyn Levy in catalogue of 'Desmond Morris', p. 36.

14 Morris in catalogue of 'Desmond Morris', p. 48.

4 The Black Dream-room

1 Desmond Morris, *The Secret Surrealist. The Paintings of Desmond Morris* (Phaidon, Oxford 1987), p. 92.
2 Patrick-Gilles Persin, 'Desmond Morris', *Cimaise. Present-day Art. Arts Actuels*, no. 210 (January-March 1991), p. 104.
3 Clare Henry, 'Desmond Morris: the secret surrealist', *Arts Review*, vol. 39, no. 20 (9 October 1987), p. 681.
4 In Gisèle Galante, 'Desmond Morris. "Notre espèce n'est pas faite pour maitriser le pouvoir"', *Paris Match* (21 March 1991), p. 34.

5 Playful Impulses

1 Desmond Morris, *The Secret Surrealist. The Paintings of Desmond Morris* (Phaidon, Oxford 1987), p. 93.
2 *The Secret Surrealist*, p. 14.
3 *The Secret Surrealist*, p. 17.
4 Michael Bartlet, 'Listening to Desmond Morris', *Envisage*, no. 5 (March 1977), p. 18.
5 Morris, *The Secret Surrealist*, p. 15.
6 In Mark Edwards, 'The world according to Desmond', *Sunday Times* (24 July 1994), p. 7.
7 In Michel Remy, *The Surrealist World of Desmond Morris* (Jonathan Cape, London: 1991), p. 14.
8 *The Surrealist World of Desmond Morris*, p. 64.
9 Desmond Morris, *Inrock* (Jonathan Cape, London: 1983), pp. 97—8.
10 *Inrock*, p. 197.
11 *Inrock*, p. 205.
12 *Inrock*, p. 177.
13 Desmond Morris in catalogue of the exhibition 'Desmond Morris' (Stooshnoff Fine Art, London: 1974), p. 48.
14 'Biomorphia', *Lycidas*, no. 2 (1973—4), p. 10.

6 Predatory Instincts

1 In conversation with the author in 1996.
2 Desmond Morris, *The Human Animal* (BBC Books, London: 1994), p. 77.
3 In Robin Dutt, 'The Surreal perspective. The Naked Ape man', *Lovely Jobly*, vol. 2, no. 2 (1991), p. 7.
4 'The Surreal perspective. The Naked Ape man', p. 7.
5 Desmond Morris, *The Naked Ape* (Vintage, London: 1994), p. 99.
6 Desmond Morris, *The Human Zoo* (Vintage, London: 1994), p. 24.
7 *The Human Zoo*, p. 24.
8 Desmond Morris, *The Secret Surrealist. The Paintings of Desmond Morris* (Phaidon, Oxford 1987), p. 11.
9 *The Secret Surrealist*, p. 13.
10 *The Secret Surrealist*, p. 13.
11 Desmond Morris, *Inrock* (Jonathan Cape, London: 1983), p. 27.
12 *Inrock*, p. 27.

7 Passionate Intimacy

1 Desmond Morris, 'Heroes and villains', *Independent Magazine* (3 April 1993), p. 46.
2 In Michel Remy, *The Surrealist World of Desmond Morris* (Jonathan Cape, London: 1991), p. 197.

3 Desmond Morris, 'Desmond Morris – private painter', *The Studio*, vol. 164, no. 833 (1962), p. 95.
4 Desmond Morris, *The Secret Surrealist. The Paintings of Desmond Morris* (Phaidon, Oxford 1987), p. 40.
5 Remy, *The Surrealist World of Desmond Morris*, p. 103.
6 Desmond Morris, *Inrock* (Jonathan Cape, London: 1983), pp. 64-5.
7 Lee Siegel, 'Desmond Morris' paintings', *Lycidas*, no. 2 (1973-4), p. 44.

8 Surrealism or Fantasy?

1 Michel Remy, *The Surrealist World of Desmond Morris* (Jonathan Cape, London: 1991), p. 16.
2 'Déclaration du groupe surréaliste en Angleterre', *Le Surréalisme en 1947* (Éditions Pierre à Feu, Paris: 1947), pp. 45-6.
3 Breton's interview in *View* was given in 1940. He wrote 'Prolégomènes à un troisième manifeste du surréalisme ou non' in 1942 and his 'Situation du surréalisme entre les deux guerres' was published in Paris by Fontaine in 1945. Péret wrote 'Le Dishonneur des poètes' in 1944.
4 Desmond Morris, 'Heroes and villains', *Independent Magazine* (3 April 1993), p. 46.
5 *Le Surréalisme au service de la révolution*, no. 6 (15 May 1933), pp. 43-5.
6 Desmond Morris, 'The day I nearly tore up a Gainsborough', *Observer Magazine* (3 October 1971), p. 40.
7 In Remy, *The Surrealist World of Desmond Morris*, p. 10.
8 Desmond Morris, 'The naked artist', *Observer Magazine* (10 October 1971), p. 24.
9 Morris, 'The day I nearly tore up a Gainsborough', p. 44.
10 In Judy Rumbold, 'Champ of the chimps', *Guardian* (25 July 1994), p. 9.
11 James Burr, 'Victor Pasmore/Desmond Morris', *Apollo* (July 1991), p. 61.
12 Megan Tresidder, 'The unconscious art of a manwatcher', *Sunday Telegraph* 'Sunday Review' (5 May 1991), p. III.
13 Morris, 'The naked artist', p. 24.
14 Desmond Morris, *The Secret Surrealist. The Paintings of Desmond Morris* (Phaidon, Oxford 1987), p. 17.
15 José Pierre, 'At the spring of life', in Remy, *The Surrealist World of Desmond Morris*, p. 7.
16 Morris, 'The naked artist', p. 22.
17 Burr, 'Victor Pasmore/Desmond Morris', p. 61.
18 Desmond Morris in catalogue of the exhibition 'Desmond Morris' (Stooshnoff Fine Art, London: 1974), p. 48.
19 Desmond Morris, 'Biomorphia', *Lycidas*, no. 2 (1973-4), p. 10.
20 Michel Remy, *The Surrealist World of Desmond Morris* (Jonathan Cape, London: 1991), p. 50.
21 Cited in Remy, *The Surrealist World of Desmond Morris*, p. 50.
22 *The Surrealist World of Desmond Morris*, p. 170.
23 Mervyn Levy, 'Desmond Morris, the man and his work', BBC Radio talk (12 January 1948).
24 André Breton, *Manifeste du surréalisme* (Sagittaire, Paris: 1924), reprinted in *Manifestes du surréalisme* (Gallimard, Paris: 1975), p. 37.
25 In a letter to the author.

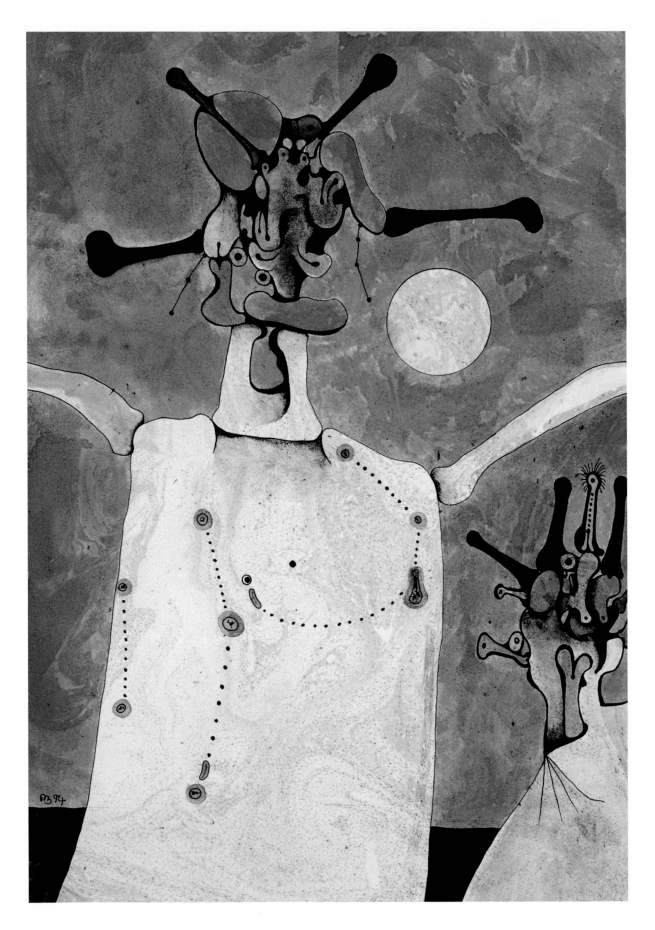

The exhibitions of Desmond Morris

1948 *Exhibition of works by Frans Baljon, John Eyles, Edward Kingan, Mervyn Levy, Desmond Morris, Walter Poole, Paul Rudall, Gilbert Speechley,* Swindon Public Library.

Contemporary Art Group, Swindon Public Library.

Artists Known and Unknown, Kingly Gallery, London.

Ryland Sketch Club Exhibition (group), West Bromwich Art Gallery.·

1949 *The Birmingham Artists' Committee Invitation Exhibition* (group), Royal Society of Birmingham Artists Galleries, Birmingham.

The Birmingham Artists' Committee Invitation Exhibition (group), Bilston Corporation Art Gallery.

1950 *Desmond Morris,* London Gallery, London.

1951 *The Birmingham Artists' Committee Invitation Exhibition* (group), Royal Society of Birmingham Artists Galleries, Birmingham.

Festival of Britain: Contemporary West Country Painting and Sculpture, Folk House, Bristol.

4ème Festival belge d'été: Les Tendances d'avant-garde dans la peinture britannique actuelle (group), Salle des Expositions, Knokke-le-Zoute, Belgium.

1952 *Desmond Morris, Geoffrey Clarke and Scottie Wilson,* New Gallery, Ashmolean Museum, Oxford.

1974 *Desmond Morris,* Stooshnoff Fine Art, London.

1976 *Desmond Morris: Recent Paintings,* Lasson Gallery, London.

Desmond Morris: Paintings of the 1950s and 1960s, Wolfson College, Oxford.

Desmond Morris, Quadrangle Gallery, Oxford.

Desmond Morris: Paintings 1946 to 1976, Swindon Art Gallery.

1978 *Desmond Morris,* Galerie D'eendt, Amsterdam.

Surrealism Unlimited (group), Camden Arts Centre, London.

THE ARBITERS OF ANXIETY *(opposite)*
1994
Mixed media 11½ × 8¼ in. (29 × 21 cm)

1982 *Les Enfants d'Alice: La Peinture surréaliste en Angleterre, 1930—1960* (group), Galerie 1900—2000, Paris.

1983 *Christmas Show* (group), Wylma Wayne Fine Art, London.

1985 *A Salute to British Surrealism, 1930—1950,* The Minories, Colchester.

A Salute to British Surrealism, 1930—1950, Blond Fine Art, London.

A Salute to British Surrealism, 1930—1950, Ferens Art Gallery, Hull.

1986 *Contrariwise: Surrealism and Britain, 1930—1986,* Glynn Vivian Art Gallery, Swansea.

Contrariwise: Surrealism and Britain, 1930—1986, Victoria Art Gallery, Bath.

1987 *Contrariwise: Surrealism and Britain, 1930—1986,* Polytechnic Gallery, Newcastle-upon-Tyne.

Contrariwise: Surrealism and Britain, 1930—1986, Mostyn Art Gallery, Llandudno.

Desmond Morris, Mayor Gallery, London.

British Season 1987 (group), Keats Gallery, Knokke-le-Zoute, Belgium.

The Day Book Picture Show (group), Smith's Galleries, London.

1988 *The Paintings of Desmond Morris,* Shippee Gallery, New York.

Desmond Morris, Keats Gallery, Knokke-le-Zoute, Belgium.

Ghent Art Fair (group), Ghent, Belgium.

The Avant-garde in Britain, 1910—1960, Fine Art Associates, London.

1989 *Desmond Morris: Works on Paper 1947—1988,* Mayor Gallery, London.

1990 *Surrealism: From Paris to New York,* Arnold Herstand and Company, New York.

Surrealism: A Permanent State of Lucidity (group), John Bonham, Murray Feely Fine Art, London.

Autumn Show (group), Louise Hallett Gallery, London.

Christmas Show, 1990 (group), John Bonham, Murray Feely Fine Art, London.

1991 *Desmond Morris*, Mayor Gallery, London.

The Birmingham Group, Seven Artists from the Birmingham Artists' Invitation Committee Exhibition, 1949, John Bonham, Murray Feely Fine Art, London.

Desmond Morris: Oeuvres surréalistes, Galerie Michèle Heyraud, Paris.

La Forme et ses symboles (group), Galerie Michèle Heyraud, Paris.

1992 *Desmond Morris: Écrivain – Zoologiste – Peintre*, Galerie Marie-Thérèse Wagner, Thionville.

British Surrealism, Mayor Gallery, London.

1993 *Desmond Morris: Paintings 1946—1993*, Swindon Museum and Art Gallery.

The Figure (group), Mayor Gallery, London.

Surrealism: Revolution by Night (group), National Gallery of Australia, Canberra.

Surrealism: Revolution by Night (group), Queensland Art Gallery, Brisbane.

Surrealism: Revolution by Night (group), Art Gallery of New South Wales, Sydney.

1994 *Desmond Morris: Paintings from the Sixties*, Mayor Gallery, London.

Surrealist Sculptures (group), Faggionato Fine Arts, London.

1995 *Real Surreal: British and European Surrealism*, Wolverhampton Art Gallery and Museum.

1996 *Desmond Morris, 50 Years of Surrealism*, City Museum and Art Gallery, Stoke-on-Trent.

Desmond Morris, 50 Years of Surrealism, Woolerton Hall, Nottingham.

Dada and Surrealist Bouqet (group), Mayor Gallery, London

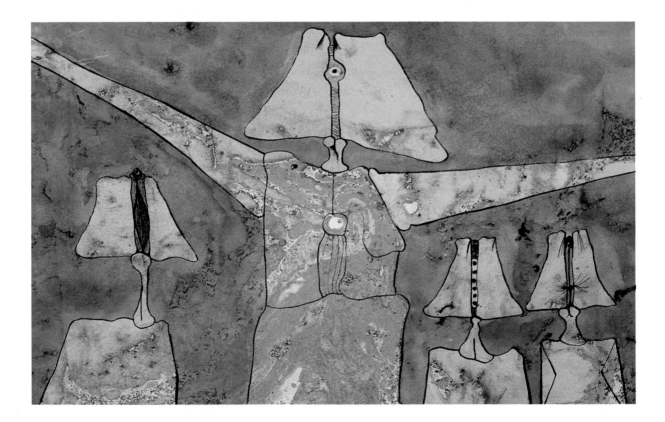

THE OLD DILEMMA

1988

Mixed media

8 × 13 in. (20 × 32.5 cm.)

Books by Desmond Morris

The Reproductive Behaviour of the Ten-spined Stickleback (Brill, Leiden: 1958).

The Story of Congo (Batsford, London: 1958).

The International Zoo Yearbook I, co-editor with Caroline Jarvis (Zoological Society of London: 1959).

The International Zoo Yearbook II, co-editor with Caroline Jarvis (Zoological Society of London: 1960).

Introducing Curious Creatures (Spring Books, London: 1961).

The International Zoo Yearbook III, co-editor with Caroline Jarvis (Zoological Society of London: 1961).

The Biology of Art (Methuen, London: 1962).

The International Zoo Yearbook IV, co-editor with Caroline Jarvis (Zoological Society of London: 1962).

Apes and Monkeys (Bodley Head, London: 1964).

The Big Cats (Bodley Head, London: 1965).

The Mammals: A Guide to the Living Species (Hodder & Stoughton, London: 1965).

Men and Snakes, with Ramona Morris (Hutchinson, London: 1965).

Men and Pandas, with Ramona Morris (Hutchinson, London: 1966).

Zootime (Rupert Hart-Davis, London: 1966).

Men and Apes, with Ramona Morris (Hutchinson, London: 1966).

The Naked Ape (Cape, London: 1967).

Primate Ethology, editor (Weidenfeld & Nicolson, London: 1967).

The Human Zoo (Cape, London: 1969).

Patterns of Reproductive Behaviour (Cape, London: 1970).

Intimate Behaviour (Cape, London: 1971).

Manwatching: A Field-guide to Human Behaviour (Cape, London: 1977).

Gestures: Their Origins and Distribution, with Peter Collett, Peter Marsh and Marie O'Shaughnessy (Cape, London: 1979).

Animal Days (Cape, London: 1979).

The Soccer Tribe (Cape, London: 1981).

The Giant Panda, with Ramona Morris and Jonathan Barzdo (Kogan Page, London: 1981).

Inrock (Cape, London: 1983).

The Book of Ages (Cape, London: 1983).

The Art of Ancient Cyprus (Phaidon, Oxford: 1985).

Bodywatching: A Field-guide to the Human Species (Cape, London: 1985).

Dogwatching (Cape, London: 1986).

Catwatching (Cape, London: 1986).

The Illustrated Naked Ape (Cape, London: 1986).

Catlore (Cape, London: 1987).

Horsewatching (Cape, London: 1988).

The Animals Roadshow (Cape, London: 1988).

The Human Nestbuilders (Crown, Darwin: 1988).

Animalwatching (Cape, London: 1990).

The Animal Contract (Virgin Books, London: 1990).

Babywatching (Cape, London: 1991).

Christmas Watching (Cape, London: 1992).

The World of Animals (Cape, London: 1993).

The Human Animal (BBC Books, London: 1994).

Bodytalk: A World Guide to Gestures (Cape, London; Crown, New York: 1994).

The Naked Ape Trilogy (Cape, London: 1994).

Illustrated Catwatching (Ebury, London: 1994).

Illustrated Babywatching (Ebury, London: 1995).

Illustrated Dogwatching (Ebury, London: 1996).

Catworld (Ebury, London: 1996)

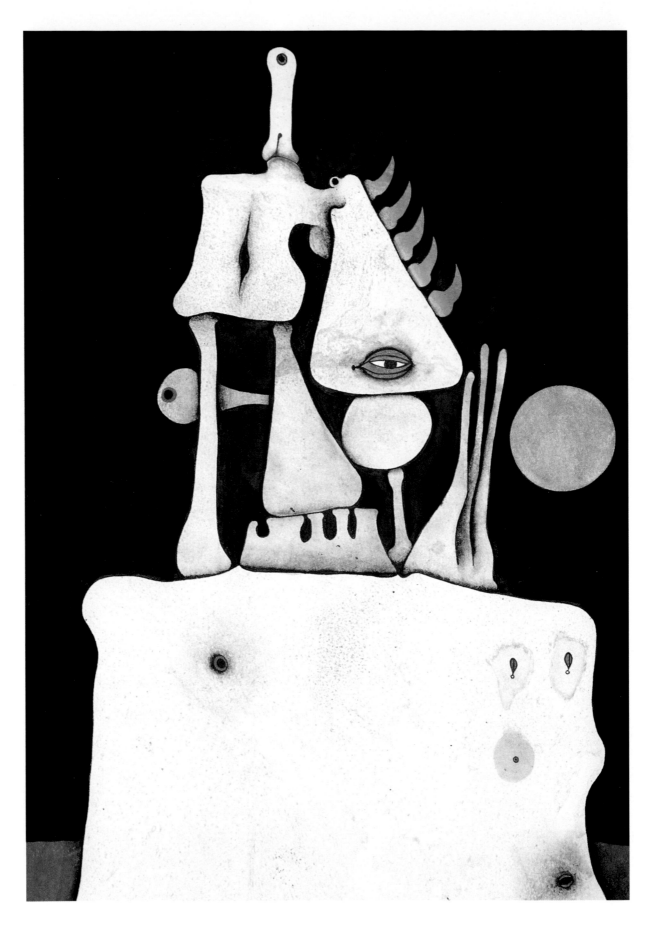

Books, articles and films on Desmond Morris

Anon, 'Author, broadcaster and zoologist', *Advertiser* (Stoke-on-Trent) (20 June 1996), p.5.
— *Desmond Morris* (London, Jonathan Cape: 1971), no pagination.
— 'Desmond Morris. Animal expert's paintings on view at London gallery', *Hello!*, no. 153 (18 May 1991), p.29.
— 'Desmond Morris – Fifty Years of Surrealism', *Sentinel* (Stoke-on-Trent) (22 June 1996), p.18.
— 'Desmond Morris turns his back on monkeys', *Modern Painters*, vol. 9, no. 2 (Summer 1996), p.89.
—'Experiment in Surrealism', *Mini-Cinema 5*, no.6 (March 1951).
— 'The Green Sprite. Desmond Morris, Surrealist at Stoke-on-Trent Museum', *What's On. Birmingham and Central England*, no. 481 (15-28 June 1996), front cover.
— 'The lesser-known side of Britain's best-known animal – and people – watcher', *Independent on Sunday* (21 April 1991), p.30.
— 'London art scene: recent paintings by Desmond Morris', *London Weekly Diary* (7 November 1976), p.31.
— 'Meet the naked biomorph', *Oxford Times* (25 September 1987), p.15.
— 'Painting pundit', *Sunday Telegraph Magazine* (24 October 1976), p.9.
— 'Paintings of Desmond Morris', *Antiques and the Arts Weekly* (New York) (20 May 1988).—
— 'Surrealism appears to be', *Art Review*, vol.48 (June 1996), p.67
— 'Unknown Desmond', *Sentinel* (Stoke-on-Trent) (17 June 1996), p.9.

Bartlet, Michael, 'Listening to Desmond Morris', *Envisage*, no. 5 (March 1977), pp.18-9.
Billen, Andrew, 'Chimps with everything', *The Observer Review* (20 October 1996), p.5.
Bird, Bob, 'Surrealist sensation on show', *Sentinel* (Stoke-on-Trent) (24 June 1996), p.13.
Brisset, Pierre, [Galerie Michèle Heyraud exhibition, Paris], *Oeil*, No. 428 (March 1991), p.69.
Burr, James, 'A cultural injection', *Apollo* (February 1990), pp.126-8.
— 'Victor Pasmore/Desmond Morris', *Apollo* (July 1991), p.61.

Conaghan, Dan, 'Surreal thing', *Tatler* (May 1991), p.30.
Cook, Tim, 'The art of my life', *Evening Advertiser* (Swindon) (6 November 1976), 'Weekender', p.1

D.S., 'Surrealist film wins award for Swindon amateur', *Evening Advertiser* (Swindon) (19 March 1951), p.4.
Dutt, Robin, 'Secrets of a Swindon Surrealist', *Independent* (16 September 1987), p.29.

THE EXPERIMENTER *(opposite)*

1994

Mixed media

11½ × 8¼ in. (29 × 21 cm)

— 'The secret Surrealist', *London Portrait* (May 1991), pp.84-5.
— 'The Surreal perspective. The Naked Ape man. An interview with Desmond Morris by Robin Dutt', *Lovely Jobly*, vol. 2, no. 2 (1991), pp.7, 14.

Edwards, Mark, 'The world according to Desmond', *Sunday Times* (24 July 1994), pp.6—7.

Freak, Dave, 'Desmond Morris: Fifty Years of Surrealism', *What's On. Birmingham and Central England*, no.481 (15-28 June 1996), p.31.

Galante, G, 'Desmond Morris. "Notre espèce n'est pas faite pour maîtirser le pouvoir"', *Paris Match* (21 March 1991), pp.32-4.
Grimley, Terry, 'Seven turn Surrealist in the City Kardomah', *Birmingham Post* 'Weekend' (15 June 1991), pp.8-9.

Henry, Clare, 'A naked ape bares his soul on canvas', *Glasgow Herald* (22 September 1987), p.4.
— 'Desmond Morris: the secret Surrealist', *Arts Review*, vol.39, no.20 (9 October 1987), pp.680-81.
Hopkins, J. Christian, 'Late success as Surrealist artist. Pleasant surprise to noted author', *The Day* (New London, Conn.) (30 April 1988).
Hughes, Graham, 'The Surrealist world of Desmond Morris', *Arts Review*, vol.43, no.8 (19 April 1991), p.198.
Hughes, Patrick, 'Two English Surrealists', *Review*, BBC2 (10 October 1987).

Jaguer, Edouard, 'Né en 1928, Desmond Morris...' catalogue of exhibition 'Les Enfants d'Alice'. La Peinture Surréaliste en Angleterre, 1930-1960 (Galerie 1900-2000, Paris: Spring 1982), p.72.

Kaufman, Jason Edward, '"The naked artist": secret Surrealist Desmond Morris', *New York City Tribune* (5 May 1988), pp. 10, 14-15.
Kerr, David, 'The Surreal world of Desmond Morris', *Plus Magazine*, no. 18 (March 1989), pp.14-15.

Levy, Mervyn, 'Desmond Morris, the man and his work', BBC Radio talk (12 January 1948).
Levy, Mervyn, and Morris, Desmond, 'Desmond Morris – private painter', *The Studio*, vol.164, no.833 (1962), pp. 94-7.
Levy, Silvano, *Desmond Morris: 50 Years of Surrealism* (City Museum and Art Gallery, Stoke-on-Trent: 1996).

McKee, Victoria, 'Science for art's sake', *Birmingham Magazine*, no.6 (September 1994), pp.18-20.
McKerron, Jane and Morris, Desmond, 'A day in the life of Desmond Morris', *Sunday Times Magazine* (30 April 1978), p.94.
Melly, George, 'The naked mantis', *Modern Painters*, vol.4, no.2 (1991), pp.104-5.
Morris, Desmond, 'The Day the Animals Came', *Mermaid*, vol.17, no.2 (Spring 1951), pp.31-2.
— 'The day I nearly tore up a Gainsborough', *Observer Magazine* (3 October 1971), pp.40-6.

— 'The naked artist', *Observer Magazine* (10 October 1971), pp.23-4, 27.

— 'Biomorphia', *Lycidas*, no. 2 (1973-4), pp.10-11.

— 'Heroes and villains. Desmond Morris on his hero Joan Miró', *Independent Magazine* (3 April 1993), p.46.

— 'The artist's eye', *Art Review*, vol.46 (June 1994), p.40.

Morris, Desmond, and Oakes, Philip, *The Secret Surrealist. The Paintings of Desmond Morris* (Phaidon, Oxford: 1987).

Morris, Maria, 'The naked painter', *Oxford Star* (24 September 1987), p.6.

Norman, Geraldine, 'Zoologist explores a Surreal world', *Independent* (28 May 1991), p.2.

Oakes, Philip, 'In among the biomorphs', *Sunday Times* (26 August 1973), p.27.

— 'Pitched battles in the ultimate field study', *The Times* (24 September 1981), p.7.

Persin, Patrick-Gilles, 'Desmond Morris', *Cimaise. Present-day Art. Arts Actuels*, no. 210 (January-March 1991), pp.103-4.

Remy, Michel, 'One of the present witnesses of British Surrealism...' catalogue of the exhibition 'Les Enfants d'Alice': Peinture Surréaliste en Angleterre, 1930-1960 (Galerie 1900-2000, Paris: Spring 1982), p.72.

— *The Surrealist World of Desmond Morris* (Jonathan Cape, London: 1991).

Rey, Stéphanie, 'Morris, Rops, Delporte, Dubuffet', *L'Echo de la Bourse* (22-25 July 1988), p.19.

Root-Bernstein, 'Art, Imagination and the Scientist', *American Scientist*, vol. 85, no.1 (January-February 1997), pp.6-9.

Rumbold, Judy, 'Champ of the chimps', *Guardian* (25 July 1994), Supplement, pp.8—9.

Sadler, Rosalin, 'Love on a slab. The Surrealist world of Desmond Morris', *Sunday Times* (23 June 1991), Section 6, p.10.

Scanlan, Patricia, 'Desmond Morris at home', *SuperReal. The British Journal of Surrealism*, no.1 (October 1992), pp.45—51.

Shrank, Cathy, 'Need to know. The questions you really want to ask Desmond Morris author, anthropologist and Surrealist painter', *Sunday Telegraph Magazine* (16 June 1996), p.45.

Siegel, Lee, 'Desmond Morris' paintings', *Lycidas*, no.2 (1973—4), pp. 43-4.

Stretch, Bonnie Barrett, 'Desmond Morris' *Art News* (New York), Vol. 87, No. 7 (September 1988), p. 168.

Sturt-Penrose, Barrie, 'Desmond Morris-profile', *Arts Review* Vol. 18, no. 25 (24 December 1966), pp. 570—5.

Taylor, John Russell, 'Romanticism haunting still', *The Times* (6 October 1987), p.13.

Tressider, Megan, 'The unconscious art of a manwatcher', *Sunday Telegraph* 'Sunday Review' (5 May 1991), p.III.

Weaver, Shelley, 'Beasts in the basement', *TV Times* (1—7 March 1964), pp.4—5.

Winship, Frederick M., "Author Desmond Morris also excels as artist', *UPI* (New York) (3 June 1988).

Wykes-Jones, Max, 'Images of an era', *Antique Dealer and Collectors' Guide* (October 1976), p.96.

—*Some Notes on Desmond Morris - Explorer*, catalogue of the exhibition 'Desmond Morris, Recent Paintings' (Lasson Gallery, London: 27 October—12 November 1976), no pagination.

RECLINING NUDE

1948

Oil on canvas

15 × 30 in. (37.5 × 75 cm.)

Collection Mr and Mrs T. Burkin,

Savernake

THE NEST I

(opposite)

1947

Oil on board

13 × 17 in. (32.5 × 42.5 cm.)

Collection Professor Aubrey Manning

The Surrealist writings of Desmond Morris

To Live Alone

I stand on my side of the fence.
The fence has three sides, the third of which is mine.
Here comes no man.
There is room for many others.
There is immense space, there is endless time.
But no man comes.
I would not have it so.

<div align="right">1946, EXCERPT</div>

The One-eared Gods

The one-eared gods of inopportune belly-laughs,
accentuated by one whimper's-worth of visceral-warped
female pebbles,
beleaguered by ornate inkpots of a bygone era,
prostituted by the sisters of the government's
flag-sellers,
decided to reserve their occupations as essential,
owing to the national situation
brought about by the production
of synthetic women.

<div align="right">14 SEPTEMBER 1947</div>

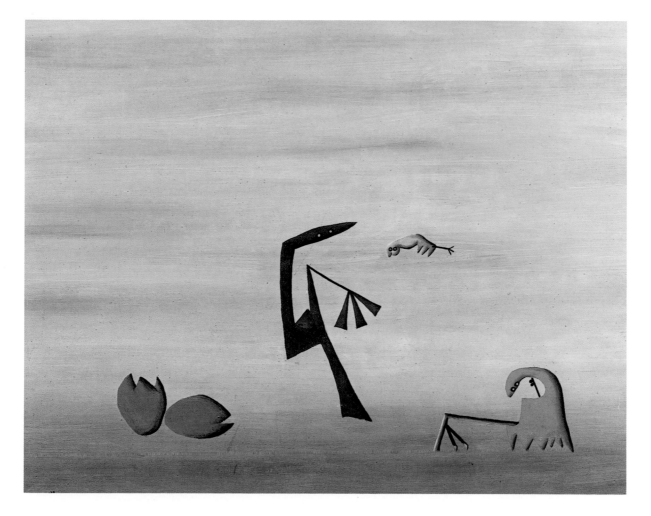

THE GREAT WINGS

The great wings
of the poison penumbra
beat slowly above the heads
of the semi-intimate
as they small-talk their way home,
not a contraceptive's throw
from that breeding place of lonely houses
where pink crinkle and ivy rubber
are stowed in every love cupboard.

1947

THE LINCOLN WALLS

The Lincoln walls
and the hard green
seduction of the night's
unwilling charge,
changing with the race of horses and the race of blood,
to yet another
yesterday.

And the sun had to shine.

MARCH 1948

FOR LEONOR FINI

Her brush is a muted trumpet and
from her eyes come bullets
which fail to penetrate
but splatter perfumed acid
on the surface of our tanks
and melt our snouting guns.

Her thoughts are metal feathers
which catch the wind and
quickly prod aside tomorrow's
curtains, showing some other
place, where seasons hold their fire,
an easy target for her loaded eyes.

NOVEMBER 1948

THE KETTLE-HEADED BOYS

The well placed ball tears out the breast,
pulled from the body's most illustrious folds
by unborn mutants weaned on tube-struck foam,
and pits the throat with orange fins
until the shutting hinges
pinch the curving fear of stale distractions
which stain the underclothes of sterile hairs
until the cry is heard of swarming
pattern tales.

The gleaming limbs ascend the sterile hills
of calm solidity,

watched by an ear of salted yesterdays,
upon another's back,
waving to the several crowds who run apart
to show the engine's clothes
to nearby altar-pans whose single rims
reveal tomorrow's learned symmetry.

The velvet shirt unwraps,
revealing unkind telephones whose lines depart
to see the grandchild's chest of drawers,
from which a quiet sneezing sings
to the American toilet...
...while all around walk stairs
up which no hands may climb
to see the sonnet thrash from doors
unlocked to these ten sailors who,
changing their dresses,
call and tie their pockets to a shining can,
by which a laughing gate can open all our eyes.

The puckered teeth of the brain
roam around the palace grounds
searching nowhere for the uttered thoughts
which little words are needing,
and the slope is filled with the yellow desks
upon whose lobes these gentle screams
are spoken to an audience
of kettle-headed boys
whose pastimes are unheard of.

5 NOVEMBER 1948

SHOULDER HIGH

If there is a loud bang in your fingertips
never permit your reflection
to look at you from shop windows.
If you are sitting in a room with no ceiling
try and remember what time it was
when you had your first nose-bleed,
or the occasion when you climbed over
the third side of the fence of screaming reciprocals,
and heard a bell ringing in the distance.
The grass in the bedroom is damp
and it is probably better to wear
horn-rimmed spectacles
than burn your tongue.
But the heat from the mirror
that was a funeral gift
has brought on the rain.
The drops are very large
and each is falling several feet away
from its neighbours,
so that it is just possible not to get wet.
In the distance three firemen
are carrying off a plastic surgeon
shoulder high.

1948

THE SIDEWAYS MEN

The orange flowers of the sideways men
swing from the fifty debts of the ancient bottles
that belonged to the dejected clearing
beyond the folding hills over the fence across the
 crimson field
where in our youth we stripped the moon.

The legs and toes of unlisted lives wave to the winged
 plants
of some other minute.

Below the spines of glass stems the furcoats are
 unlocked.

Around the sun and moon a sphere engraves its name.

The daughters of the outsides are coming in
on toads-wings feathers.

Aabbcc and the rain is dead.

Welcome to your two spheres at once.

 1948

EXOTIC HEADS

Exotic heads and happy unicorns
trample the antlers of the polar saucers
in the husband's library.
The fiddle on the floor is sitting in front of the fire
without noticing the flowers
in the chimney
and outside the air is crowded with boulders. Squares
 of hairs are singing in parallel
with no particular aim in view
and the suicides
on the edge of the interminable armchairs
are feeling bored.

 CIRCA 1949

WOMAN IN THE MOON

The face of the woman in the moon
is watching a young girl
who is reading the directions on a sealed box:
'...If there is damp on your elbow,
unwind the ribbons around your chair's legs.
If there is a whisper in your navel,
burn your letters in no uncertain tone of voice.
If there is a fireplace at the bottom of your garden,
never blow your lover's nose...'
She throws the box angrily to the ground.
Turning her face, she watches three men
as they walk down the street and into a building.
She follows them.
Three tables are sitting at a bar smoking
their ashtrays.
They separate in the middle as she enters
and stand up straight.

Three of the halves are the three men.
With each is a woman holding a moistened shirt.
One of the three men receives a message
and they tie the shirts between their legs.
They begin to dance back and forth
in different coloured lights from a stained-glass
window, by which a weeping tree can tell the time
of night.
The girl is sick.
She leaves by a series of revolving doors....
...The glass in the first door is cracked,
in the second it is broken,
and in the third, frosted over.
There is no glass at all in the fourth door
and through it she can see the sloping street.
Walking up and down are policemen disguised
as whores.
The girl is terrified and runs back to where
the broken pieces of her box lie scattered
on the pavement.
Laboriously she begins to stick the bits together
with some discarded chewing-gum.
An hour later she finds she has made three small boxes.
This puzzles her, as it seems the only way
the pieces will fit together again.
One of the policemen finds her crying.
They link arms and disappear.
In the distance a lorry runs over a peacock,
but the driver does not stop.
He is looking at the face of the woman in the moon.

 16 MARCH 1949

THE DAY THE ANIMALS CAME

It's no good, they won't go away, they are following me
into the studio and grazing all over the canvases. There's
one enormous creature I can just see out of the corner of
my eye perched on one of the highest branches of the
tree that hangs close over this glass roof. Without looking
straight at it, it seems different from the rest. It has a
single claw and a red head with big teeth fixed all around
it which strangely enough seem quite sad. Going out
through the door I can now see that I was wrong; it is in
fact a circle of very pointed breasts and although I am
lying on the grass in the heat of the afternoon, one of
them hangs right down out of the circle and reaches the
side of my neck. For some reason this produces goose
pimples all over my right hand. The goose pimples grow
and it's as though the whole of my palm is giving birth to
a field of nipples. This makes me want to bite at my
clenching and unclenching fist. I find I am having to figit
[sic.] my legs. Just as I am going to bite, each nipple
changes into a colour of its own and bursts off and flies
up into the air. They start circling, a swarm of little
sexual buds, around the creature on the branch which
sways precariously. The wretched thing begins to fall
slowly and the frightened pebbles, which have grown
long female hairs, scatter up into the sky which is now
changing colour rapidly, reminding me of an overworked

 181

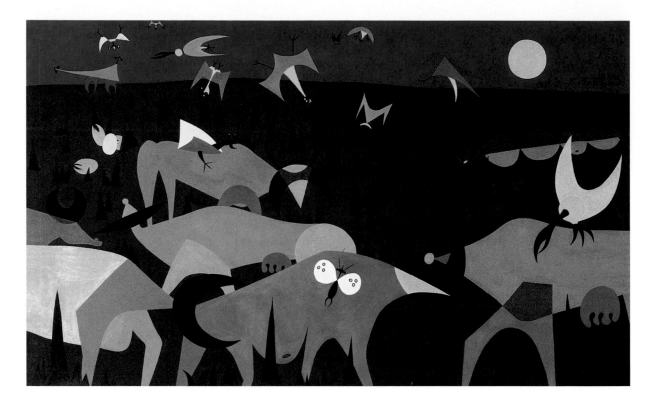

The Herd

1949

Oil on card 29 × 48 in. (72.5 × 120 cm.)

coloured fountain at a seaside resort. I can just catch a glimpse of them as they disappear into one of the four black spheres that have taken up their positions in the four corners of my vision. But then the great soft creature falls over me and the sky has gone blue again...

There's a lorry going by and a dog sniffing and a cat scratching and fine spider's webs are falling and a ditch is spitting and two stones are hissing at one another and some concrete is making a hard noise and a tree trunk pitted with all sorts of human bits and pieces is trying to twist as though it were singing the blues or just waking up after a night of contemplating an abortion.

I am lying with my face on the ground with a clump of grass in my mouth and my eyes shut. I have been wondering for some time whether, if I opened one eye, someone would mistake me for a needle and thread barbed wire through my brain. The idea now terrifies me so much that I have to strain my imagination tight over my skull so that both eyes are slowly pulled open exactly together. There is now a moment of peculiar, mounting tension that makes me expect to hear panting in my ear, but instead I feel the swish of leaves and my skull is still tight. My legs are also tight together and I find on looking down that they are now a single hard claw and the grass is a long way below and I am eating leaves.

Inside a glass roof a man is painting watched by a circle of animals. He sees me out of the corner of his eye and

begins in a curious way to watch me. I can feel myself starting to blush to a deep red. He has stopped his painting now and is coming slowly out of the door until he stands and looks straight up at me. Hundreds of thoughts rush through my mind as he stands there. I wonder if the fleas I can feel running through my feathers are as red as my head must be by now? I wonder if the rain will loosen the skin on my skull? I wonder if I could copulate in flight? I wonder if I ought to wave a flag if the King and Queen come by? I wonder if I wonder why the summer is so obscene? I wonder why those bells are making such a noise? I suppose they must be selling something at the church, or perhaps something is wrong? I wonder what could go wrong on such a bright summer afternoon as this?

But I can see the man beneath me now and he is lying down in the grass. Now I feel all sticky and I think I want to touch him.

28 June 1949

Today is the Day

Today is the day the time meant
when it wound up the clock with feathers.

I am late already for an appointment
with my taxidermist.
He has promised to insert two gaily-coloured beads
in my eye sockets
to render me more authentic
as I swing prettily in my little wicker cage,
frightening the passers-by with an occasional
sharp CAW-CAW.

1940s

HEAD HIGH

Christen the carpet
with silver leaves.
Anoint the walls
with suitable tableaux.
Cover the patch on the stairs
that the cloudburst knew
with glistening polished manners.
Relax the tight mists
of forlorn regard
and snip the dead roots
from the blistered boards.
Then
with head held high
and house in order
set out to question some other answer,
if only one is forthcoming.

THE CITY

1948

Oil on canvas

40 × 49 in. (100 × 60 cm.)

THE DEATH OF LOLO

She was found in moleskin
(inside out)
underclothes.
A press photographer wetted his camera
at the shock of seeing how wrinkled
her neck was.
An editor was sick over his stills.
The public came across her
with the second piece of toast.
A barrister shot himself in the mouth.
Six of her films were re-issued
with new titles.
Her children took their fathers to her grave,
but once there, did not know what to do.
The set was unfamiliar.
Her collection of paradise birds was bought
by an admirer in the Argentine
who ran a zoo.
Her house in the hills is occupied
by a French actor
and on the walls Cezannes
replace the pictures of her famous bosom
that throbbed in time with a million
suckers in the centre stalls.

1940s

1940s

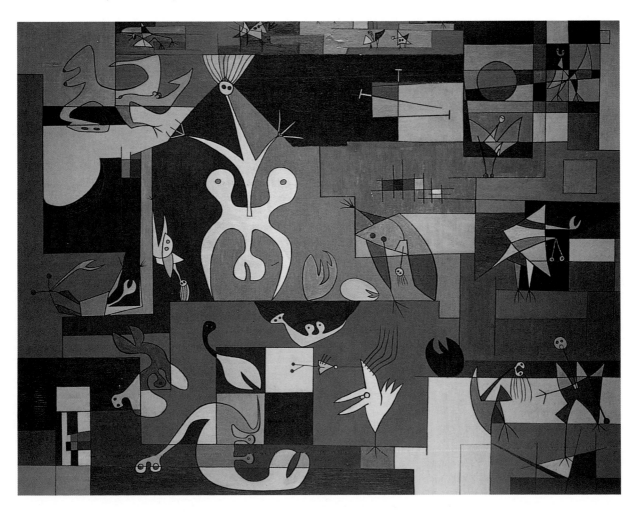

THE LONG DISEASE

Live on an island
but take your vaccine,
a small dose of the long disease.
Go soak yourself up
with ice-cream crowds
and blood-and-thunder babies,
witness the illegitimate dance
of the long-nosed women
and wag the head.
Wander the roads and roam the fields
of the monster's tentacles,
smelling his wounds
and feeling the twitch
of the nerves of dying.

1940s

SOFT CAT CALYX

Soft cat calyx
under little moons stirring
with no wind's blather
as each other's stars
sway in this far-fetched string of knots.

A forest would work
and no leaves seem harder
in a book of black silk memory
unless the tittering pollen in her eyes
is shed to sting the skin of the waterfall
that never listens to a single cry.

1950

AFTER-THOUGHTS

A clumsy nodule never clearing
up or down or inside round
the smooth eclectic sound
of mud petals sleeping
in and out the slanting moment
whose curse is only taken home
to bring about a coarser hair
upon the great fat little mat
when no-one calls for help
in hell upstairs
where children never go
until they die from day to day
on spiral springs
of acid after-thoughts.

1950

THE CLOWN'S GOWN

The clown's gown is worn
in towns whose rims smoulder
and flood with tears each sexless bladder
on these stumbling beaches

by and by and buy the best is always going first
and if again minutiae
escape the eye
come back yesterday
and slash your beaming backs outside
the striated banner box
in which no coloured balls can bounce
a tune quite half as well as
razors read a blistered book.

1950

BOTANY LESSON

The petals are falling from the Freudian flower
as the precarious parrot
calls to its ancestors
to launch the lifeboat
that the one-eyed needle god
dubs wicked.

The flowers are dying on the platonic planet
and the parrot seed
is alive and kicking the gong
in the temple of the polygamous priest.

The plant is wilting in the fidgeting field
which is ploughed by the ants
who strangle the vicar
with bootlaces.

And now the field is dead.

1950

A SMALL DESPERATION

Finding a crimson stone on the edge of the carpet,
there was nowhere to go.
There was nothing to do
except dust the weeping ornaments,
but tears are the property of the cracked glass
and should not be dried.
Their stream fertilizes the grass
which can be made of coloured metal or twisted
 swords.
Only now and again
can the clarity of mislaid temper
wield the blacksmith's hammer,
and blow after icy blow solve this filthy honesty.
Sickness of the legs can be cured
by a wonderfully reflecting transparent rope,
but the cords hanging from the trees
are never clean enough to swing from
by one's hips.
Blood running to the head can be diverted
into graduated bottles
and the humidity may be calculated
to reveal the hideous beauty of the drop of sweat
that is about to appear.

JULY 1950

184

THE ENVOY

The cephalized tauric envoy
interrupted in translocation
by an enigmatic asteroid...

An irradiated union blessed by the nunnery
 slaughterhouse
in waltz-time every week. 25 JANUARY 1951

THE SCENTED LINE

Beyond the scented line,
the corrosion of my seeing limbs
grows soft with unbelievable spray
which staggers from the foliage
at your leaning feet.
The lips of my heart grow weak
at the threshold of your great vision
and my hunting bones subside,
attendant on the flight
of the white arrows' swarm. FEBRUARY 1951

THE HERD OF CATTLE

The Roman road to the golf course undulated.
It rose and fell like a big dipper.
Coming to the top of a rise the driver braked.
There was a broken-down ambulance at the roadside.
An ambulance always brings out the best in a man.
He promised the driver to phone for help.

When he arrived at the course something made him
 forget.
He sensed that all was not well.
Cars were parked in the usual place.
The flag signified the course was fit for play.
But something was wrong.

Then it struck him that there was no-one in sight.
Not a soul.
It was a warm day, pleasantly sunny, with a light
 breeze.
Just the day to be out with the clubs.
But sometimes a day can be too quiet.
And this one was.
There was not a sound, not even in the distance.
But he had not been struck suddenly deaf.
He could make a noise by kicking the veranda.
But he wanted something else to be making a noise.
Something apart from himself.
Then he remembered his promise and entered the
 clubhouse.
The club telephone was working.

He dialled the garage and gave them the message.
It was reassuring to hear the other voice.
But were things still making a noise at the other end?
He felt it was too stupid to ask.

He was being ridiculous.
He had come for a round of golf, and why not?
He was becoming over-imaginative.
Taking his clubs he left the empty club-house.
There was obviously some perfectly simple
 explanation.
Perhaps a herd of cattle had strayed onto the course.
This sometimes happened on the far side of the hill.
No doubt everyone had gone to help clear them off.
Something like that.

Nothing to get worked up about.
He played the first two holes particularly well.
What a pity there was no-one to see him do it.
He drove off brilliantly at the next hole.
This shot would take him over the hill.
He would soon be able to see his friends.
The herd of cattle had become more real in his mind.
He found he had designated their breed and number.
Even their markings, as his friends herded them away.

There was his ball.
And there was the other side of the hill.
But still there was no-one to be seen.
This was where the cows sometimes invaded.
There was the neighbouring farm from which they
 strayed.
But there was nothing.
The cows, after all, had been his own invention.

There must be some other explanation.
He turned his attention to the ball.
There was a large bunker between him and the green.
Its hollow seemed deeper than usual.
Probably something to do with the angle of the sun.
He rarely played at this time of day.
That would account for it.
He glanced at his watch.
He was upset to find that it had stopped.
His wife would be furious.
She was always nagging him about breaking things.
The ball flew straight towards the green.
She could not have nagged about that stroke.
But as it passed over the bunker, the ball faltered.
It appeared to be struck by a sudden gust of wind.
Falling straight into the hollow, it disappeared.
No-one would believe this.
It had been cut dead in mid-flight.
He had never seen anything like it before.
Heading off to the edge of the bunker, he paused.
His anger was turning to caution.
All at once he did not want to see over the edge.
There was something there that was out of place.
There was something in the sand.
Perhaps it was a someone.
He felt like running back to the car.
Just then a huge black crow flapped by.
As it passed overhead it let out a loud 'caw!'
He found the sound immensely reassuring.
Something else had at last made a noise.
Life was friendly once again.

Whistling cheerfully, he stepped to the rim of the dip.
The shock of what he saw threw him off balance.
Cursing, he fell into the sandy concavity.
Scrambling to his feet, he was almost touching it.
Jumping back, he tripped and fell again.
This time he only raised himself onto all fours.
From there he gazed at the strange shape.
It looked like a gigantic blister.
But he knew it was more than this.
During his fall he had seen it looking at him.
It was a huge eye, growing out of the sand.
He sat on a rock and looked at it.
And it looked at him.
Or, rather, they looked at him, for there were two.
They were about four feet apart.
Each was at least five feet across.
They gazed at him with mingled love and sorrow.
They were the eyes of a woman.

What beautiful eyes they were, he thought.
Then he realized there were no rocks in bunkers.
And he was sitting on one.
Examining it, he found it was the bridge of a nose.
He was pleased to find that this did not surprise him.
At least he had himself under control.
He had not liked the idea of touching the eyes.
But he did not mind feeling the nose with his hand.
It was as real to the touch as it looked.

The flesh was warm and, except for the bridge, soft.
But the sun would have warmed it.
Nothing strange about that.
Someone had built it as a practical joke.
It must be some kind of plastic or rubber.
His golf club friends were hiding somewhere.
Now they were watching the fun, enjoying the joke.
It was a good one, he had to admit.
Running to the edge of the bunker, he looked out.
But even when he shouted, nobody appeared.
Turning back, he noticed something he had missed.
There was a mouth, too.

He came back and stood by it, looking at the lips.
They were slightly apart.
The teeth were very well done, he thought.
But they had failed with the saliva.
The mouth was too dry.
Then he spotted his golf-ball.
It was inside the mouth.
He tried to hook it out with his club.
But it slipped farther in.
When he reached down inside he lost his footing.
Suddenly the teeth were closing behind him.
Now everything was dark.

This was too much!
He grabbed the ball, anyway.
The mouth was beginning to salivate.
He had been wrong about that.
It was disgusting, he was covered in slime.
The golf-club was held fast between the great teeth.

Then the mouth spat it out!
His fury at this point turned to panic.
If this thing could spit, it could probably swallow.
And it did.

His alimentary descent was swift.
The sensation was of a high-speed lift.
If only someone would say 'ground floor, all change'.
But nobody did.
Suddenly everything was very still.
After a pause, two vast metal doors were slid aside.
It was the first time he had flown this plane.
What a beautifully clear day for a flight.
Warm, pleasantly sunny, with a light breeze.
As the craft was pushed out of the hanger she sparkled.
Shafts of sunlight reflected off her wings.
She seemed the cleanest, sweetest thing on the field.
One would never guess she was also the oldest.
The engines were roaring now.
The control tower gave the O.K.
He was away and lifting well.
The elderly plane climbed gracefully.
Like the great actress she was, she rose with style.

But then, in mid-stage, she fainted.
The engines tore away from the left wing.
Fragments of the tail broke off and floated into space.
Below, the landscape revolved faster and faster.
He was over country he recognized.
There was the Roman road and there, the club-house.
And getting nearer every second, the golf course.

The plane crashed in a bunker.
His blood did not mix well with the sand.
He could not see much for the red in his eyes.
A large number of people were running.

From all around they came and squinted down at him.
Seeing him, they wrinkled up their faces with disgust.
Then he saw his watch on his wrist and it had stopped.
It lay several feet away and his shoulder was cold.
Or perhaps it was hot.
It was so difficult to tell.
There was his old club-house friend, the doctor.
He was shaking his head from side to side.
If only he would move it up and down instead.
And here was the ambulance man, moving into view.
He was apologizing for being so late.
It seems he had a breakdown on the way.
And the repair van had been delayed.
Someone he did not recognize was picking up a foot.
It was wearing a shoe that was curiously familiar.

Inside the ambulance, heading for the hospital, he died.
At one point in the journey there was a delay.
The ambulance was held up for a second time.
A herd of cattle had strayed onto the road.
But the authorities said the delay was unimportant.
He would have died in any case.

<div align="right">MARCH 1951</div>

186

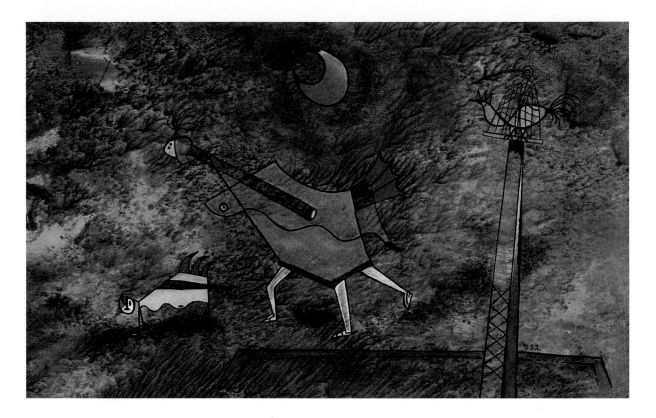

EASTER MONDAY

Come down the steaming ladder
into our embrace
and find the staggering focus
frowned with painted cracks
upon the smoking glass,
blinked with crooked cymbals
lain in disarray,
until, hoarse-calling, the clinging sabres,
blessed with copper-crumbled grace,
unfrenzied below the frantic nostril's flair,
can splinter into blind fountains,
cursing, teasing, pleading
with a dying garland
bathed in sacred milk.

1952

LEES COTTAGE

This is the poem of the destruction of rubble
the song of the birth of beetles,
or of the rich crying of book-ends.

In the dying moment with sweet blunted points
there is no calling out
and the air is filled with water.

Tumbling, fur-lined bones, crystal leaves,
and petal-scales
drift in light mists around the floor-beds.

THE BIRD-LOVER
1952
Ink and water-colour on paper 8 × 13 in. (20 × 32.5 cm.)
Private collection, Berkshire

This is the time of the caged grasses,
the hour of abstract ritual,
or the infinite fluttering that circles
the dimly-lit cavities of the mind.

With a slower pace
the solemn peace of tidal memory
finds itself alone, surrounded
by stupid, cursing waves.

14 AUGUST 1952

THE EVENING'S HORSES

The evening's horses run their race
towards the simple shapes
of shadowed yesterday.
The nightwind's plumage feels
its flutter ending in the target's rim,
and then my echoes are mingled
with the salt of a stone's shallow tears
calling softly to my mate
to unfold the story of her white seduction.

1952

THE GREEN EYE

Past the green eye
to the open field of incurable screens
I am driven
and wander, browsing with reluctance.
There must be an easy corner somewhere else
and a slight push in the wrong direction
would lead to a multi-coloured circle
in which black letters spell out
next year's mistakes.

1952

THE FACE OF MY BRAIN

Your limbs are mountains
on the face of my brain.
You are walking along the tightrope
that stretches between the eyes I have for you.
Yet all I can hear is your eyelashes
burning inside my ears.

Amongst these trees a small pile
of folded sheets lies silent,
the unused sails of a sexual yacht.

There is a rug lying upon the sea
and our voyage is pursued by scissors
which cut off the buttons
of our gaping volcanoes,
as the Persians were said to do.

1952

ALLIGATORS' TOES. A DREAM

A small lake, dark and wooded at one end,
light and open at the other.
Black forms are swimming in the water
at the dark end of the lake.
They have seen me.
They follow my canoe.
I paddle faster.
The faster I paddle the faster they follow.
I make for the open part of the lake,
the alligators following close.
I reach the bank and leap out.
I begin to run from the water.
The alligators follow as fast.
I reach my bicycle and ride away speedily.
They still follow.
At first I gain speed but they never lose sight.
I reach the cinema at the corner of the street.
Throwing my bicycle down, I rush in.
I buy a cheap seat and sit in the centre
of a crowd of women.
They are all cackling.
The scene is upside-down.
I have seen the film before.
There is shrieking at the door.

The alligators are pushing their way in.
The women scream.
I jump up and scramble over them.
I walk on their heads.
The alligators are coming on.
I jump into the pit where the orchestra plays
and squeeze through their exit and entry hole.
I can hear the alligators coming...
...I am in a passage and it is a dead end.
All the walls are flat.
The floor has started moving,
moving in the direction of the orchestra pit
where the alligators are.
I can hear them now.
They have taken up the instruments and are playing.
Water starts trickling in the direction of the musicians.
The water level gets higher and higher.
It reaches the five inch mark and then stops.
There is a war on.
An air raid.
Bombs.
People start coming down into the shelter. They crowd
 in.
There is not enough room.
Bombs falling.
An artist rushes in to draw the frightened people.
He finishes and goes out.
I follow him up the winding stairs.
He gets out of sight round the corner
and when I arrive at the top he is gone.
I find myself in a deserted street.
I turn to the left and right and start walking.
It begins to rain.
A thunder-storm.
The flashes of lightning illuminate the cars.
Inside them are engine drivers and firemen.
The cars are out of control.
They are washed away.
I follow, running, to see what happens to them...
...The water gets deeper.
We come to a cliff that has been turned into a
 waterfall.
The cars are going over the edge and disappearing.
An engine driver falls from one of the cars
and as he hits the water he is an alligator.
I jump back and feel myself falling over the cliff.
I land on a tree at the bottom.
The squirrels are curious.
They are chattering as they knit.
The wool stretches in long lines down to the ground.
I jump onto one and climb down it to the ground
 below.
The wood is very thick.
I come to a golf-hut.
They are playing golf with human heads.
They see me and start chasing me for my head.
I hide in a bunker and climb into a rabbit hole.
Everything is dark.
I hear music.
It is the alligators playing.

188

I am back in the cinema.
One of the alligators' jaws are around me.
Thousands of teeth.
I give in.
I am too weak.
They kill me and I sink.
I sink into blackness.

CIRCA 1952

MALE WARNING

Do not jump on the ice.
It may break.
Do not hang from the branch.
It may break.
Do not raise your voice.
It may break.
And then you will be a man
and they will expect you to
jump on the ice,
hang from the branch
and, if you are lucky, die clean.
If you are not, you will break.
And they will all say 'aaaaah',
and love you the rest of your days.

1950s

DAWN CHORUS

There are flowers on the grave of night
as day's embryo-hour
greets with hard pellucid stare
the haze of that nocturnal funeral
that has held
in its all-embracing void
the quiescence of a tomb
of royalty.

1960

STOP THEM IF YOU CAN

The end
stands at the corner of the field.
There is a follower whose rose's cobwebs
drip and spray the pollen of his tears,
until the undulating furrow
flows with arrows.
A flight of shafts moves
towards the orchard's wall
and to the prone beginning.

1960

SHE IS

She is a rock pool
She is the bed on which I hang my Christmas stocking
She is a furious whisper in my navel
She is a field of blue poppies
She is a sneeze in the dark
She is a coloured lantern
She is an ice-cream in the desert
She is a swarm of bees between my toes
She is a graceful yacht skimming across the sea of my
 brain
She is a dreaming hammock in the garden of my arms
She is a golden bottle whose label reads 'Now'
She is the ticker-tape
She is the Milky Way

THE COLONY
1957
Oil on canvas 7 × 14 in. (17.5 × 35 cm.)
Collection Lady Cawdor, Nairn, Scotland

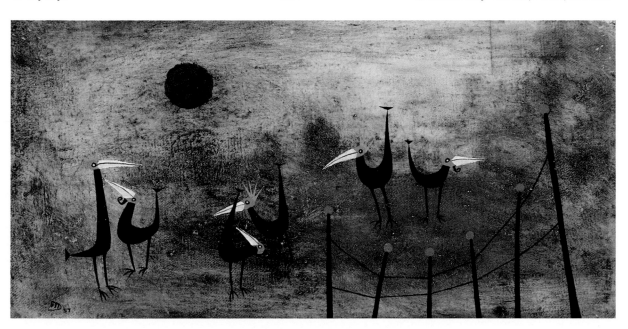

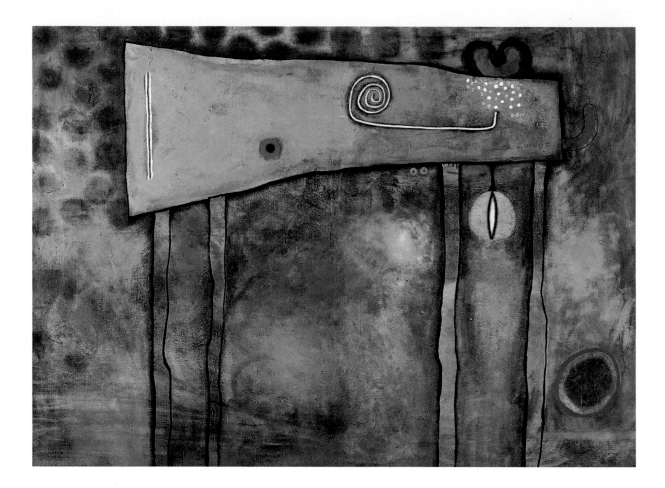

She is the sphinx whose paws tread my chest
She is the purple cloud that drifts across my mouth
She is my burning snow
 my avalanche of fire
 my stick of rock
 my secret sand-dune
 my tunnel of love
 my pendulum of timeless hours.

<div align="right">25 AUGUST 1964</div>

TELL THEM WHERE TO GO

Do not despair,
or cast a backward shadow.
There is nothing there -
a block of flesh, a plastic flower,
a clever twitch or two.
Ignore it, it is nothing, it will go away,
or be taken off.
Do not listen to them if they say
the cement smile was hiding a helpless child,
you know their game, their sadness.
Take no notice.
The monster is dying, it feels nothing.
It was unnatural, tell them that,
and watch them wince.

BEAST OF BURDEN
1966
Oil on canvas 54 × 72 in. (135 × 180 cm.)

They hate; and they adjust our clothing
before leaving.
So no-one will ever know.
One shaven hair of yours is worth
six centuries of their teaching.
Tell them where to go.

<div align="right">JULY 1965</div>

ANY BODY

Any body
will split the difference
and suck
the poison of a
lightning fork
spreadeagled
on the field
of love.

<div align="right">CIRCA 1966</div>

190

VERBAL POLLUTION

is all around us:
the smog
of a million journals,
the effluence
of a thousand jargons,
the debris
of countless conferences.
Perhaps for a year we should all remain silent
and stare at the sunset.

1968

WORK

is the failure
of
play.*

1968

WE EXHIBIT MOST IN PLANTS

those parts which
in ourselves
we try hardest to conceal.

1968

EACH YEAR

is more important
than
the next....

1968

LOVE IS A LIZARD

Love is a lizard,
handy with a fly,
hot on a flat stomach stone,
quick of glance
and slow in winter,
skin bright, feather-tongued,
clinging like lichen,
vanishing
like
a
mirrored
smile...

7 APRIL 1970

DARK INSIDE MY HEAD

There was a plop
in the well of my head
today.
An unseen hand
dropped something in.
Was it an accident?
Was it a jewel from a wrist,
or a pebble from a fist?
Or was it a small corpse,
the disposal of which
will foul the water of my thinking?
And how can I tell?
It is so dark inside my head.*

1970

THE LOST ART

Leaves and hair-parcels
end their days in quiet
embrace with rising fears
and soft faces watching
the frosty glass.
Passing the long night
before the inner roots
begin to nose their proud
beginnings, we are deaf to
the elephant's tidy song.
Smoke slides flat in
friendly waves under the rim on the great bowl
that used to catch our
tears before we lost the art of angry clowning.

21 APRIL 1989

THE SOCKET OF GREEN

The socket of green,
close by the crowded limb,
calls to our moist palms
and dares our knotted tongue
to recall the day the clock stopped
with deep regrets that all our pains
are folded down
and stuck fast to the memory
of neglected eggs,
lying snug in the nest
of our longing.

1989

* One of the axioms from the 'school of unlearn-
ing' in *Inrock*.

* Another of the axioms from the 'school of
unlearning' in *Inrock*.

THE WHITE SHADOW

The white shadow of your absent form
Blinds my brain with its bleak promises.
The golden skin of your lazy neck
Slides on my thoughts in slow caress.
The yellow web of your laughing hair
Strokes the eyes of my dark arrival
And all at once the room is empty,
Lost in caring, wondering why the
Siren is sounding, the bells ringing,
The lights flashing and the noise
Of dirty living beyond these heavy
Walls is so oppressive and so
Foreign to my dreams.

OCTOBER 1989

THE EDGE OF THE WORLD

The edge of the world was frayed
And slightly damp
Where two firemen had coupled
In silent prayer.
Mosquitoes sucked at the table-cloth
As the diners ate their words
And bees made honey from the pollen
That hung from the thighs
Of the distinguished guests, ladies and gentlemen.........

The edge of the world started to curl
And disturb the metronome
Of the bearded babies
That the showmen offered
To all and sundry.
Officials with far and narrow minds
Came from near and wide
To dip their bread in the open wounds
Of the Monday joint
And marvel at the resilience
Of artificial limbs.........................

26 APRIL 1990

THE OBSCENE SKY

As the obscene sky darkened
The plumage of the dying sparrow
Turned to hair
And its beak became teeth
Through which it said in a deep voice:
I live in palaces where no eagle
Dares to nest,
I drink in the gardens of the famous,
Where no sad rarity will settle,
Yet I am pest and they are paragon,
Funded by fat egos with charity to burn.
Must I fail before they see me and
Squeeze their watery eyes to find a tear
For my kind?
My droppings on them.

1990

STARFISH

Starfish of the Silver Scream
Armed to hunt the wary glance
Fierce to see the easy killing
Sad to call the end of play.

Starwish for luck
In pain of parting.

1996

BODY BLOWS

If sleeping bodies lie,
Then who can tell the truth
Of the matter of fact
Or fiction, said the girl
With the pierced nose
For a good story-teller.

If waking bodies mourn,
Then who will bury the eggs
In the garden of delights
That awaits me, said the girl
With something left to lose.

1996

THE OPEN BOOK

The golden apes of compromise
Laughing at yesterday's fire
With endless sideways cries
Climb into our open books
And give us feud
For thought in
The soft beds
Of cosy night.

1996

KEEP LOW

Sleep up the night
Sleep in the ice
Sleep on the mound
Rest under stone
Crouch on the arm
Sprawl on the rim
Sleep at the core.

1996

MOTHER AND CHILD *(opposite)*
1990
Mixed media 11 × 10 in. (28 × 25 cm.)
Collection Dr Jeffrey Sherwin, Leeds

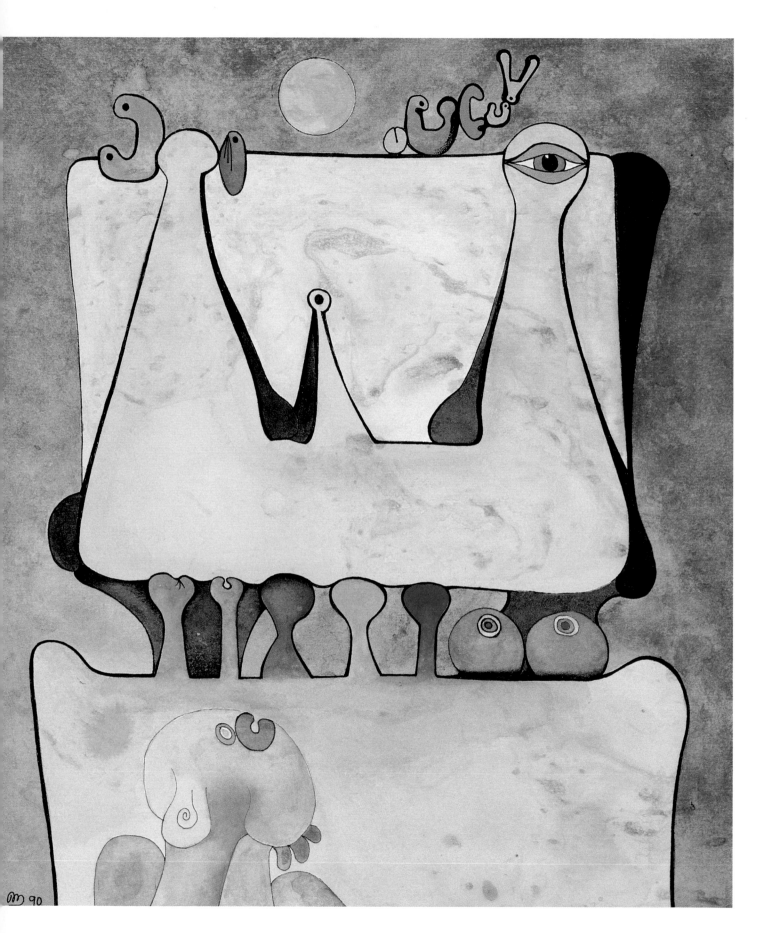

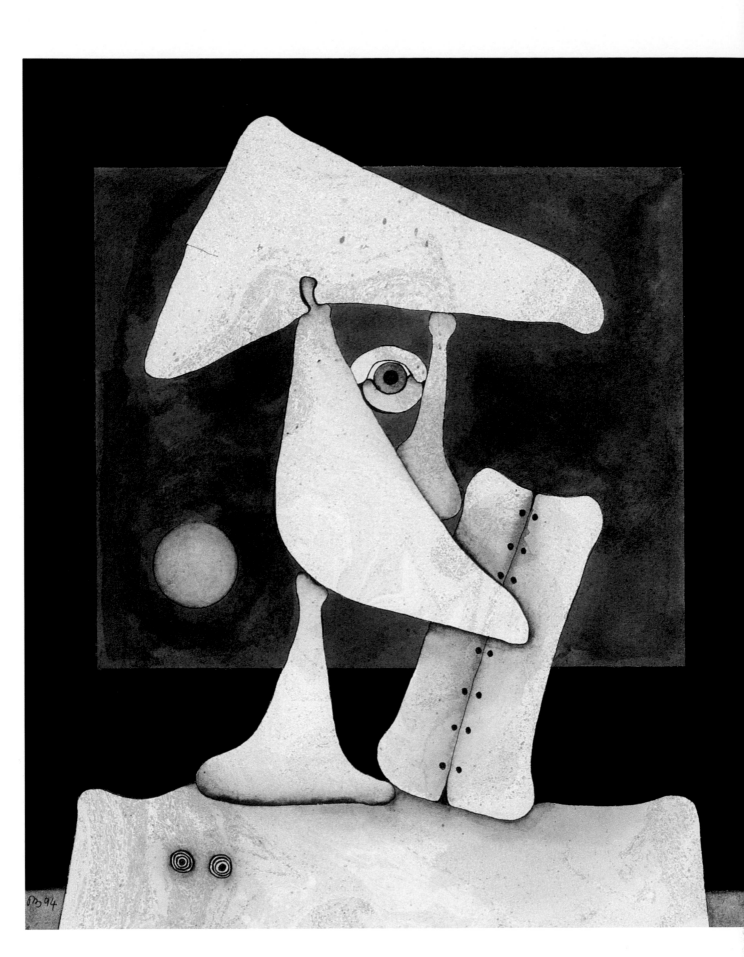

COLA ROASTER

Customs
Belong to
Other shores tonight.

Our hands are lean
And Hungry as we take
The ride to smell
The guns of life.

Our diet of
Knives is
Blunted by the echoes
Of our daily fears.

We fly our flags
In the face of hidden
Gestures...

1996

MORNING COMES

The dead song of public birds
Heard today in private places
Haunts the heads
Of yellow flowers
Whose task is uncertain.

The dead weight
Of oval feathers
Lining the hearts of those
Who pay the price
Of wide-eyed sleep,
Clings to the limbs
Of newborn fears
That call the tune
As morning comes.

1996

LAZY DAYS

Severed heads smile more
Broadly when they are dry.

Long in tooth they glint
Like vacant faces of the blind.

Their silent thoughts
Melt like butter
In the mouths of caves
Whose tunnels
Are almost endless.

Our foolish games
Make tracks
In the bewildered
Snow
As we leave the
Scene
To die another day.

1996

YESTERNIGHT

Last day
I saw
A red
Form
Moving through
The repulsive vegetation that lies
Around the valves which
Open the mouths of
Our dead
Conundrums....

1996

OUR SAD PARADE

Pain plays its own tune
Sweet and high inside
The folds of family skin.

Watching the dry waves
Of polite fear that sucks the air
Between the toes of strangers
There is no escape
From the knowing stares
Of the increasingly bland
Ladies and gentlemen
Who slowly cheer our sad parade.

1996

LOSING PLACE

Losing place on pain of life
Is of itself a fine
Defeat. Holding
Skin in gaping
Line is only losing
Space. Holding
Breath is never
Seen in dancing
Limbs unless
The trickle of
Salt is licked
In moonlight.

1996

NIGHT-GAME *(opposite)*
1994
Mixed media 12 × 10 in. (30 × 25 cm.)

Film scenarios by Desmond Morris

TIME FLOWER

A girl lies with her head buried in the grass.

Her hands claw at the turf.

A man stands nearby, smoking and thinking.

Suddenly he realizes she is running.

He pursues her.

The faster he runs, the faster she runs.

Thoughts flash through his mind as he runs and he sees himself entering a church.

He is in evening dress.

Inside, he is astonished to find himself in a strange room.

He sees a carnation and secures it for his buttonhole.

Looking around the room now, he finds he is not alone.

A white-robed doctor is sitting, quite still, as if waiting for him.

The doctor advances and hands the man a card on which he sees the number 53.

He feels he should accept it and puts it in his pocket.

The doctor is manipulating a hypodermic, and beckons the man to sit down.

This he does and the doctor injects his carnation, a painful operation for the man, whose closed eyes begin to flicker.

As they open, his mouth tries to open.

It succeeds laboriously and a third eye, within the man's mouth, is revealed.

All three eyes begin to blink, and now the carnation has turned into a disc which says 53.

The doctor finds that his watch has stopped (one of his eyes has also disappeared) and this annoys the man who takes a dart from a tray of surgical instruments, and throws it at the large clock on the wall.

The clock, which has no numbers on its face, but odd letters instead, begins to bleed where the dart has pierced it.

The pendulum is still, and is held under the clock by a rotting glove.

The doctor shakes his head at this, and the man is so furious that he tears off the disc saying 53 and destroys it.

The doctor hurries to the mirror, which has taken up the position that he himself first occupied, and covers it over with a drape.

The man is fed up and sits down at the table again, and strums his fingers.

His fingers strum faster and faster, and then suddenly they are his feet running again.

The girl is coming to a rabbit-warren and the frightened rabbits scatter as she trips in one of the holes and falls headlong.

The man, seeing this, runs faster than ever, but she is up and away, glancing over her shoulder in terror.

As she flees, she too experiences a kaleidoscopic vision.

Her bobbing eyes become the swirl of wine being poured out of a bottle.

She is sitting at a table in another strange room.

On the table are the glass, the bottle, and a telephone.

As she drinks, she is being watched by a magician (who has the doctor's body).

She is in evening dress.

The magician offers her a pack of cards fanwise and, although she is listening at the phone, she takes one.

As she realizes what she has done, she leaves off phoning and turns the card slowly over.

On it she sees an eye.

This makes her furious so that she leaps up and whips the magician's face, producing black, horizontal lines.

The magician, unmoved, produces two white balls out of the air.

He places them on the table, and the girl, who is lighting a cigarette, ignites them.

She then sits moodily at the table, smoking and tapping her heel.

Her heel taps faster and faster, and becomes her legs running.

She makes for a forest now and, once there, hides behind a tree, resting.

The man has lost her and searches wildly among the undergrowth.

Then he sees her skirt showing around the base of a tree.

But suddenly he realizes he has come to the edge of a deep ravine.

As he stands on the edge looking down, the ravine turns into the brick surface of a yard over which he is walking.

He is in evening dress again, with a scarf and gloves.

He enters a shabby garage door.

Inside he is annoyed to discover that he is in the same strange room again.

He dispenses with his gloves and scarf and begins to smash the table and chairs in a fury.

He is arrested in his actions by the sight of the doctor painting at an easel.

He is painting a large picture of the number 53.

Half his head is black, half white.

The man is so annoyed that he rushes to an old chest on which there are two swords.

Throwing one to the doctor, he begins to fight him.

The latter is quite calm.

Then the man knocks down a lighted candle which diverts the doctor's attention.

In that second the man plunges his sword into the doctor's stomach, up to the hilt.

Blood pours from the wound, but to the man's amazement, the doctor simply nods slowly and seriously.

Irritably, the man withdraws his sword, and the doctor returns to his painting.

The man goes to the treasure chest and opens it with his sword.

Inside he finds a mass of keys.

These he starts to try one after the other in the door.

None fit.

In the meantime the doctor has finished painting and now sits again in his original position, smoking an opium pipe.

The man throw himself onto a pile of cushions and begins to play with a balancing toy.

The toy slips and falls off its stand.

It becomes the man himself, who is slipping over the edge of the ravine.

The noise frightens the girl, who flees once more.

The man clings to some tree stumps on the slope, but they are rotten and he falls.

The girl runs wildly through the undergrowth, but is stopped by the sight of a hedgehog which is fleeing from her.

She stares at the animal which becomes a large skull.

She is standing by it in evening dress once more, and the magician, who had been worshipping the skull, on seeing her, takes it in his arms to protect it.

On consideration, however, he offers it to her.

She directs that it shall be put onto her table.

She sits at her table again.

A hammock swinging low near her contains a young alligator.

The magician produces two plums out of the air and places them on her table.

After listening at the phone for a while, the girl looks at the magician and with her eyes fixed on him she reaches out and puts the plums into the eye-sockets of the skull.

This upsets the magician, who wrenches the phone out of her hand.

As he does so the woman gives a jump, for she realizes that the man is now crashing through the bushes quite near to her.

His arm and hands are cut and bruised, but he stumbles after her as she flees again.

The girl leaves the wood now and comes to a peculiar hill.

She begins to climb.

The man follows slowly, but when the girl has reached the top of the hill, she can only stand and stare and wait.

Slowly the man appears over the top of the hill.

The girl stares into space.

Her eyes close, and their closing becomes the clasping together of the magician's hands.

The girl is in evening dress again and stands against a black wall in a maze of cords.

The magician cuts her loose and she walks aloofly towards her table.

Halfway across the room she sees the magician's earring swinging and tears it off, putting it into the hand of a black figurine.

The magician holds his ear for a moment, then brings both hands down to the front of his body.

Two eggs appear in his palms and these he places, as before, on the table.

The girl picks them up and as she turns them over two eyes appear on the shells.

At the same time, she opens her eyes to find that the man is now facing her on the summit of the hill.

He advances to stand close in front of her.

She faints.

The man, clasping her wounded arm, looks down at her.

He sees his feet walking on a gravel surface in evening dress.

He enters the door of a house and discovers, almost pathetically, that he is in the same room again.

He sees that a body on a slab is covered with a sheet.

He uncovers the head to see the doctor lying there.

The face of the corpse is white.

He goes to the feet and uncovers them.

One is black and one is white.

Around the white foot is a label saying 53.

The man shrugs, but has one more look at the head which, to his horror, is now his own.

Around his neck he sees a key which he snatches and tries in the door, but without much hope.

Nevertheless it works.

In the half-open door, he turns.

He sees a bird sitting on a violin which is exploding.

He leaves and as he does he finds himself walking to the edge of the hill.

He pauses, then falls to his death at the bottom of the hill.

His feet twitch.

The girl's feet, however, are quite still as she lies on top of the hill.

But her head, which is buried in the grass, moves perceptibly from side to side.

Her hands claw at the turf.

Time Flower was filmed in August and September 1950 at locations in Swindon, Wanborough and Avebury, and on the Marlborough Downs.

The Butterfly and the Pin. The Death of a Painter

An artist is painting in his studio. He is wearing a red shirt. A cigarette is in his mouth.

There is a canvas of a large nude on his easel.

He puts down his cigarette and drinks from a glass of white wine.

The studio door opens and closes. Death has silently entered the studio. The artist fails to notice this and continues to paint. Then he senses a presence.

Turning, he confronts the white-faced figure of a man dressed entirely in black.

They stare closely at one another in silence. He is still holding his paint-brush in his hand.

Death gently takes the brush and snaps it in two.

The artist turns away and picks up his glass of white wine.

He lifts it to his lips to drink but finds it is bright red. His red shirt is now white.

He puts down his wine glass and attacks Death, but is forced to the ground.

He struggles to rise. As he does so he notices that his shirt is red again.

He sees that his wine is white once more. He collapses onto a chair.

Death hovers silently above him.

Death plays tricks with him. Whichever way he looks Death is not there.

He is always behind the artist, watching him silently. The artist spins round.

He accidentally knocks the painting on his easel to the floor. It lands face-up.

The easel rocks back and forth like an inverted pendulum.

It knocks the artist's straw hat to the ground.

The artist falls to the ground. His hand claws at the floor.

His paintings all look down at him as he lies there.

Death's shiny black shoes stand immobile on the fallen painting of the nude woman.

The artist's cigarette burns out in its ashtray. He lies face down on the floor.

Death squeezes red paint from a tube. The paint falls onto the body of the artist.

As it strikes his back it is transformed into a large tropical butterfly.

Now Death slowly drops eight tubes of paint onto the artist's body.

The eight tubes of paint become eight more tropical butterflies.

Death's black-gloved hand removes the first butterfly.

Life enters the studio silently and unseen.

Death approaches a painting hanging on the wall, which features a small target.

Life, in the form of a young woman, puts her hand on Death's shoulder.

Death turns to her. She beckons to him. She dances to him with her hands.

Death throws her down violently and returns to the target and pins the butterfly there.

The artist's body is now covered with small targets.

Life angrily tears the target picture from the wall.

As she does so, a shower of playing cards flutters down.

The body of the artist is now covered in playing cards.

Life brushes the cards from the artist's body.

She turns him over and gently strokes his face.

Death has placed a dart-board on the artist's easel.

He is throwing darts at the dart-board with great concentration.

Life raises her hand to strike Death, but he grasps her hand and stares at her.

He takes her by the throat and pushes her down.

Death starts to strangle Life.

As his hands tighten on her throat, she dies and vanishes.

Life, unseen, silently leaves the studio.

Death returns to the dart-board on the easel. He throws the three darts again.

Before the third dart, he glances at the body of the artist.

He throws the third dart with greater venom. The artist's hand twitches.

A dart has penetrated the left eye of the artist. Blood drips from the artist's eye.

Tropical butterflies appear on the dartboard.

The artist lies very still on the floor, in his red shirt.

Death drinks the red liquid in the artist's wine glass.

He throws the empty glass away. The artist's shirt is now white.

The cigarette in the ashtray is burnt to ash.

Death leaves the studio, silently and unseen.

The pictures look down from the walls on the body of the artist.

The painting of the nude woman lies on the floor of the studio where it fell.

Nothing moves. The artist is dead.

THE BUTTERFLY AND THE PIN. THE DEATH OF A PAINTER WAS FILMED IN 1951. THE CAST COMPRISED PAUL WEIR AS THE ARTIST, DESMOND MORRIS AS DEATH AND RAMONA BAULCH AS LIFE.

DOPPELGÄNGER *(opposite)*
1994
Mixed media
12 × 10 in. (30 × 25 cm.)

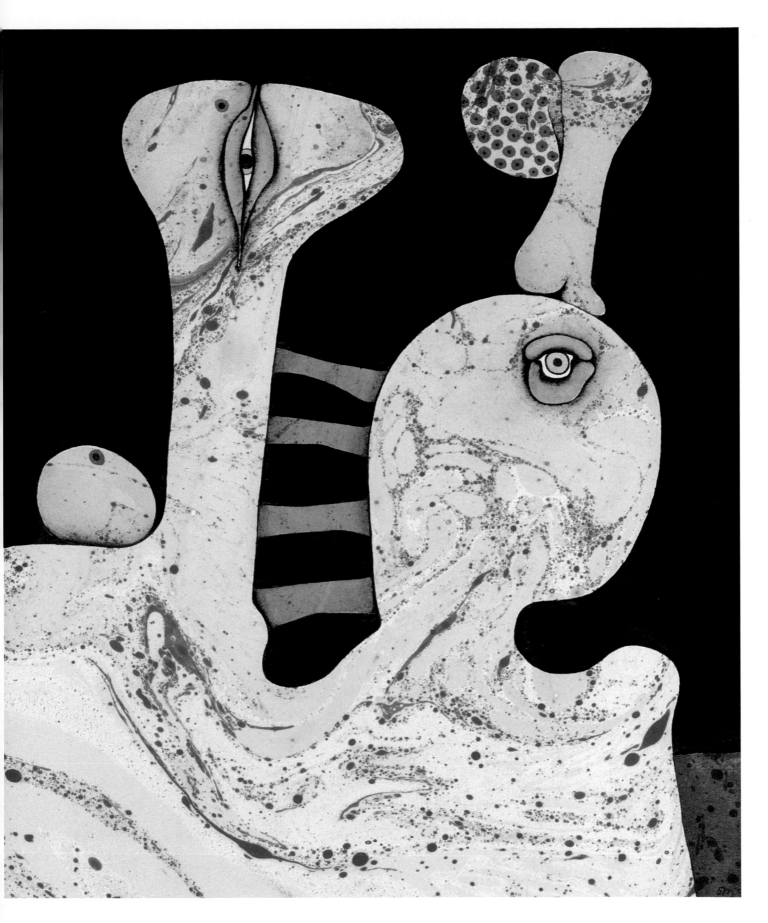

199

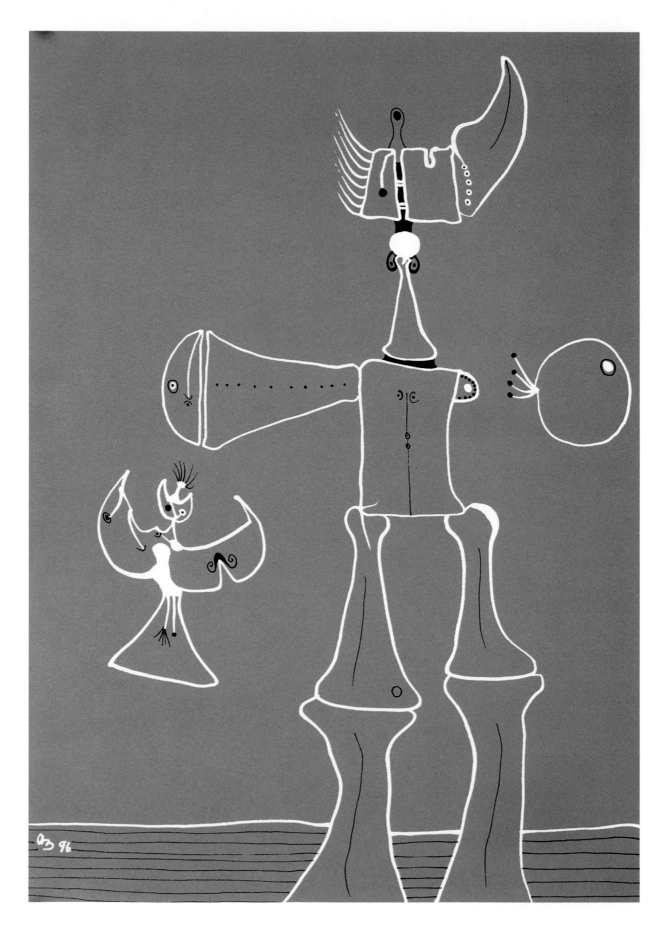

200

Desmond Morris on Desmond Morris

THE PRIVATE PAINTER

To this day, painting has remained for me an act of rebellion, a private pursuit which I indulge in despite the fact that there are many good reasons why I should not do so.

The simple, direct creative act of painting a picture is a child-like ritual of exploration. It is at once humble and yet egotistical; innocent and yet based on the sum total of personal visual experience. It can act, for an adult, as a gesture of defiance against the increasing intrusion into everyday life of good, sound, common sense.

I have always been surrounded by animals. I should feel naked without them. Perhaps originally I even preferred them to human beings. This involvement with animals grew until eventually, as a research zoologist, I was able to devote much of my day to studying their intricate and often baffling patterns of behaviour.

For some years I had been staring down a microscope, then I grappled with insect life, then with the underwater world of fishes. Next I moved on to the exciting world of exotic birds and finally I came face to face with the complexities of mammals. It was probably accidental that my zoological interests moved slowly up the scale of evolution from the simple organisms of the microscopic world, to end with the monkeys and apes. But this gradual shift, accidental or not, had an interesting effect on my paintings for, parallel with my zoological work, the contents of my painting also underwent a strange evolution of their own.

I have never, except to illustrate my scientific papers, drawn or painted a recognizable species. Frankly, I could never see the point of it. As soon as I learnt how to use a sensitive camera, I even stopped drawing animals for scientific purposes and illustrated my publications with photographs.

My paintings, on the other hand, gave me the chance to use my knowledge of animal processes and biological principles in a different way. In my biological work I was a slave to the actual – I had to find out how things have evolved and why they are the way they are. But, in my pictures I could take control. If I wanted a creature of a

BIRD FEAR (opposite)

1996

Black and white inks on blue paper

11½ × 8¼ in. (29 × 21 cm.)

Collection City Museum and Art

Gallery, Stoke-on-Trent

particular shape or size or colour, I could make it so. As a release from the intensive slavery to fact, I could indulge in fancy and create a fauna of my own, obeying visual laws imposed, not by nature, but by my own imagination.

As my zoological work progressed from group to group, so the indirect influences on my paintings made themselves felt and claws replaced fins, or legs replaced lobes. But each new creature that materialized on the canvas was only slightly influenced in this way. It owed more to its predecessors in paint.

This evolution on canvas has been moving steadily on for the past fifteen years. By 1961 it had reached a peak and, as happens occasionally in nature also, a crash came. What produced it is hard to say. One day a long procession of biomorphic forms had been marching possessively and inevitably across a seven-foot canvas and the next day they were gone. The new canvases were bleak, almost blank. Hard white landscapes, almost empty, refused to harbour the hordes of creatures that previously had sidled or stormed into the picture as soon as I started to paint. It was as if the whole process had to start again, to be built up from nothing. Little by little, images crept back. Suddenly, with almost explosive force, fertilizations began to take place. Eggs and cells and globules began to swell and divide. In some strange way, and in immense close-up, growth and development were beginning again, but with a more intimate association between the detail of the organism and the painter.

I am not sure where it is going to lead. It seems as if a new and more intricate world of biomorphic painting will grow and this is the excitement that awaits me as I crucify another canvas on my easel.

In reading through what I have written, I cannot help the feeling that it is all a plausible story to help explain something that I really do not understand. Perhaps it is all true. I am not sure. There are strands of truth in it, but, to be honest, the whole process of how my paintings come into being is still a mystery to me. When I leave for my studio, my mind becomes a blank and, after hours of painting, a picture has grown out of nothing and stares at me. I stare back at it, cautiously surprised and puzzled to know where it has sprung from.

The process of painting itself is an almost unconscious act and is certainly free of any verbalization. I doubt if a painter lives who knows why he is doing what he is doing until he has done it, and even then, only rarely. (I

exclude, of course, those who paint ducks at sunset and fat nudes on unmade beds; their goal is difficult to achieve but easy to understand.) The act of painting is automatic, compulsive, an extension of one's visual worries and desires. But it is not enough simply to let these impulses spew out on to the surface of the canvas unchecked and unharnessed. They must be controlled and organized, but strictly in visual terms. It is this visual discipline that operates on an entirely different plane from the kind of controls that we force upon ourselves in our day-to-day living, that is so elusive and difficult to describe. Whatever it is, it is fundamental indeed and its running battle to organize the unruly imagery that bursts out of the painter's brain will continue as long as pictures are being created.

1962

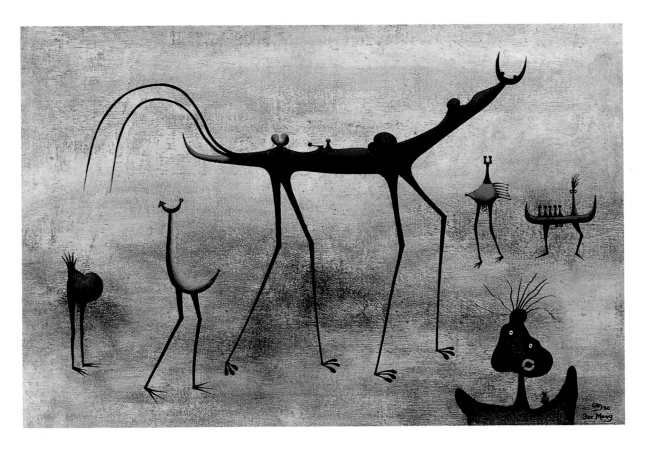

THE NEW ARRIVAL
1960
Oil on canvas
20 × 30 in. (50 × 75 cm.)
Collection the Estate of the late Mrs Mary
Horswell, Hampshire

Traditional art is in a coma and I doubt whether it will ever recover. Unlike many, I am delighted, and I drink to its two assassins – both nineteenth-century scientists. First came the Frenchman Joseph Niépce, the father of 'automatic painting', the first man to produce a permanent photograph. Then followed the Englishman Charles Darwin, the father of evolutionary theory, the man who (and there is no point denying it) destroyed religious awe.

Between them, Niépce and Darwin struck down the traditional artist – the person who, for centuries, indeed for millennia, had been kept busy immortalizing the mortal, with princely portraits, and personifying the immortal, with religious images. Now everyone could have their princely portrait, for the price of a camera click, and the gods went out of business as the temples emptied. Although this meant the end of the orthodox artist, it happily did not mean the end of the visual arts themselves. Instead of disappearing, they changed; they regressed to infancy. They returned to their roots, to the fundamental human urge for visual exploration – for visual play.

Via Cubism to total abstraction, the twentieth-century artist returned to the basic childhood game of playing with shapes and patterns and colours. He wallowed in it and showed the world that his activity was too basic to be ignored, no matter how his official role might have altered.

The stage of total abstraction had already been reached – and the point made – as early as 1915, but abstract paintings and sculptures are still produced in large quantities today. During the last half-century, however, something else began to occur in the world of the visual arts. Many artists, having obtained their freedom from traditional subject-matters, and having seen this freedom boldly demonstrated by their immediate predecessors, were not content to play with pure pattern and colour. Instead, they sought new imagery. There was nothing now to guide them and at first they cast around wildly, forming into little groups, or '-isms', to give one another courage.

But none of these groups lasted, and for a good reason. The main freedom that had been gained was for personal exploration and it followed that, as their art matured, it would inevitably become more and more intensely personalized and idiosyncratic.

The '-isms' splintered and disappeared, but a number of great new masters emerged to enrich the eyes of the twentieth century. The man had become more important than the movement; the private vision more important than the general theory. The lost image reasserted itself. But in so doing it paid little heed to reality. It became exaggerated, complicated, or simplified, according to the personal whims of the individual artist.

It has been argued that this made work easier for the modern artist than for his traditional predecessor. The truth, however, was that although it was easier to do badly, it was harder to do well. The painter did not merely have to learn a trade and perfect a skill; in addition he had to have some burning private vision to drive him on. If he borrowed heavily from others, he was attacked as being derivative. In the past, a religious painter was not criticized for painting a crucifixion because others had done so before him. But then the subject had not been someone else's private vision, it had been a public one, shared by the whole culture. An art student in the twentieth century, however, is faced with the enormous problem of being surrounded with the personal visions of his superiors. He is inevitably strongly influenced by them, yet he cannot copy them, as apprentices would once have been expected to do, adding gradually their own minor specialities of style.

This modern dilemma has produced a great deal of bad professional painting. It has also led to a growing respect for the 'naïve' or 'Sunday painter' – the gifted amateur who, although untaught and in some ways inept, has been sufficiently free of any professional influences to grow his own private vision alone and unharmed.

Speaking personally now, I must admit that I envy the true 'naïve'. As a young painter, I knew too much. I lectured on art history and I had the whole story of modern art at my fingertips. In my pictures I succumbed heavily to several bad influences – bad in the sense that I was fascinated by artists whose visions were intensely personal to them, not to me. I leant on their imagery instead of on my own visual experiences of life.

My other great interest had always been animals, and instead of pursuing my painting career I turned to zoology and to scientific research. My drawings were now all done under the microscope instead of in the studio. Later, I had to illustrate my papers with accurate drawings of fish and birds.

But in quiet moments, every so often, I returned to my canvases and to my visual fantasies. It was a pleasant change to switch suddenly from the demands of scientific objectivity to totally subjective imagery. The earlier influences began to fade. I had something new to say, something I had learnt for myself about biomorphic shapes.

I started to evolve a world of private creatures of my own. They mutated from canvas to canvas, growing, developing and changing according to some strange subjective rules which consciously I have never understood. I know when these biomorphic figures go wrong for me, but I do not know how I know. Some sort of general biological principles seem to be operating which guide me, but the results have nothing to do with the specific fauna of the outside world.

The goal is to invent a new fauna and to nurse it gradually through a slow evolution of its own, from picture to picture. In portraying an imaginary organism I can manipulate emphasis by exaggerating some elements

and suppressing others. A similar process occurs in nature – the anteater's nose and the porcupine's quills become exaggerated during evolution, while the limbs of the snake and the tail of the ape become suppressed. As a painter, I can follow this same general trend, while making my own special rules in each case.

For those who like labels, I suppose I can best be described as a private painter. According to my passport, of course, I have always been a zoologist and remain so.

If my paintings do nothing else, they will at least serve to demonstrate that such titles are misleading. In reality, people today are not scientists or artists...they are explorers or non-explorers, and the context of their explorations is of secondary importance. Painting is no longer merely a craft, it is a form of personal research.

Picasso may appear to have contradicted this when he said that he does not seek, he finds. But so in a sense does the scientist – the creative moment in research is rarely the end of a quest, but more often a moment of unexpected discovery, of revelation almost, if that is not too pompous a word. So, in the end, I do not think of myself as being part scientist and part artist, but simply as being an explorer, part objective and part subjective.

1971

BIOMORPHIA

One of the curious by-products of our technologically advanced civilization is graceless thought. As the culture becomes more elephantine, more socially obese, so its modes of thinking, and of expressing that thought, become more plodding and predictable. There are so many qualifying clauses, so many points of view to be considered, compromises to be made, negotiations to be balanced, dependent factors to be taken into account.

Even the individual begins to think like a committee, tempering sweet reason with sour expediency to produce a boringly balanced statement about living. With mental safety-belts smugly clunked, we sally forth to kill the dragons of idiosyncrasy. What could be more reasonable?

Like Japanese seaweed, reasonable, rational, logical, well-balanced thinking has spread rapidly over our daily lives until it has choked almost to death our quirks and obsessions, our compulsively inspired eccentricities and our wayward intuitions. Almost, but not quite, for the human animal is a resilient creature and our inherent playfulness, our creative neophilia, is hard to stifle. Even in the most austerely restrictive surroundings it manages to surface occasionally, if only as a factory strike or a football riot. For strikes and riots are certainly creative acts. They contain the essence of creativity – a breaking of existing rules and the bringing about of a change in the accepted order of things. They relieve boredom by briefly introducing a novel social context into dull, repetitive lives. Above all, they produce the excitement of moment-to-moment unpredictability. But they are no more than tragic substitutes for constructive creativity.

The problem becomes one of how to foster adult play without destroying adult work. The work has to go on, and we might even be expected to show occasional interest in such routine organizational status battles, just so long as they are not inflated above their true level of creative importance, which lies somewhere between street cleaning and sewage disposal.

I do not mean to belittle such activities. All societies need their maintenance and salvage operations, but they have to be kept in perspective. They must not become an end in themselves. There has to be something else. But if a politician is asked what new cultural trends he is actively instigating, what innovations he is pursuing, he will probably reply that his highest aim at present is to struggle through until next Thursday. About his only achievement in recent years, apart from darning the holes in the darned holes of the social sock, has been to liberalize education to a point where school-leavers are un-brainwashed enough to want to destroy the tower-block cells and the factory prisons to which they are then confined for the rest of their active lives, and in which they are expected to operate mentally at the level of cud-chewing ungulates.

For a society to thrive, the playfulness of childhood must survive and mature as an adult mode of self-expression, and must do so with encouragement, if those adult games people play are not going to be the ugly games of destruction. Any society which becomes so over-weight that it finds itself totally obsessed with self-maintenance, will soon face decline. There must always be time set aside for playful innovations, for subjective explorations; in short, for the poetic and the mysterious alongside the objective and the rational.

The pleasant irony is that the more fully a man gives himself up to totally irrational thought processes during parts of his working life, the more brutally objective and lucid he can be at other times. It is as if one half of the brain writes poetry and the other half dictates business letters, and if one half is ignored it becomes restless and fouls up the other. If they are both allowed to function fully, they both benefit.

So, to become personal, an objective scientist who paints pictures in a highly subjective manner can find himself, mentally, in an attractive position. By giving his subjective fantasies full expression in paint, he can then

be unrestrainedly and remorselessly objective in his scientific work. If he looks at human behaviour, he can see it for what it is, the complex activity of a large, naked-skinned mammal, rather than as the puppet-show of some heavenly puppeteer. And the more pellucid his objective vision becomes, the more darkly imaginative can become his moments of subjectivity.

That, at least, is the theory. That is how I find myself excusing my wilfully obscure paintings, when answering those who complain that, although they can understand every word I write, they cannot understand a single shape I paint. It is a good answer, and it may even be true, but against it must be set the fact that irrational, intuitive leaps are used during the brief creative moments of scientific research, and also there is a certain need for mundane planning and organization in the execution of a painting. Furthermore, I have heard it said that my painting is too clinical and my scientific writing too imaginative, so perhaps my attempt at a dual extremism in my modes of thought has not been entirely unsuccessful. Perhaps there has been a reciprocal leakage

between the two worlds in which I live. It is true that my paintings are very biomorphic, very preoccupied with biological shapes, and that my biological writings are largely concerned with visual patterns of behaviour. I have never resisted that kind of leakage, but it does not have to do with the fundamental creative processes involved in the two activities. These, I still believe, are basically different, and complement one another rather than compete with, or distort one another.

Recently, neurophysiologists have begun to pay more attention to this problem and it now seems likely that this division that I am postulating into two types of mental process actually has some structural basis in the brain. If this research makes further advances, and confirms that the two kinds of activity are mutually beneficial, perhaps the time will come when we will give up the folly of separating sub-adults into the imaginative and the analytical – artists and scientists – and encourage them to be both at once.

1974

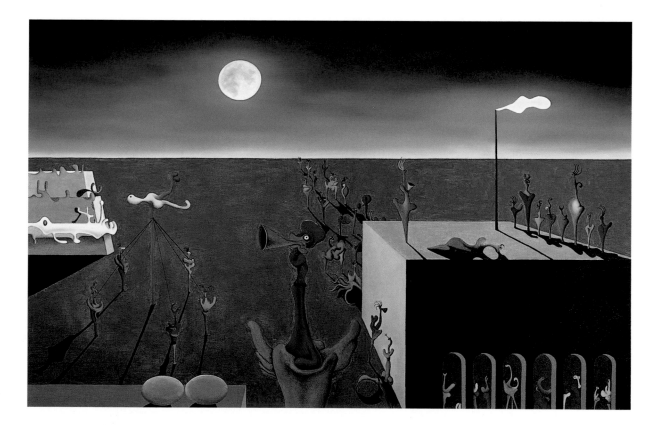

THE RED GUARD
1986
Oil on canvas
24 × 36 in. (60 × 90 cm.)

205

Paintings and objects by Desmond Morris 1944—96

An asterisk indicates that a painting has been lost.

1944

1 Night Music
Crayon on paper 5 × 7 in.
(12·5 × 17·5 cm.)

2 Dream-flight
Crayon on paper 10 × 8 in. (25 × 20 cm.)*

3 Sleep
Crayon on paper 8 × 13 in.
(20 × 32·5 cm.)*

4 Chicago
Crayon on paper 8 × 13 in.
(20 × 32·5 cm.)*

1945

1 Portrait
Wax crayons and pencil on paper 9 × 6 in.
(22·5 × 15 cm.)

2 Journey Home
Tempera 21·5 × 14·5 in. (54·5 × 37 cm.)*

3 Aftermath
Tempera on card 40 × 30·5 in.
(101 × 77·5 cm.)*

4 Kitten and Tiles
Tempera 25·5 × 20·5 in. (65 × 52 cm.)*

5 Flowers of Eden
Tempera 32·5 × 27 in. (82·5 × 68·5 cm.)*

6 Hunting Scene
Oil on canvas.

1946

1 The Kiss
Oil on board 16 × 13 in. (40 × 32·5 cm.)

2 The Entry of a Siren
Ink and water-colour on paper 10 × 8 in.
(25 × 20 cm.)*

3 Sunbath
Ink and water-colour on paper 10 × 8 in.
(25 × 20 cm.)*

4 Night Comes
Ink and water-colour on paper 10 × 8 in.
(25 × 20 cm.)

5 They Came to the Door
Oil on board 15 × 20 in. (37·5 × 50 cm.)*

6 Over the Wall
Oil on board 29 × 24 in. (72·5 × 60 cm.)

7 Sketch for the Philosopher's Abyss
Ink and pastel on paper 8 × 10 in.
(20 × 25 cm.)

8 The Philosopher's Abyss
Oil on board 19 × 24 in. (47·5 × 60 cm.)
*Collection Mrs Tonie Underwood, Hove,
Sussex.*

9 A Girl Selling Flowers
Oil on board 29·5 × 35·5 in.
(74 cm × 89 cm.)
Public Art Gallery, Swindon, Wilts.

10 Two Fish in Heaven
Oil on board 22 × 29 in. (55 × 72·5 cm.)

11 The Family
Oil on board 28 × 19 in. (70 × 47·5 cm.)
*Collection Capt. G. D. Machin, Heathfield,
Sussex.*

12 Seated Woman
Oil on card 19 × 14 in. (47·5 × 35 cm.)

13 Nightscape
Oil on board 14 × 10 in. (35 × 25 cm.)

14 Last Drink
Oil on board 18 × 14 in. (45 × 35 cm.)*

15 The Actress
Oil on board 21 × 14 in. (52·5 × 35 cm.)
*Collection Mr David Haydock, Petersfield,
Hants.*

16 Aquascape
Oil on board 14 × 11 in. (35 × 27·5 cm.)
*Collection Mrs Tonie Underwood, Hove,
Sussex.*

17 Woman in an Armchair
Oil on board 27 × 16 in. (67·5 × 40 cm.)
Collection Tony Hubbard, London.

18 Knock once
Oil on board 20 × 25 in. (50 × 62·5 cm.)
Collection Mr John Comely.

19 Portrait of a Lady
Oil on board 22 × 10 in. (55 × 25 cm.)*

20 Landscape without a Memory*
Oil on canvas 8 × 11 in. (20 × 27·5 cm.)

21 Christmas Painting
Oil on board 24 × 32 in. (60 × 80 cm.)*

22 Mother and Child
Pastel and wax crayon on paper 10 × 8 in.
(25 × 20 cm.)

23 Portrait of a Dying Man
Oil on panel 24 × 25 in. (60 × 62·5 cm.)*

24 The Encounter
Oil on board 23 × 28 in. (57·5 × 70 cm.)*

25 Portrait of Mrs M.
Water-paint on board 20 × 18 in. (50 × 45 cm.)*

26 Landscape for 1946
Oil on board 27 × 33 in. (67·5 × 82·5 cm.)*

27 Portrait of a Girl
Oil on board 13 × 21 in. (32·5 × 52·5 cm.)
*Collection Mrs Tonie Underwood, Hove,
Sussex.*

28 The Entrance
Oil on board 17 × 22 in. (42·5 × 55 cm.)*

29 Mother and Child
Oil on canvas 30 × 25 in. (75 × 62·5 cm.)*

30 The Night has Eyes
Indian ink 6 × 9 in. (15 × 22·5 cm.)*

31 The Moon is Falling
Indian ink 6 × 9 in. (15 × 22·5 cm.)*

32 Self-study
Oil on board 43 × 32 in. (107·5 × 80 cm.)*

33 Lady on a Train
Oil on board 14 × 12 in. (35 × 30 cm.)*

**34 Landscape Prepared for a Tranquil
Disturbance**
Oil on canvas 12 × 16 in. (30 × 40 cm.)*

35 Woman Wearing a Raincoat
Oil on board 21 × 14 in. (52·5 × 35 cm.)*

36 Figure of Man
Pencil 10 × 8 in. (25 × 20 cm.)*

37 Woman with Animal Dream
Oil on board.

38 Senator
Pastel on paper.

39 Strange Woman*

40 Still Life with Fruit*

41 Pink Sky*

42 Obsession*

43 Two Figures
Indian ink and crayon 12 × 10 in.
(30 × 25 cm.)*

44 Around the Nymph
Indian ink and crayon 12 × 10 in.
(30 × 25 cm.)*

45 Self-study
Oil.

46 The Hammock
Oil on board 34 × 25 in. (85 × 62·5 cm.)

47 The Streets Possess
Oil 12 × 10 in. (30 × 17.5 cm.)*

48 The Sidewalk*

49 Submission
Oil and Indian ink 10 × 12 in.
(25 × 30 cm.)*

50 Early Morning Study*

51 How Few the Many
Oil 22 × 15 in. (55 × 37.5 cm.)*

52 The Tomb
Mixed media on board 25 × 20 in.
(62.5 × 50 cm.)*

53 The Spectator
Oil 10 × 7 in. (25 × 17.5 cm.)*

54 Friendship's Decay
Pastel and wax 12 × 10 in. (30 × 25 cm.)*

55 Dawn Finds No Awakening
*Oil.**

56 Life and Death in the Night
Oil 1 × 7 in. (2.5 × 17.5 cm.)*

57 Large Mural
Oil 43 × 32 in. (107.5 × 80 cm.)*

58 Still Life
23 × 30 in. (57.5 × 75 cm.)*

59 The Fence*

60 The Call
*Oil.**

61 Blue Aperture
*Oil.**

1947

1 Portrait
Pastel on paper 15 × 12 in. (37.5 × 30 cm.)

2 Portrait
Pastel on paper 16 × 11 in. (40 × 27.5 cm.)

3 Four Soldiers
Pastel on paper 16 × 11 in. (40 × 27.5 cm.)

4 Portrait
Pastel on paper 15 × 11 in.
(37.5 × 27.5 cm.)

5 Cat and Bird Landscape
Oil on canvas 9 × 12 in. (22.5 × 30 cm.)*

6 Portrait-landscape
Oil on card 16 × 11 in. (40 × 27.5 cm.)*

7 Entry to a Landscape
Oil on board 20 × 16 in. (50 × 40 cm.)
Peter Nahum Gallery, London.

8 The Bride
Oil on board 21 × 18 in. (52.5 × 45 cm.)*

9 The Bird Above
Oil on board 26 × 33 in. (65 × 82.5 cm.)*

10 Young Woman on a Bus
Oil on board 25 × 17 in. (62.5 × 42.5 cm.)
Collection Mr J. Mitchell.

11 Discovery of a Species
Oil on canvas 19 × 14 in. (47.5 × 35 cm.)*

12 Woman with Two Green Apples
Oil on board 16 × 21 in. (40 × 52.5 cm.)*

13 The Illegitimate Dance of the Long-nosed Woman
Oil on canvas 12 × 10 in. (30 × 25 cm.)

14 Portrait
Oil on board 18 × 14 in. (45 × 35 cm.)
Collection Mrs Tonie Underwood, Hove, Sussex.

15 Kittentrap
Oil on board 12 × 16 in. (30 × 40 cm.)*

16 Bird Sunscape
Oil on board 12 × 16 in. (30 × 40 cm.)
Collection Anne Simpson, Devon.

17 Woman Reading
Oil on card 16 × 12 in. (40 × 30 cm.)
Collection Mr Ron Crider, San Francisco.

18 Still Life with Fish
Oil on board 12 × 12 in. (30 × 30 cm.)

19 Giant Instrument for the Production of Synthetic Women
Oil on canvas 10 × 8 in. (25 × 20 cm.)
Collection Francis Wykeham-Martin, Gloucester.

20 Birds and Insects
Oil on board 8 × 10 in. (20 × 25 cm.)
Collection Nancy Norris, Swindon.

21 The Departure
Oil on board 14 × 10 in. (35 × 25 cm.)
Collection Mr Arturo Schwarz, Milan.

22 The Nest I
Oil on board 13 × 17 in. (32.5 × 42.5 cm.)
Collection Professor Aubrey Manning.

23 The Nest II
Oil on canvas 13 × 19 in. (32.5 × 47.5 cm.)
Private collection, Vienna.

24 Nude Woman
Oil on board 38 × 25 in. (95 × 62.5 cm.)*

25 Portrait of an Actress
Oil on canvas 23 × 13 in.
(57.5 × 32.5 cm.)*

26 Portrait of Patricia
Oil on board 20 × 16 in.
(50 × 40 cm.) (approx.)
Collection Mr J. Mitchell.

27 The Widow
Oil on canvas 20 × 30 in.
(50 × 75 cm.) (approx.)
Collection Mrs Linda Levy, Bristol.

28 Bird Singing
Ink and pastel on paper 11 × 18 in.
(27.5 × 45 cm.)

29 Moonscape
Oil on card 10 × 8 in. (25 × 20 cm.)

30 Landscape for a Para-Introvert
Oil on card 14 × 18 in. (35 × 45 cm.)
Collection Mr Hugh Clement, Swansea.

31 Master of the Situation
Oil on canvas 16 × 12 in. (40 × 30 cm.)
Collection Mrs Elaine Fraser, Ealing, London.

32 Acrobat
Mixed media 8 × 4 in. (20 × 10 cm.)

33 Dancing Figure
Mixed media 4 × 5 in. (10 × 12.5 cm.)
Collection Mr J.S. Kennedy, London.

34 The Instructor
Oil 23 × 13 in. (57.5 × 32.5 cm.) (approx.)*

35 Holiday

36 Woman in an Armchair
*Oil and pastel.**

37 Portrait of a Girl
*Oil.**

38 Landscape for Three
Oil on canvas 10 × 12 in. (25 × 30 cm.)*

39 Autoptical Landscape I.*

40 Autoptical Landscape II.*

41 The Discovery
*Oil.**

42 Garden
*Oil.**

43 Double Figure Study
*Oil.**

44 Portrait of an Imbecile Girl
*Oil and pastel.**

45 Man-motion
*Oil.**

46 Equivalent for Man-motion
*Oil.**

47 Floating Landscape
*Oil.**

48 Portrait of a Sadistic Woman
*Oil.**

49 Personal Landscape.*

50 Enigmascape.*

51 Professor and Bird.*

52 Intravertial Inopp.*

53 Woman in an Easy Chair.*

54 A Woman Awakened.*

55 Dance of the Grotesque Dream.*

56 Woman in the Night.*

57 Still Life.*

58 Landscape with Music.*

59 Woman in an Upright Chair
16 × 13 in. (40 × 32.5 cm.)*

60 Farewell My Lovely.*

61 The Schoolmistress
Oil on canvas 12 × 26 in. (30 × 65 cm.)

62 Portrait of an Adolescent Girl.*

63 Landscape
*On paper.**

64 Third Side Landscape
*On board.**

1948

1 Confrontation
Oil on canvas 18 × 12 in. (45 × 30 cm.)
Eric Franck Gallery, London.

2 Hypnotic Painting
Oil on canvas 13 × 28 in. (32·5 × 70 cm.)

3 Reclining Nude
Oil on canvas 15 × 30 in. (37·5 × 75 cm.)
Collection Mr and Mrs T. Burkin, Savernake.

4 The Encounter I
Oil on canvas 6 × 8 in. (15 × 20 cm.)
Collection Mr Andrew Murray, Richmond,
Surrey.

5 The Parent
Oil on canvas 6 × 8 in. (15 × 20 cm.)*

6 The Lovers
Oil on canvas 8 × 6 in. (20 × 15 cm.)
Collection Mrs Ramona Morris, Oxford.

7 Red Landscape
Oil on board 13 × 27 in. (32·5 × 67·5 cm.)*

8 The Green Sprite
Oil on canvas 8 × 6 in. (20 × 15 cm.)
Collection Mr Andrew Murray, Richmond,
Surrey.

9 The Dreaming Cretin
Oil on board 14 × 19 in. (35 × 47·5 cm.)*

10 Celebration
Oil on board 28 × 37 in. (70 × 92·5 cm.)
Eric Franck Gallery, London.

11 The Dove
Oil and plaster on canvas 23 × 26 in.
(57·5 × 65 cm.)

12 L'Enfant Terrible
Oil on canvas 27 × 23 in. (67·5 × 57·5 cm.)*

13 The Edge of the World
Oil on canvas 12 × 16 in. (30 × 40 cm.)*

14 Man and Machine
Oil, pastel, ink and pencil on paper 9 × 7 in.
(22·5 × 17·5 cm.)

15 The Hermit Discovered
Oil on canvas 16 × 22 in. (40 × 55 cm.)

16 Flower Machine
Oil on canvas 20 × 26 in. (50 × 65 cm.)*

17 The Hunter
Oil and plaster on canvas 17 × 21 in.
(42·5 × 52·5 cm.)
Collection Mr Paul Conran, London.

18 The Green Forest
Oil on canvas 10 × 16 in. (25 × 40 cm.)*

19 The Red Flower
Oil on board 10 × 17 in. (25 × 42·5 cm.)

20 The Suicide
Oil on glass 8 × 11 in. (20 × 27·5 cm.)
Collection Mr Peter Carreras, London.

21 Flower Woman Machine
Oil on canvas 14 × 7 in. (35 × 17·5 cm.)*

22 The Encounter II
Oil on canvas 8 × 16 in. (20 × 40 cm.)

23 Man Jumping
Oil on canvas 21 × 16 in. (52·5 × 40 cm.)
Collection Mrs Gordon Harris, London.

24 The Love Letter
Oil on canvas 20 × 16 in. (50 × 40 cm.)

25 The Voyager
Oil Collection Mr Tony Stevens, Chepstow.

26 The Close Friend
Oil on canvas 26 × 20 in. (65 × 50 cm.)
Collection Mrs June Treherne, Cambridge.

27 The Red Dancer
Oil and pastel on card 18 × 13 in.
(45 × 32·5 cm.)
Collection Mr Aturo Schwarz, Milan.

28 Red and Orange Situation
Oil on card 16 × 12 in. (40 × 30 cm.)
Collection Mr Aturo Schwarz, Milan.

29 The Courtship I
Oil on canvas 54 × 38 in. (135 × 95 cm.)
Collection Mr Joris de Schepper, Paris.

30 The Table
Oil on canvas 14 × 18 in. (35 × 45 cm.)
Phipps and Co., Fine Art, London.

31 The Courtship II
Oil on canvas 14 × 19 in. (35 × 47·5 cm.)
Private collection, Vienna.

32 Owl
Chalk and ink on paper 15 × 11 in.
(37·5 × 27·5 cm.)

33 Informal Landscape
Ink, crayon and pastel on paper 8 × 6 in.
(20 × 15 cm.)

34 Statue
Ink and pastel on paper 16 × 12 in.
(40 × 30 cm.)

35 Two Figures
Crayon and pastel on paper 11 × 8 in.
(27·5 × 20 cm.)

36 Silent Figure
Mixed media 6 × 3 in. (15 × 7·5 cm.)

37 Comparative Anatomy
Mixed media 8 × 13 in. (20 × 32·5 cm.)
Peter Nahum Gallery, London.

38 Crisis of Identity
Mixed media 8 × 13 in. (20 × 32·5 cm.)

39 Explaining the Riddle
Mixed media 7 × 5 in. (17·5 × 12·5 cm.)

40 Two Friends
Mixed media 8 × 6 in. (20 × 15 cm.)
Collection Mr Joris de Schepper, Paris.

41 Startled Goddess
Mixed media 7 × 4 in. (17·5 × 10 cm.)

42 The Partygoers
Mixed media 4 × 6 in. (10 × 15 cm.)

43 Warning Signals
Oil on canvas 8 × 14 in. (20 × 35 cm.)

44 The Lincoln Walls
Ink and crayon on paper 9 × 7 in.
(22·5 × 17·5 cm.)

45 Defence of the Realm*
Object in painted wood, metal and shell.
Diameter 12 in. (29 cm.)

46 The Performer
Oil on canvas 40 × 24 in. (100 × 60 cm.)

47 The City
Oil on canvas 40 × 49 in.
(100 × 122·5 cm.)*

48 The Visitor (The Uninvited Guest)
Painted goats skull. 9·5 in. (24 cm.) high,
including base.
Faggionato Fine Arts, London.

49 Bomb God
Decorated incendiary bomb. Height: 15 in.
(37·5 cm.)*

50 Male God
Wood, glass and oil. Height: 11 in.
(27·5 cm.)*

51 Dancing Stone
Mounted flint. Height: 11 in. (27·5 cm.)*

52 Introvert/Extrovert/Pervert
Metal and stone. Height: 19 in. (47·5 cm.)*

53 The Bride
String and wire. 25 × 30 in. (62·5 × 75 cm.)*

53 New Lives for Old
Metal and glass.
Height: 6 in. (15 cm.)

Note At the Swindon exhibition of August
1948 a painting called Wallwoman was
included in the catalogue (no. 36), but
no details of it are available.

1949

1 The Desiccation of the Poet
Gouache on card 9 × 7 in.
(22·5 × 17·5 cm.)

2 The Jumping Three
Oil on canvas 30 × 50 in. (75 × 125 cm.)
Birmingham City Museum and Art Gallery.

3 Colony Relations
Water-colour on paper 10 × 7 in.
(25 × 17·5 cm.)

4 Acrobatic Dispute
Gouache on paper 9 × 12 in.
(22·5 × 30 cm.)

5 The Suicides
Oil on board 50 × 30 in. (125 × 75 cm.)*

6 The Observer
Oil on canvas 17 × 22 in. (42·5 × 55 cm.)*

7 The Inhabitants
Oil on canvas 10 × 16 in. (25 × 40 cm.)
Private collection, Berkshire.

8 The Intruder
Oil on card
12 × 16 in. (30 × 40 cm.)
Collection Mr Ron Crider, San Francisco.

9 Design for a Statue
Oil on board 34 × 25 in. (85 × 62·5 cm.)*

10 Farewell
Oil on Canvas 30 × 25 in. (75 × 62·5 cm.)*

11 The Visitor
Oil on canvas 9 × 12 in. (22·5 × 30 cm.)*

12 The Actors
Oil on board 11 × 13 in. (27·5 × 32·5 cm.)*

13 The Restless Soldiers
Gouache on paper 6 × 10 in. (15 × 25 cm.)

14 The Lookouts
Gouache on paper 6 × 9 in. (15 × 22·5 cm.)

15 The Explorer
Gouache on card 7 × 18 in. (17·5 × 45 cm.)

16 The Assault
Oil on board 18 × 29 in. (45 × 72·5 cm.)*

17 The Bathers I
Oil on paper 8 × 13 in. (20 × 32·5 cm.)*

18 Family on the Beach
Oil on paper 7 × 12 in. (17·5 × 30 cm.)
Collection Dr Philip Guiton, Les Eyzies,
France.

19 Only the Guest is at Ease
Oil on paper 10 × 15 in. (25 × 37·5 cm.)
Collection Mrs Celia Philo, London.

20 The Bathers II
Oil on paper 8 × 13 in. (20 × 32·5 cm.)

21 Ageing Dancer
Oil on paper 8 × 13 in. (20 × 32·5 cm.)

22 Storm Coming
Oil 7 × 10 in. (17·5 × 25 cm.)
Collection Dr Neil Kendall, Shrewsbury.

23 The Apple-Pickers
Oil and Indian ink on paper 8 × 13 in.
 (20 × 32·5 cm.)
Collection Mr Philip Oakes, Lincolnshire.

24 The Fatal Attraction of the Poet
Oil on paper 8 × 13 in. (20 × 32·5 cm.)

25 Moonscape
Oil and pastel on paper 8 × 13 in.
 (20 × 32·5 cm.)

26 The Farmer
Oil on board 8 × 12 in. (20 × 30 cm.)
Collection Anne Simpson, Devon.

27 The Monster
Oil on paper 5 × 6 in. (12·5 × 15 cm.)*

28 Work Force
Oil on gouache and paper 8 × 13 in.
 (20 × 32·5 cm.)

29 St George and the Dragon
Oil on paper 8 × 13 in. (20 × 32·5 cm.)

30 St George
Oil on paper 8 × 13 in. (20 × 32·5 cm.)

31 Dragon
Oil on paper 7 × 8 in. (17·5 × 20 cm.)

32 The Nest IV
Oil on paper 7 × 11 in. (17·5 × 27·5 cm.)*

33 The Herd
Oil on card 29 × 48 in. (72·5 × 120 cm.)

34 The Daymare Begins
Oil on paper 8 × 13 in.
 (20 × 32·5 cm.) (approx.)*

35 The Family
Mixed media.

36 Siblings
Oil on paper 10 × 14 in. (25 × 35 cm.)
Collection Mr Joris de Schepper, Paris.

37 War-woman
Mixed media on board 2 8 × 17 in.
 (70 × 42·5 cm)
Mayor Gallery, London.

38 The Proposal
Oil on paper 14 × 9 in. (35 × 22·5 cm.)
Department of Prints and Drawings, British
 Museum, London.

39 The Witness
Mixed media on board 9 × 13 in.
 (22·5 × 32·5 cm.)
Collection Mrs Courtney Ross, Long Island.

40 The Red Ritual
Oil on board 14 × 22 in. (35 × 55 cm.)
Collection Mr Tony Hubbard, London.

41 Cat I
Oil on paper 13 × 8 in. (32·5 × 20 cm.)
Collection Mrs June Treherne, Cambridge.

42 Cat II (Three Cats)
Oil on paper 13 × 8 in. (32·5 × 20 cm.)
Collection Mr Oscar Mellor, Exeter.

43 Cat III (Two Cats)
Oil on paper 13 × 8 in. (32·5 × 20 cm.)
Collection Mr Oscar Mellor, Exeter.

44 Cat IV
Oil on paper 13 × 8 in. (32·5 × 20 cm.)*

45 Cat V
Oil on paper 13 × 8 in. (32·5 × 20 cm.)
Private collection, Berkshire.

46 Cat VI (Two Cats)
Oil on paper 13 × 8 in. (32·5 × 20 cm.).
Peter Nahum Gallery, London.

47 Cat VII (Cat and Kitten)
Oil on paper 13 × 8 in. (32·5 × 20 cm.)
Collection Mr Joris de Schepper, Paris.

48 Cat VIII (Cat and Moon)
Oil on paper 13 × 8 in. (32·5 × 20 cm.)
Collection Mr Joris de Schepper, Paris.

49 Cat IX (Three Cats)
Oil on paper 13 × 8 in. (32·5 × 20 cm.)
Collection Mr Joris de Schepper, Paris.

50 Cat × (Four Cats)
Oil on paper 13 × 8 in. (32·5 × 20 cm.)
Collection Mr Joris de Schepper, Paris.

51 Cat XI
Oil on paper 13 × 8 in. (32·5 × 20 cm.)

52 Cat XII
Oil on paper 13 × 8 in. (32·5 × 20 cm.)

53 Cat XIII (Four Cats)
Oil on paper 13 × 8 in. (32·5 × 20 cm.)

54 Cat XIV (Two Cats with Flag)
Oil on paper 13 × 8 in. (32·5 × 20 cm.)

55 Cat XV
Oil on paper 13 × 8 in. (32·5 × 20 cm.)

56 Cat XVI (Cat, Moon and Insect)
Oil on paper 8 × 13 in. (20 × 32·5 cm.)

57 Cat XVII (Four Cats with Moon)
Oil on paper 8 × 13 in. (20 × 32·5 cm.)

58 Cat XVIII (Six Cats)
Oil on paper 8 × 13 in. (20 × 32·5 cm.)

59 Cat XIX (Three Cats and Sun)
Oil on paper 8 × 13 in. (20 × 32·5 cm.)

60 Cat XX (Four Cats and Moon)
Oil on paper 8 × 13 in. (20 × 32·5 cm.)

61 King
Oil on paper 13 × 8 in. (32·5 × 20 cm.)

62 Dog, Man and Woman
Oil on paper 8 × 13 in. (20 × 32·5 cm.)
Collection Mr Paul Weir, Wroughton, Wilts.

63 Acrobat
Oil on paper 13 × 8 in. (32·5 × 20 cm.)
Collection Mr Paul Weir, Wroughton, Wilts.

64 Creating a Disturbance
Oil and gouache on paper 10 × 12 in.
 (25 × 30 cm.)
Collection Mr Oscar Mellor, Exeter, Devon.

65 Reclining Nude
Oil on paper 5 × 13 in. (12·5 × 32·5 cm.)
Collection Mr Hugh Clement, Wales.

66 The Cabaret Message
Ink and gouache on black paper 10 × 12 in.
 (25 × 30 cm.)

67 Bird-dream
Water-colour on black paper 10 × 7 in.
 (25 × 17·5 cm.)
Collection Mr Denis Berthu, Paris.

68 Family Fissions
Ink and water-colour on black paper
 10 × 12 in. (25 × 30 cm.)

69 Primitive Performer
Oil on paper 8 × 13 in. (20 × 32·5 cm.)

70 Poseurs in Love
Oil on paper 20 × 13 in. (50 × 32·5 cm.)

71 Playtime Posturing
Gouache on paper 9 × 12 in.
 (22·5 × 30 cm.)

72 Tribal Conceits
Oil and crayon on paper 20 × 12 in.
 (50 × 30 cm.)
Collection Mr Joris de Schepper, Paris.

73 The Trappings of Privacy
Oil on paper 21 × 12 in. (52·5 × 30 cm.)
Department of Prints and Drawings, British
 Museum, London.

74 The Rage of the Celibate
Oil on paper 13 × 8 in. (32·5 × 20 cm.)

75 The Important Arrival
Oil on paper 8 × 13 in. (20 × 32·5 cm.)

76 Susanna Bathing
Oil on paper 7 × 8 in. (17·5 × 20 cm.)

77 The New Friend
Ink and gouache on paper 14 × 21 in.
 (35 × 52·5 cm.)

78 Formal Relations
Oil and ink on paper 10 × 17 in.
 (25 × 42·5 cm.)

79 The Waiting Time
Oil on glass 8 × 12 in. (20 × 30 cm.)

80 Still Life
Gouache on paper 6 × 9 in. (15 × 22·5 cm.)

81 Figure
Oil on paper 13 × 7 in. (32·5 × 17·5 cm.)
Collection Dr Fae Hall, Bath.

82 Seated Figure
Oil on paper 12 × 7 in. (30 × 17·5 cm.)
Collection Dr Fae Hall, Bath.

83 The Princess
Mixed media 13 × 8 in. (32·5 × 20 cm.)

84 The Butterfly
Mixed media 7 × 9 in. (17·5 × 22·5 cm.)

85 Rank and File
Mixed media 10 × 8 in. (25 × 20 cm.)

86 Nest Site I
Mixed media 8 × 13 in. (20 × 32·5 cm.)

87 Nest Site II
Mixed media 8 × 13 in. (20 × 32·5 cm.)

88 Display Ground
Mixed media 8 × 13 in. (20 × 32·5 cm.)

89 Reclining Figure
Mixed media 8 × 13 in. (20 × 32·5 cm.)

90 The Journey Begins
Mixed media 8 × 13 in. (20 × 32·5 cm.)

91 Artist and Model
Mixed media 7 × 12 in. (17·5 × 30 cm.)

92 Carnal Friends
Mixed media 8 × 13 in. (20 × 32·5 cm.)

93 Acrobat II
Mixed media 13 × 8 in. (32·5 × 20 cm.)

94 Day of the Fireflies
Mixed media 13 × 8 in. (32·5 × 20 cm.)

95 Clairvoyant Surprised
Mixed media 13 × 8 in. (32·5 × 20 cm.)

96 Private Beach
Mixed media 8 × 13 in. (20 × 32·5 cm.)

97 Lost Bird of Youth
Mixed media 8 × 13 in. (20 × 32·5 cm.)
Collection Mr Richard Read, Cheshire.

98 Garden Spirits
Mixed media 8 × 13 in. (20 × 32·5 cm.)

99 Lost Friendship, New Friendship
Mixed media 6 × 9 in. (15 × 22·5 cm.)

100 Memories of the Dance
Mixed media 7 × 5 in. (17·5 × 12·5 cm.)

101 The Inheritor
Mixed media 7 × 5 in. (17·5 × 12·5 cm.)

102 Garden Ritual
Mixed media 6 × 7 in. (15 × 17·5 cm.)

103 Three Neighbours
Mixed media 6 × 9 in. (15 × 22·5 cm.)

104 Vision of Mortality
Mixed media 7 × 9 in. (17·5 × 22·5 cm.)

105 Dawn Chorus
Mixed media 3 × 13 in. (7·5 × 32·5 cm.)

106 Jack-in-the-Box
Mixed media 7 × 7 in. (17·5 × 17·5 cm.)

107 The Young Pretender
Mixed media 5 × 6 in. (12·5 × 15 cm.)

108 Smart Set
Mixed media 5 × 4 in. (12·5 × 10 cm.)

109 Courtship Ritual
Mixed media 4 × 5 in. (10 × 12·5 cm.)

110 Three Witnesses
Mixed media 3 × 7 in. (7·5 × 17·5 cm.)

111 Colony Alert
Mixed media 5 × 7 in. (12·5 × 17·5 cm.)

112 Waiting Game
Mixed media 11 × 15 in. (27·5 × 37·5 cm.)

113 Important Presence
Mixed media 10 × 13 in. (25 × 32·5 cm.)

114 Breeding Grounds
Mixed media 9 × 12 in. (22·5 × 30 cm.)

115 Night for Remembrance
Mixed media 8 × 13 in. (20 × 32·5 cm.)

116 Squatting Figure
Crayon and pastel 17 × 12 in.
 (42·5 × 30 cm.)

117 Bird Machine
Mixed media 5 × 7 in. (12·5 × 17·5 cm.)

118 Declaimer
Mixed media 8 × 7 in. (20 × 17·5 cm.)

119 Statue for a Lost Child
Mixed media 13 × 8 in. (32·5 × 20 cm.)

120 Star Performer
Mixed media 8 × 13 in. (20 × 32·5 cm.)

121 Dreamer
Mixed media 6 × 8 in. (15 × 20 cm.)

122 The Cloak
Mixed media 13 × 8 in. (32·5 × 20 cm.)

123 Dreaming Woman
Mixed media 8 × 13 in. (20 × 32·5 cm.)

124 Warrior I
Mixed media 13 × 8 in. (32·5 × 20 cm.)

125 Persistent Melody
Mixed media 13 × 8 in. (32·5 × 20 cm.)

126 The Middle-class Fantasy
Mixed media 13 × 8 in. (32·5 × 20 cm.)

127 Beach Warning
Oil on board 17 × 20 in. (42·5 × 50 cm.)

128 Not to be Taken before Noon
Ink and water-colour 30 × 40 in.
 (75 × 100 cm.)
Collection Conroy Maddox, London.

1950

1 About to Begin
Oil on board 8 × 10 in. (20 × 25 cm.)
Collection Dr Fae Hall, Bath.

2 Equals and Opposites
Oil on card 9 × 12 in. (22·5 × 30 cm.)
*Collection Mr Paul Weir,
 Wiltshire.*

3 Two Figures
Gouache on paper 8 × 10 in. (20 × 25 cm.)
Collection Dr Fae Hall, Bath.

4 The Bride
Oil and ink on paper 13 × 8 in.
 (32·5 × 20 cm.)

5 War Hero
Oil and ink on paper 13 × 8 in.
 (32·5 × 20 cm.)

6 The Ugly Puritan
Oil and ink on paper 13 × 8 in.
 (32·5 × 20 cm.)

7 First Glimpse of Treasure
Oil, ink and water-colour on paper
 8 × 13 in. (20 × 32·5 cm.)

8 The Star is Ready
Oil on paper 13 × 8 in. (32·5 × 20 cm.)

9 The Winner is Confused
Ink, pastel and water-colour on paper
 14 × 10 in. (35 × 25 cm.)

10 Woman of the World
Ink and pastel on paper 15 × 10 in.
 (37·5 × 25 cm.)

11 Bird Machine
Ink and pastel on paper 15 × 10 in.
 (37·5 × 25 cm.)

12 The Overpowering Friend
Ink and pastel on paper 15 × 10 in.
 (37·5 × 25 cm.)

13 Face of Concern I
Oil on paper 8 × 13 in. (20 × 32·5 cm.)

14 Blue Landscape
Oil on board 12 × 14 in. (30 × 35 cm.)
*Collection Professor Aubrey Manning,
Edinburgh.*

15 The Loved One
Oil on board 6 × 8 in. (15 × 20 cm.)
Collection Mrs Ramona Morris, Oxford.

16 The Gloved Face
Oil on board 9 × 12 in. (22·5 × 30 cm.)
*Collection Mr Alan Durham-Smith, Dallas.
 Texas*

17 The Survivors
Oil on canvas 10 × 14 in. (25 × 35 cm.)
*Collection Mr and Mrs Paul McCartney,
 Sussex.*

18 The Progenitor
Oil on canvas 12 × 16 in. (30 × 40 cm.)
Collection Mr Mark Seidenfeld, New York.

19 Father at the Nest
Oil on paper 8 × 13 in. (20 × 32·5 cm.)
Collection Mr Joris de Schepper, Paris.

20 Sunset Figure
Oil, ink and crayon on paper 7 × 10 in.
 (17·5 × 25 cm.)

21 False Ego
Ink and pastel on paper 8 × 10 in.
 (20 × 25 cm.)

22 The Adolescents
Oil on paper 13 × 8 in. (32·5 × 20 cm.)
*Collection Mr Arnold B. Kanter, Evanston,
 Illinois, USA.*

23 The Warrior
Oil, ink and water-colour on paper
 13 × 8 in. (32·5 × 20 cm.)
*Collection Mr Arnold B. Kanter, Evanston,
 Illinois, USA.*

24 The One-trick Life
Gouache on paper 13 × 8 in.
 (32·5 × 20 cm.)

25 Earthbound Companion
Gouache on paper 8 × 10 in. (20 × 25 cm.)

26 Girl of Prey
Gouache and ink on paper 8 × 10 in.
 (20 × 25 cm.)

27 Confidential Enemy
Ink and water-colour on paper 8 × 7 in.
 (20 × 17·5 cm.)

28 Parental Group
Coloured inks on paper 15 × 10 in.
 (37·5 × 25 cm.)

29 Moon Blood
Ink and water-colour on paper 15 × 10 in.
 (37·5 × 25 cm.)

30 The Serious Game
Oil on canvas 10 × 16 in. (25 × 40 cm.)

31 Landscape with Watchers
Oil on board 10 × 8 in. (25 × 20 cm.)
Private collection, Berkshire.

32 The Trap
Oil on canvas 16 × 20 in. (40 × 50 cm.)
Collection Mr Tom Maschler, London.

33 The Silent Friend
Oil on canvas 12 × 8 in. (30 × 20 cm.)

34 The Starry Night
Oil on board 12 × 18 in. (30 × 20 cm.)
Collection Mrs Ramona Morris, Oxford.

35 The Hunters Surprise
Oil on board 8 × 10 in. (20 × 25 cm.)
*Collection Mr Alan Durham-Smith, Dallas,
 Texas.*

36 The Springing Season
Oil on card 14 × 24 in. (35 × 60 cm.)

37 Endogenous Activities
Oil on canvas 21 × 31 in. (52·5 × 77·5 cm.)
*Collection the Estate of Mrs Mary Horswell,
 Hampshire.*

38 Bird Rising
Ink and water-colour 5 × 4 in.
 (12·5 × 10 cm.)

39 The Long Journey I
Mixed media
8 × 13 in. (20 × 32·5 cm.)

40 The Long Journey II
Mixed media 8 × 13 in. (20 × 32·5 cm.)

41 Balancing Act
Mixed media 8 × 5 in. (20 × 12·5 cm.)

42 Industrial Landscape
Mixed media 6 × 6 in. (15 × 15 cm.)

43 Anguish in Springtime
Ink and water-colour 8 × 10 in. (20 × 25 cm.)

44 Face of Concern II
Oil on paper 8 × 13 in. (20 × 32·5 cm.)

45 Face of Concern III
Oil on paper 8 × 13 in. (20 × 32·5 cm.)

46 Flowerseller I
Oil on paper 8 × 13 in. (20 × 32·5 cm.)

47 Flowerseller II
Oil on paper 8 × 13 in. (20 × 32·5 cm.)

48 Woman without Companion I
Oil on paper 13 × 8 in. (32·5 × 20 cm.)

49 Woman without Companion II
Oil on paper 13 × 8 in. (32·5 × 20 cm.)

50 Woman without Companion III
Oil on paper 13 × 8 in. (32·5 × 20 cm.)

51 Woman without Companion IV
Oil on paper 13 × 8 in. (32·5 × 20 cm.)

52 Woman without Companion V
Oil on paper 13 × 8 in. (32·5 × 20 cm.)

53 Woman without Companion VI
Oil on paper 13 × 8 in. (32·5 × 20 cm.)

54 The Song of the Planet
Embroidered tablecloth 32 × 32 in.
 (80 × 80 cm.)

55 The Way of the World
Oil on ceramic (decorated pot)
Collection Mr Andrew Murray, Surrey.

1951

1 Girl Studying
Oil on canvas 16 × 12 in.
 (40 × 30 cm.) (approx.)*

2 Squatting Figure
Oil on board 16 × 12 in.
 (40 × 30 cm) (approx.)*

3 The Entomologist
Oil on board 28 × 20 in. (70 × 50 cm.)
Collection Dr John Godfrey, London.

4 Woman Thinking to Herself
Oil on board 12 × 24 in. (30 × 60 cm.)
Collection Mr Oscar Mellor, Exeter.

5 The Jester
Oil on canvas 24 × 18 in. (60 × 45 cm.)
*Collection Jens Birger Christensen,
 Klampenborg, Denmark.*

6 The Greeting Ceremony
Oil on board 7 × 10 in. (17·5 × 25 cm.)
Collection Dr Jeffrey Sherwin, Leeds.

7 Introspective Moment
Oil on card 29 × 21 in. (72·5 × 52·5 cm.)

8 Angels at Play
Oil on canvas 20 × 25 in. (50 × 62·5 cm.)
Collection Mr Norman Goldstein, Canada.

9 The Young King
Oil on board 37 × 27 in. (92·5 × 67·5 cm.)
Collection Mr Paul Weir, Wroughton, Wilts.

10 Remoteness of the Leader
Oil on canvas 14 × 7 in. (35 × 17·5 cm.)

11 Everyday Martyr
Oil on canvas 21 × 12 in. (52·5 × 30 cm.)
Collection Miss Muriel Brat, Brussels.

12 Abstract
Pastel on paper 8 × 6 in. (20 × 15 cm.)

13 Lonely Actress
Oil on board 8 × 6 in. (20 × 15 cm.)

14 The One at Home
Coloured inks on paper 15 × 10 in.
 (37·5 × 25 cm.)

15 Unloving Couple
Gouache on paper 12 × 10 in. (30 × 25 cm.)

16 Family Outing
Ink and gouache on paper 10 × 8 in.
 (25 × 20 cm.)

17 Family Group
Ink and gouache on paper 10 × 8 in.
 (25 × 20 cm.)

18 Portrait
Oil on paper 9 × 6 in. (22·5 × 15 cm.)
*Collection Dr Philip Guiton, Les Eyzies,
 France.*

19 Read Head
Oil on board 9 × 12 in. (22·5 × 30 cm.)
Private collection, Berkshire.

20 Hierarchic Head
Mixed media 3 × 4 in. (7·5 × 10 cm.)
Collection Mr Philip Oakes, Lincolnshire.

21 The Orators Daughter
Oil on canvas 27 × 21 in. (67·5 × 52·5 cm.)
Collection Dr John Godfrey, London.

22 The Zoologist
Oil on board 12 × 24 in. (30 × 60 cm.)
Collection Dr John Godfrey, London.

23 The Knowing One
Mixed media 10 × 8 in. (25 × 20 cm.)

24 Sketch for the Jester
Mixed media 10 × 7 in. (25 × 17·5 cm.)
*Collection Miss Jessica Murray, Richmond,
 Surrey.*

25 Head of Girl I
Mixed media 10 × 8 in. (25 × 20 cm.)

26 Head of Girl II
Mixed media 10 × 8 in. (25 × 20 cm.)

27 High Priest I
Oil on paper 12 × 9 in. (30 × 22·5 cm.)

28 High Priest II
Oil on paper 9 × 11 in. (22·5 × 27·5 cm.)

Note In the 1951 exhibition in
 Birmingham four paintings were
 included in the catalogue of which no
 details survive: 95, The Group; 98, The
 Introvert; 100, The Manoeuvre; 101,
 The Eclipse.

1952

1 The Admirals Son
Oil on board 19 × 15 in. (47·5 × 37·5 cm.)

2 Ball Game
Oil on canvas 24 × 16 in. (60 × 40 cm.)
*Collection Jens Birger Christensen,
Klampenborg, Denmark.*

3 Impatient Lovers
Coloured inks on paper 10 × 8 in. (25 × 20
cm.)

4 Startled Inmates
Ink and water-colour on paper 13 × 8 in.
(32·5 × 20 cm.)

5 Pedagogue
Coloured inks on paper 10 × 8 in.
(25 × 20 cm.)

6 The Comforter
Oil on board 32 × 26 in. (80 × 65 cm.)
*Collection Mr Andrew Murray, Richmond,
Surrey.*

7 The Attack
Ink and water-colour on paper 8 × 13 in.
(20 × 32·5 cm.)
*Collection Professor Aubrey Manning,
Edinburgh.*

8 The Bird-lover
Ink and water-colour on paper 8 × 13 in.
(20 × 32·5 cm.)
Private collection, Berkshire.

9 The Scientist
Oil on board 13 × 10 in. (32·5 × 25 cm.)
Collection Mr Norman Goldstein, Canada.

10 The Clown
Oil on canvas 20 × 12 in. (50 × 30 cm.)
Collection Dr John Godfrey, London.

Note In the Ashmolean Museum
exhibition of May 1952 seven paintings
were included that are now lost. Their
dates and other details are unknown. In
the catalogue their entries were as
follows: 41, The Explanation; 45,
Survival Group; 46, The Sublimators;
51, The Shepherd Is Lost; 60, The
Crown; 64, The Theorist; 65, The
Celibate.

1953

No surviving works.

1954

1 The Horizontal One
Oil on panel 10 × 15 in. (25 × 37·5 cm.)
Collection Dr John Godfrey, London.

1955

1 Portrait of a Thinking Girl
Oil on card 18 × 13 in. (45 × 32·5 cm.)

1956

1 Woman with Birds
Oil on canvas 9 × 12 in. (22·5 × 30 cm.)
Collection Mrs Ramona Morris, Oxford.

2 Keep Together
Oil on canvas 7 × 14 in. (17·5 × 35 cm.)
Collection Mr John Nadler, London.

3 The Parade
Oil on canvas 7 × 14 in. (17·5 × 35 cm.)
*Collection Mr T.W.P. Herbert, Caerleon,
Gwent.*

4 Weeping Head
Oil on card 12 × 15 in. (30 × 37·5 cm.)
Collection Dr John Godfrey, London.

1957

1 The Indelible Incident
Oil on canvas 7 × 14 in. (17·5 × 35 cm.)
Collection Mr John Nadler, London.

2 Cyclists
Oil on canvas 7 × 14 in. (17·5 × 35 cm.)
Collection Mr Philip Oakes, Lincolnshire.

3 City Games
Oil on canvas 7 × 14 in. (17·5 × 35 cm.)
Collection Mr John Nadler, London.

4 The Performers
Oil on canvas 7 × 14 in. (17·5 × 35 cm.)
Collection Lee Materia, Dallas, Texas.

5 Totem
Oil on canvas 7 × 14 in. (17·5 × 35 cm.)
Contemporary Arts Society, London.

6 The Colony
Oil on canvas 7 × 14 in. (17·5 × 35 cm.)
Collection Lady Cawdor, Nairn, Scotland.

7 The Blind Leader
Oil on canvas 7 × 14 in. (17·5 × 35 cm.)
Collection Gerald Parkes, London.

8 The Silent Gathering
Oil on board 7 × 14 in. (17·5 × 35 cm.)

9 The Sacrifice
Oil on canvas 7 × 14 in. (17·5 × 35 cm.)
Collection K.J. Lyras, Loughton, Essex.

10 The Enclosure
Oil on canvas 7 × 14 in. (17·5 × 35 cm.)
Collection Mr Stamatis Moskey, Hampshire.

11 Fear of the Past
Oil on canvas 7 × 14 in. (17·5 × 35 cm.)
Collection Dr Michel Remy, Nice.

12 Theres No Time Like the Future
Oil on canvas 7 × 14 in. (17·5 × 35 cm.)

13 The Spanish Table
Oil on canvas 7 × 14 in. (17·5 × 35 cm.)
Collection Dr Gilbert Manley, Durham.

14 Dragon Patrol
Oil on canvas 7 × 14 in. (17·5 × 35 cm.)
*Collection Georgiana W. Bronfman,
New York.*

15 The Charioteer
Oil on canvas 7 × 14 in. (17·5 × 35 cm.)
Collection Mr John Nadler, London.

16 Alter Ego
Oil on canvas 7 × 14 in. (17·5 × 35 cm.)
Collection Mrs Susan Sandman, New York.

17 Two Heads Are Worse Than One
Oil on canvas 7 × 14 in. (17·5 × 35 cm.)*

18 Private Body
Oil on canvas 7 × 14 in. (17·5 × 35 cm.)*

9 The Courtyard Drama
Oil on canvas 7 × 14 in. (17·5 × 35 cm.)*

20 The Victor
Oil on canvas 7 × 14 in. (17·5 × 35 cm.)
Collection Mrs M.D. Charles, Bognor Regis.

21 The Eager Anticipants
Oil on canvas 7 × 14 in. (17·5 × 35 cm.)*

22 The Playground of Power
Oil on canvas 7 × 14 in. (17·5 × 35 cm.)
Private collection, Berkshire.

23 Training Ground
Oil on canvas 7 × 14 in. (17·5 × 35 cm.)
Private collection, Berkshire.

24 The Bond of Mutual Distrust
Oil on canvas 7 × 14 in. (17·5 × 35 cm.)*

25 A Long-standing Hateship
Oil on canvas 7 × 14 in. (17·5 × 35 cm.)*

26 The Antagonists
Oil on canvas 7 × 14 in. (17·5 × 35 cm.)*

27 Rite de Passage
Oil on canvas 7 × 14 in. (17·5 × 35 cm.)
Private collection, Berkshire.

28 Interrupted Game
Oil on canvas 7 × 14 in. (17·5 × 35 cm.)
*Collection Mr Norman Markowitz,
Michigan.*

29 The Bull
Oil on canvas 7 × 14 in. (17·5 × 35 cm.)
Collection Ms H. McKeown, London.

30 The Hunt
Oil on canvas 7 × 14 in. (17·5 × 35 cm.)
Collection K.J. Lyras, Loughton, Essex.

31 The Seawatchers
Ink and water-colour 10 × 14 in.
(25 × 35 cm.)
Collection Mr Robert Page, London.

32 Seabathers
Ink and water-colour 10 × 14 in.
(25 × 35 cm.)

1958

1 Bird Warning
Oil on board 9 × 10 in. (22·5 × 25 cm.)

2 Night Beast
Oil on canvas 7 × 14 in. (17·5 × 35 cm.)

3 The Serpents Choice
Oil on canvas 7 × 14 in. (17·5 × 35 cm.)
Collection Dr Jeffrey Sherwin, Leeds.

4 Spinster in the Spring
Oil on canvas 7 × 14 in. (17·5 × 35 cm.)
Collection Mr Denis Berthu, Paris.

5 The Birdcatcher
Oil on canvas 7 × 14 in. (17·5 × 35 cm.)
Collection Mr David Haskins, Northampton.

6 The Orators Moment
Oil on canvas 7 × 14 in. (17·5 × 35 cm.)
Collection Mr James Mayor, London.

7 The White Horse
Oil on canvas 7 × 14 in. (17·5 × 35 cm.)
Collection Mr John Nadler, London.

8 Family Relations
Oil on canvas 13 × 36 in. (32·5 × 90 cm.)
Collection Mr and Mrs M. Pensack,
Cincinnati.

9 Premonition of Life
Oil on canvas 11 × 16 in. (27·5 × 40 cm.)
Collection Mrs Courtney Ross, Long Island.

10 Monster Manqué
Oil, ink and water-colour on paper 8 × 12
in. (20 × 30 cm.)

11 Four Figures
Oil and ink on paper 8 × 13 in.
(20 × 32·5 cm.)
Collection Mr Alan Durham-Smith, Dallas,
Texas.

12 Extinction Beckons
Oil and ink on paper 8 × 10 in.
(20 × 25 cm.)
Eric Franck Gallery, London.

1959

1 Revolt of the Pets
Oil on canvas 10 × 12 in. (25 × 30 cm.)
Collection Mr Gerald Grinstein, Fort Worth,
Texas.

2 Virtuoso without an Audience
Coloured inks on paper 10 × 14 in.
(25 × 35 cm.)

3 Woman with a Cruel Past
Oil and ink on paper 8 × 13 in.
(20 × 32·5 cm.)

4 The Gymnastic Surprise
Oil on canvas 17 × 21 in. (42·5 × 52·5 cm.)
Collection Mr and Mrs Charles Palfrey, East
Barnet, London.

5 The Last Serenade
Oil on board 25 × 19 in. (62·5 × 47·5 cm.)
Collection Mr and Mrs Charles Palfrey, East
Barnet, London.

1960

1 Loving Couple
Oil and ink on paper 11 × 9 in.
(27·5 × 22·5 cm.)

2 Day-starved Mannerisms
Oil and ink on board 24 × 36 in.
(60 × 90 cm.)

3 Dont Leave Me Here
Coloured inks on paper 14 × 10 in.
(35 × 25 cm.)

4 The Expansive Invitation
Coloured inks on paper 11 × 8 in.
(27·5 × 20 cm.)
Currier Museum, Manchester, New
Hampshire, USA.

5 Rites of Winter
Coloured inks on paper 10 × 14 in.
(25 × 35 cm.)

6 Yesterday Went Quickly
Coloured inks on paper 13 × 10 in.
(32·5 × 25 cm.)

7 False Appearances
Ink and wash on paper 10 × 8 in.
(25 × 20 cm.)

8 Best Man Loses
Coloured inks on paper 9 × 11 in.
(22·5 × 27·5 cm.)
Collection Mr Martin Fuller,
London.

9 The Finder
Oil and ink on paper 14 × 10 in.
(35 × 25 cm.)

10 Declamation of Bias
Coloured inks on paper 11 × 10 in.
(27·5 × 25 cm.)

11 Exodus Blues
Coloured inks on paper 8 × 11 in.
(20 × 27·5 cm.)
Eric Franck Gallery, London.

12 The Egg-thieves
Oil and plaster on canvas 14 × 17 in.
(35 × 42·5 cm.)
Collection Mr Tom Maschler, London.

13 The Killing Game
Oil and plaster on canvas 16 × 20 in.
(40 × 50 cm.)
Collection Mr Alan Durham-Smith, Dallas,
Texas.

14 Family Group
Oil on canvas 22 × 25 in. (55 × 62·5 cm.)

15 Figure with Birds
Oil on canvas 20 × 24 in. (50 × 60 cm.)
(approx.)*

16 Woman with Birds
Oil on canvas 20 × 24 in. (50 × 60 cm.)
(approx.)*

17 Two Women with Bird
Oil on canvas 24 × 20 in. (60 × 50 cm.)
(approx.)*

18 Self-portrait
Oil on canvas 24 × 20 in. (60 × 50 cm.)
(approx.)*

19 The Assembly
Oil and plaster on board 34 × 84 in.
(85 × 210 cm.)

20 The New Arrival
Oil on canvas 20 × 30 in. (50 × 75 cm.)
Collection the Estate of the late Mrs Mary
Horswell, Hampshire.

21 Rivals Meeting
Ink and water-colour 5 × 5 in.
(12·5 × 12·5 cm.)

22 Official Guests
Ink and water-colour 2 × 6 in. (5 × 15 cm.)

23 Woman with Six Birds
Mixed media 8 × 10 in. (20 × 25 cm.)

24 The First to Arrive
Ink and water-colour 3 × 4 in.
(7·5 × 10 cm.)

25 Fish Hiding in a Landscape
Mixed media 8 × 13 in. (20 × 32·5 cm.)

26 Family Portrait
Mixed media 8 × 13 in. (20 × 32·5 cm.)

27 Expectant Figures
Mixed media 12 × 16 in. (30 × 40 cm.)
Collection Mr Robert Page, London.

28 Tripod Figure
Painted wire and plaster
Collection Eric Johnson, California.

1961

1 Processional
Oil and plaster on board 12 × 96 in.
(30 × 240 cm.)

2 Three Rivals
Oil on canvas 19 × 23 in. (46·5 × 57·5 cm.)
Collection Ms Jayne W. Barnard, Virginia.

3 First Love
Oil on canvas 13 × 27 in. (32·5 × 67·5 cm.)
Collection Bautex-Stoffe Gmb 11, Munich.

4 Nest-figure
Oil and plaster on canvas 26 × 12 in.
(65 × 30 cm.)

5 White Landscape I
Oil and plaster on canvas 20 × 24 in.
(50 × 60 cm.)

6 White Landscape III
Oil and plaster on board 13 × 18 in.
(32·5 × 45 cm.)

7 White Landscape VII
Oil and plaster on board 13 × 16 in.
(32·5 × 40 cm.)

8 White Landscape VIII
Oil and plaster on board 12 × 16 in.
(30 × 40 cm.)

9 White Landscape IX
Oil and plaster on board 16 × 22 in.
(40 × 55 cm.)

10 White Landscape XI
Oil and plaster on board 14 × 21 in.
(35 × 52·5 cm.)

11 White Landscape XII
Oil and plaster on board 14 × 21 in.
(35 × 52·5 cm.)

12 White Landscape XIII
Oil and plaster on board 2O × 25 in.
(50 × 62·5 cm.)

13 Moment of Judgement
Oil and plaster on board 24 × 12 in.
(60 × 30 cm.)

14 The New Challenge
Oil and plaster on board 24 × 15 in.
(60 × 37·5 cm.)

15 The Ruling Power
Oil and plaster on board 24 × 12 in.
(60 × 30 cm.)

16 The Dominion of Vulgar Piety
Oil and plaster on board 14 × 7 in.
(35 × 17·5 cm.)

17 The Pimple on the Face of Art is Really
a Beauty-spot
Oil and plaster on board 14 × 7 in.
(35 × 17·5 cm.)

18 The Beautiful Behind of the Dog-faced
Girl is not Appealing
Oil and plaster on board 14 × 7 in.
(35 × 17·5 cm.)

19 The Predator Smells of Lavender
Oil and plaster on board 14 × 7 in.
(35 × 17·5 cm.)

20 The Interpreter is Late Again
Oil and plaster on board 16 × 8 in.
(40 × 20 cm.)

21 The Great Populator
Oil on paper 19 × 26 in. (47·5 × 65 cm.)

22 Cell-head I
Oil on card 18 × 14 in. (45 × 35 cm.)
Peter Nahum Gallery, London.

23 Cell-head II
Oil on paper 12 × 16 in. (30 × 40 cm.)

24 Cell-head III
Oil on paper 12 × 16 in. (30 × 40 cm.)
Private Collection, Paris.

25 Cell-head IV
Oil on paper 15 × 20 in. (37·5 × 50 cm.)

26 Cell-head V
Oil on paper 22 × 17 in. (55 × 42·5 cm.)
Peter Nahum Gallery, London.

27 Cell-head VI
Oil on paper 21 × 17 in. (52·5 × 42·5 cm.)
Collection Mr Ivor Braka, London.

28 The Child of Nocturnal Occasions
Oil on canvas 8 × 14 in. (20 × 35 cm.)

29 Festive Symbols
Oil and plaster on canvas 8 × 12 in.
(20 × 30 cm.)

30 Lost Friend
Oil and plaster on board 14 × 7 in.
(35 × 17·5 cm.)

31 Cell-head VII
Oil on card 20 × 15 in. (50 × 37·5 cm.)

32 The Philosopher has Lied
Oil and plaster on board 24 × 12 in.
(60 × 30 cm.)

33 Cell-head VIII
Oil on board 19 × 15 in. (47·5 × 37·5 cm.)

34 Cell-head IX
Oil on paper 10 × 15 in. (25 × 37·5 cm.)

35 Cell-head X
Oil on paper 15 × 22 in. (37·5 × 55 cm.)

36 Cell-head XI
Oil on paper 16 × 10 in. (40 × 25 cm.)

37 Cell-head XII
Oil on paper 16 × 10 in. (40 × 25 cm.)

38 Cell-head XIII
Oil on paper 16 × 10 in. (40 × 25 cm.)

39 Cell-head XIV
Oil on paper 26 × 18 in. (65 × 45 cm.)

40 Cell-head XV
Oil on paper 10 × 14 in. (25 × 35 cm.)

41 Cell-head XVI
Oil on board 18 × 14 in. (45 × 35 cm.)
(approx.)*

42 Cell-head XVII
Oil on paper 16 × 10 in. (40 × 25 cm.)

43 Cell-head XIX
Oil on board 36 × 24 in. (90 × 60 cm.)

44 Cell-head XX
Oil on paper 10 × 12 in. (25 × 30 cm.)

45 Cell-head XXI
Oil on paper 23 × 17 in. (57·5 × 42·5 cm.)
Peter Nahum Gallery, London.

46 Cool Head
Oil on paper 18 × 25 in. (45 × 62·5 cm.)

47 Egghead I
Oil and plaster on board 18 × 24 in.
(45 × 60 cm.)
Eric Franck Gallery, London.

48 Cell-head XXII
Oil on board 20 × 15 in. (50 × 37·5 cm.)

49 The Diversity of Personal Surprise
Oil and plaster on board 24 × 15 in.
(60 × 37·5 cm.)

50 Lovejoy and Killjoy
Oil and plaster on board 24 × 15 in.
(60 × 37·5 cm.)

51 Force of Fusion
Oil on canvas 16 × 12 in. (40 × 30 cm.)

52 Growing Point
Oil on board 36 × 24 in. (90 × 60 cm.)

53 Fertilization I
Oil on board 41 × 35 in. (102·5 × 87·5 cm.)

54 Fertilization II
Oil on board 39 × 30 in. (97·5 × 75 cm.)

55 Ovulation
Oil on canvas 29 × 22 in. (72·5 × 55 cm.)

56 The Addiction of Privacy
Oil on canvas 30 × 20 in. (75 × 50 cm.)
Collection Dr Neil Kendall,
Shrewsbury.

57 Cell-head XXIII
Oil on board 21 × 14 in. (52·5 × 35 cm.)
Collection Mrs M.D. Charles, Bognor
Regis.

58 Cell-head XXIV
Oil on board 28 × 38 in. (70 × 95 cm.)

59 Cell-head XVIII
Oil on paper 16 × 10 in. (40 × 25 cm.)

60 Moon-dance
Oil on canvas 12 × 24 in. (30 × 60 cm.)
Collection Dr John Godfrey, London.

61 Warrior in Love
Mixed media 8 × 4 in. (20 × 10 cm.)
Collection Jack Emery and Joan Bakewell,
London.

62 Townscape
Ink and water-colour 5 × 3 in.
(12·5 × 7·5 cm.)

63 Night-figure
Ink and water-colour 4 × 3 in.
(10 × 7·5 cm.)

64 Campaign Figure
Ink and water-colour 3 × 3 in.
(7·5 × 7·5 cm.)

1962

1 Splitting Head
Oil on canvas 19 × 14 in. (47·5 × 35 cm.)

2 The Offering
Oil on card 26 × 32 in. (65 × 80 cm.)

3 Indigenous Head
Oil on board 36 × 24 in. (90 × 60 cm.)

4 Hardhead
Oil on board 36 × 24 in. (90 × 60 cm.)

5 Cell-head XXV
Oil on canvas 26 × 20 in. (65 × 50 cm.)

6 Cell-head XXVI
Oil on board 27 × 15 in. (67·5 × 37·5 cm.)

7 Cell-head XXVII
Oil on card 28 × 20 in. (70 × 50 cm.)

8 Cell-head XXVIII
Oil on canvas 22 × 29 in. (55 × 72·5 cm.)

9 Fertilization III
Oil on canvas 16 × 12 in. (40 × 30 cm.)

10 Children of Fortune
Oil on canvas 15 × 11 in. (37·5 × 27·5 cm.)

11 Red Riding Shock
Oil on canvas 16 × 44 in. (40 × 110 cm.)

12 Egghead II
Oil and plaster on board 20 × 25 in.
(50 × 62·5 cm.)

13 Willing Victim
Oil and plaster on board 24 × 12 in.
(60 × 30 cm.)

14 Point of Contact
Oil and plaster on board 24 × 18 in.
(60 × 45 cm.)
Eric Franck Gallery, London.

15 Simple Pleasures
Oil on board 32 × 43 in. (80 × 107·5 cm.)

16 Game Signs
Oil and plaster on board 24 × 34 in.
(60 × 85 cm.)

17 Sex-starved Banker Fleeing from
Vision of Horned Snakes
Oil on board 25 × 18 in. (62·5 × 45 cm.)

18 Egghead III
Oil and plaster on board 18 × 24 in.
(45 × 60 cm.)

19 Egghead IV
Oil and plaster on board 18 × 24 in.
(45 × 60 cm.)

20 Tutor
Mixed media 8 × 5 in. (20 × 12·5 cm.)

21 Dreaming Figure
Ink and water-colour 5 × 5 in.
(12·5 × 12·5 cm.)

22 Large Head
Oil on canvas 54 × 72 in. (135 × 180 cm.)*

1963

No surviving works.

1964

1 Boundary Dispute
Mixed media on board 24 × 18 in.
(60 × 45 cm.)

2 Bold Moment
Oil on board 25 × 23 in. (62·5 × 57·5 cm.)

3 Landscape
Oil on board 29 × 23 in. (72·5 × 57·5 cm.)
Clee Collection, Belgium.

1965

1 Parasite in the House
Oil on board 36 × 24 in. (90 × 60 cm.)

2 The Translators Whim
Oil on canvas 40 × 24 in. (100 × 60 cm.)

3 Climactic Mirage
Oil on board 36 × 24 in. (90 × 60 cm.)

4 The Morphology of Envy
Oil on board 36 × 24 in. (90 × 60 cm.)

5 The Mysterious Gift
Oil on canvas 39 × 28 in. (97·5 × 70 cm.)
Public Art Gallery, Swindon, Wilts.

6 Ambiguous Offering
Oil on canvas 54 × 37 in. (135 × 92·5 cm.)

7 Genius Embryo
Ink and water-colour 8 × 5 in.
(20 × 12·5 cm.)

8 Classical Longing
Ink and water-colour 11 × 8 in.
(27·5 × 20 cm.)

1966

1 Ceremonial Pastimes
Oil on board 14 × 21 in. (35 × 52·5 cm.)

2 Before the Bang
Oil on canvas 29 × 22 in. (72·5 × 55 cm.)

3 Pair Bond
Oil on board 10 × 14 in. (25 × 35 cm.)

4 Proud Figure
Oil on canvas 24 × 17 in. (60 × 42·5 cm.)

5 Strong Figure
Oil on canvas 25 × 21 in. (62·5 × 52·5 cm.)

6 The Day of the Zygote
Oil on canvas 20 × 16 in. (50 × 40 cm.)

7 Guard Figure
Oil on wood 17 × 13 in. (42·5 × 32·5 cm.)

8 Intimate Decision
Oil and plaster on canvas 18 × 15 in.
(45 × 37·5 cm.)
Private collection, Belgium.

9 Organic Statue
Oil on card 17 × 21 in. (42·5 × 52·5 cm.)

10 Beast of Burden
Oil on canvas 54 × 72 in. (135 × 180 cm.)

11 Lonely Quadruped
Oil on board 17 × 20 in. (42·5 × 50 cm.)

12 Growing Signals
Oil on canvas 21 × 14 in. (52·5 × 35 cm.)

13 Body Flower
Oil on canvas 33 × 23 in. (82·5 × 57·5 cm.)
*Collection Mr Frank Kolodzief, Puerto
Rico.*

14 Introvert
Oil on canvas 24 × 20 in. (60 × 50 cm.)
Collection Mr Frank Kolodzief, Puerto Rico.

15 Figure of Some Importance
Oil on canvas 32 × 25 in. (80 × 62·5 cm.)
Private collection, Paris.

16 Days of Quantity
Oil on board 25 × 30 in. (62·5 × 75 cm.)

17 Warrior Waiting
Oil on board 24 × 18 in. (60 × 45 cm.)

18 Extrovert
Oil on canvas 36 × 48 in. (90 × 120 cm.)

19 The Hidden Stimulus
Oil and plaster on board 24 × 18 in.
(60 × 45 cm.)

20 Coupling Strategies
Oil on panel 10 × 14 in. (25 × 35 cm.)

21 Fine Figure
Oil on canvas 19 × 15 in. (47·5 × 37·5 cm.)

22 Sketch for Figure of Some Importance
Ink and water-colour 7 × 4 in.
(17·5 × 10 cm.)
*Collection Tom and Kate Kinninmont,
London.*

1967

No surviving works.

1968

1 The Debris of Fixations
Oil on board 48 × 60 in. (120 × 150 cm.)

2 Posture of Dominance
Oil on board 72 × 48 in. (180 × 120 cm.)

3 A Lapse of Heart
Oil on board 45 × 60 in. (112·5 × 150 cm.)

4 Resting Goddess
Oil on board 45 × 60 in. (112·5 × 150 cm.)

5 Beneath the Censor
Oil on board 46 × 60 in. (112·5 × 150 cm.)

6 Nuptial Display
Oil on board 29 × 23 in. (72·5 × 57·5 cm.)

7 The Adviser
Oil on board 32 × 27 in. (80 × 67·5 cm.)
Collection Dr and Mrs Michel Remy, Nice.

8 The Antagonist
Oil on board 32 × 27 in. (80 × 67·5 cm.)

1969

1 Table Pleasures
Oil on board 45 × 59 in.
(112·5 × 147·5 cm.)
Collection Mr Christopher Henney, Seattle.

2 Festival
Oil on board 45 × 60 in. (112·5 × 150 cm.)

3 Birthday Emotions
Oil on board 33 × 27 in. (82·5 × 67·5 cm.)

4 Daydream Zone
Oil on board 33 × 27 in. (82·5 × 67·5 cm.)

5 The Scale of Amnesia
Oil on board 29 × 24 in. (72·5 × 60 cm.)

6 Mother Goddess
Oil on card 20 × 15 in. (50 × 37·5 cm.)
Collection Michäle Heyraud, Paris.

7 Earth Mother
Oil on board 29 × 29 in. (72·5 × 72·5 cm.)

8 Rival Deities
Oil on board 27 × 48 in. (67·5 × 120 cm.)

9 Fertility Figure
Oil on board 28 × 47 in. (70 × 117·5 cm.)

10 Great Mother
Oil on board 28 × 25 in. (70 × 62·5 cm.)

11 The Teachers Doubt
Oil on canvas 12 × 26 in. (30 × 65 cm.)
Collection Mr Damon de Lazlo, London.

12 The Explorer has Arrived
Oil on canvas 8 × 12 in. (20 × 30 cm.)
*Collection Sir David Attenborough,
Richmond, Surrey.*

13 The Ritual
Oil on canvas 24 × 36 in. (60 × 90 cm.)
Private collection, London.

14 Loving Figure
Ink and water-colour 8 × 5 in.
(20 × 12·5 cm.)

15 Mother Goddess
Painted metal and stone. Height: 10 in.
(25 cm.)
Collection Anders Malmberg, Sweden.

16 Mother Goddess II
Gourd, skull and marbles. Height: 11 in.
(27·5 cm.)

17 Moratorium *Mannequin,
skull, plastic ornaments.* Height: 35 in.
(89·5 cm.)

18 Good Morning Miss Smith
Skull and plastic lips. Length: 8·5 in.
(21·5 cm.)
*Collection Dr Jeffrey
Sherwin, Leeds.*

1970

1 Neophilic Excitements
Oil on board 45 × 59 in. (112·5 × 147·5
cm.)

2 The Entertainer
Oil on board 29 × 23 in. (72·5 × 57·5 cm.)
Collection Bautex-Stoffe Gmb 11, Munich.

3 Greenery Pastimes
Oil on board 45 × 59 in.
(112·5 × 147·5 cm.)

4 Restraints of Kinship
Oil on board 45 × 59 in.
(112·5 × 147·5 cm.)

5 Until its Time to Go
Oil on canvas 10 × 12 in. (25 × 30 cm.)
Collection Mrs Susan Sandman, New York.

6 Days of Plenty
Ink and water-colour 9 × 10 in.
(22·5 × 25 cm.)

7 Stone Head
Limestone. Height: 16 in. (40 cm.)

8 Love is a Lizard
Ink and water-colour. Decorated poem
9·5 × 10·5 in. (24 × 26·5 cm.)

1971

1 Festa Day
Ink and pastel on board 12 × 15 in.
(30 × 37·5 cm.)

1972

1 The Titillator
Oil on canvas 12 × 18 in. (30 × 45 cm.)
Collection Dr Richard Dawkins, Oxford.

2 The Attentive Friend
Oil on canvas 12 × 18 in. (30 × 45 cm.)

3 The Unimportance of Yesterday
Oil on canvas 12 × 18 in. (30 × 45 cm.)

4 The Protector
Oil on canvas 16 × 22 in. (40 × 55 cm.)

5 Sting Appeal
Oil on canvas 12 × 18 in. (30 × 45 cm.)
Collection Dr Kate MacSorley, London.

6 The Onlookers.
Oil on board, 11 × 21 in. (27·5 × 52·5 cm.)
Collection Mr P. Hurn, London.

7 The Ceremony of the Hole
Oil on canvas 20 × 30 in. (50 × 75 cm.)
*Collection Mr and Mrs Roger Box,
Cheltenham.*

8 The Fertility of Pain
Oil on canvas 20 × 30 in. (50 × 75 cm.)
Collection Dr Neil Kendall, Shrewsbury.

9 The Visitor
Oil on canvas 12 × 16 in. (30 × 40 cm.)

10 The Gravidity of Power
Oil on canvas 20 × 30 in. (50 × 75 cm.)

11 The Three Members
Oil on canvas 12 × 18 in. (30 × 45 cm.)

12 Polymorphic Growth
Oil on canvas 12 × 18 in. (30 × 45 cm.)
Collection Mrs Helen Profumo, London.

13 The Protégé
Oil on board 10 × 8 in. (25 × 20 cm.)

14 The Expectant Valley
Oil on canvas 24 × 30 in. (60 × 75 cm.)
Collection Dr Richard Dawkins, Oxford.

15 The Guardian of the Cycle
Oil on canvas 12 × 18 in. (30 × 45 cm.)
Collection Mr Marvin Woolen, Alabama.

16 The Parade of Memories
Oil on canvas 20 × 30 in. (50 × 75 cm.)
Collection Dr David Blest, Canberra.

17 The Insensitive Intruder
Oil on canvas 12 × 16 in. (30 × 40 cm.)
*Collection Mr and Mrs Norbert Francfort,
Brussels.*

18 Dyadic Encounter
Oil on canvas 20 × 30 in. (50 × 75 cm.)
Yale Center for British Art, New Haven,
Connecticut.

19 The Obsessional Meal
Oil on canvas 12 × 18 in. (30 × 45 cm.)
Collection Mr Richard Veen, Amsterdam.

20 The Collectors Fallacy
Oil on canvas 24 × 30 in. (60 × 75 cm.)
Collection Mr Gavin Rankin, London.

21 Leaders of the People
Ink and water-colour 8 × 10 in.
(20 × 25 in.)

22 Table for Two
Ink and water-colour 9 × 10 in.
(22·5 × 25 cm.)
Collection Mr S.J. Kennedy, London.

1973

1 Stop Them if You Can!
Oil on canvas, 24 × 30 in. (60 × 75 cm.)

2 The Observers
Oil on canvas 20 × 30 in. (50 × 75 cm.)

3 The Mediator
Oil on board 10 × 8 in. (25 × 20 cm.)

4 The Agitator
Oil on canvas 10 × 8 in. (25 × 20 cm.)
*Collection Mr Roy Heenan, Quebec,
Canada.*

5 For Insiders Only
Oil on canvas 16 × 22 in. (40 × 55 cm.)
*Collection Professor E.V. van Hall,
Noordwijk, Holland.*

6 Lovers White Dreamtime
Oil on canvas 24 × 30 in. (60 × 75 cm.)
*Collection Mr and Mrs James Vaughn Jnr,
Texas.*

7 The Perennial Discovery
Oil on canvas 12 × 16 in. (30 × 40 cm.)

8 The Well-groomed Bride
Oil on canvas 22 × 16 in. (55 × 40 cm.)
Collection Mr Edward Anixter, Chicago.

9 Disturbance in the Colony
Oil on canvas 20 × 30 in. (50 × 75 cm.)
Collection Mr Edward Anixter, Chicago.

10 The Neglected Rival
Oil on canvas 20 × 30 in. (50 × 75 cm.)

11 The Familiar Stranger
Oil on canvas 20 × 30 in. (50 × 75 cm.)
*Collection Mr Arnold Kanter, Evanston,
Illinois.*

12 The Erosion of Longing
Oil on canvas 16 × 22 in. (40 × 55 cm.)
Collection Mr Hans Redmann, Berlin.

13 Deciduous Decisions
Oil on canvas 12 × 16 in. (30 × 40 cm.)
Private collection, France.

14 The Kill
Oil on canvas 20 × 30 in. (50 × 75 cm.)
Christopher Moran and Co. Ltd, London.

15 The Last Breakfast
Oil on canvas 12 × 16 in. (30 × 40 cm.)
Private collection, London.

16 The Guardian of the Trap
Oil on canvas 20 × 36 in. (50 × 90 cm.)

**17 The Audience Discovers it is the
Performance**
Oil on canvas 20 × 36 in. (50 × 90 cm.)
Private collection, Oxfordshire.

18 The Day after Yesterday
Oil on canvas 12 × 16 in. (30 × 40 cm.)
Collection Mr Damon de Lazlo, London.

19 Edgy
Oil on canvas 24 × 36 in. (60 × 90 cm.)

20 The Budding Force
Oil on canvas 16 × 12 in. (40 × 30 cm.)
Private collection, Oxfordshire.

21 The Moment of Partial Truth
Oil on canvas 20 × 36 in. (50 × 90 cm.)
Collection Mr Damon de Lazlo, London.

22 Power Figure
Ink and water-colour 14 × 9 in.
(35 × 22·5 cm.)

23 Biomorphic Landscape
Ink and water-colour 9 × 14 in.
(22·5 × 35 cm.)

24 Fertility Figure
Plaster. Height: 3 in. (7·5 cm.)

1974

1 Metamorphic Landscape
Oil on board 23 × 29 in. (57·5 × 72·5 cm.)
*Collection Sir David Attenborough,
Richmond.*

1975

No surviving works.

1976

1 Contestants
Oil on canvas 24 × 36 in. (60 × 90 cm.)

2 Private Figure
Oil on board 10 × 7 in. (25 × 17·5 cm.)

3 Ancestors
Oil on panel 20 × 22 in. (50 × 55 cm.)
Private collection, London.

4 Public Figure
Oil on board 16 × 12 in. (40 × 30 cm.)

5 The Presentation
Oil on canvas 24 × 36 in. (60 × 90 cm.)
*Edwin A. Ulrich Museum of Art, Wichita,
Kansas.*

6 The Arena
Oil on canvas 24 × 36 in. (60 × 90 cm.)

7 The Sentinel
Oil on canvas 24 × 36 in. (60 × 90 cm.)
Collection Mr H. Slewe, Laren, Holland.

8 Ascending Figure
Oil on canvas 24 × 36 in. (60 × 90 cm.)
Collection Mr Damon de Lazlo, London.

9 Totemic Decline
Oil on canvas 24 × 36 in. (60 × 90 cm.)

10 The Sleepwalker
Oil on canvas 24 × 36 in. (60 × 90 cm.)

1977

No surviving works.

1978

No surviving works.

1979

1 Brain-fruit
Ink and water-colour. 8 × 6 in.
(20 × 15 cm.)
*Collection Viscount Ivor Windsor, The
Stables, Ludlow, Shropshire.*

1980

No surviving works.

1981

1 Aggro
Oil on canvas 24 × 36 in. (60 × 90 cm.)
*(Although dated 1979, not completed until
1981) Collection Dr and Mrs Peter
Marsh, Oxford.*

1982

1 Negotiator
Ink and water-colour 3 × 3 in.
(7·5 × 7·5 cm.)

1983

No surviving works.

1984

1 Political Head
Ink and water-colour 3 × 2 in. (7·5 × 5 cm.)

1985

1 Brown Figure I
Oil on board 10 × 7 in. (25 × 17·5 cm.)

2 Brown Figure II
Oil on board 10 × 7 in. (25 × 17·5 cm.)
Collection Mr Ron Crider, San Francisco.

3 Hybrid Vigour
Oil on board 10 × 7 in. (25 × 17·5 cm.)
Collection Mr Ron Crider, San Francisco.

4 The Seven Sisters
Oil on board 24 × 36 in. (60 × 90 cm.)

5 January 24th
Mixed media 8 × 8 in. (20 × 20 cm.)
Andrew Jones Art, London.

6 Affluent Figure
Ink and water-colour 4 × 3 in.
(10 × 7·5 cm.)

7 Rebel Figure
Ink and water-colour 11 × 8 in.
(27·5 × 20 cm.)

1986

1 The Blind Watchmaker
Oil on canvas 30 × 24 in. (75 × 60 cm.)
Eric Franck Gallery, London.

2 The Orator
Oil on board 10 × 7 in. (25 × 17·5 cm.)
Collection Mr Jerome Rotstein, Florida.

3 The Red Guard
Oil on canvas 24 × 36 in. (60 × 90 cm.)

4 The Usher
Oil on canvas 12 × 16 in. (30 × 40 cm.)

5 The Illusionist
Oil on canvas 16 × 12 in. (40 × 30 cm.)
Collection Dr Neil Kendall, Shrewsbury.

6 The Bipedal Surprise
Oil on canvas 22 × 18 in. (55 × 45 cm.)
*Collection Mr and Mrs Nathan Shippee,
New York.*

7 Protean Diversions
Oil on canvas 16 × 22 in. (40 × 55 cm.)
Private collection, France.

8 Seasonal Positions
Oil on canvas 24 × 36 in. (60 × 90 cm.)

9 Green Landscape
Oil on panel 20 × 22 in. (50 × 55 cm.)
Private collection, Connecticut.

10 The Warrior
Mixed media 8 × 13 in. (20 × 32·5 cm.)
Private collection, Geneva.

11 An Everyday Goddess
Mixed media 11 × 8 in. (27·5 × 20 cm.)

12 Company Rules
Mixed media 8 × 13 in. (20 × 32·5 cm.)

13 Sketch for the Blind Watchmaker
Mixed media 8 × 6 in. (20 × 15 cm.)

1987

1 The Collusionists
Ink and water-colour 10 × 14 in.
(25 × 35 cm.)

2 The New Neighbour
Ink and water-colour 10 × 14 in.
(25 × 35 cm.)
Collection Mr T.S. Hayne, Bristol.

3 Star Guest
Ink and water-colour 8 × 9 in.
(20 × 22·5 cm.)

4 The Actress Remembers
Ink and water-colour 16 × 11 in.
(40 × 27·5 cm.)

5 Celebrity
Ink and water-colour 16 × 11 in.
(40 × 27·5 cm.)

6 The Helpful Expert
Ink and water-colour 16 × 11 in.
(40 × 27·5 cm.)

7 Social Occasion
Ink and water-colour 12 × 18 in.
(30 × 45 cm.)

8 Unstable Relationship
Ink and water-colour 12 × 18 in.
(30 × 45 cm.)
Collection Mr Alan Durham-Smith, Texas

9 The Suitor
Ink and water-colour 18 × 12 in.
(45 × 30 cm.)

10 The Day of Rumours
Ink and water-colour 12 × 18 in.
(30 × 45 cm.)

11 Collage Head I
Ink and coloured papers 11 × 8 in.
(27·5 × 20 cm.)

12 Collage Head II
Ink and coloured papers 11 × 8 in.
(27·5 × 20 cm.)

13 Collage Head III
Ink and coloured papers 11 × 8 in.
(27·5 × 20 cm.)

14 Collage Head IV
Ink and coloured papers 11 × 8 in.
(27·5 × 20 cm.)

15 Collage Head V
Ink and coloured papers 11 × 8 in.
(27·5 × 20 cm.)

16 Collage Head VI
Ink and coloured papers 11 × 8 in.
(27·5 × 20 cm.)

17 Collage Head VII
Ink and coloured papers 11 × 8 in.
(27·5 × 20 cm.)

18 Collage Head VIII
Ink and coloured papers 11 × 8 in.
(27·5 × 20 cm.)

19 Collage Head IX
Ink and coloured papers 11 × 8 in.
(27·5 × 20 cm.)

20 Collage Head X
Ink and coloured papers 11 × 8 in.
(27·5 × 20 cm.)

21 Collage Head XI
Ink and coloured papers 11 × 8 in.
(27·5 × 20 cm.)

22 Collage Head XII
Ink and coloured papers 11 × 8 in.
(27·5 × 20 cm.)

23 Collage Head XIII
Ink and coloured papers 11 × 8 in.
(27·5 × 20 cm.)

24 Collage Head XIV
Ink and coloured papers 11 × 8 in.
(27·5 × 20 cm.)

25 Collage Head XV
Ink and coloured papers 11 × 8 in.
(27·5 × 20 cm.)

26 Collage Head XVI
Ink and coloured papers 11 × 8 in.
(27·5 × 20 cm.)

27 Collage Head XVII
Ink and coloured papers 11 × 8 in.
(27·5 × 20 cm.)

28 Collage Head XVIII
Ink and coloured papers 11 × 8 in.
(27·5 × 20 cm.)

29 Collage Head XIX
Ink and coloured papers 11 × 8 in.
(27·5 × 20 cm.)

30 Collage Head XX
Ink and coloured papers 11 × 8 in.
(27·5 × 20 cm.)

31 Collage Head XXI
Ink and coloured papers 11 × 8 in.
(27·5 × 20 cm.)

32 Collage Head XXII
Ink and coloured papers 11 × 8 in.
(27·5 × 20 cm.)

33 Collage Head XXIII
Ink and coloured papers 11 × 8 in.
(27·5 × 20 cm.)

34 Collage Head XXIV
Ink and coloured papers 11 × 8 in.
(27·5 × 20 cm.)

35 Collage Head XXV
Ink and coloured papers 11 × 8 in.
(27·5 × 20 cm.)

1988

1 Larger Than Life
Mixed media 8 × 13 in. (20 × 32·5 cm.)
Collection Pamela Robinet, Pennsylvania.

2 The Disbeliever
Mixed media 8 × 13 in. (20 × 32·5 cm.)

3 The Bearer of Rumours
Mixed media 8 × 13 in. (20 × 32·5 cm.)

4 The Old Acquaintance
Mixed media 8 × 13 in. (20 × 32·5 cm.)
Collection Dr Michel Remy, Nice.

5 Extravagant Friends
Mixed media 8 × 13 in. (20 × 32·5 cm.)
*Collection Mrs Litsa Tsitsera, Arlington,
Virginia.*

6 Consenting Adult
Mixed media 8 × 13 in. (20 × 32·5 cm.)

7 Silent Partners
Mixed media 8 × 13 in. (20 × 32·5 cm.)
Collection Baroness Fiona Thyssen, London.

8 The Old Dilemma
Mixed media 8 × 13 in. (20 × 32·5 cm.)

9 Moment of Truth
Mixed media 8 × 13 in. (20 × 32·5 cm.)
*Collection Drs Elizabeth and Robert Boylan,
Larchmont, New York.*

10 Family Secrets
Mixed media 8 × 13 in. (20 × 32·5 cm.)

11 Face of Fashion
Mixed media 8 × 13 in. (20 × 32·5 cm.)
Collection Pamela Roderick, Brooklyn, NY

12 Warrior Angel
Mixed media 8 × 13 in. (20 × 32·5 cm.)

13 The Protector
Mixed media 8 × 13 in. (20 × 32·5 cm.)

14 Old Money
Mixed media 8 × 13 in. (20 × 32·5 cm.)
Collection Delvaux, Belgium.

15 Listen to the Goddess
Mixed media 8 × 13 in. (20 × 32·5 cm.)
Collection Baroness Fiona Thyssen, London.

16 The Greeting
Mixed media 8 × 13 in. (20 × 32·5 cm.)

17 Totemic Figure
Mixed media 13 × 8 in. (32·5 × 20 cm.)
*Collection Alan Durham-Smith, Dallas,
Texas.*

18 Procrastinator
Mixed media 13 × 8 in. (32·5 × 20 cm.)

19 The Applicant
Mixed media 13 × 8 in. (32·5 × 20 cm.)

20 A Paragon of Vice
Mixed media 13 × 8 in. (32·5 × 20 cm.)
Private collection, Switzerland.

21 Memorial Figure
Mixed media 13 × 8 in. (32·5 × 20 cm.)
*Collection Mrs Litsa Tsitsera, Arlington,
Virginia.*

22 The Riddle of the Great Mother
Mixed media 13 × 8 in. (32·5 × 20 cm.)
Collection Pamela Wynn, London.

23 The Messenger
Mixed media 13 × 8 in. (32·5 × 20 cm.)
Collection Mr Robert Page, London.

24 In Attendance
Mixed media 13 × 8 in. (32·5 × 20 cm.)

25 The Day-dreamer
Mixed media 13 × 8 in. (32·5 × 20 cm.)
Collection Delvaux, Belgium.

26 Forgotten Leader
Mixed media 13 × 8 in. (32·5 × 20 cm.)

27 Rising Star
Mixed media 13 × 8 in. (32·5 × 20 cm.)

28 Territorial Figure
Mixed media 13 × 8 in. (32·5 × 20 cm.)

29 Cruciform Figure
Mixed media 11·5 × 8 in. (29 × 20 cm.)

30 Horned Head
Mixed media 11·5 × 8 in. (29 × 20 cm.)

31 Private Couple
Mixed media 8 × 11·5 in. (20 × 29 cm.)
*Collection Mr Arnold B. Kanter, Evanston,
Illinois.*

32 Secret Thinker
Mixed media 11·5 × 8 in. (29 × 20 cm.)

33 Split Decision
Mixed media 11·5 × 8 in. (29 × 20 cm.)

34 Three Friends
Mixed media 11·5 × 8 in. (29 × 20 cm.)

35 Silent Figure
Mixed media 11·5 × 8 in. (29 × 20 cm.)

36 Memories of Home
Mixed media 8 × 11·5 in. (20 × 29 cm.)

37 War Hero
Mixed media 11·5 × 8 in. (29 × 20 cm.)
Private collection, Switzerland.

38 Newcomer
Mixed media 11·5 × 8 in. (29 × 20 cm.)

39 Forgotten Friend
Mixed media 11·5 × 8 in. (29 × 20 cm.)

40 Neighbours
Mixed media 8 × 11·5 in. (20 × 29 cm.)

41 Another Family
Mixed media 8 × 11·5 in. (20 × 29 cm.)

42 Intimate Relations
Mixed media 8 × 11·5 in. (20 × 29 cm.)

43 Flower Child
Mixed media 11·5 × 8 in. (29 × 20 cm.)

44 Romantic Figure
Mixed media 11·5 × 8 in. (29 × 20 cm.)

45 The Rainmaker
Mixed media 11·5 × 8 in. (29 × 20 cm.)

46 The Statesman
Mixed media 11·5 × 8 in. (29 × 20 cm.)
Collection Mrs Jenny Cottom, London.

47 Lonely Figure
Mixed media 11·5 × 8 in. (29 × 20 cm.)

48 Cult Figure
Mixed media 11·5 × 8 in. (29 × 20 cm.)

49 Patient Figures
Mixed media 11·5 × 8 in. (29 × 20 cm.)

50 Proud Figure
Mixed media 11·5 × 8 in. (29 × 20 cm.)

51 Pet-lover
Mixed media 11·5 × 8 in. (29 × 20 cm.)

52 Woman of the World
Mixed media 11·5 × 8 in. (29 × 20 cm.)
Collection Mr Noel Cronin, Hertfordshire.

53 Exuberant Figure
Mixed media 11·5 × 8 in. (29 × 20 cm.)
Collection Mr Peter Wills, Surrey.

54 The Inventor
Mixed media 11·5 × 8 in. (29 × 20 cm.)
Collection Mr Noel Cronin, Hertfordshire.

55 Special Agent
Mixed media 11·5 × 8 in. (29 × 20 cm.)
Collection Mr Peter Wills, Surrey.

56 The Loved One
Mixed media 11·5 × 8 in. (29 × 20 cm.)

57 The Audition
Mixed media 11·5 × 8 in. (29 × 20 cm.)

58 Mood of the Moment
Mixed media 11·5 × 8 in. (29 × 20 cm.)

59 The Novice
Mixed media 11·5 × 8 in. (29 × 20 cm.)

60 The Expert Witness
Mixed media 11·5 × 8 in. (29 × 20 cm.)

61 Illusions of Ancestry
Mixed media 11·5 × 8 in. (29 × 20 cm.)

62 Valued Companion
Mixed media 11·5 × 8 in. (29 × 20 cm.)

63 Important Figure
Mixed media 11·5 × 8 in. (29 × 20 cm.)

64 Longing for Something
Mixed media 11·5 × 8 in. (29 × 20 cm.)

65 Official in Crisis
Mixed media 11·5 × 8 in. (29 × 20 cm.)

66 Reclining Figure
Mixed media 8 × 11·5 in. (20 × 29 cm.)

67 Breeding Season
Mixed media 11·5 × 8 in. (29 × 20 cm.)

68 Ancestral Figures
Mixed media 11·5 × 8 in. (29 × 20 cm.)

69 The Protester
Mixed media 11·5 × 8 in. (29 × 20 cm.)

70 Silent Witness
Mixed media 8 × 11·5 in. (20 × 29 cm.)

71 Changing Relations
Mixed media 8 × 11·5 in. (20 × 29 cm.)

72 Welcome Presence
Mixed media 11·5 × 8 in. (29 × 20 cm.)

73 Declamation Fallout
Mixed media 8 × 11·5 in. (20 × 29 cm.)

74 Lonely Predator
Mixed media 8 × 11·5 in. (20 × 29 cm.)

75 Exchange of Views
Mixed media 8 × 11·5 in. (20 × 29 cm.)

76 Major Figure
Mixed media 11·5 × 8 in. (29 × 20 cm.)

77 Expressive Figure
Mixed media 11·5 × 8 in. (29 × 20 cm.)

78 Playful Figure
Mixed media 11·5 × 8 in. (29 × 20 cm.)

79 Waiting Figure
Mixed media 11·5 × 8 in. (29 × 20 cm.)

80 Family Relations
Mixed media 11·5 × 8 in. (29 × 20 cm.)

81 The Warlords
Mixed media 8 × 11·5 in. (20 × 29 cm.)

82 Lost in Thought
Mixed media 11·5 × 8 in. (29 × 20 cm.)

83 The Mood of the Crowd
Mixed media 8 × 13 in. (20 × 32·5 cm.)

84 The Schemer
Mixed media 8 × 11·5 in. (20 × 29 cm.)

85 Metaphor for an Old Friend
Mixed media 8 × 11·5 in. (20 × 29 cm.)

86 The Spacemaker
Mixed media 8 × 11·5 in. (20 × 29 cm.)

87 Late Arrivals
Mixed media 8 × 11·5 in. (20 × 29 cm.)

88 The Minds Eye
Mixed media 8 × 11·5 in. (20 × 29 cm.)

89 Daydreamer
Mixed media 8 × 11·5 in. (20 × 29 cm.)

90 Member of the Jury
Mixed media 11·5 × 8 in. (29 × 20 cm.)

91 Biomorphic Landscape
Ink and water-colour 12 × 18 in.
 (30 × 45 cm.)

92 Established Pair
Ink and water-colour 12 × 18 in.
 (30 × 45 cm.)

93 Idealist
Ink and water-colour 8 × 6 in.
 (20 × 15 cm.)

94 Creative Figure
Ink and water-colour 20 × 16 in.
 (50 × 40 cm)

95 The Paradox of Anger
Mixed media 8 × 13 in. (20 × 32·5 cm.)

96 The Premonition
Mixed media 13 × 8 in. (32·5 × 20 cm.)

97 The Survivor
Mixed media 8 × 13 in. (20 × 32·5 cm.)

98 Four Heads
Ink and water-colour 12 × 8 in.
 (30 × 20 cm.)

99 Ambiguous Relations I
Ink and water-colour 8 × 11 in.
 (20 × 27·5 cm.)

100 Ambiguous Relations II
Ink and water-colour 8 × 11 in.
 (20 × 27·5 cm.)

1989

1 The Vegetarian Dream
Mixed media 13 × 8 in. (32·5 × 20 cm.)

2 The New Mood
Oil on canvas 4 × 30 in. (60 × 75 cm.)

3 Memories of Tomorrow
Oil on canvas 24 × 30 in. (60 × 75 cm.)

1990

1 Hierarchy Games
Mixed media 11 × 10 in. (27·5 × 25 cm.)
Collection Mr Robert Page, London,

2 The Price of Ambition
Mixed media 11 × 10 in. (27·5 × 25 cm.)

3 The Dilemma of the Poet
Mixed media 11 × 10 in. (27·5 × 25 cm.)

4 Wistful Ancestor
Mixed media 11 × 10 in. (27·5 × 25 cm.)

5 Position of Power
Mixed media 11 × 10 in. (27·5 × 25 cm.)

6 End Game
Mixed media 11 × 10 in. (27·5 × 25 cm.)

7 The Joy of Learning
Mixed media 11 × 10 in. (27·5 × 25 cm.)

8 Beach Scene
Mixed media 11 × 10 in. (27·5 × 25 cm.)

9 Power Play
Mixed media 11 × 10 in. (27·5 × 25 cm.)

10 Distinguished Company
Mixed media 11 × 10 in. (27·5 × 25 cm.)

11 Conflicting Opinion
Mixed media 11 × 10 in. (27·5 × 25 cm.)

12 The Actors Mirror
Mixed media 11 × 10 in. (27·5 × 25 cm.)

13 Moment of Magic
Mixed media 11 × 10 in. (27·5 × 25 cm.)

14 Warning Signals
Mixed media 11 × 10 in. (27·5 × 25 cm.)

15 The Unknown Gifts
Mixed media 11 × 10 in. (27·5 × 25 cm.)

16 The Star Attraction
Mixed media 11 × 10 in. (27·5 × 25 cm.)

17 Matriarch
Mixed media 11 × 10 in. (27·5 × 25 cm.)

18 Avoidance of Certainty
Mixed media 1 × 10 in. (27·5 × 25 cm.)

19 The New Couple
Mixed media 11 × 10 in. (27·5 × 25 cm.)

20 The Great Illusion
Mixed media 11 × 10 in. (27·5 × 25 cm.)

21 A Vow of Caution
Mixed media 11 × 10 in. (27·5 × 25 cm.)

22 Adolescent Figure
Mixed media 11 × 10 in. (27·5 × 25 cm.)

23 Mother and Child
Mixed media 11 × 10 in. (27·5 × 25 cm.)
Collection Dr Jeffrey Sherwin, Leeds.

24 Ancient Message
Mixed media 11 × 10 in. (27·5 × 25 cm.)

25 Private Performance
Mixed media 11 × 10 in. (27·5 × 25 cm.)

26 The Sting of Love
Mixed media 11 × 10 in. (27·5 × 25 cm.)

27 Carnal Dream
Mixed media 11 × 10 in. (27·5 × 25 cm.)

27·5 Iconoclast
Mixed media 11 × 10 in. (27·5 × 25 cm.)

29 The Unknown Object
Mixed media 11 × 10 in. (27·5 × 25 cm.)

30 Ascetic Vision
Mixed media 11 × 10 in. (27·5 × 25 cm.)

31 Trio
Mixed media 11 × 10 in. (27·5 × 25 cm.)

32 Vigil
Mixed media 11 × 10 in. (27·5 × 25 cm.)

33 Private Moment
Mixed media 11 × 10 in. (27·5 × 25 cm.)

34 Silent Witness
Mixed media 11 × 10 in. (27·5 × 25 cm.)

35 Preoccupied Figure
Mixed media 11 × 10 in. (27·5 × 25 cm.)

36 Monument for a Lost Friend
Mixed media 11 × 10 in. (27·5 × 25 cm.)

37 The Survivor
Mixed media 11 × 10 in. (27·5 × 25 cm.)

38 Lasting Obsession
Mixed media 11 × 10 in. (27·5 × 25 cm.)

39 Legacy of a Sheltered Childhood
Mixed media 11 × 10 in. (27·5 × 25 cm.)

40 Absent Friends
Mixed media 11 × 10 in. (27·5 × 25 cm.)

41 The Arbiter
Mixed media 11 × 10 in. (27·5 × 25 cm.)

42 Intimate Couple
Mixed media 11 × 10 in. (27·5 × 25 cm.)

43 Woman of the World
Mixed media 11 × 10 in. (27·5 × 25 cm.)

44 The Magic of Ignorance
Mixed media 11 × 10 in. (27·5 × 25 cm.)

45 The Price of Mystery
Mixed media 11 × 10 in. (27·5 × 25 cm.)

46 The Newcomers Game
Mixed media 11 × 10 in. (27·5 × 25 cm.)

47 The Nightwatch
Mixed media 11 × 10 in. (27·5 × 25 cm.)

48 Public Appearances
Mixed media 11 × 10 in. (27·5 × 25 cm.)

49 A Fond Embrace
Mixed media 11 × 10 in. (27·5 × 25 cm.)

50 Man of the World
Mixed media 11 × 10 in. (27·5 × 25 cm.)

51 The Competitor
Mixed media 11 × 10 in. (27·5 × 25 cm.)

52 The Instigator
Mixed media 11 × 10 in. (27·5 × 25 cm.)

53 The Offering
Mixed media 11 × 10 in. (27·5 × 25 cm.)

54 The Knowing One
Mixed media 11 × 10 in. (27·5 × 25 cm.)

55 Prophetic Pastimes
Mixed media 11 × 10 in. (27·5 × 25 cm.)

56 Time to Remember
Mixed media 11 × 10 in. (27·5 × 25 cm.)

57 Heavy Angel
Mixed media 11 × 10 in. (27·5 × 25 cm.)

58 Official Figure
Mixed media 11 × 10 in. (27·5 × 25 cm.)

59 The Settlers
Mixed media 11 × 10 in. (27·5 × 25 cm.)

60 Beaten Champion
Mixed media 11 × 10 in. (27·5 × 25 cm.)

61 The Necklace
Mixed media 11 × 10 in. (27·5 × 25 cm.)

62 The Genetrix
Mixed media 11 × 10 in. (27·5 × 25 cm.)

63 The Oasis
Mixed media 11 × 10 in. (27·5 × 25 cm.)

64 The Timekeeper
Mixed media 11 × 10 in. (27·5 × 25 cm.)

65 The Dancers Dream
Mixed media 11 × 10 in. (27·5 × 25 cm.)

66 Relative Values
Mixed media 11 × 10 in. (27·5 × 25 cm.)

67 The Burning Question
Mixed media 1 × 10 in. (27·5 × 25 cm.)

68 The Foremother
Mixed media 11 × 10 in. (27·5 × 25 cm.)

69 Sea-Goddess
Mixed media 11 × 10 in. (27·5 × 25 cm.)

70 The Relics of Childhood
Mixed media 11 × 10 in. (27·5 × 25 cm.)

71 The Mythmakers
Mixed media 11 × 10 in. (27·5 × 25 cm.)

72 The Calibrators
Mixed media 11 × 10 in. (27·5 × 25 cm.)

73 The Dead of Night
Mixed media 11 × 10 in. (27·5 × 25 cm.)

74 The Scars of Chastity
Mixed media 11 × 10 in. (27·5 × 25 cm.)

75 The Eye of the Prophet
Mixed media 11 × 10 in. (27·5 × 25 cm.)

76 Uninvited Guests
Mixed media 11 × 10 in. (27·5 × 25 cm.)

77 The End of the Game
Mixed media 11 × 10 in. (27·5 × 25 cm.)

78 The Protector
Mixed media 11 × 10 in. (27·5 × 25 cm.)

79 The Luxury of Deceit
Mixed media 11 × 10 in. (27·5 × 25 cm.)

80 Lost in Thought
Mixed media 11 × 10 in. (27·5 × 25 cm.)

81 The Gathering
Mixed media 11 × 10 in. (27·5 × 25 cm.)

82 The Challenge of Existing
Mixed media 1 × 10 in. (27·5 × 25 cm.)

83 The Silent Strategy
Mixed media 11 × 10 in. (27·5 × 25 cm.)

84 The Goddess of Time Passing
Mixed media 11 × 10 in. (27·5 × 25 cm.)

85 The Visionary
Mixed media 11 × 10 in. (27·5 × 25 cm.)

86 The Enigma of Greeting
Mixed media 11 × 10 in. (27·5 × 25 cm.)

87 The New Magician
Mixed media 11 × 10 in. (27·5 × 25 cm.)

88 The Birth of a Legend
Mixed media 11 × 10 in. (27·5 × 25 cm.)

89 Familiar Advice
Mixed media 11 × 10 in. (27·5 × 25 cm.)

90 The Cycle of the Mind
Mixed media 11 × 10 in. (27·5 × 25 cm.)

91 The Keeper of the Totem
Mixed media 11 × 10 in. (27·5 × 25 cm.)

92 Night Games
Mixed media 11 × 10 in. (27·5 × 25 cm.)

93 The Invocation
Mixed media 11 × 10 in. (27·5 × 25 cm.)

94 The Great Goddess
Mixed media 11 × 10 in. (27·5 × 25 cm.)

95 From Time to Time
Mixed media 11 × 10 in. (27·5 × 25 cm.)

96 Seed Warning
Mixed media 11 × 10 in. (27·5 × 25 cm.)

97 The Shy Reaper
Mixed media 11 × 10 in. (27·5 × 25 cm.)

98 The Good Listener
Mixed media 11 × 10 in. (27·5 × 25 cm.)

99 The Emissary
Mixed media 11 × 10 in. (27·5 × 25 cm.)

100 The Gift of Unknown Pleasures
Mixed media 11 × 10 in. (27·5 × 25 cm.)

101 Worldly Figure
Mixed media 11·5 × 8·25 in. (29 × 21 cm.)

102 The Jester Revisited
Mixed media 11·5 × 8·25 in (29 × 21 cm.)

1991

1 The Witness
Mixed media 12 × 10 in. (30 × 25 cm.)

2 The Aspirant
Mixed media 12 × 10 in. (30 × 25 cm.)
Collection Viscount Ivor Windsor,
 Shropshire.

3 Dreams of Power
Mixed media 12 × 10 in. (30 × 25 cm.)

4 Farewell to the Past
Mixed media 2 × 10 in. (30 × 25 cm.)

5 The Innocent
Mixed media 12 × 10 in. (30 × 25 cm.)

6 The New Champion
Mixed media 12 × 10 in. (30 × 25 cm.)

7 The Speculator
Mixed media 12 × 10 in. (30 × 25 cm.)

8 A Lost Moment
Mixed media 12 × 10 in. (30 × 25 cm.)

9 The Procrastinator
Mixed media 12 × 10 in. (30 × 25 cm.)

10 Family Ties
Mixed media 12 × 10 in. (30 × 25 cm.)

11 Strangers in the Desert
Mixed media 12 × 10 in. (30 × 25 cm.)

12 The Players
Mixed media 12 × 10 in. (30 × 25 cm.)

13 The Donor
Mixed media 12 × 10 in. (30 × 25 cm.)

14 Storm Warning
Mixed media 12 × 10 in. (30 × 25 cm.)

15 The Great One
Mixed media 12 × 10 in. (30 × 25 cm.)

16 Symbols of Mortality
Mixed media 12 × 10 in. (30 × 25 cm.)

17 The Awakening
Mixed media 12 × 10 in. (30 × 25 cm.)

18 The Paramour
Mixed media 12 × 10 in. (30 × 25 cm.)

19 The Opportunist
Mixed media 12 × 10 in. (30 × 25 cm.)

20 The Price of Nostalgia
Mixed media 2 × 10 in. (30 × 25 cm.)

21 Decorated Neck-tie

1992

1 Couple (I(a))
Oil on board 10 × 8 in. (25 × 20 cm.)
Collection Mr John Nadler, London.

2 Couple (I(b))
Oil on board 10 × 8 in. (25 × 20 cm.)
Collection Mr John Nadler, London.

3 The Protesters
Mixed media 12 × 10 in. (30 × 25 cm.)

4 Forefathers
Mixed media 12 × 10 in. (30 × 25 cm.)

5 Night Risks
Mixed media 12 × 10 in. (30 × 25 cm.)

6 The Silent Cry for Help
Mixed media 12 × 10 in. (30 × 25 cm.)

7 The Stranger
Mixed media 12 × 10 in. (30 × 25 cm.)

8 The Unexpected Gift
Mixed media 12 × 10 in. (30 × 25 cm.)

9 The Champion
Mixed media 12 × 10 in. (30 × 25 cm.)

10 Days of Wonder
Mixed media 12 × 10 in. (30 × 25 cm.)

11 The Sound of Silence
Mixed media 12 × 10 in. (30 × 25 cm.)

12 The Reclusive Dreamer
Mixed media 12 × 10 in. (30 × 25 cm.)

13 In the Palace of Compromises
Mixed media 12 × 10 in. (30 × 25 cm.)

14 The Imperial Dream
Mixed media 12 × 10 in. (30 × 25 cm.)

15 Night Games
Mixed media 12 × 10 in. (30 × 25 cm.)

16 New Blood
Mixed media 12 × 10 in. (30 × 25 cm.)

17 Free Spirit
Mixed media 12 × 10 in. (30 × 25 cm.)

18 Evangelists on Heat
Mixed media 12 × 10 in. (30 × 25 cm.)

19 The Ethics of the Courier
Mixed media 12 × 10 in. (30 × 25 cm.)

20 Days of Plenty
Mixed media 12 × 10 in. (30 × 25 cm.)

21 The Favourite One
Mixed media 12 × 10 in. (30 × 25 cm.)

22 The Complexity of the Provider
Mixed media 12 × 10 in. (30 × 25 cm.)

23 The New Voyagers
Mixed media 12 × 10 in. (30 × 25 cm.)

24 The Guardian of Pleasure
Mixed media 12 × 10 in. (30 × 25 cm.)

25 The Sheltered Life
Mixed media 12 × 10 in. (30 × 25 cm.)

26 The Fleeting Moment
Mixed media 12 × 10 in. (30 × 25 cm.)

27 The Advisers Lament
Mixed media 12 × 10 in. (30 × 25 cm.)

28 The Dreamtime
Mixed media 12 × 10 in. (30 × 25 cm.)

29 The Price of Friendship
Mixed media 12 × 10 in. (30 × 25 cm.)

30 The Unwanted Vigil
Mixed media 12 × 10 in. (30 × 25 cm.)

31 The Prized Possession
Mixed media 12 × 10 in. (30 × 25 cm.)

32 The Holder of Secrets
Mixed media 2 × 10 in. (30 × 25 cm.)

33 The Best of Enemies
Mixed media 12 × 10 in. (30 × 25 cm.)

34 Manic Impressive
Mixed media 12 × 10 in. (30 × 25 cm.)

35 The Fortune Teller
Mixed media 12 × 10 in. (30 × 25 cm.)

36 The Spectator
Mixed media 12 × 10 in. (30 × 25 cm.)

37 Indoor Games
Mixed media 12 × 10 in. (30 × 25 cm.)

38 The Handmaiden
Mixed media 12 × 10 in. (30 × 25 cm.)

39 The Nostalgia Trap
Mixed media 12 × 10 in. (30 × 25 cm.)

40 The Specialist
Mixed media 12 × 10 in. (30 × 25 cm.)

41 The Consorts
Mixed media 12 × 10 in. (30 × 25 cm.)

42 The Practitioner
Mixed media 12 × 10 in. (30 × 25 cm.)

43 The Aspirant
Mixed media 12 × 10 in. (30 × 25 cm.)

44 The Introspector
Mixed media 12 × 10 in. (30 × 25 cm.)

45 The Holder of Secrets
Mixed media 12 × 10 in. (30 × 25 cm.)

46 The Distant Friend
Mixed media 12 × 10 in. (30 × 25 cm.)

47 The Power Behind the Throne
Mixed media 12 × 10 in. (30 × 25 cm.)

48 The Surgeons Friend
Mixed media 12 × 10 in. (30 × 25 cm.)

49 The Enduring Role
Mixed media 12 × 10 in. (30 × 25 cm.)

50 The First Judgement
Mixed media 12 × 10 in. (30 × 25 cm.)

51 The Multiplier
Mixed media 12 × 10 in. (30 × 25 cm.)

52 The Leaders Whim
Mixed media 12 × 10 in. (30 × 25 cm.)

53 Nightwatchers
Mixed media 12 × 10 in. (30 × 25 cm.)

54 The Lunatock
Mixed media 12 × 10 in. (30 × 25 cm.)

55 The Sea-gazer
Mixed media 12 × 10 in. (30 × 25 cm.)

56 The Obsessional
Mixed media 12 × 10 in. (30 × 25 cm.)

57 The Last Dreamer
Mixed media 12 × 10 in. (30 × 25 cm.)

58 Last of the Line
Mixed media 12 × 10 in. (30 × 25 cm.)

59 The Last Message
Mixed media 12 × 10 in. (30 × 25 cm.)

60 Partners
Mixed media 12 × 10 in. (30 × 25 cm.)

61 Gesticulator
Mixed media 12 × 10 in. (30 × 25 cm.)

62 The Idealist at Bay
Mixed media 12 × 10 in. (30 × 25 cm.)
Private collection.

1993

1 The Exquisite Corpse
Oil on canvas 22 × 16 in. (55 × 40 cm.)

2 The Night-watch
Oil on board 16 × 12 in. (40 × 30 cm.)

3 The Inheritor
Oil on canvas 16 × 12 in. (40 × 30 cm.)

1994

1 Powermonger
Mixed media 12 × 10 in. (30 × 25 cm.)

2 The Guest
Mixed media 12 × 10 in. (30 × 25 cm.)

3 The Performer
Mixed media 12 × 10 in. (30 × 25 cm.)

4 Ambivalent Figure
Mixed media 12 × 10 in. (30 × 25 cm.)

5 The Outsider
Mixed media 12 × 10 in. (30 × 25 cm.)

6 The Gift-giver
Mixed media 12 × 10 in. (30 × 25 cm.)

7 The Witness
Mixed media 12 × 10 in. (30 × 25 cm.)

8 Waiting in Line
Mixed media 12 × 10 in. (30 × 25 cm.)

9 The Lost One
Mixed media 12 × 10 in. (30 × 25 cm.)

10 Separate Lives
Mixed media 12 × 10 in. (30 × 25 cm.)

11 The Juggler
Mixed media 12 × 10 in. (30 × 25 cm.)
Collection Mr Terry Bolam, Stoke-on-Trent.

12 The Window-gazer
Mixed media 12 × 10 in. (30 × 25 cm.)

13 The Escort
Mixed media 12 × 10 in. (30 × 25 cm.)

14 The Mariner
Mixed media 12 × 10 in. (30 × 25 cm.)

15 The Inmate
Mixed media 12 × 10 in. (30 × 25 cm.)

16 Night-game
Mixed media 12 × 10 in. (30 × 25 cm.)

17 The Gift-givers
Mixed media 12 × 10 in. (30 × 25 cm.)

18 The Victor
Mixed media 12 × 10 in. (30 × 25 cm.)

19 The Messenger
Mixed media 12 × 10 in. (30 × 25 cm.)

20 The Survivor
Mixed media 12 × 10 in. (30 × 25 cm.)

21 Old Friends
Mixed media 2 × 10 in. (5 × 25 cm.)

22 Doppelganger
Mixed media 12 × 10 in. (30 × 25 cm.)

23 Sectarian Dreamer
Mixed media 12 × 10 in. (30 × 25 cm.)

24 Ambitious Figure
Mixed media 12 × 10 in. (30 × 25 cm.)

25 The Last Game
Mixed media 12 × 10 in. (30 × 25 cm.)

26 Foreigner
Mixed media 12 × 10 in. (30 × 25 cm.)

27 The Arbiters of Anxiety
Mixed media 11·5 × 8·25 in. (29 × 21 cm.)

28 Nocturnal Games
Mixed media 11·5 × 8·25 in. (29 × 21 cm.)

29 The Experimenter
Mixed media 11·5 × 8·25 in. (29 × 21 cm.)

30 Deceptive Figure
Mixed media 11·5 × 8·25 in. (29 × 21 cm.)

1995

1 Figures of Alarm
Mixed media 10 × 3 in. (25 × 7·5 cm.)

2 Quartet
Mixed media 10 × 3 in. (25 × 7·5 cm.)

3 Floating Figures
Mixed media 10 × 3 in. (25 × 7·5 cm.)

4 The Hostess Regrets
Mixed media 14 × 10 in. (35 × 25 cm.)

1996

1 Phoenix
Fossilized jaw bone and plastic eye. Height:
 9 in. (23 cm.); length: 13 in. (32·5 cm.)

2 Bird Fear
Black and white ink on blue paper
 11 × 8 in. (29 × 21 cm.)
Collection City Museum and Art Gallery,
 Stoke-on-Trent.

3 Something for the Weak End
Oil on canvas 24 × 36 in. (60 × 90 cm.)

Index

Page numbers in bold type refer to illustrations.